The Art of Gold
The Legacy of Pre-Hispanic Colombia

The Art of Gold
The Legacy of Pre-Hispanic Colombia
Collection of the Gold Museum in Bogotá

Photos
Juan Mayr

Texts
Clara Isabel Botero, Roberto Lleras Pérez,
Santiago Londoño Vélez and Efraín Sánchez Cabra

TEZONTLE

FONDO DE CULTURA ECONÓMICA

México - Argentina - Brasil - Chile - Colombia - España
Estados Unidos - Guatemala - Perú - Venezuela

BANCO DE LA REPÚBLICA
MUSEO DEL ORO - BOGOTÁ D. C.

SKIRA

Design
Marcello Francone

Editing
Timothy Stroud

Layout
Serena Parini

Translations
Language Consulting Congressi srl,
Milan, by Leslie Rey

First published in Italy in 2007 by
Skira Editore S.p.A.
Palazzo Casati Stampa
via Torino 61
20123 Milano
Italy
www.skira.net

© Banco de la República, 2007
© Fondo de Cultura Económica, 2007
Carretera Picacho-Ajusco 227, 14200
México, D.F.
www.fondodeculturaeconomica.com
© Ediciones Fondo de Cultura
Económica Ltda.
Carrera 16 No. 80-18, Bogotá, Colombia
www.fce.com.co
© 2007 by Skira editore

Printed and bound in Italy. First edition

ISBN-13: 978-88-7624-776-7
ISBN-10: 88-7624-776-9

Distributed in North America by Rizzoli
International Publications, Inc.,
300 Park Avenue South, New York,
NY 10010.
Distributed elsewhere in the world
by Thames and Hudson Ltd., 181a High
Holborn, London WC1V 7QX,
United Kingdom.

Credits

Photos of the Gold Museum Collection
Juan Mayr Maldonado

Acknowledgements
Andrés Mayr Herrera
Clark Manuel Rodríguez

Texts
Clara Isabel Botero
Roberto Lleras Pérez
Santiago Londoño Vélez
Efraín Sánchez Cabra

Captions for Photos of the Gold Museum Collection
Luz Alba Gómez del Corral

Technical data sheets, Gold Museum Collection
Sandra Patricia Mendoza

Photos
Fabián Alzate
Photographic Archive of the Duque Gómez family.
Photographic Archive of the Gold Museum of the Banco de la República.
ESRI–Data and Maps, 2004/PROSIS PROCALCULO/ La Silueta.
Andrés Hurtado
Óscar Monsalve
Guillermo Muñoz
NASA
Lothar Petersen, Archive of the Colombian Institute of Anthropology and History.
Diego Samper
Alberto Sierra Restrepo
Rudolf Schrimpff
Gerardo Reichel-Dolmatoff, Archive of the Luis Ángel Arango Library.
Photographic Archive Villegas y Asociados S.A.

Illustrations
Mateo López Parra

Maps and timeline
Marco Fidel Robayo Moya

Sources of illustrations and maps
Ancient Fund of the National Library of Colombia, Bogotá.
The Royal Library, Manuscripts and Rare Books, PO Box 2149, DK-1016 Copenhagen K, Denmark, www.kb.dk/elib/mss/poma/
The Pierpont Morgan Library, New York. Photo: David A. Loggie.
Bildarchiv Preussischer Kulturbesitz, Berlin, Germany.
Bodleian Library, Oxford University, United Kingdom.
Cop. Bibliothèque centrale du Muséum National d'Histoire Naturelle Paris, 2005, Fonds Bibliothèque du Musée de l'Homme.
Vue du lac de Guatavita, A. Humboldt, Thibault F, 1813.
Album of indigenous antiquities, Photographic Archive of the Gold Museum of the Banco de la República, Bogotá.

Consultancy for illustrations, maps and photographs of current indigenous groups

Gold Museum:
Roberto Lleras Pérez
Luz Alba Gómez del Corral
Sandra Patricia Mendoza
Juanita Sáenz Samper
María Alicia Uribe Villegas

Sonia Archila Montañez
Eudocio Becerra Vijidima
Patricia Navas
Leonor Herrera Ángel
Margarita Rosa Serje de la Rosa

Contents

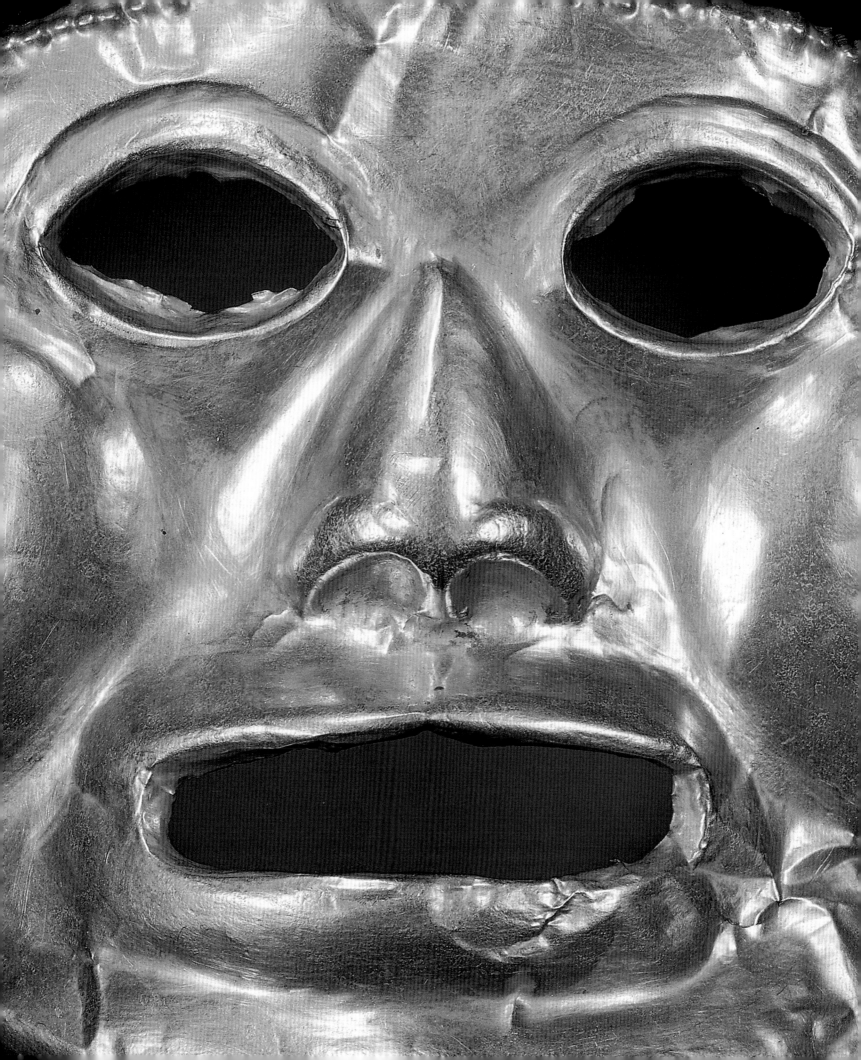

On the Trail of El Dorado

On the trail of El Dorado: travellers, scientists and antiquarians

The astonishment and curiosity that the Spaniards' armour, lances and silver Christ figures produced in the sixteenth century inhabitants of America was in sharp contrast to the European fascination at the sight of men and women who glistened in the tropical sun, decked from head to foot in gold, feathers and multi-coloured beads. This was a confrontation between two different concepts of the world, two systems of thought, two ways of life. The prehispanic societies that the Europeans found in the territory currently known as Colombia created their own symbolic, iconographic and visual universe, which was represented masterfully in objects made by their goldsmiths.

During four centuries of colonial life, the attitudes that Spaniards, and later Creoles (Latin Americans of Spanish extraction), assumed towards the miscellany of goldwork objects produced by the indigenous societies—and found in their temples, homes, burial sites and places of offering—were essentially typified by two overlapping elements: the search for El Dorado and religious ideas on Evil. A reference to the "golden man" arose very early in the *Historia general y natural de las Indias* (General and Natural History of the Indes) in which Gonzalo Fernández de Oviedo reported that a native in Quito had told him of the existence of a golden king who "with a certain gum or liquid that smells very nice greases himself every morning and on that grease he places ground gold and his whole person is covered in gold from his heels to his head". Later the chronicler Juan de Castellanos, in his *Elegías de varones ilustres de las Indias* (Elegies on Illustrious Men of the Indes), indicated the existence of sacrifices in lakes in the Province of Bogotá and that "a certain king, without clothing and on a raft, went into a lake to make an offering […] and on him a quantity of ground gold from his feet to his forehead, he was radiant as a sunbeam". The legend of El Dorado was reaffirmed years later in the *Noticias historiales de las conquistas de tierra firme en las Indias* (Historical Records of the Conquests of the Mainland in the Western Indes) written between 1621 and 1623 by Fray Pedro Simón, who, besides repeating the claimed existence of a lake where a *cacique* went on a raft completely covered in powdered gold and made offerings, also indicated the existence of the lake of Guatavita as the "more frequented and

famous adoratory". Juan Rodríguez Freyle put together the accounts of the previous chroniclers and located the ceremony of the golden man who made offerings in the lake of Guatavita, as he related in 1636:

"In that lake a large raft of rushes was made, decking it out with everything spectacular that they had […] they undressed the heir, greased him with a sticky mixture and covered him with powdered and ground gold, in such a way that he was all covered in this metal. The golden Indian made his offering, tossing all the gold that he had into the lake […]. This the Indian did in the ceremony with which they received the new chosen one who was recognised as their master and prince. It is from this ceremony that the celebrated name of El Dorado is taken that has cost so many lives and properties".

These stories created interest among the Europeans, along with greed over the riches to be found in this lake and other offering places; they were also of overriding importance in the choice of the routes taken by the conquistadors in Colombian territory, to whom finding the legendary golden man became a high priority. Starting from 1550, with the establishment of the *Real Audiencia de Santa Fe* (Spanish Colonial High Court), the objects manufactured by indigenous peoples were divided into two main categories: those made with feathers, wood, shell and bone which were considered as "idols of the devil" and therefore systematically confiscated from their owners, exorcised and destroyed; those made of gold and emeralds, of great interest to Europeans, were conserved and then melted down in the currency houses. For more than three centuries, a veil of silence covered the vestiges of the prehispanic cultures.

At the end of the eighteenth century an early re-evaluation of the ancient world of Colombia, arose with the writings of Padre Antonio Julián on Tairona society, in his work *La Perla de América, la provincia de Santa Marta* (The Pearl of America, the Province of Santa Marta), the description of the archaeological site of San Agustín by Francisco José de Caldas and the writings on the Muisca religion by Father José Domingo Duquesne. There thus emerged a concern for the preservation and study of the objects of the past, which began

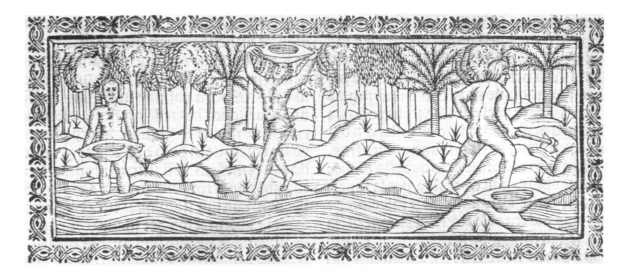

Indians taking gold out of the rivers, from the work *Crónica de las Indias: la hystoria general de las indias*. Gonzalo Fernández de Oviedo, Seville, 1547. (Ancient Fund of the National Library of Colombia, Bogotá)

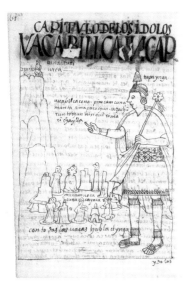

Capítulo de los ídolos, by Guamán Poma de Ayala. (The Royal Library, Manuscripts and Rare Books, Copenhagen, Denmark)

to be considered very tentatively by a handful of learned people as "antiquities" and "objects of science". In 1801, Alexander von Humboldt, besides describing the famous lake of Guatavita from a scientific and naturalistic viewpoint, emphasised the indigenous monuments of three American regions: those of Mexico, Peru and the "monuments of the Muiscas Indians, ancient inhabitants of the high plateaux of Bogotá".

The nineteenth century and the rediscovery of the past

From the time of independence from Spain in 1819, and during the rest of the nineteenth century, attitudes towards and conceptions of prehispanic objects were based on the works of naturalists, physicians and historians and the descriptions of Colombian and foreign travellers who found prehispanic sites or objects and published their discoveries. From 1850, a spirit of curiosity and scientific research in relation to the objects of goldwork began to take shape in Colombia. The pioneer was physician, metallurgist and chemist Ezequiel Uricoechea, with his work *Memoria sobre las antigüedades neogranadinas* (1854). In this work, published in Berlin, Uricoechea proposed to highlight objects of goldwork as "antiquities" that it was necessary to preserve, emphasising the metalworking technologies of the *tunjos*, objects used as votive offerings by the Muiscas. As a result of work conducted in Antioquia by the Colombian Chorographic Commission between 1850 and 1859, Italian geographer Agustín Codazzi

unearthed a tomb that seemed to be an "underground temple" on the site of Pajarito, Yarumal. There a variety of objects were found, including a *poporo* (a lime container, now in the Gold Museum), which was acquired during the nineteenth century by Antioquian businessman Coriolano Amador. From the middle of the century, tomb-robbing in the regions in the south of Antioquia and Caldas reached its peak as an economic activity, framed within the process of colonisation of frontier lands by emigrants coming from the central regions of Antioquia. The search for gold accompanied the curiosity of the Antioquian settlers, for whom tomb-robbing became an established industry with experts whose experience was passed down from generation to generation. Several Antioquians formed important archaeological collections, of which an outstanding one was begun in 1840 by merchant Leocadio María Arango. Through the exchange of objects from his warehouses, this man was able to amass an extraordinary and valuable collection with which he formed a private museum of national and international renown and ended up with 246 gold, 2 silver, 160 stone and 2,600 ceramic objects. In the same period, in 1856, in the high plateaux of Cundiboya, some peasants came upon a Muisca raft made of gold in the lake of Siecha. This raft, used in the ceremony of offering and consecration of the future *cacique*, was, according to physician and researcher Liborio Zerda, reliable proof of the existence of the ceremony of El Dorado that the chroniclers had described:

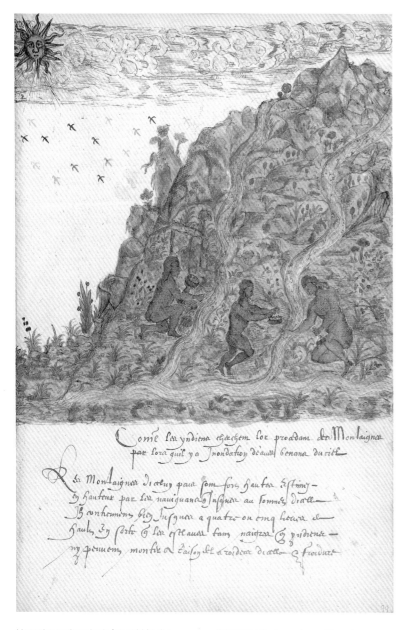

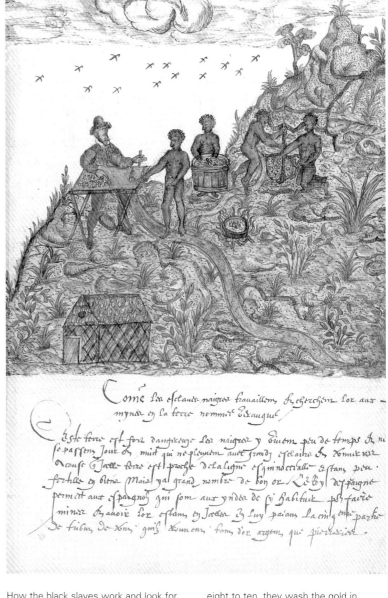

How the natives look for gold in the mountains when there are floods that come from the sky. The mountains of this region are very high. The navigators estimate that they have a height of near to four or five leagues up to the peak, and the black slaves and the Indians could not reach there due to the steep terrain and the cold temperatures. In these high mountains there is a large quantity of gold that is recovered in the rain that forms small streams that carry gold in small grains and that the Indians collect in the lower part of the mountains in small vessels like the one that can be appreciated here.

It represents a great wealth and convenience, besides the fact that the water that comes down from the mountains is extremely good to drink and does not harm any person. It is very nutritious, because it has been with the gold and it has the virtue that those who drink it urinate it quickly and it liberates stones and other things from their kidneys.
(The Pierpont Morgan Library, New York. MA 3900, F 99. Photo: David A. Loggie)

How the black slaves work and look for gold in the mines in the land called Verugua (Panama). This region is very dangerous. The Negroes live there for a short time and no day passes without rain, lightning and thunder, because this land is very near to the equinoxial line. Not being fertile in products, this land has a lot of gold. The king of Spain allows the Spaniards in the Indies to settle to have mines and to possess the gold, provided they pay the tribute of one fifth of all that they find in gold, silver and precious stones. The Spaniards do not force nor permit the Indians to work in the mines, fearing that they might know the value of the gold, since if they were to know it, they would go to war and they would look for it in the country. The Spaniards buy a large number of Negroes from Africa to be used as slaves and when the Negroes have finished their day's work, on coming out of the mines, in groups of

eight to ten, they wash the gold in barrels half full of water. Then they pour it into an iron vessel and they place it by the fire for it to dry off. When it is dry, they take it to the Steward, whom they call "Maitre d'hotel", to see and know, according to the weight, how much gold there is. They must give him, as tribute, the value of the gold that corresponds to the weight of three ducats per day. If it so happens that they do not find gold on one day, they must in any case pay the Steward the weight in gold that corresponds to three ducats. If they recover a greater quantity, they will make a gain.
(The Pierpont Morgan Library, New York. MA 3900, F 100. Photo: David A. Loggie)

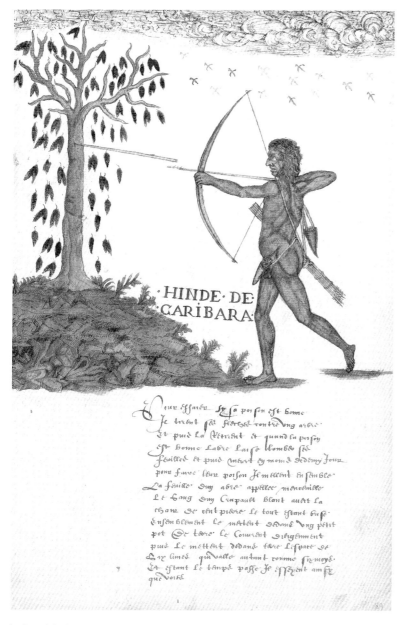

Indian of Caribara. To test whether the poison is effective, they stick their arrows into a tree and then retract them. When the poison is effective, the leaves of the tree fall off and the tree dies in less than half a day. To make the poison, they mix the leaf of a tree called "mensenilla", the blood of a toad and the meat of a centipede, crush it and put it in a small ceramic vessel, covering it carefully and they bury it in the ground for six "limas", which is approximately six months. When this time has gone by, they test the arrows, as can be seen here.
(The Pierpont Morgan Library, New York. MA 3900, F 89. Photo: David A. Loggie)

The ceremonies of the Indians,
engraving by Theodor de Bry.
(Bildarchiv Preussischer Kulturbesitz, Berlin, Germany)

The burial of a king,
engraving by Theodor de Bry.
(Bildarchiv Preussischer Kulturbesitz, Berlin, Germany)

The royal workshop of gold objects,
engraving by Theodor de Bry.
(Bildarchiv Preussischer Kulturbesitz, Berlin, Germany)

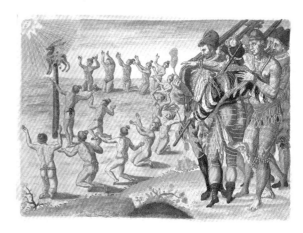

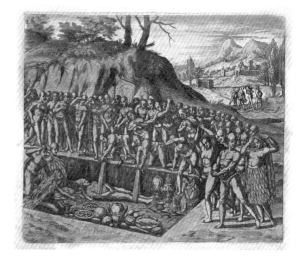

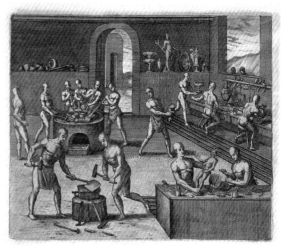

Guatavita Lagoon
(*Vue du lac de Guatavita*, A. Humboldt,
Thibault F., 1813)

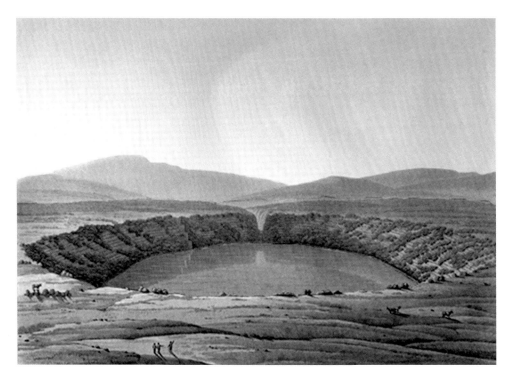

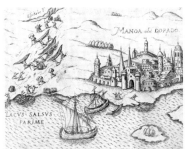

The fabulous city of Manoa or El Dorado.
(Bodleian Library, Oxford University,
United Kingdom)

Carib Indians by Benoit.
(Cop. Bibliothèque centrale du Muséum
National d'Histoire Naturelle, Paris, 2005,
Fonds Bibliothèque du Musée
de l'Homme)

"It undoubtedly represents the religious ceremony of the chieftain of Guatavita surrounded by Indian priests on the rush raft that took them to the centre of the lake on the day of the offering. The smallest figure in front of the chieftain probably represents some dignitary or member of the royal family, responsible for carrying the objects that were to be thrown into the lagoon as offerings".

The raft came into the possession of the German consul in Bogotá, Salomón Koppel, who sent it to the Ethnographic Museum in Berlin at the end of the 1880s. During the trip to Berlin, the raft was destroyed in a fire in the port of Bremen.

In much the same way as in the colonial period, the dreams, delusions and greed of the tomb-robbers in the regions of Antioquia and Quindío created a new myth of El Dorado, and in their search they plundered tombs and sold thousands of objects to be melted down and end up as ingots in the currency houses. At the same time, though slowly and tentatively, the temporal horizon of Colombian history began to be extended during the nineteenth century: it was accepted that the past of the Republic of Colombia was not limited to the four centuries since the Spanish Conquest, and as a consequence the conceptions of and attitudes towards prehispanic objects and monuments were re-evaluated. The "idols of the devil" that were melted down in the colonial period became *relics* and *antiquities* that it was necessary to conserve and investigate.

A new understanding of the past

Interest in the archaeology, ethnology, ethnohistory and linguistics of the Americas by European academics became established in the early decades of the twentieth century. German archaeologist and ethnologist Theodor Konrad Preuss and North American archaeologist John Alden Mason were in Colombia conducting the first systematic investigations—in San Agustín (1913–14) and the Sierra Nevada de Santa Marta (1922). From 1930, the influence of American thought, especially the work of Manuel Gamio, Moisés Castro and José Carlos Mariátegui, considerably influenced intellectual and artistic sectors, causing the emergence of a view that the indigenous peoples and their artefacts were the source of nationality. In 1938 the Colombian government set up the National Archaeological Service, representing a first step towards the institutionalisation of archaeological investigation using scientific methods, and, to mark the 400th anniversary of the foundation of Bogotá, the first archaeological and ethnographic exhibition in Colombia was carried out. In 1941 the government created the National Ethnological Institute under the direction of French ethnologist Paul Rivet. It was there that the first professional archaeologists were trained, thanks to the Colombian ethnologist Gregorio Hernández de Alba and German Justus Wolfram Schottelius. The immensity of the virgin territory that was Colombia as regards to archaeological and ethnographic studies was, for the first generations of archaeologists and ethnologists of the National Ethnological Institute,

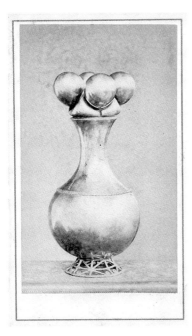

Visiting card of the poporo quimbaya.
Photo by Wills and Restrepo.
(Personal archive)

Album of indigenous antiquities
presented by the Government of
Colombia in the Archaeological
Exhibition, Madrid 1892. (Album of
indigenous antiquities, photographic
archive, Gold Museum of the Banco de
la República, Bogotá)

Luis Duque Gómez in San Agustín, 1945.
(Duque Acosta family archive)

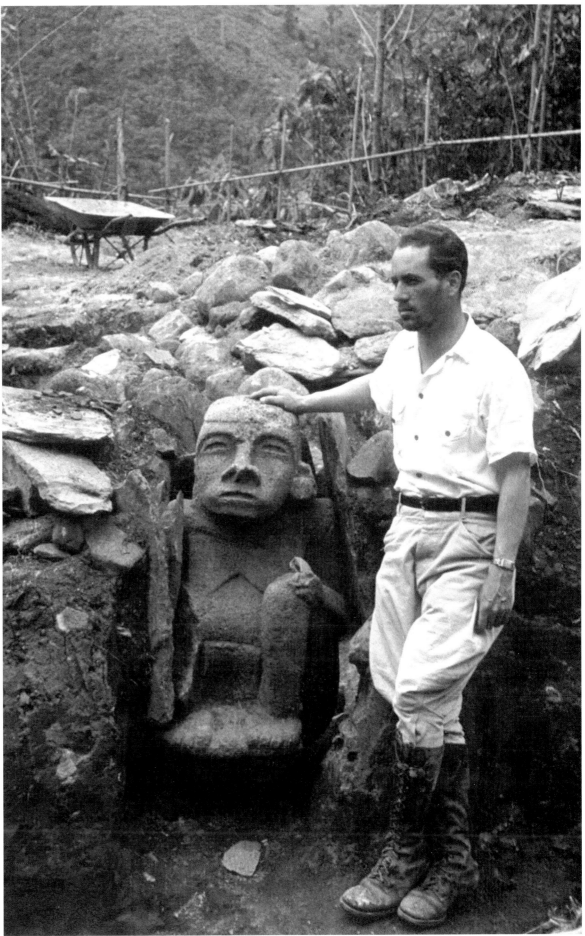

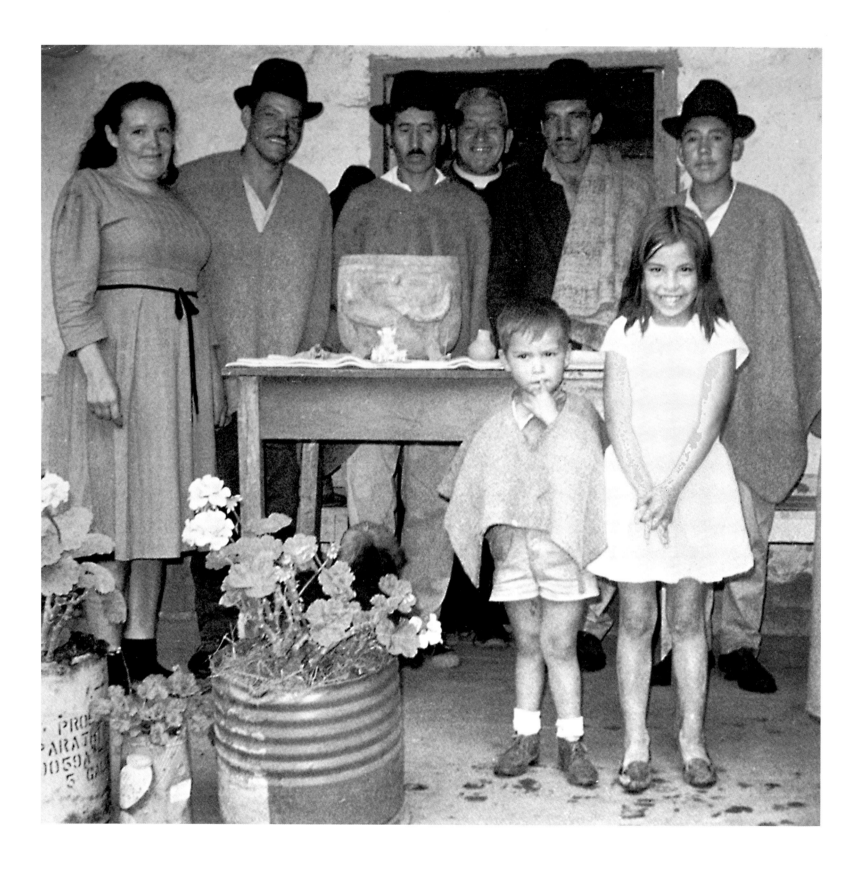

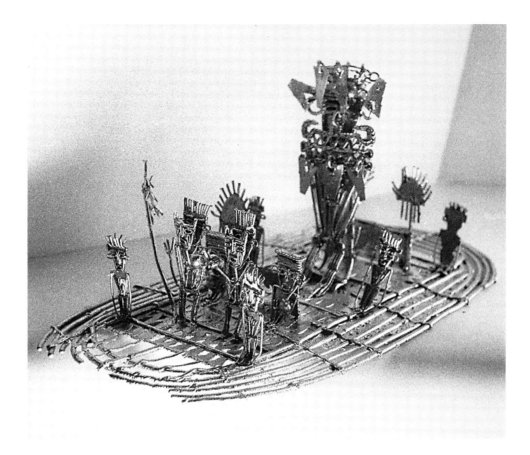

the point of departure for a life devoted to scientific investigation. From the Sierra Nevada de Santa Marta and the plains of the Caribbean and from San Agustín to Santander, these investigators travelled all over Colombia, overcoming difficulties of all kinds in order to record, analyse and publish the results of their work. Systematic excavations of a stratigraphic type began and field reports multiplied. The creation of regional ethnological institutes in Magdalena, Antioquia, Cauca and the Atlantic region consolidated the regional archaeology. The Ethnological Institute of Magdalena had a fundamental role in this regard; within its sphere, beginning in 1954, Gerardo Reichel-Dolmatoff and his wife and colleague Alicia Dussán conducted a systematic research and a plan for excavations over an area extending from lower Magdalena to the Gulf of Urabá. This work changed the country's archaeological panorama and its significance in the American context. Through their excavations they demonstrated the major importance of the Caribbean Coast in sedentarisation processes and in the emergence of agriculture and pottery, not only in Colombia but in South America generally. Meanwhile, the studies in other regions of the country provided a fuller view of the various cultural sequences in these regions. This is the case of San Agustín, the Cauca Valley, the Pacific Coast and the high plateaux of Cundinamarca and Boyacá, among others. In 1969, the discovery of a gold Muisca raft, on which there appears a central figure accompanied by his retinue, supported the stories of the El Dorado myth with a real representation of the consecration of a Muisca cacique.

Colombian archaeology has expanded over the last forty years, largely thanks to the patronage of the Foundation of National Archaeological Investigations of the Banco de la República, founded in 1971. The understanding of the prehispanic past was significantly increased; today, at the beginning of the twenty-first century, we have a chronological framework ranging from the first known occupation of the territory by hunter-gatherer groups until the configuration of the most important chiefdom societies; furthermore, the regional periodisation has been refined, as has its characterisation in terms of socio-cultural processes. The re-evaluation of the prehispanic period has been of immense importance for Colombia over recent decades. There has been a change in terms of national identity and the way in which Colombians perceive their own society, a society that has come to value its roots in the ancient prehispanic societies and to consider the prehispanic metalwork of Colombia—investigated, conserved and exhibited to the public by the Gold Museum of the Banco de la República—as one of the marvels of ancient America.

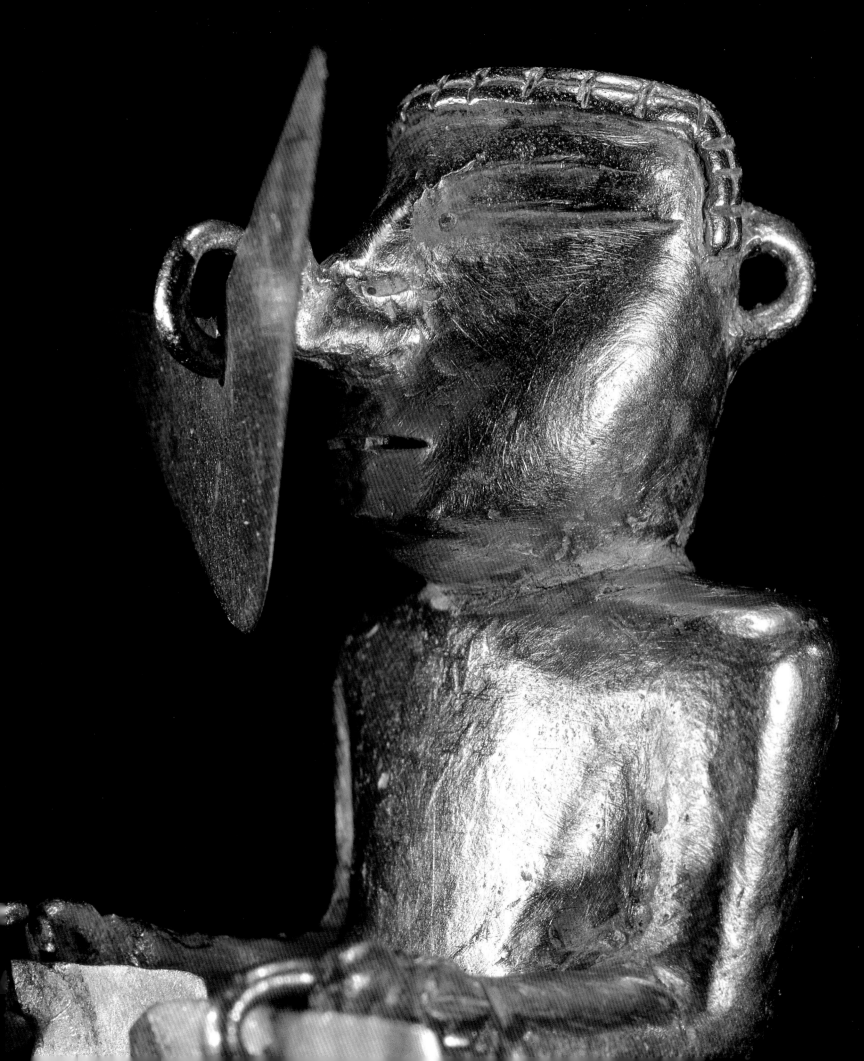

Colombia in the World

Geographical location

Photo of America (NASA photo)

Photo of Colombia with archaeological zones (Photo: PROSIS)

When the first inhabitants arrived in the territory of what today is Colombia, nearly fifteen thousand years ago, they found an extraordinarily diverse geographical environment offering resources and possibilities of all kinds. The key to the success of the Colombian territory for adaptation by human groups has always been its heterogeneity, for, though the location within the tropical climate band implies a climate of warm, stable temperatures, in Colombia all possible variations occur. The existence of the mountain ranges, with their offshoots and inter-Andean valleys, together with the combined influence of the Pacific Ocean and the Caribbean Sea, allowed the development of multiple ecosystems and local forest formations, which differed considerably from each other.

The very special location of Colombia in the north-western corner of the South American continent, crossed by the Andes and bathed by two seas, transformed it early on into a strategic area. What today is Colombian territory participated, at its southern end, in the coast-mountain-forest linear scheme that characterises the Andean region and that allows rapid displacements between different thermal floors over short distances. In the north, on the other hand, the crossings were facilitated along the river valleys to end up in the plains of the Caribbean. In the east, the endless plains of the Meta and Arauca communicate with the region of the Orinoco and the Guayana Massif. In the same direction, a little further south, following the courses of the rivers that have their sources in the Andes, we enter the wonderful world of the Amazon Forest. In the infinite variability of the landscape, everything is connected and intertwined, opening up paths and spaces that the original inhabitants were able to exploit well.

For the first Americans, heterogeneity, far from being a problem, was an absolute advantage. Archaeological investigations have discovered that in some areas, such as the Caribbean coast, even before the discovery of agriculture, the inhabitants were able to remain in stable settlements for centuries, since the various surrounding ecological environments offered them abundant food. When this was scarce in one environment, for example in the marshes, then they could resort to the rivers, the sea, the savanna, the mangrove swamp or the forest and so ensure their survival without the need to move over long distances.

When our ancestors began to domesticate plants and to make agricultural cultivations, the

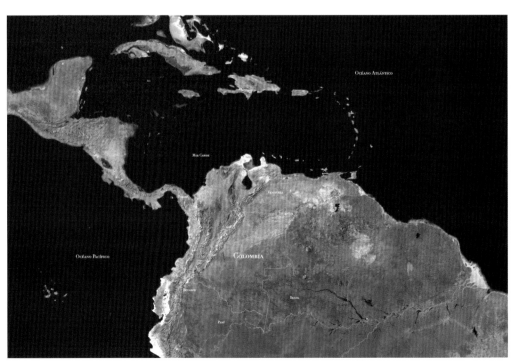

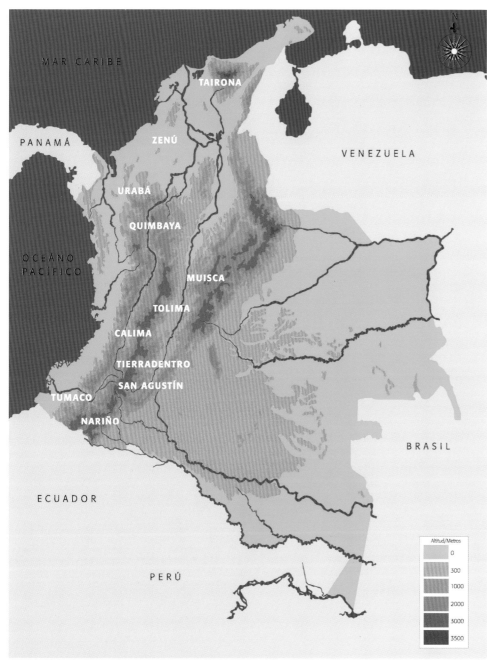

MAR CARIBE

PANAMÁ

OCÉANO
PACÍFICO

TAIRONA

ZENÚ

URABÁ

QUIMBAYA

MUISCA

TOLIMA

CALIMA

TIERRADENTRO

SAN AGUSTÍN

TUMACO

NARIÑO

VENEZUELA

BRASIL

ECUADOR

PERÚ

Altitud/Metros

| 0 |
| 300 |
| 1000 |
| 2000 |
| 3000 |
| 3500 |

Map of Colombia with archaeological
zones

diversity of the territory was also favourable to
them: there were warm climates for the domes-
tication of cotton, temperate ones for maize, cold
ones for potatoes, dry ones for fique (a textile
plant), and humid ones for yucca. This same di-
versity influenced the conformation of local sub-
sistence patterns and, in the long term, regional
cultures to suit their environments. In many cas-
es, however, the communities opted to extend
over various different environments. The Muiscas,
in the Eastern Cordillera, cultivated maize and
potato in the cold thermal floor, but they also
kept crops of cotton and coca in the temperate
lands of the slopes of the Magdalena Valley and
hunted deer and rodents in the eastern plateaux.

Of course, not everything was always so
favourable. Archaeology records periods of ex-
treme climatic changes that caused major diffi-
culties to the indigenous populations. On the
plains of the north there were seasons in which
the lashing of hurricanes from the Caribbean
caused serious flooding, while the climatic in-
versions of the phenomena of El Niño and La
Niña in the Pacific Ocean caused ruined crops
and razed whole valleys. Prolonged periods of
drought eroded and impoverished the land on the
eastern slope of the Sierra Nevada de Santa Mar-
ta and then, as today, cave-ins and avalanches oc-
curred from time to time. But not only the climate
affected the lives of the prehispanic inhabitants;
there are areas in which volcanoes were particu-
larly active in the past, and it is believed that the
volcanic chain that crosses the Andean area in the
current Department of Nariño made permanent
human settlements in that region practically im-
possible until the early centuries AD. In the peri-
od when the Spanish conquistadors travelled
through the centre of the country, the recollections
of the terrible eruptions of the Nevado del Ruiz
volcano were still fresh in the memories of the na-
tive peoples.

The geography of the country, generous and
threatening at the same time, marked its inhab-
itants and offered them the opportunity to con-
struct their lives in a thousand different forms,
many of them represented in the pieces of the col-
lection of the Gold Museum. This natural and his-
torical feature still endures today.

Cultures of Pre-Hispanic Gold

Symbolism and aesthetics
in the ancient metalwork of Colombia

The symbolic value of gold

The Old World conceived gold as a sign of wealth that was the embodiment par excellence of what was scarce and coveted. The economic might of nations was measured by their capacity to accumulate precious metals and the search for it in distant lands prompted a great colonial expansion by the major powers.

In contrast with this appreciation in terms purely as a commodity, for the prehispanic aboriginals of Colombia gold had a profound symbolic value. Its colour and shine led to an analogy being established with the Sun, the golden disk, the father of gold and a powerful symbol of fertility. The physical and chemical properties of the metal enabled various textures and colour tones to be created—from pale yellow to reddish hues—that were integrated into the political functions and rituals of the objects produced. Gold objects have been found mainly in sepulchres of various types, as well as in caves, places of worship and the foundations of ritual constructions.

The goldsmiths were anonymous transformers who converted profane metals into sacred forms of high cultural and artistic significance. With them they produced two major types of objects: simple ones and complex ones. Included among the simple ones, which are the most abundant, are a large variety of personal decorations, such as nose ornaments, ear ornaments, breastplates and pendants, used by the common people, as well as some tools. The complex objects are highly attractive and elaborate as regards manufacturing technology and design; they were intended for important figures such as rulers, shamans and respected elders. Included among these objects are body ornaments, some musical instruments, emblems of rank and power, figures for sacred offerings and containers for the consumption of ritual substances.

The size, level of elaboration and quantity of metal objects that were possessed indicated power and membership of a social elite. The attractive face and body ornaments that modified the appearance of those who used them and the exclusive access to ritual and prestige objects rendered visible and enhanced the authority of the wearer.

In their ritual function, the votive figures, the utensils for the consumption of hallucinogens, the emblems of power and the adornments for sculptures, constructions and pottery all expressed mythical conceptions of the Universe, human beings, animals and fertility, and reflected the idea of *transformation*, which was a fundamental concept in the prehispanic mentality. In this, the crucial character was the shaman, the agent of a set of beliefs and religious practices that brought the Cosmos, Nature and Man into direct relationship. An expert on the tradition, he was attended in his flight by assistant beings—generally representations of the "spirits" of birds of prey—and he possessed special powers that enabled him to act as a healer, mediator, guardian of fertility and the balance of natural forces. By the use of psychoactive substances, he experienced the sensation of separation between the spirit and the body, transforming himself in his imagination into an animal with mythical attributes that "travelled" to other dimensions.

Geometry and figuration

The existence of regional aesthetics, each with their own formal characteristics, is a distinctive feature of the ancient metalwork of Colombia. Two major iconographic groupings are found in it: geometrical decorations and figurative representations. The most frequently occurring geometrical elements are circles, semicircles, ovals and half-moons. Lines, points, rectangles, squares, rhombuses, spirals, steps, crosses, chequered grids and stars with several points also appear. This wide repertoire of forms, present with varying degrees of importance in the metalwork, pottery, painting and textiles, could be a system of abstract expressions of mythical thought, perhaps based on schematisations of phenomena from nature and certain human products such as weaving. Beyond its immediate utilitarian functions, weaving was characterised by defined models of composition, the repeated application of basic principles of design, and a conscious aesthetic sense.

The figuration was to meet descriptive or expressive purposes, and frequently sought to develop volumetric values by the enhancement of

light, shade and texture. It was based on symmetrical compositions around a central axis, which we may suppose to reveal a deliberate search for order, harmony and balance. The anthropomorphic and zoomorphic pieces, and the combinations of the two, show varying degrees of realism, stylisation and fantasy, starting from the aesthetic interpretation of the peoples, the natural habitat, and the plant and animal world. Although it is the small objects that predominate, these have monumental qualities due to the handling of the proportions of their parts with respect to the whole.

The human figure was one of the most frequent motifs, starting from stylistic conventions that seem to give precedence to social rather than individual ideals. There was a major interest in creating typologies or icons, the anatomical characteristics of which affirm cultural and symbolic features. Seated or standing, they are frequently characterised by their rigidity, frontal orientation and absence of facial expression. The body may show body painting, arm and leg ligatures or cranial deformations; and the posture of the hands, arms and feet may have a meaning. When integrated with zoomorphic motifs, this expresses the idea of transformation. In some archaeological areas it is the male figures that predominate, while in others females are more frequent, illustrating the differences in the roles performed by the two sexes.

Two tendencies may be distinguished in the figuration: the naturalistic and the interpretative. The former case is manifested in objects that faithfully reproduce human forms and features as well as activities or experiences characteristic of the human condition. In the latter case, the representation is simplified to the maximum until it approaches geometrical forms, but without losing essential figurative attributes in the contours or body masses, as is the case of the anthropomorphic or ornithomorphic patterns and their combinations. Less frequent, but of great aesthetic and cultural interest, are the objects based on products from the plant realm, such as pumpkins, calabashes, flowers and types of maize, as well as representations of dwellings and human groups in ritual activities.

Zoomorphic figures abound with the repeated presence of various species of birds, which were considered shamanic animals due to their ability to fly. There are also felines, snakes, toads, frogs, ducks, lizards and bats, among others. Produced following various formal standards of realism or schematisation, these objects may be understood to be manifestations of mythical thought, as symbols of the forces of nature and as ways of appropriating the abilities and attributes of the animals represented.

Altiplano Nariñense, south of Colombia.
Photo: Diego Miguel Garcés/Villegas
Editores.

Nariño

The cold Andean highlands, the valleys of the department of Nariño and the north of Ecuador were settled by societies of farmers and shepherds that maintained relationships of exchange with neighbouring regions. They developed a structure of social behaviour and thought that had a dual character, expressed symbolically through opposites in nature, such as the Sun and the Moon, night and day, masculine and feminine. Two types of funeral trousseaux from the same era, found in shaft tombs of great depth, suggest that two groups of chieftains coexisted who used outstanding gold objects as emblems of power.

Their metalwork reveals a peculiar interest in geometry, particularly in the items for personal ornament. The designs have pure geometrical patterns that combine positive and negative motifs and seek to create rhythm and balance. Also found are schematised silhouettes of birds, as well as zoomorphic stylisations integrated into geometrical shapes in objects for use on the body. Metal disks, intended to produce visual and hypnotic effects during ceremonies, have the deliberate application of contrasting colours and textures. A set of Pan pipes reveals the importance that music had in these societies.

In the representations of human figures the stillness and exaggeration of the volumes are typical. The male figures seated on a bench express a message about power. While the fingers are indicated simply by quick incisions, the face is shown in greater detail, with the depiction of large half-closed eyes and swollen cheeks reflecting the importance that coca-chewing had.

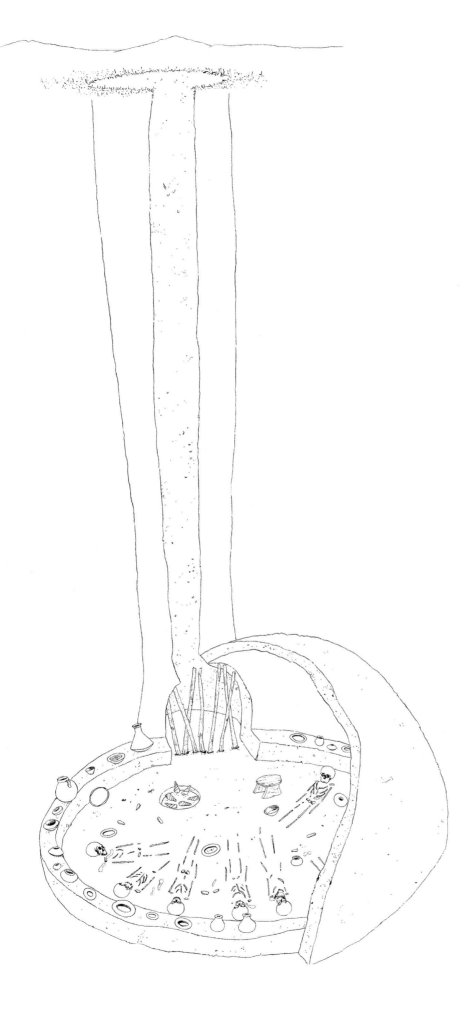

Map of the Nariño archaeological region.

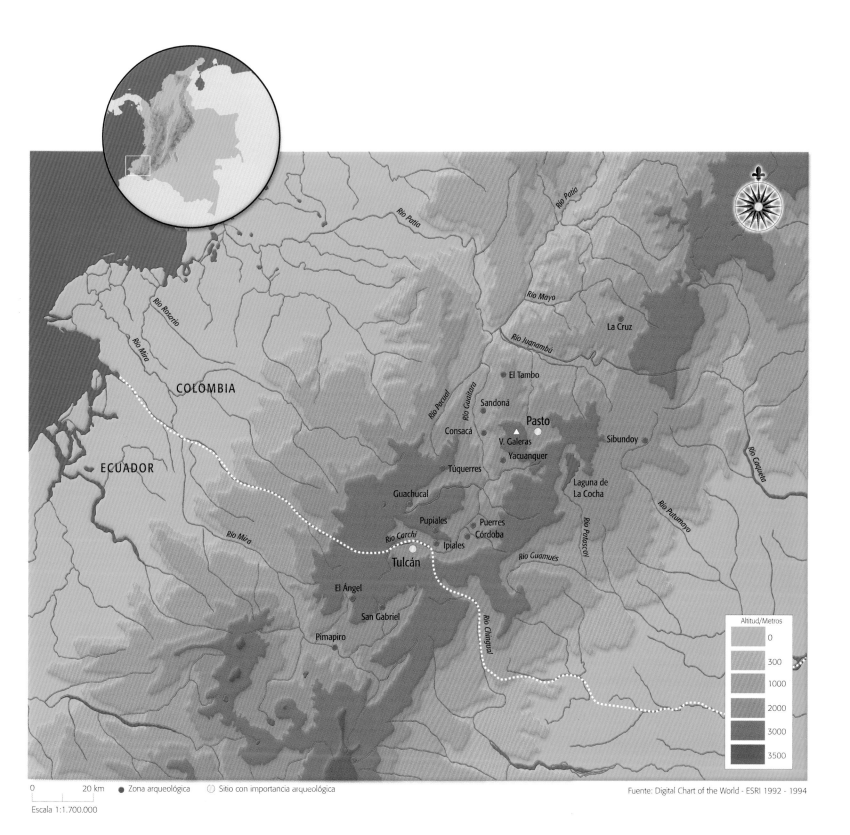

COLOMBIA

ECUADOR

Río Rosario

Río Mira

Río Patía

Río Patía

Río Mayo

La Cruz

Río Juanambú

El Tambo

Río Pacual

Río Guaitara

Sandoná

Pasto

Consacá

V. Galeras

Sibundoy

Yacuanquer

Túquerres

Laguna de
La Cocha

Río Caquetá

Guachucal

Río Putumayo

Pupiales

Puerres

Río Patascoy

Córdoba

Río Carchi

Ipiales

Río Guamués

Tulcán

El Ángel

Río Mira

San Gabriel

Río Chingual

Pimapiro

Altitud/Metros	
	0
	300
	1000
	2000
	3000
	3500

0 20 km ● Zona arqueológica ○ Sitio con importancia arqueológica

Escala 1:1.700.000

Fuente: Digital Chart of the World - ESRI 1992 - 1994

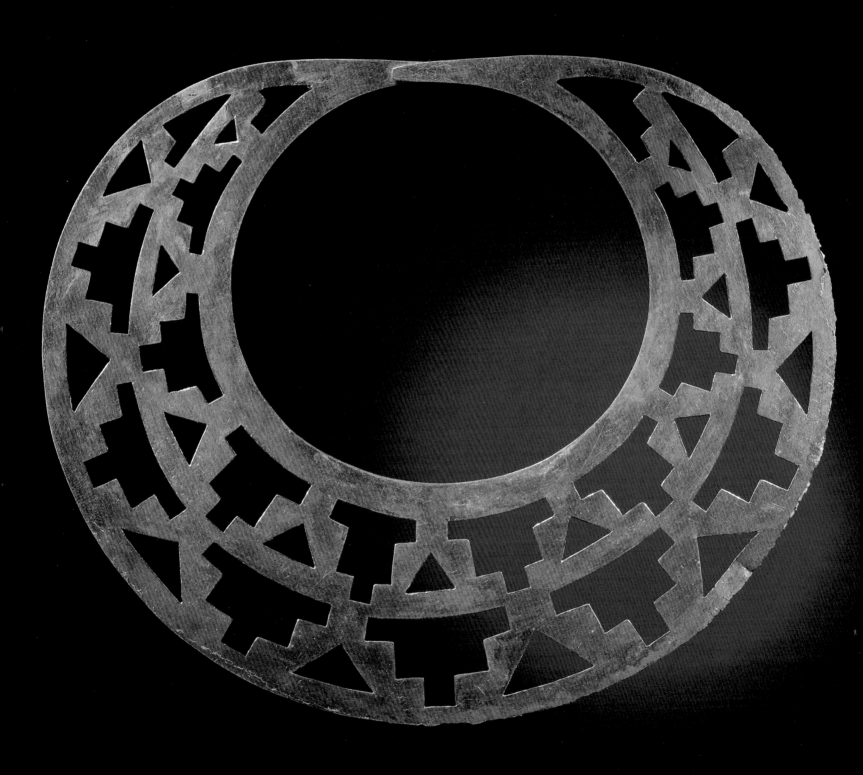

Nose ornament
13.2 x 15.9 cm
Pupiales, Nariño
1250 AD
Reg. O20099
In this harmonious nose ornament made of gilded *tumbaga*, the artist has achieved an unequalled formal interplay between the void and the solidity of the metal.

Pan pipes
16.6 x 8.2 cm
Pupiales, Nariño
600 AD–1700 AD
Reg. O23666
In the Central Andes, the harmony and musical integrity of the Pan pipes, dual instruments, require the simultaneous construction of two flutes with complementary sounds. The goldsmiths of Nariño gave material form to the concept of duality present in their thought and vision of the world by using gold and silver, metals associated with the Sun and the Moon.

Ear ornaments
2.3 x 2.8 cm
2.2 x 3 cm
Guachucal, Nariño
600 AD–1700 AD
Reg. O22025
Reg. O22026
Two hummingbirds in positions of sustained flight suck nectar from these flowers. The birds' beaks go through the flowers to become the wire that enables these ear ornaments to be attached to the ear lobe.

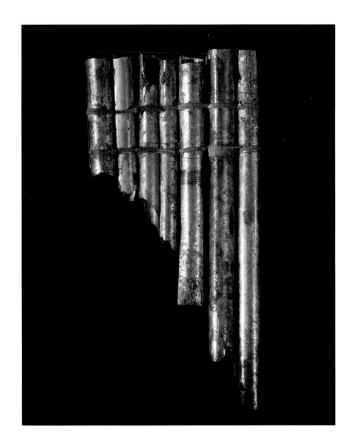

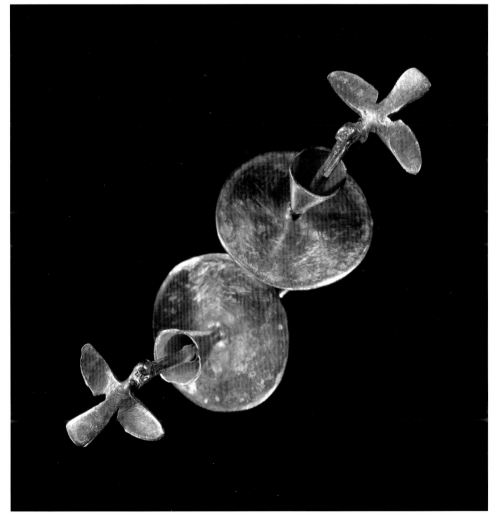

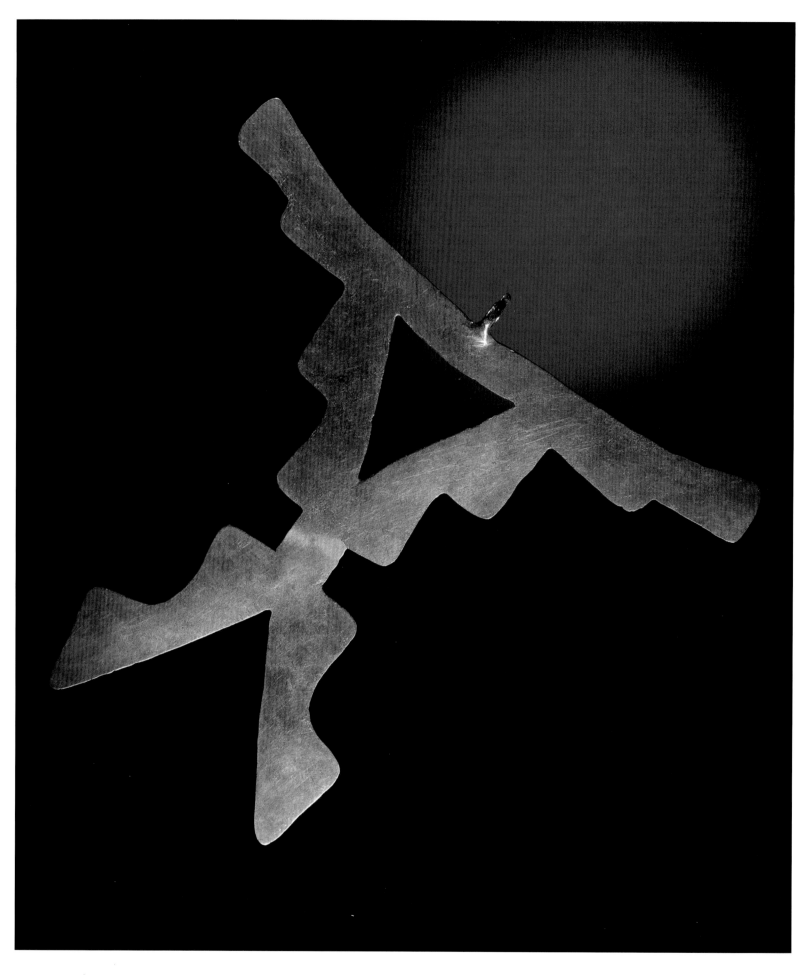

Breastplate
15.1 x 16.2 cm
Ipiales, Nariño
600 AD–1700 AD
Reg. O17177
Skilled in the art of schematisation, in
this pendant the goldsmiths of Nariño
synthesised the flight of the American
swallow-tailed kite, a bird with a forked
tail. The stepped forms evoke the
plumage of the wings.

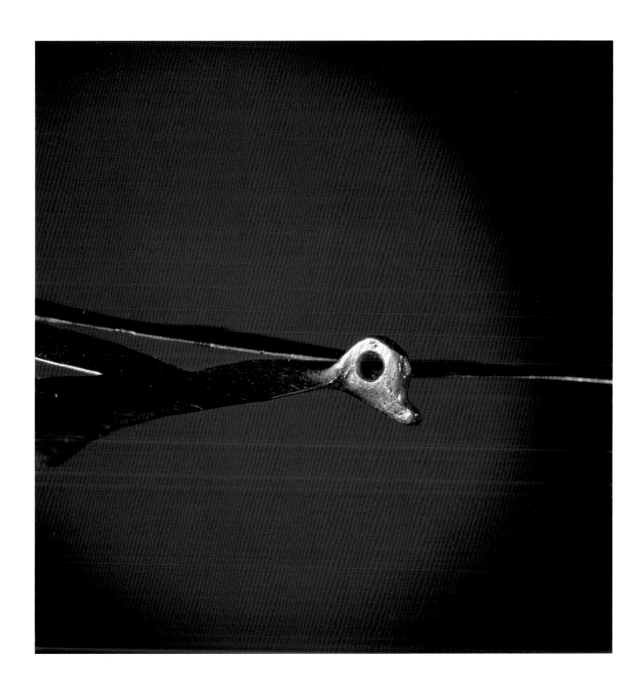

Ear pendants
11.6 cm
11.5 cm
Consacá, Nariño
600 AD–1700 AD
Reg. O25393
Reg. O25394
These ear ornaments were almost
certainly used in dances and ceremonies
of a ritual nature. The ordered repetition
of small faces around one large one
gives the piece rhythm and balance,
at the same time giving it the sensation
of movement.

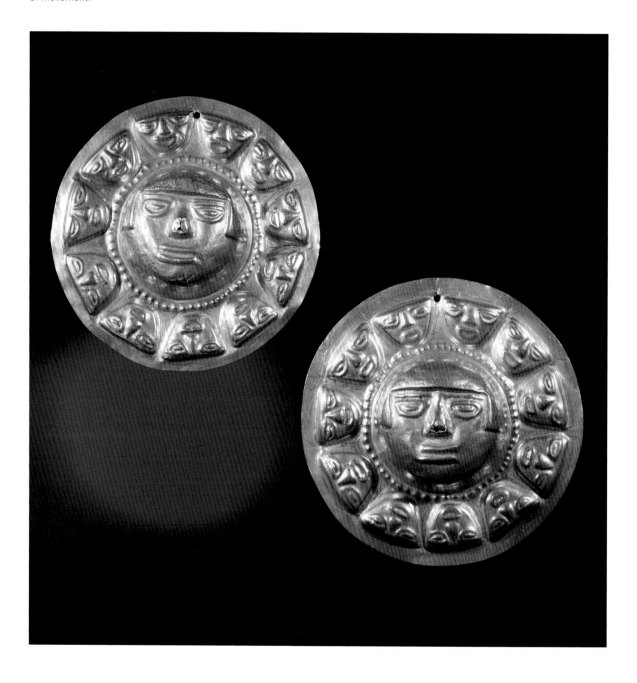

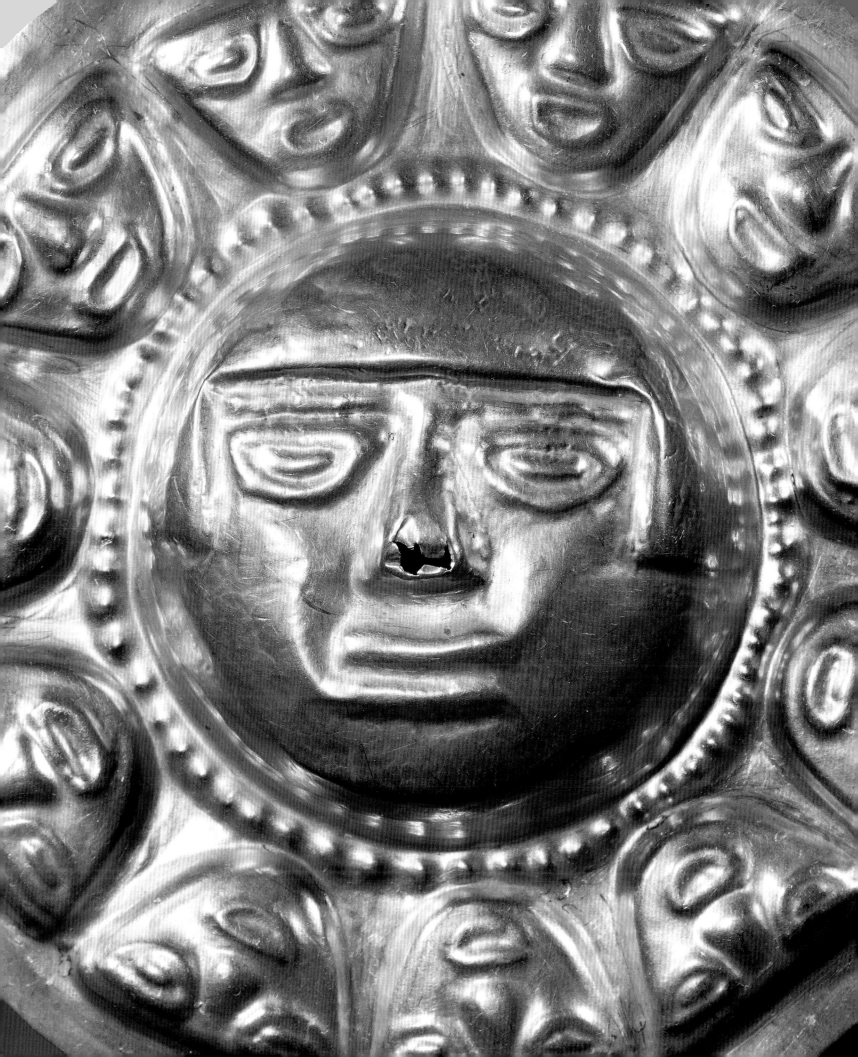

Nose ornament
8.4 x 23.2 cm
Pupiales, Nariño
845 AD
Reg. O16631
In Nariño geometrical forms were
the main ornamental elements used:
triangles, rectangles, circles and squares
are the most frequently employed.
When the wearer danced, this nose
ornament produced various light effects.

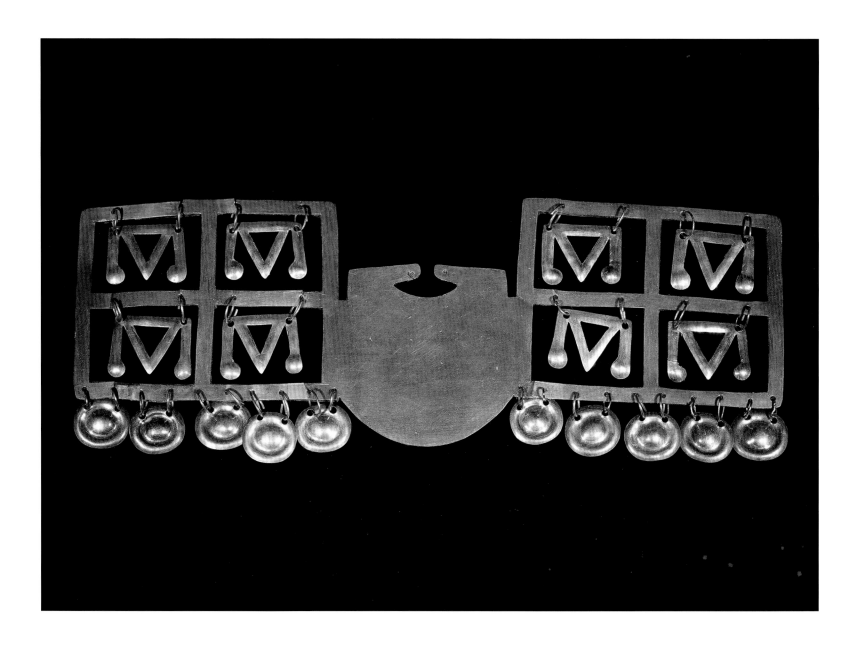

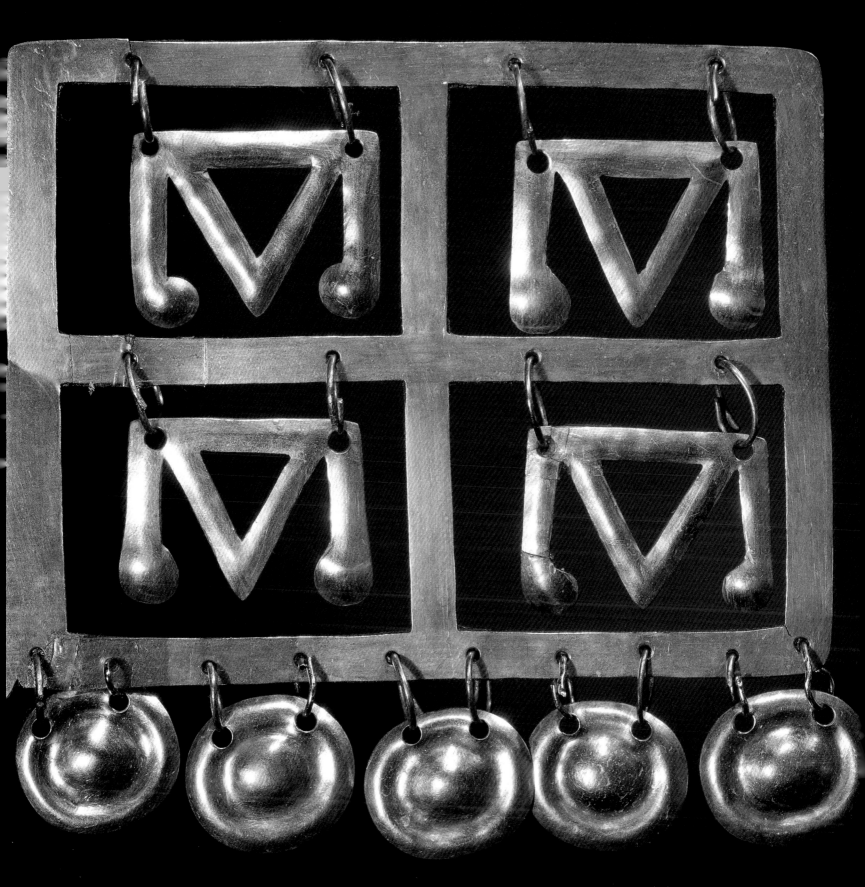

Ear pendants
17.1 cm
17.5 cm
Ipiales, Nariño
600 AD–1700 AD
Reg. O31640
Reg. O31641
Silver pendant ear ornaments. Their design, in the shape of an eight-pointed star, present in the decoration in the negative painting of ceramic goblets and petroglyphs of the region, is recognised by the current indigenous peoples of Nariño as the "Sun of the Pastos".

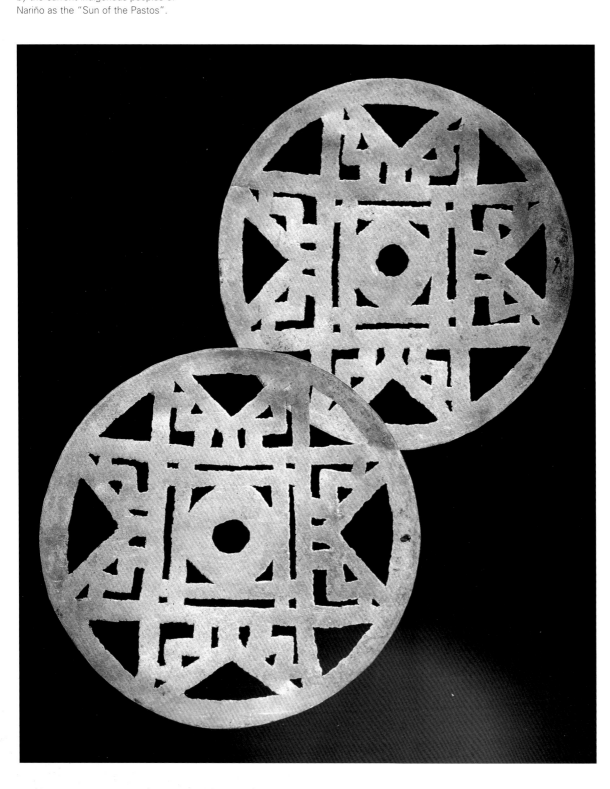

Rotating discs
Left to right
14.9 cm / 15 cm / 14.8 cm / 16.5 cm / 15.3 cm
Pupiales, Nariño / Pupiales, Nariño / El Tambo, Nariño / Pupiales, Nariño / El Tambo, Nariño
600 AD–1700 AD
Reg. O21220 / Reg. O21222 / Reg. O21523 / Reg. O25191 / Reg. O21521
Set of discs
Decorated with motifs with contrasting colours and textures, these discs were probably made to rotate suspended from a string to produce hypnotic effects in ceremonies of a ritual nature.

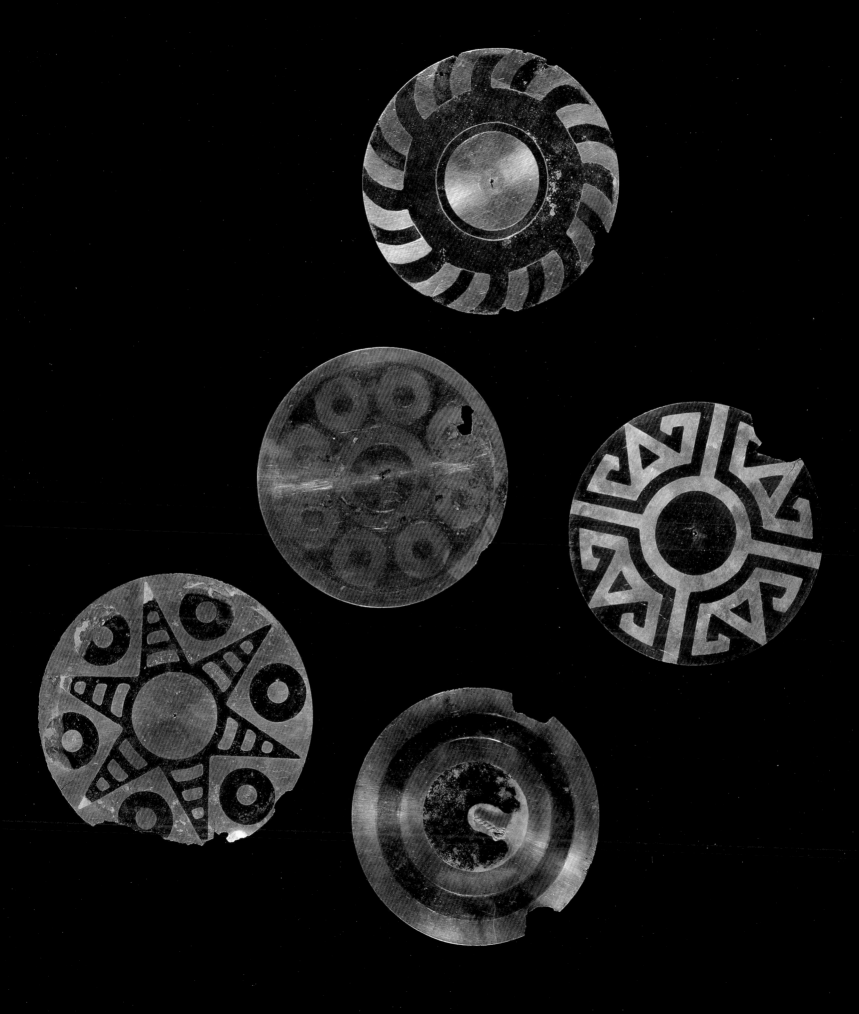

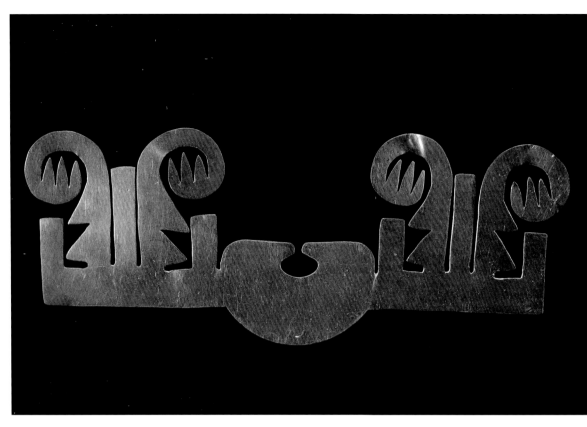

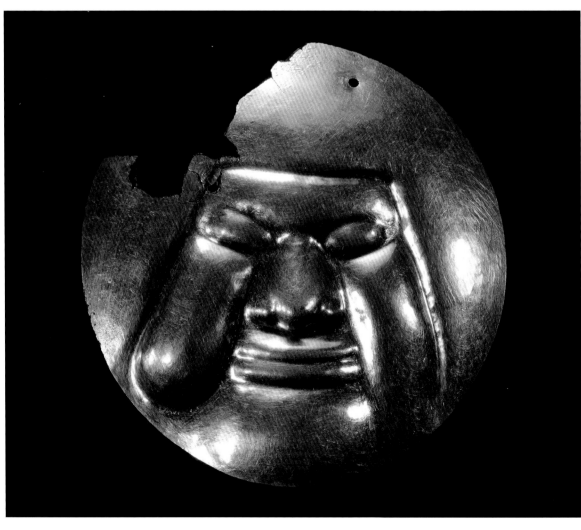

Nose ornament
6.2 x 16.4 cm
Pupiales, Nariño
600 AD–1700 AD
Reg. O29028
Attractive golden nose ornaments with outstanding symmetry gave force and power to the great leaders.

Breastplate
13.7 cm
Pupiales, Nariño
1250 AD
Reg. O20111
Representations of male figures with their cheeks swollen through chewing the sacred coca leaf are common in Nariño, as in this breastplate.

Ear ornaments
10 cm / 10.4 cm
Guachucal, Nariño
600 AD–1700 AD
Reg. O22041 / Reg. O22042
The importance of monkeys in the Altiplano of Nariño is reflected in the countless number of objects that they adorn. In this pair of ear ornaments, the artist has ably captured the plasticity and dynamism of these animals.

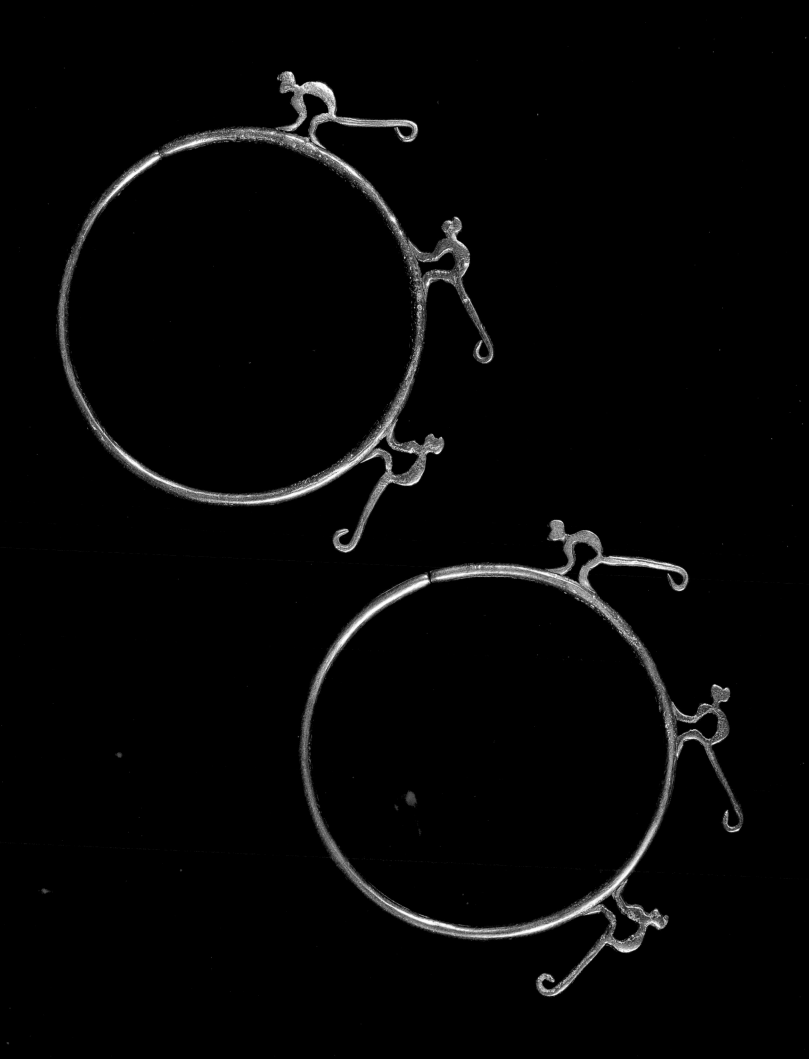

Figures
Left to right
18.3 x 13 x 13.5 cm /
15.5 x 12 x 11.5 cm
unknown / Ipiales, Nariño
600 AD–1700 AD
Reg. C05583 / Reg. C03097
The bench is a symbol of power both in prehispanic art and among the current indigenous groups of Colombia.
The male figure sitting on it therefore represents a shaman or a high-ranking figure.

In tombs that can be as much as 40 metres in depth, figures of women have been found sitting on the floor to accompany male figures on benches. Her skirt, possibly made from llama hair, has a decoration that is common in the Central Andes.

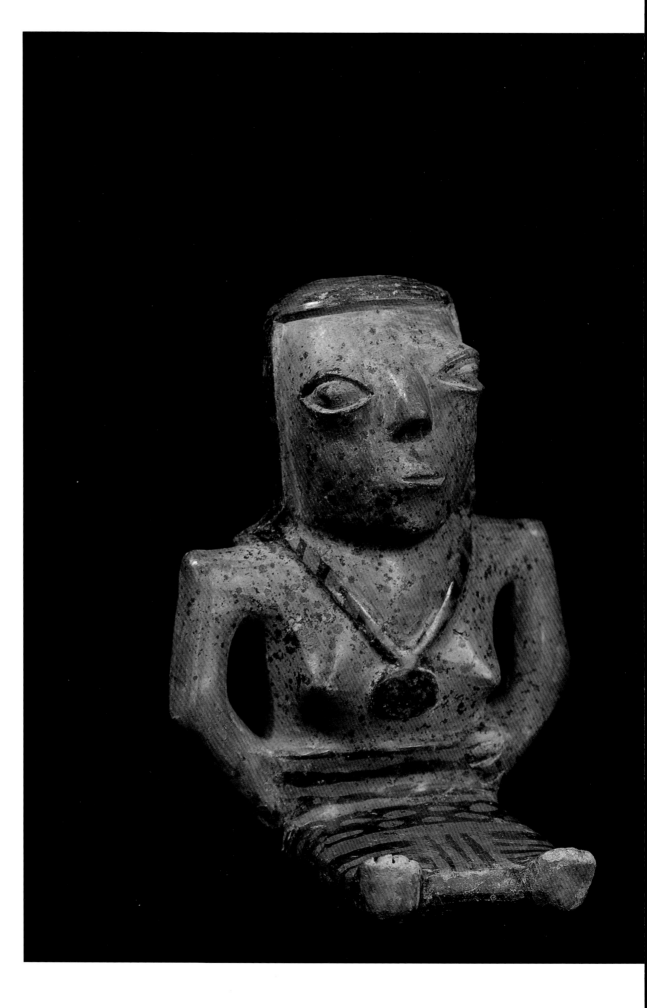

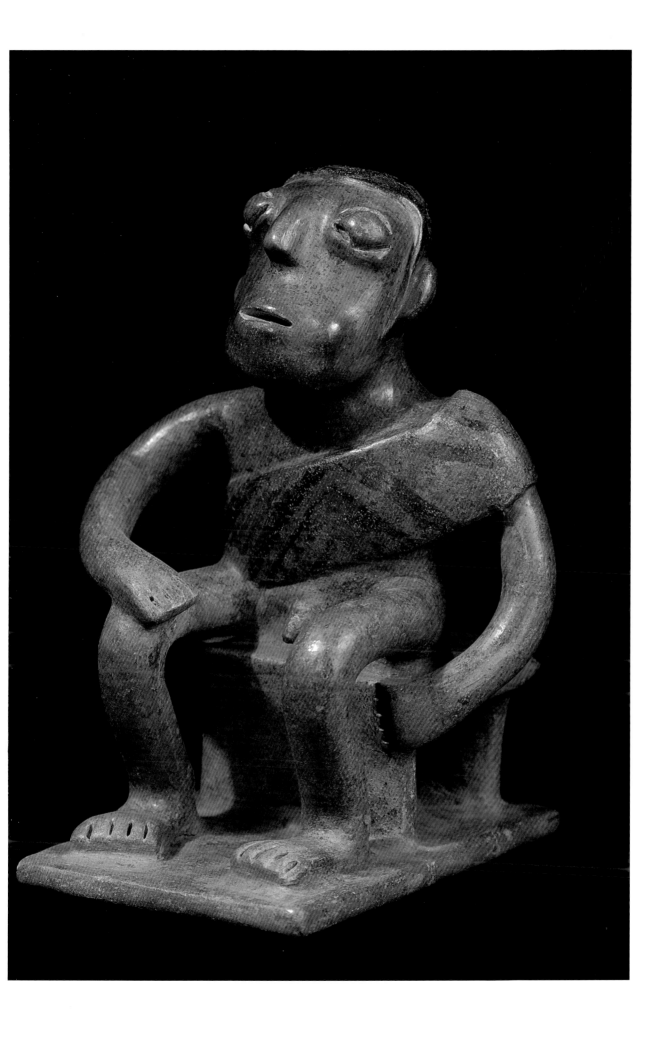

La Tolita, Ecuador.

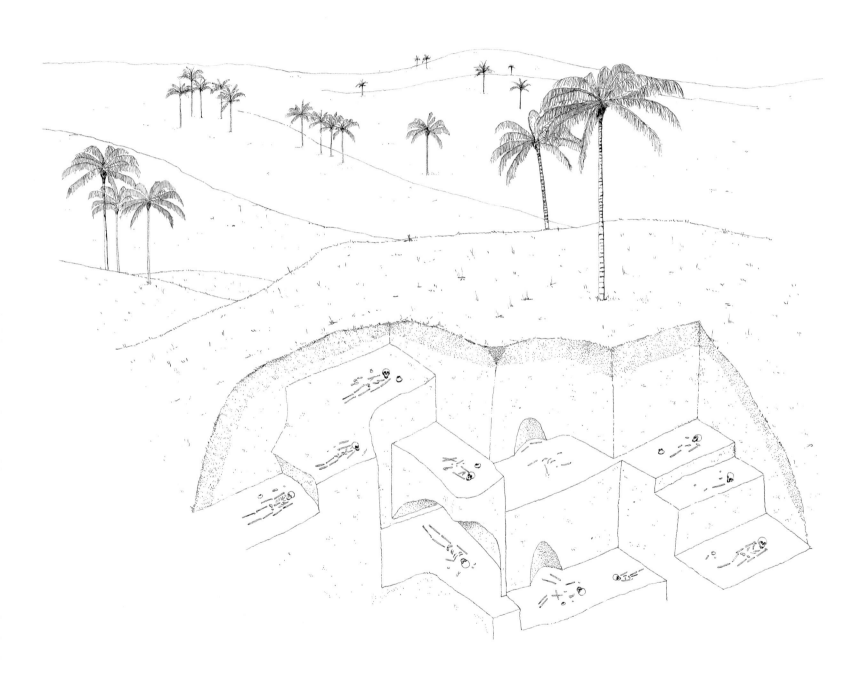

Map of the Tumaco archaeological region.

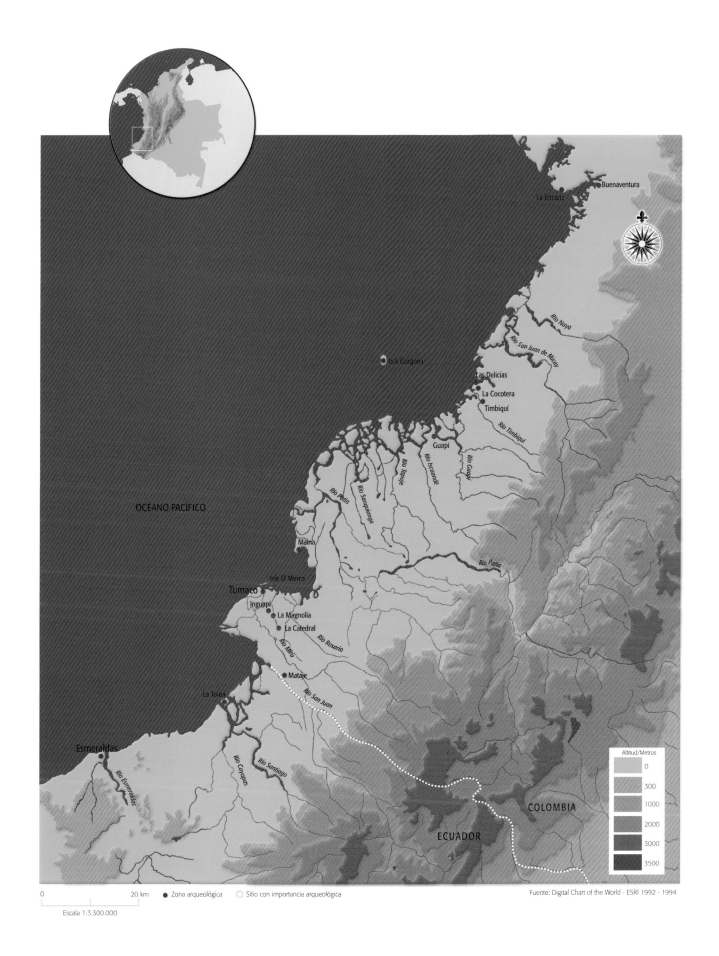

OCÉANO PACÍFICO

Buenaventura
La Bocana

Río Naya
Río San Juan de Micay

Isla Gorgona
Las Delicias
La Cocotera
Timbiquí
Río Timbiquí

Guapí
Río Guapí
Río Iscuandé
Río Tapaje
Río Sanguianga

Río Patía

Maima

Río Patía

Isla El Morro
Tumaco
Inguapí
La Magnolia
La Catedral
Río Rosario
Río Mira

Mataje
Río San Juan

La Tolita

Esmeraldas

Río Esmeraldas
Río Cayapas
Río Santiago

COLOMBIA

ECUADOR

Altitud/Metros
0
300
1000
2000
3000
3500

0 20 km ● Zona arqueológica ○ Sitio con importancia arqueológica

Escala 1:3.300.000

Fuente: Digital Chart of the World - ESRI 1992 - 1994

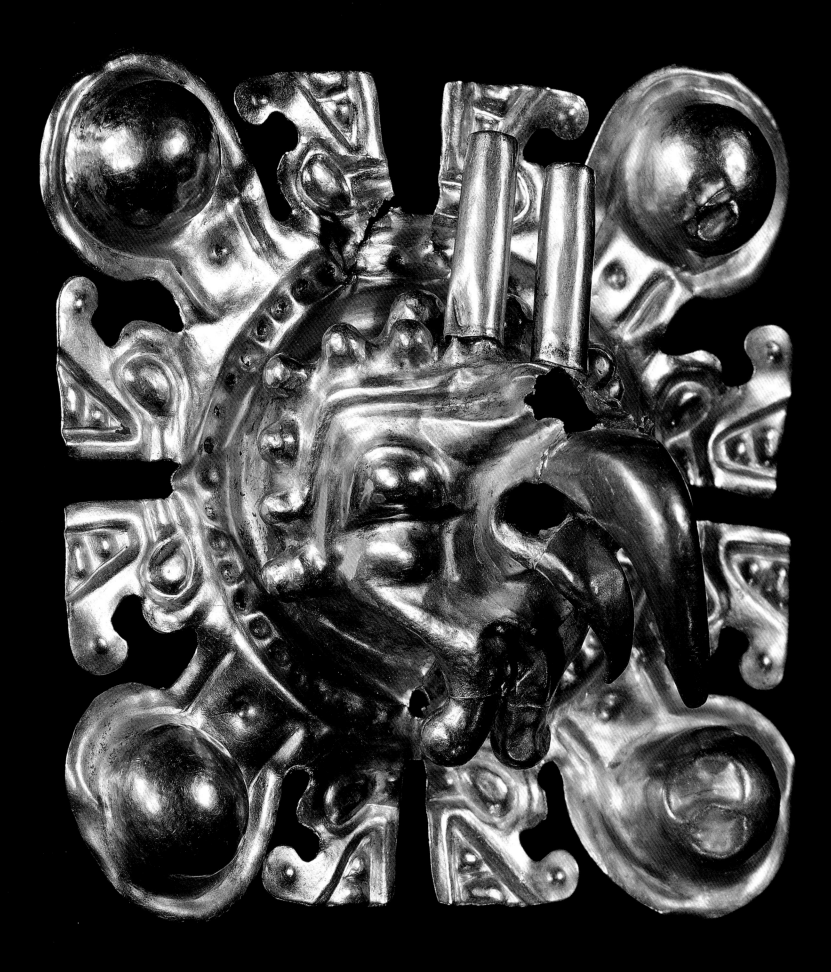

Ear ornament cover
5 x 8.4 cm
Cauca Valley
500 BC–300 AD
Reg. O29253
Ear ornament cover with the head
of a condor surrounded by snakes in dual
compositions. The prominent beak of
this bird of prey was made of platinum,
a very hard metal, used exclusively
by the goldsmiths of Tumaco.

Ear ornaments
2.7 x 2.8 cm
2.7 x 2.9 cm
Inguapí, Tumaco, Nariño
500 BC–300 AD
Reg. O22765
Reg. O22764
Two-colour ear ornaments made from
gold and platinum. Not being able to
achieve the high temperatures required
to melt platinum, the goldsmiths of
Tumaco added nuggets of this metal to
cast gold and hammered it to give form
to the pieces. This technique is known
as sintering.

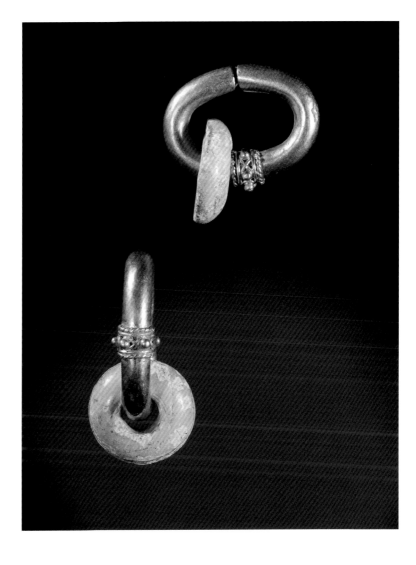

Ear pendants
16.1 x 6.2 cm
16 x 6.2 cm
Tumaco, Nariño
500 BC–300 AD
Reg. O33676
Reg. O33677
Ear pendants hammered and
embossed starting from a gold sheet.
The decoration, in the form of a human
with feline features, common in Tumaco
iconography, alludes to the symbolic
transformation into an animal.

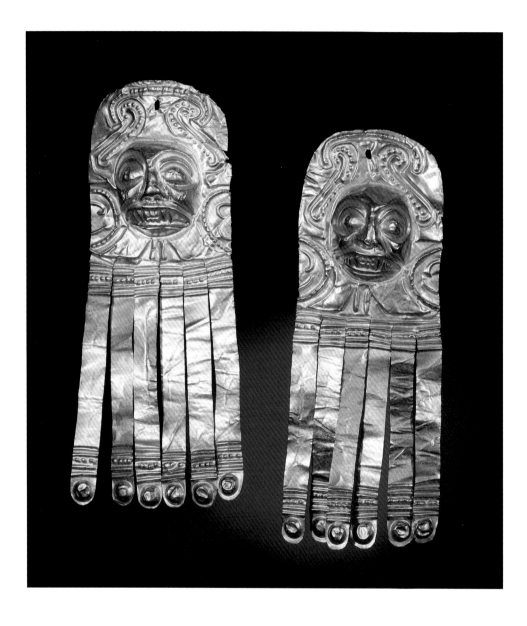

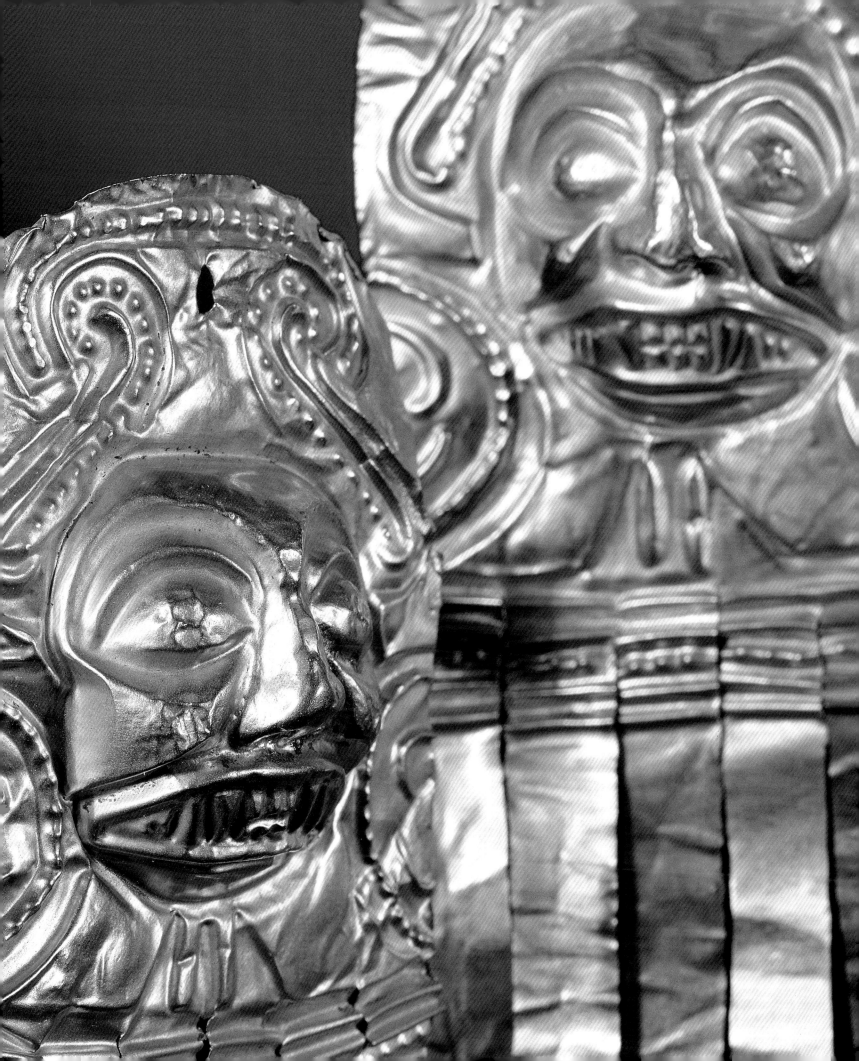

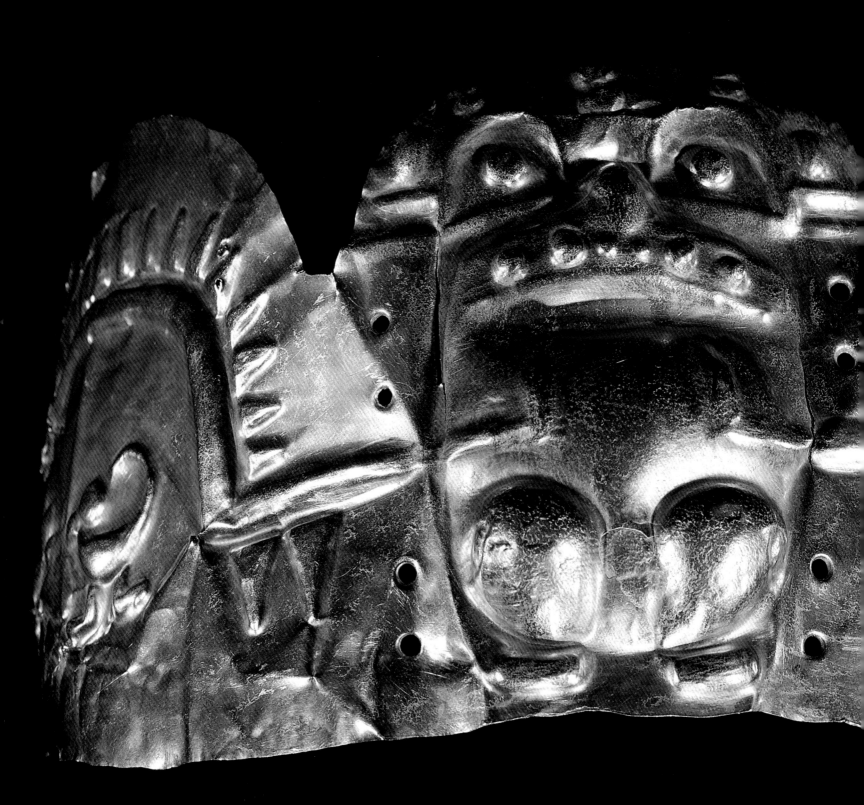

Diadem
38.3 x 13 cm
unknown
500 BC–300 AD
Reg. O00094
The owl, a nocturnal bird, seems to be the ornamental motif of this diadem. Its large size, together with the type of animal represented, gave force and power to the wearer.

Application
1.3 x 1.7 cm
Restrepo, Cauca Valley
500 BC–300 AD
Reg. O09241
Wires and tiny gold spheres welded together are part of the design of this gold ear ornament. In Tumaco goldwork it is possible to find objects with a large format as well as small and diminute elements that were apparently used attached to larger objects.

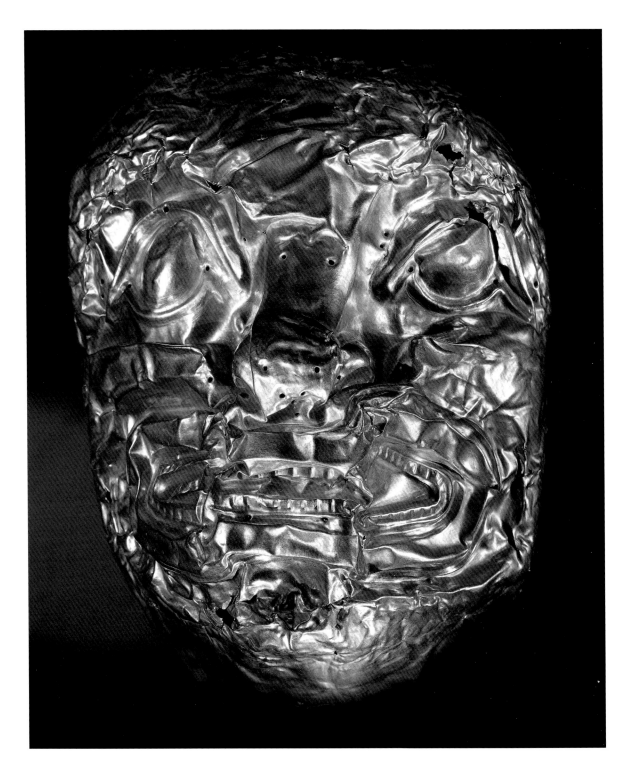

Mask
29.9 x 21.6 cm
Nariño
500 BC–300 AD
Reg. O29480
The lateral holes that surround this large mask with feline features lead us to suppose that it was part of the decoration of a sacred space. The small front holes were very probably used to hang metal and stone decorations.

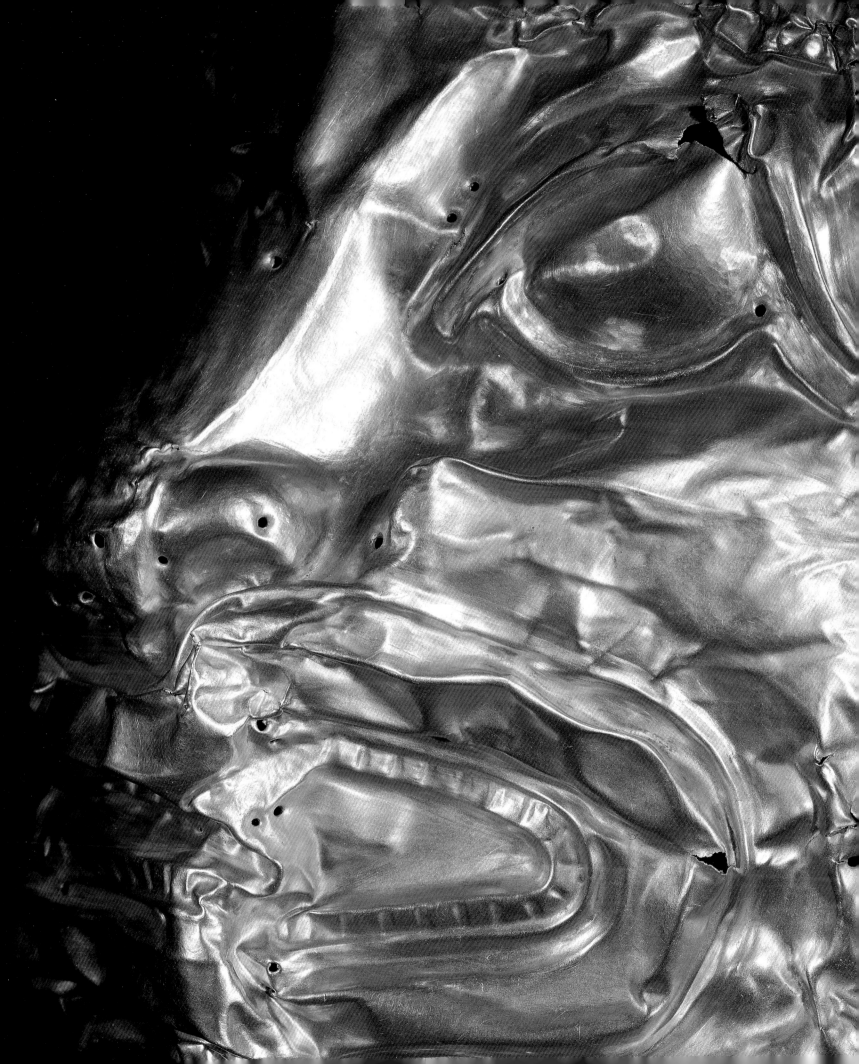

Container
34 x 34 x 15.5 cm
Río Rosario, Tumaco, Nariño
500 BC–300 AD
Reg. C13121
Offering holder in the form of a
ceremonial dwelling. Found inside it
were a fish-shaped pendant, a nose
ornament and gold pincers, with several
Morralla emerald beads. We are unable
to ascertain the significance of the
offering.

Head
10.5 x 10.5 cm
Tumaco, Nariño
500 BC–300 AD
Reg. C12762
The heads of Tumaco offer unrivalled
information on hierarchies,
physiognomies and ethnic groups.
This individual's soft, fine features have
been successfully captured by the artist.

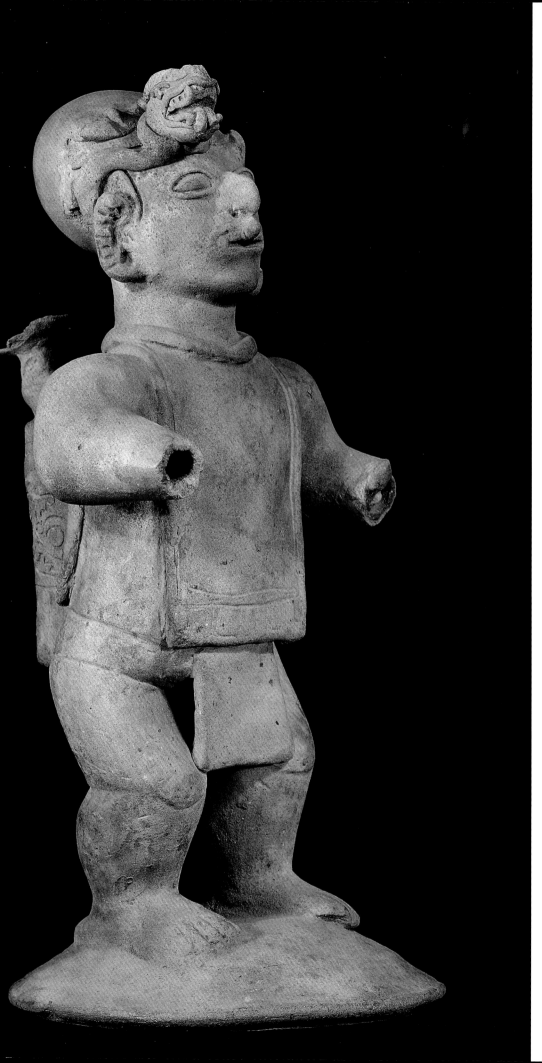

Figure
52.5 x 26 cm
Tumaco, Nariño
500 BC–300 AD
Reg. C12819
Male figure with rich attire, in which the
head ornament in the shape of a snake
stands out. Deformations of the head
were represented extensively by the
ceramists of Tumaco. This practice has
also been acknowledged on the
archaeological registers of other regions
of America.

Figure
31 x 20.8 cm
unknown
500 BC–300 AD
Reg. C13436
Female figures realistically and
dramatically representing old age.
The deep wrinkles on the forehead and
cheeks, the bent back, fallen breasts
and few remaining teeth reveal the
heavy weight of the years.

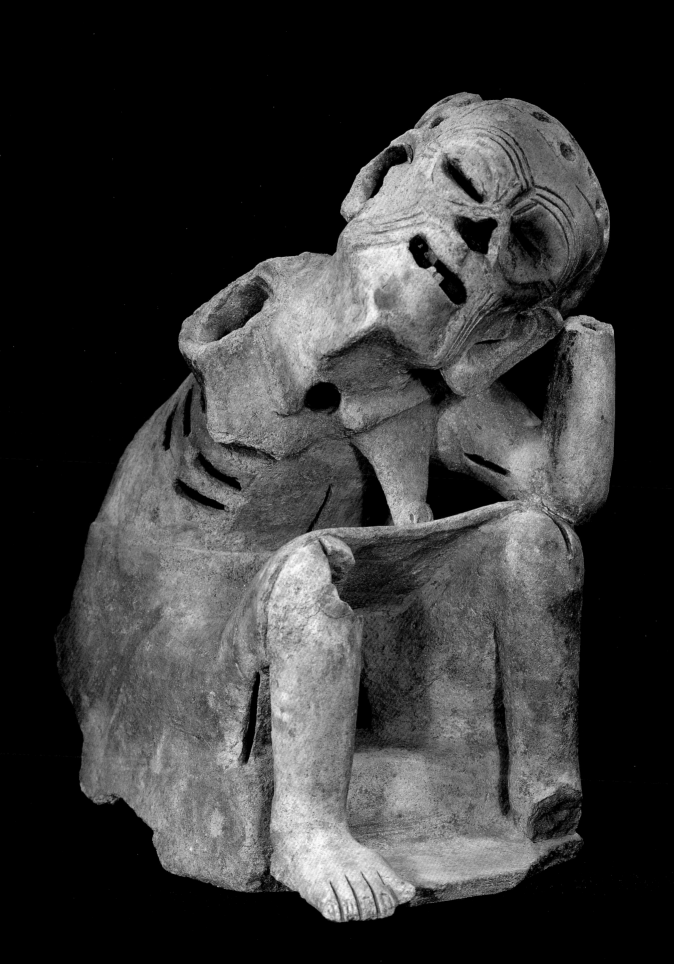

Calima

The upper and middle region of the river Calima and the fertile plains of the river Cauca in the department of Valle del Cauca were occupied by hunter-gatherer societies evolving towards agriculture. Four major periods can be distinguished in their history: Pre-Ceramic, Ilama, Yotoco-Malagana and Sonso.

During the Ilama period, ceramic objects were created that expressed a close relationship between individuals and nature. The human figures show the application of paint and geometrical incisions; typical figures are the so-called *canasteros* (basket-carriers), who carry a sort of a basket on their backs, as well as recipients with double spouts.

During the Yotoco-Malagana period, the area was populated by farmers who built terraces for sowing and dwelling, drainage systems and networks of roads. The leaders had specialists who manufactured pottery decorated with negative painting as well as colourful metal objects indicating social hierarchisation, in which basic elements are repeated and superimposed. The naturalistic motifs, present in objects to serve the affirmation of political and economic power, ceremonial worship and the transformation of personal appearance, were stylised until the essential features were obtained by means of wavy lines. The dippers for *poporos* (lime containers) have detailed finishes with felines and shamanic figures. An emblematic human typology, known as the "Yotoco icon", which expresses values and beliefs, is repeated in diadems, pendants and breastplates.

Discovered in 1992, the so-called Malagana treasure comes from a stratified community whose elite had access to magnificent ceramic objects and gold, which were apparently only destined to be part of funerary regalia. The presence of feminine and animal figures, the rounded treatment of the forms, the intense facial expressions and the rectangular mouth with square teeth occurs repeatedly in them.

With the population increase that took place during the Sonso period, the agriculture gained special importance and an abundance of painted pottery was produced. The goldwork was concentrated on the production of ornaments for the face and the production of large metal sumptuary objects was abandoned.

River Cauca in the Cauca Valley
Department. Photo: Aldo Brando/Villegas
Editores.

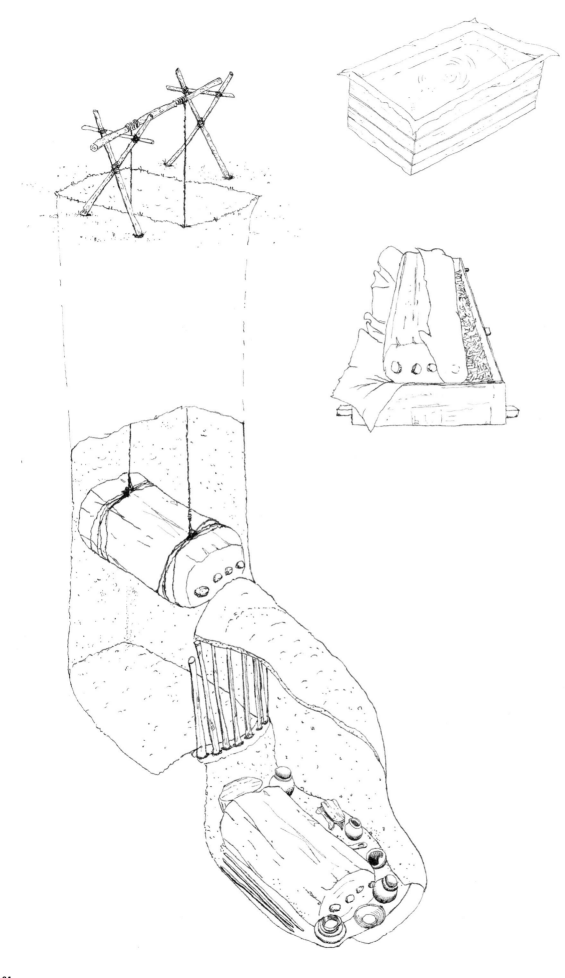

Process of excavating a wooden
sarcophagus from the Calima-Sonso
Period.

Map of the Calima archaeological region.

OCÉANO
PACÍFICO

Río Calima

Río Dagua

Río Grande

Dagua

Darién

Calima

Restrepo

Yotoco

Trujillo

Roldanillo

Bolívar

Vijes

Sonso

Yumbo

Río Palmira

Palmira

Río Bolo

Bolo San Isidro

CALI

Río Cauca

Altitud/Metros
0
300
1000
2000
3000
3500

0 50 km ● Zona arqueológica ◯ Sitio con importancia arqueológica

Escala 1:1.100.000

Fuente: Digital Chart of the World · ESRI 1992 - 1994

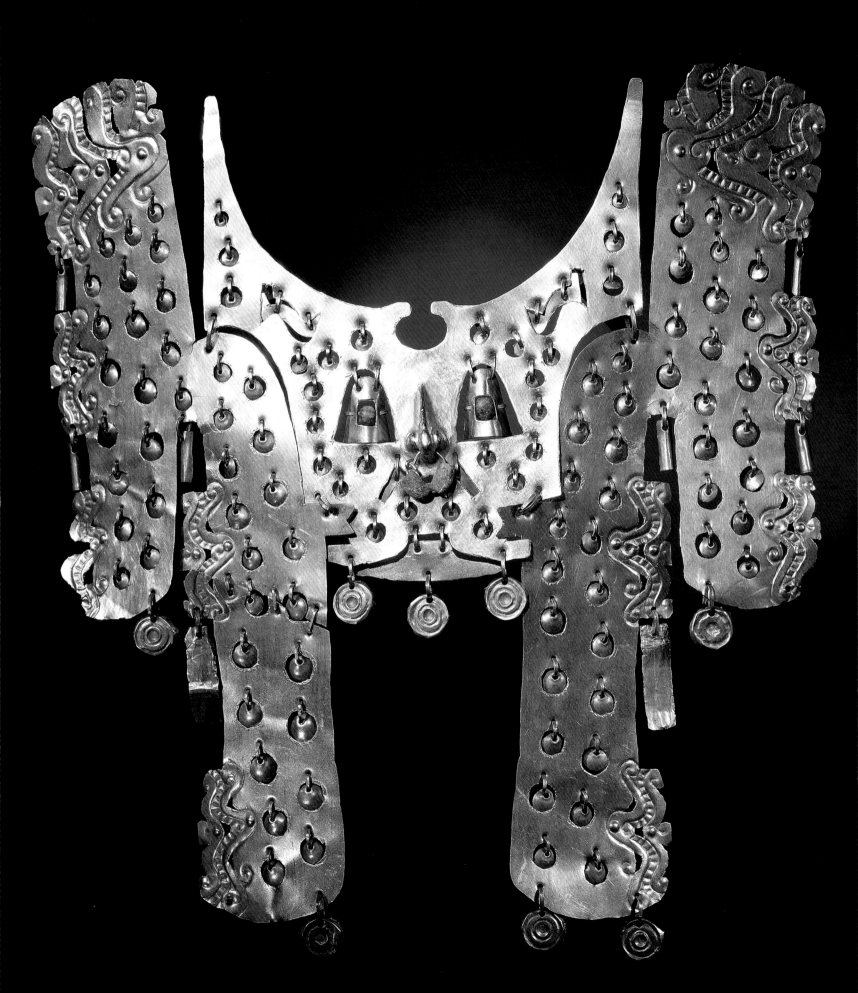

Nose ornament
22.1 x 21.1 cm
Restrepo, Cauca Valley
100 BC–1000 AD
Reg. O16637
Three main parts make up this nose ornament with the form of a schematised feline: a central one, which is the feline's head and covers the wearer's mouth, and two lateral ones, articulated with the central one, representing the animal's upper and lower limbs. The links, created using thin wire, give the animal mobility.

Breastplate
21.1 x 28.5 cm
Restrepo, Cauca Valley
100 BC–1000 AD
Reg. O00019
Large, attractive breastplates with the typical figure of a rigid and inexpressive face formed the characteristic attire of the leaders of the Calima region in the Yotoco period.

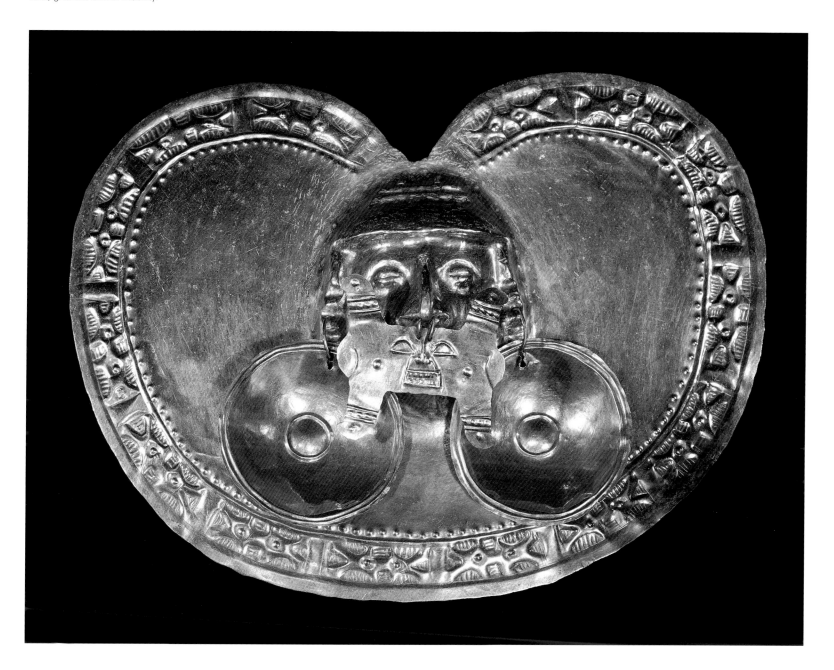

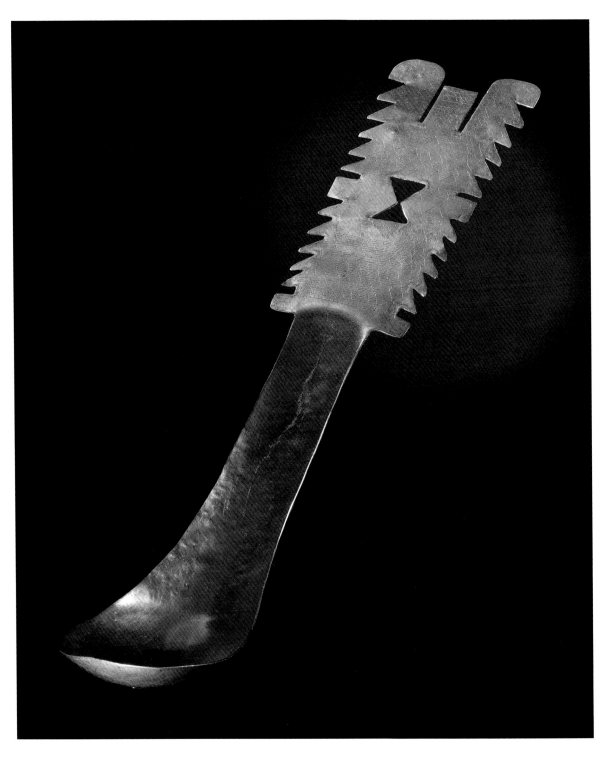

Spoon
22.5 x 4.4 cm
Restrepo, Cauca Valley
100 BC–1000 AD
Reg. O06284
A spoon for ceremonial use. The
symmetrical decoration of the handle
was possible through the employment of
cutting and fretwork techniques.

Spiral cover
14.8 x 30 cm
Restrepo, Cauca Valley
100 BC–1000 AD
Reg. O03316
A sea snail of the genus *Strombus*
formed the core of this object, of which
the fine gold sheets with which it was
covered are conserved. The societies of
the Calima region maintained trading
relations with the inhabitants of the
Pacific Coast.

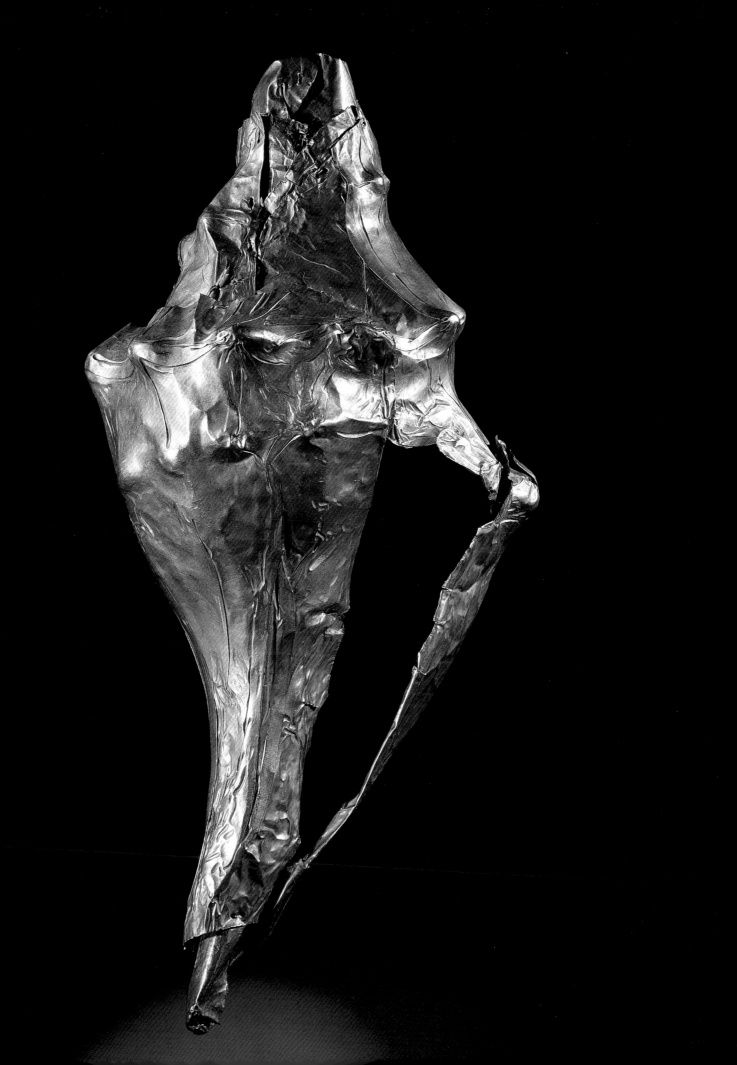

Pendant
7.1 x 3.2 cm
Restrepo, Cauca Valley
100 BC–1000 AD
Reg. O06700
Enormous diadems and nose ornaments
conceal the identity of the person who
uses them at the moment of the ritual,
transforming him into a golden man.
In his right hand this character holds
what seems to be a staff, in his left the
skin of a lizard.

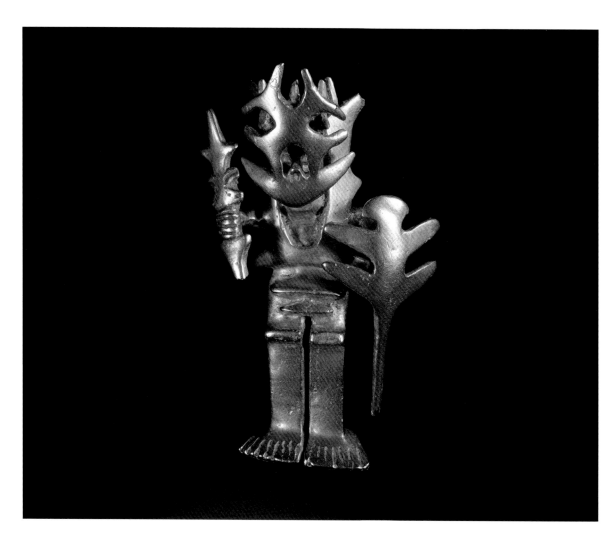

Lime stick
28 x 11.1 cm
Palmira, Cauca Valley
200 BC–200 AD
Reg. O33396
This pin in the shape of a palm was
probably part of the emblems of power
of a noble of high rank. In manufacturing
it, the goldsmiths of Calima used
hammering and cutting techniques.

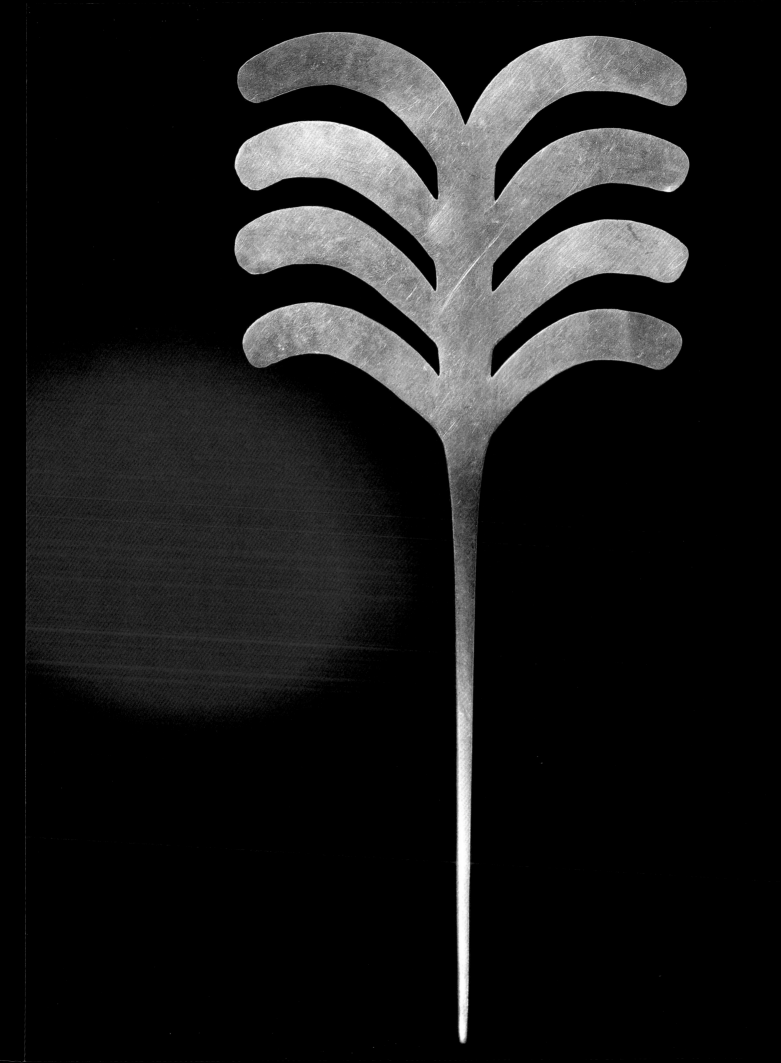

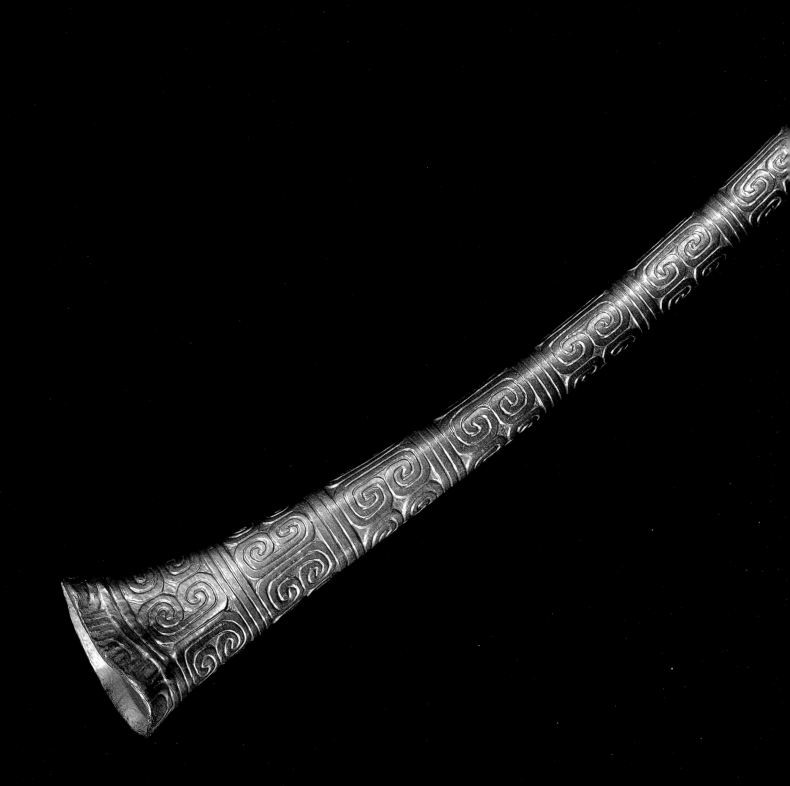

Trumpet
40 x 5.6 cm
Palmira, Cauca Valley
200 BC–200 AD
Reg. O33395
This trumpet, decorated with opposing spirals, was initially carved from three human bones or those of an aquatic mammal and then covered in fine gold sheet. This type of musical instrument, some of which only have their gold veneer remaining, is common in the Calima region.

Ear ornaments
2 x 6 cm
2 x 6 cm
Palmira, Cauca Valley
200 BC–200 AD
Reg. O33391
Reg. O33392
Hammered and then cut to form flowers, each of this pair of ear ornaments has four holes in its calyx (the part that fits into the ear), which were probably used to insert feathers as adornment.

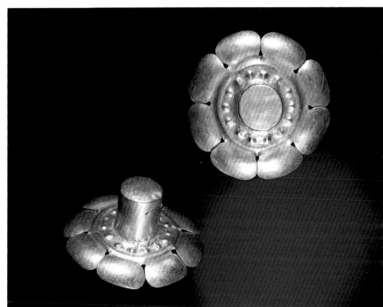

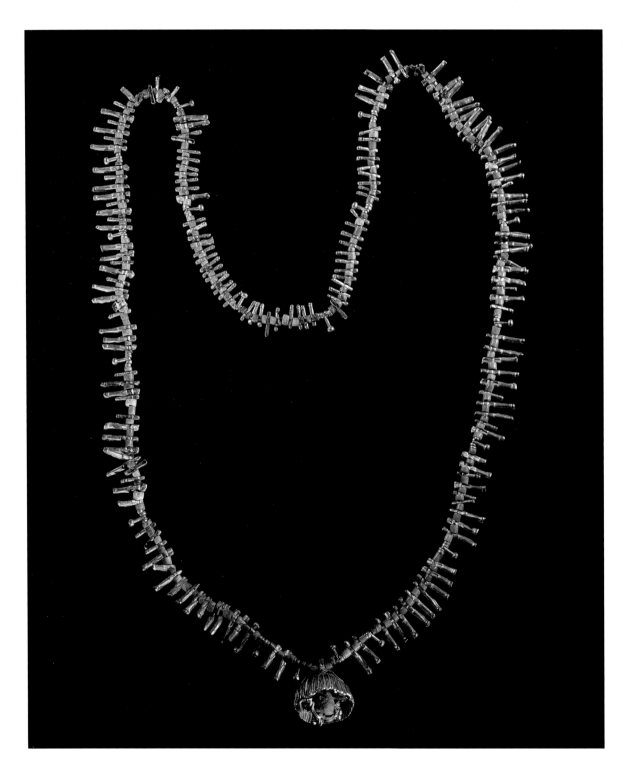

Bead necklace
3.2 x 2.5 cm
Palmira, Cauca Valley
200 BC–200 AD
Reg. O33277
This scale replica of a flower of the
genus *Pasiflora* (passion flower) consists
of three mobile parts cast by the lost-
wax method and a small stone.
Floral forms are not very frequent in
Colombian prehispanic goldwork.

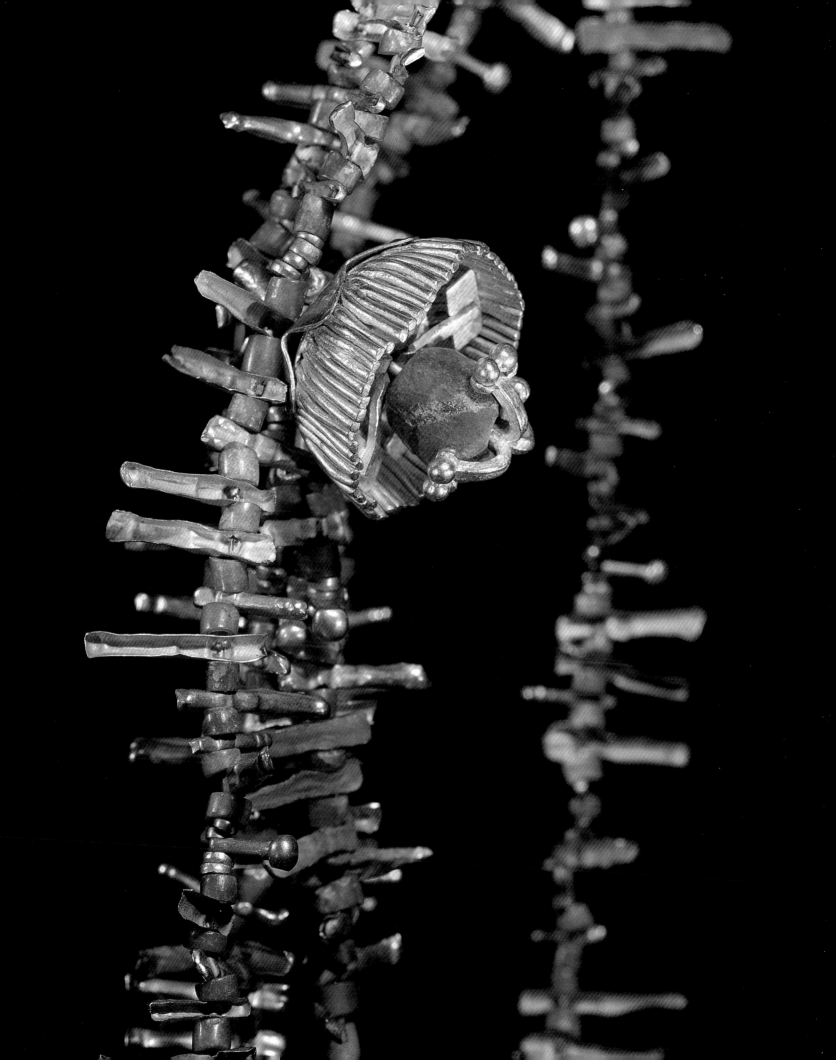

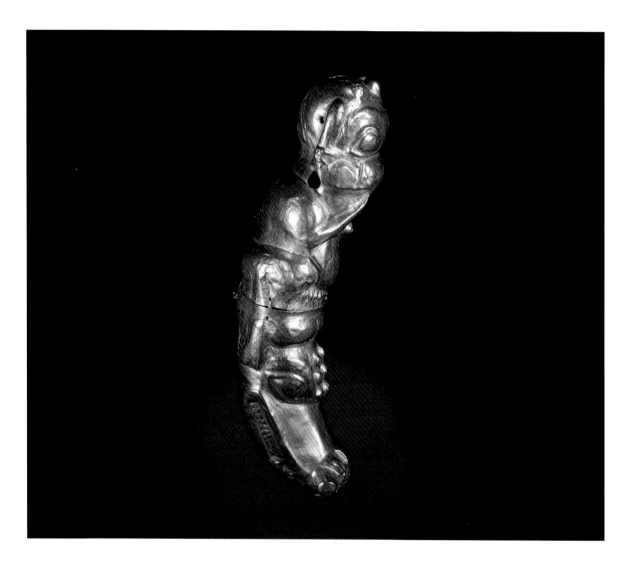

Container for lime
9.7 x 5.2 cm
7.5 x 4.9 cm
Palmira, Cauca Valley
200 BC–200 AD
Reg. O33338
Reg. O33339
This fantastic object was achieved
by hammering two gold sheets onto
another material. The upper part of this
poporo represents a human being with
animal characteristics, the lower part
shows the head of a cayman very
realistically. *Poporos* are containers for
ground lime used in the chewing of the
coca leaf.

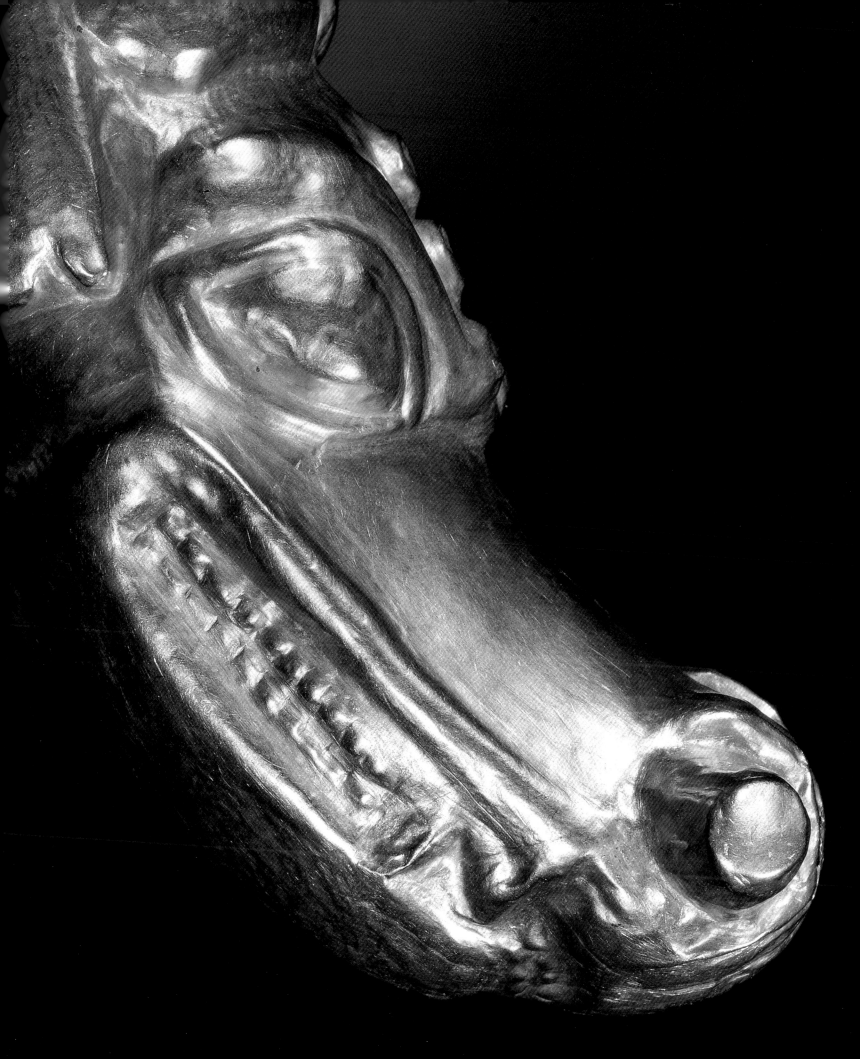

Mask
26.3 x 41.4 cm
Palmira, Cauca Valley
200 BC–200 AD
Reg. O33337
This mask was part of the funeral regalia
of the leaders of a highly hierarchical
society. With round and concave
pendants like mobile eyes, it seems to
be mocking us by sarcastically sticking
out its tongue.

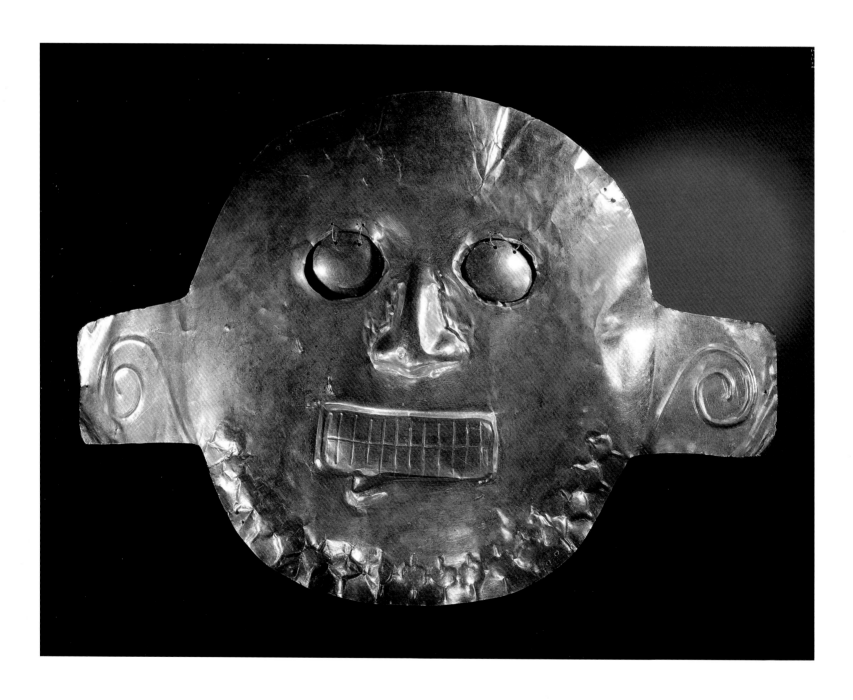

Mask
13.5 x 16 cm
Restrepo, Cauca Valley
100 BC–1000 AD
Reg. O03883
A mask with embossed decorations
simulating face painting. The mask
is an element of transformation in ritual
and in the journey after death.

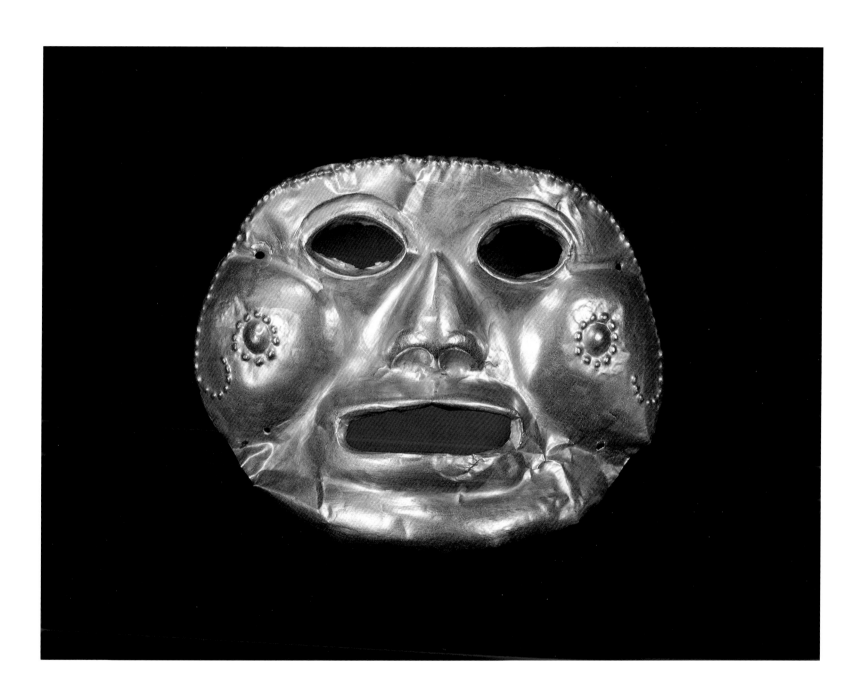

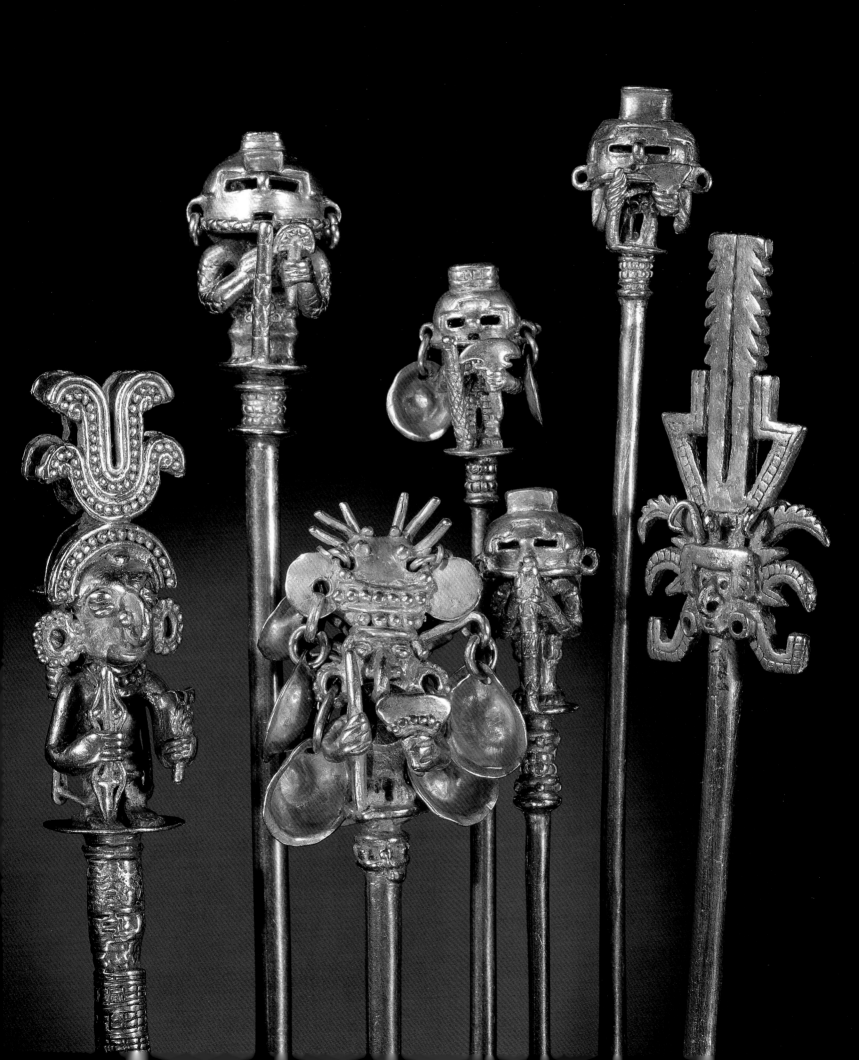

Lime sticks
Left to right
31 x 2.4 cm / 26.5 x 2.9 cm /
33 x 3.3 cm / 30 x 2.2 cm /
31.5 x 1.6 cm / 31.6 x 1.6 cm /
27.2 x 1.9 cm
unknown / unknown / unknown /
Restrepo, Cauca Valley / unknown /
unknown / Restrepo, Cauca Valley
100 BC–1000 AD
Reg. O05962 / Reg. O05759 /
Reg. O03670 / Reg. O05234 /
Reg. O03453 / Reg. O04252

A group of sticks with anthropomorphic
figures with masks.
The sticks were used to extract from the
poporos the ground lime that was
obtained from conches and sea snails.
Their tops show a variety of masked
characters and mythological animals
carrying staffs and insignias of power
in their hands.

Lime sticks
Left to right
44.4 x 2.8 cm / 30 x 2.2 cm /

31.5 x 1.6 cm / 27.2 x 1.9 cm /
31.6 x 1.6 cm
Campo Hermoso, Ataco, Tolima /
Restrepo, Cauca Valley / unknown /
Restrepo, Cauca Valley / unknown
100 BC–1000 AD
Reg. O05853 / Reg. O00026 /
Reg. O05234 / Reg. O04252 /
Reg. O03453
The tops of these pins are masterpieces
of miniature work by precolumbian
craftsmen using the lost-wax method.

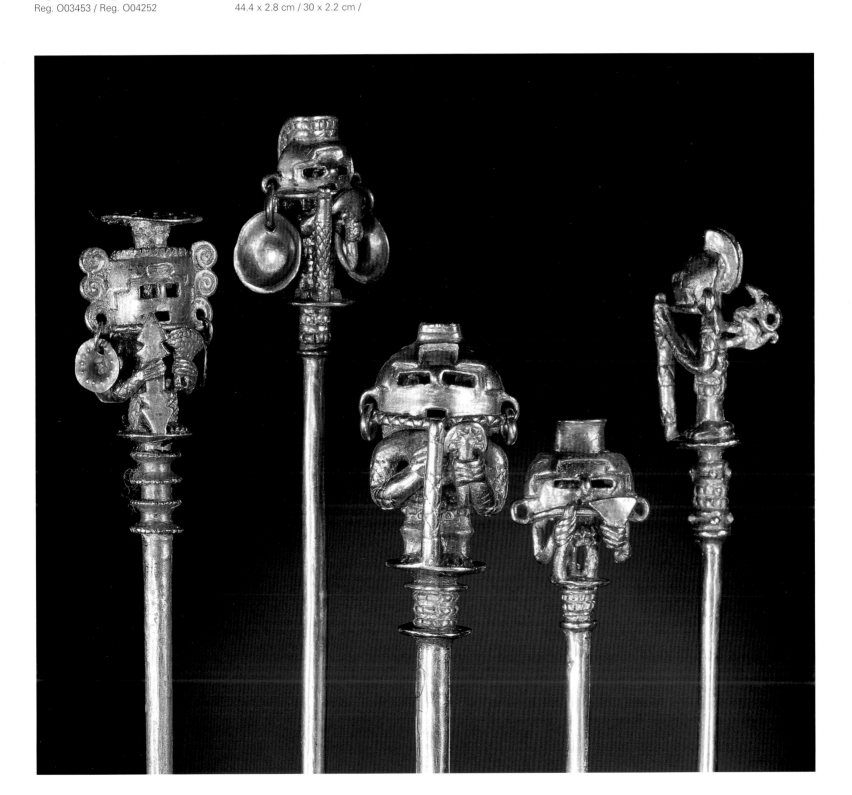

Lime sticks
Left to right
24.6 x 1.2 cm / 28 x 1.1 cm /
29 x 1.5 cm / 33.5 x 2.1 cm /
unknown / Restrepo, Cauca Valley /
unknown / unknown
100 BC–1000 AD
Reg. O06164 / Reg. O05128 /
Reg. O05235 / Reg. O05758
A group of sticks for lime with figures
of men with zoomorphic masks.

The symbolic and technological
complexity of these pins with tops
showing men with masks of felines and
snakes' tails is astonishing. Their use
must have been restricted to the upper
hierarchies.

Lime stick
26.5 x 2.9 cm
unknown
100 BC–1000 AD
Reg. O05759
Pin top with the figure of a man richly
adorned with feathers, attractive objects
for producing light and sound, as
occurred for participation in a ritual.

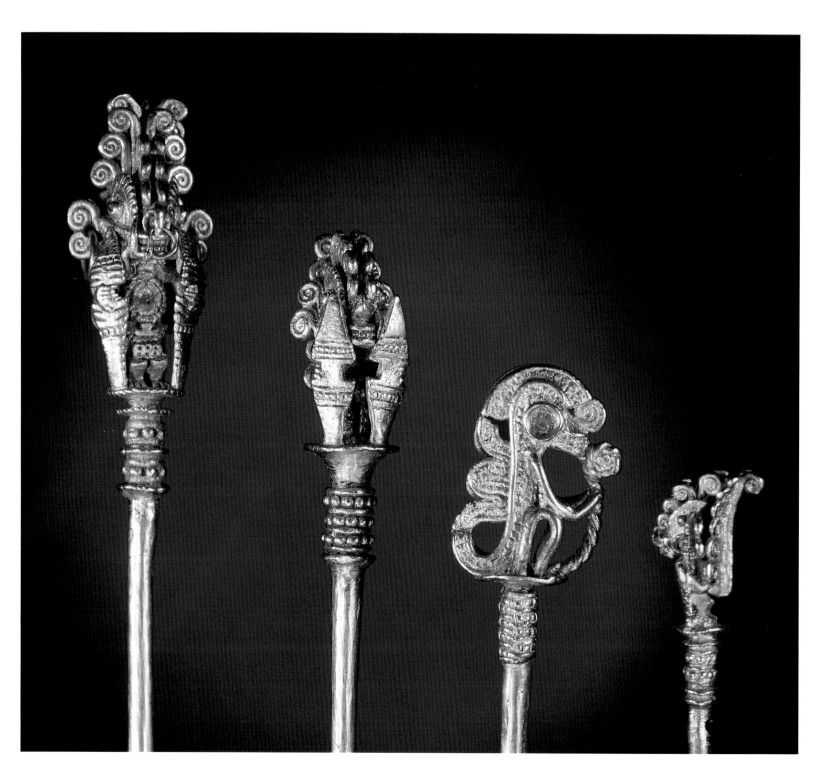

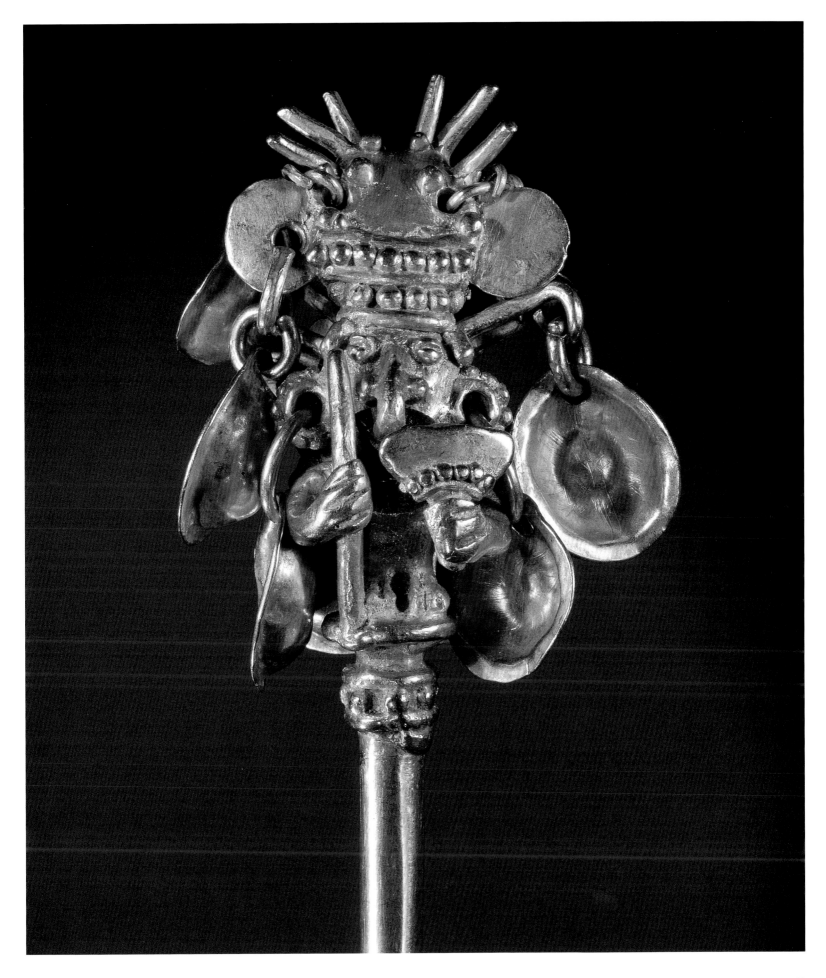

Ear ornaments
6.2 x 6.2 cm
6.1 x 6.1 cm
Restrepo, Cauca Valley
100 BC–1000 AD
Reg. O 24929
Reg. O 24930
Ear ornaments in the form of a spool
with geometrical motifs. To use them,
the ear lobe was stretched and large
gold plates were hung from them.

Nose ornament
2.3 x 2.6 cm
unknown
100 BC–1000 AD
Reg. O05544
Solid ring-shaped nose ornament, cast
in gold using the lost-wax method.

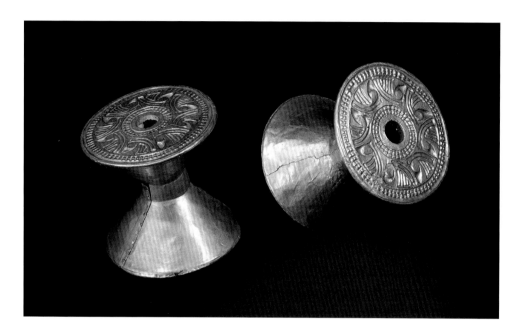

Pendant
5.4 x 2.6 cm
Palmira, Cauca Valley
200 BC–200 AD
Reg. O33350
Pendant with the three-dimensional
figure of a man, made of bone or clay
and overlaid with gold plate. The bent
position of his legs and his hands in a
resting position on his knees are a
characteristic feature in the iconography
of the Yotoco period.

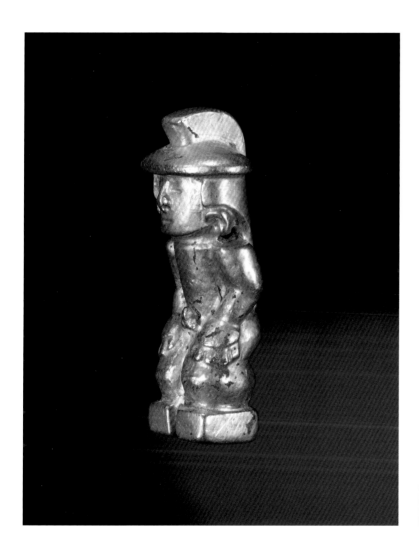
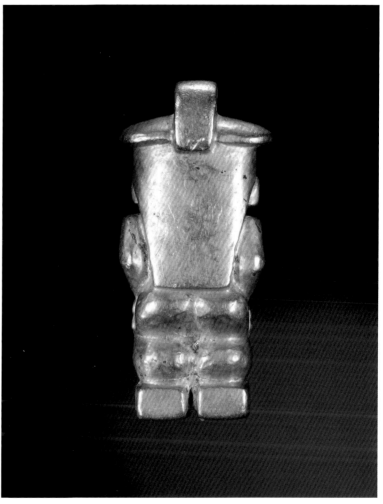

Masks
Left to right
29.7 x 49 cm / 29.5 x 53 cm
Palmira, Cauca Valley
200 BC–200 AD
Reg. O33403 / Reg. O33407
Large death masks made using the
hammering and embossing technique.

Masks
Left to right and top to bottom
26.3 x 41.4 cm / 29.5 x 53 cm / 29.7 x
49 cm / 25 x 30.5 cm
Palmira, Cauca Valley
200 BC–200 AD
Reg. O33337 / Reg. O33407 / Reg.
O33403 / Reg. O33196

Three of these immense funeral masks
were found placed on a skull in a tomb
in the cemetery in Malagana; the other
covered his feet. The holes in the sides
of these thick sheets of hammered and
embossed gold must have been used to
sew them to the cloth in which the
distinguished individual was wrapped.

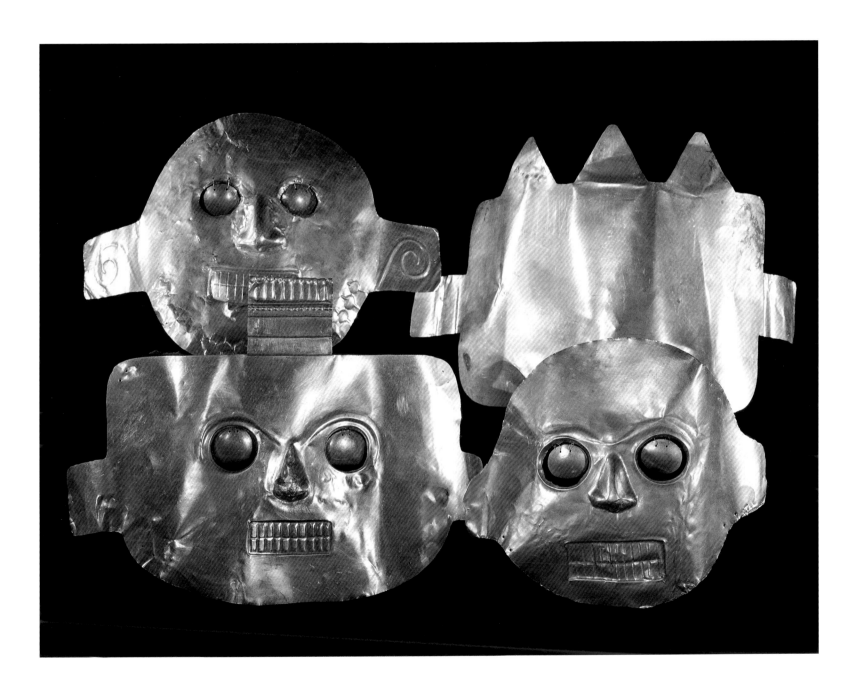

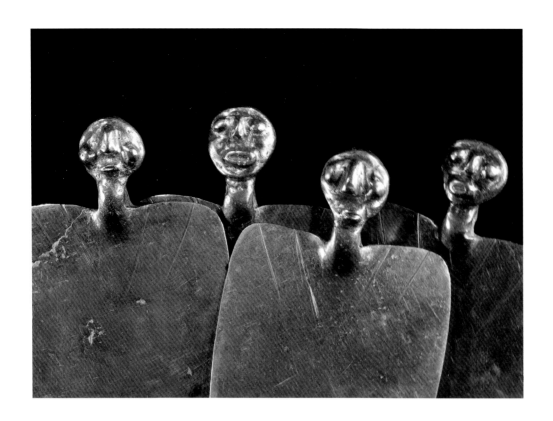

Bead necklaces
6 x 4.4 cm
Palmira, Cauca Valley
200 BC–200 AD
Reg. O33330
The hole for hanging these necklace beads, located behind the neck of the figures, causes a swelling in the front part, as though they had goitre. The representation of figures with deformities and illnesses was rare in the prehispanic world.

Container for lime
6.5 x 13.3 x 6.5 cm
Restrepo, Cauca Valley
100 BC–1000 AD
Reg. O00029
Plates embossed with mythological animals, moulded and assembled using gold nails, give form to this *poporo* with a jaguar figure.

Container for lime
7.1 x 5.4 cm
unknown
100 BC–1000 AD
Reg. O05564
Two gold plates, hammered and joined together by heating make up this *poporo* with the figure of a corncob. Maize, the product of the Sun, was the staple food of Andean prehispanic societies.

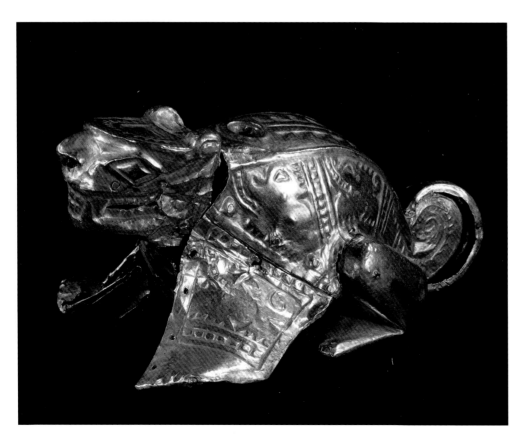

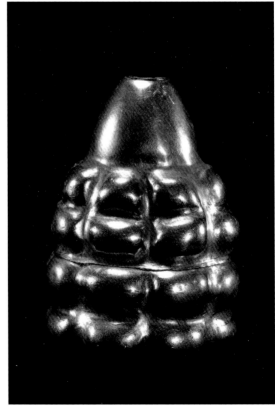

Breastplate
27.7 cm
Restrepo, Cauca Valley
100 BC–1000 AD
Reg. O06668
This face, furrowed with wrinkles and
adorned with large decorations, is that of
an old man, a leader and a man of
knowledge.

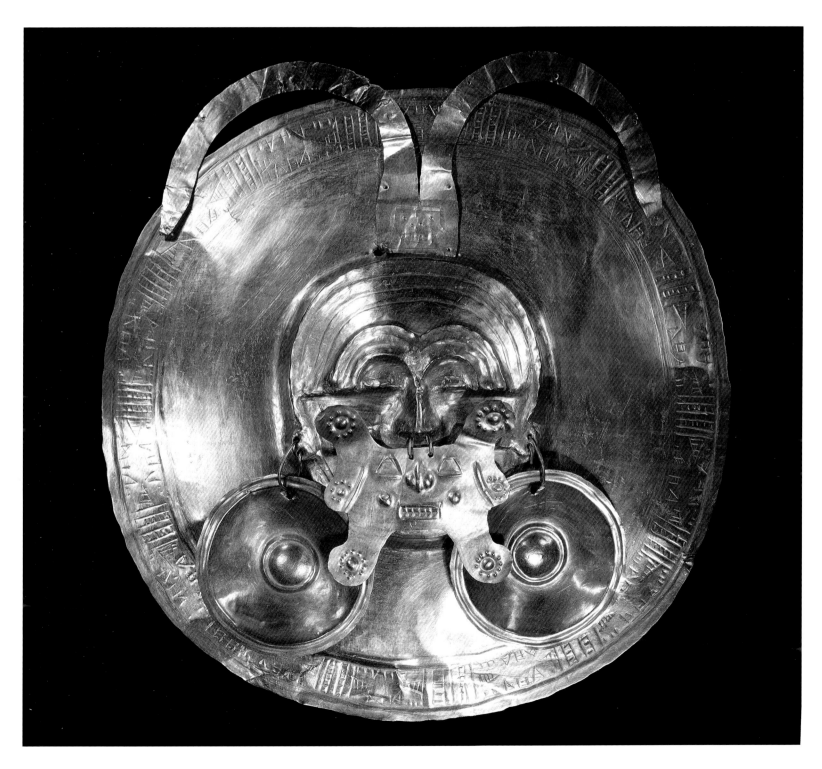

Pendant
18 x 15.3 cm
Palmira, Cauca Valley
200 BC–200 AD
Reg. O33393
This object, the function of which is
unknown, is reminiscent of the pincers
of a crustacean.

Lime stick
18.8 cm
unknown
0–600 AD
Reg. O03457
Pin top with the figure of an acrobat
in action. Human figures expressing
movement are uncommon in prehispanic
art.

Diadem
28.3 x 26.5 cm
unknown
100 BC–1000 AD
Reg. O04297
The golden face that occupies the centre
of this diadem, with nose ornament in
the shape of a jaguar and large ear
ornaments, is repeated in pendants and
breastplates of the Yotoco period.
The goldsmiths of the Calima region
created ostentatious pieces that made
up magnificent ceremonial attire.

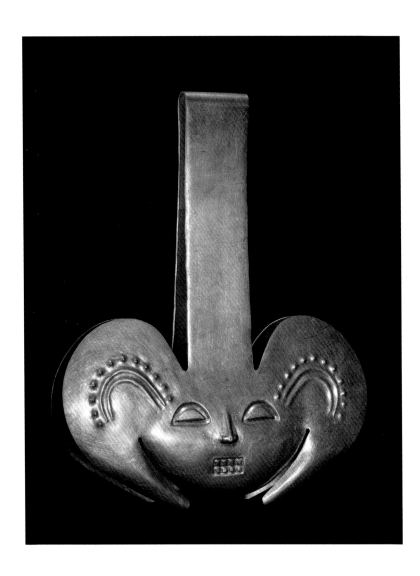

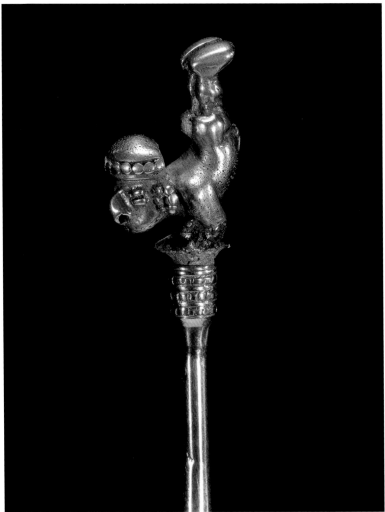

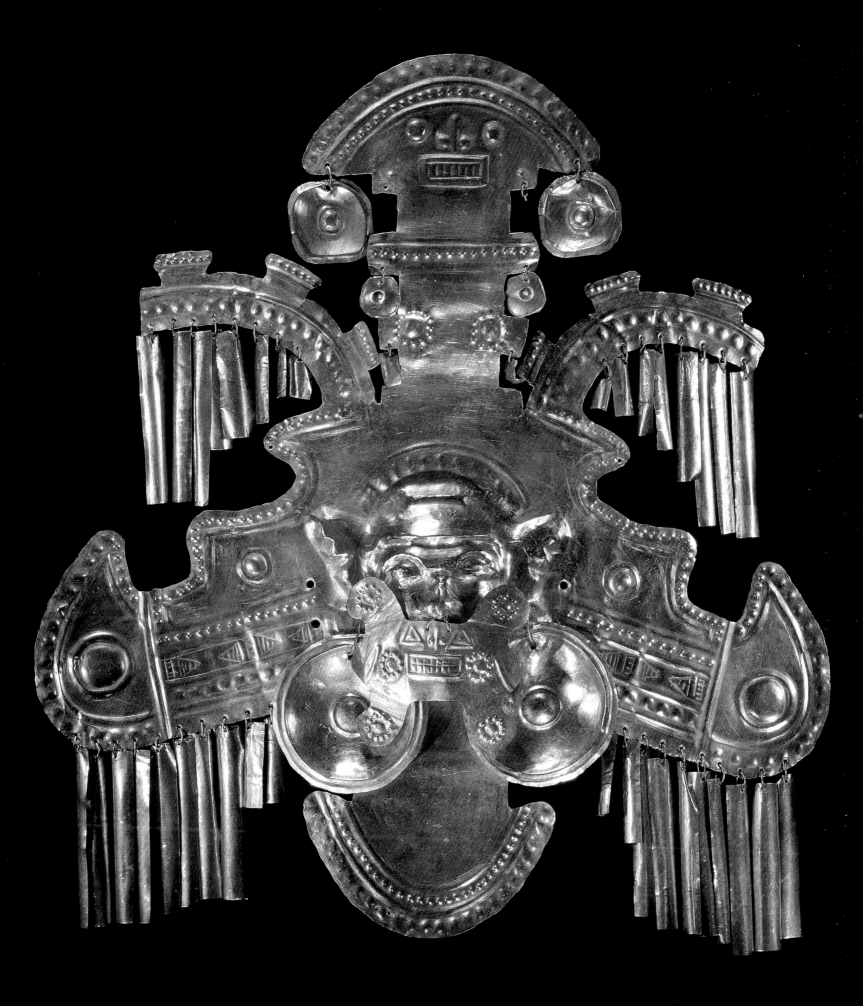

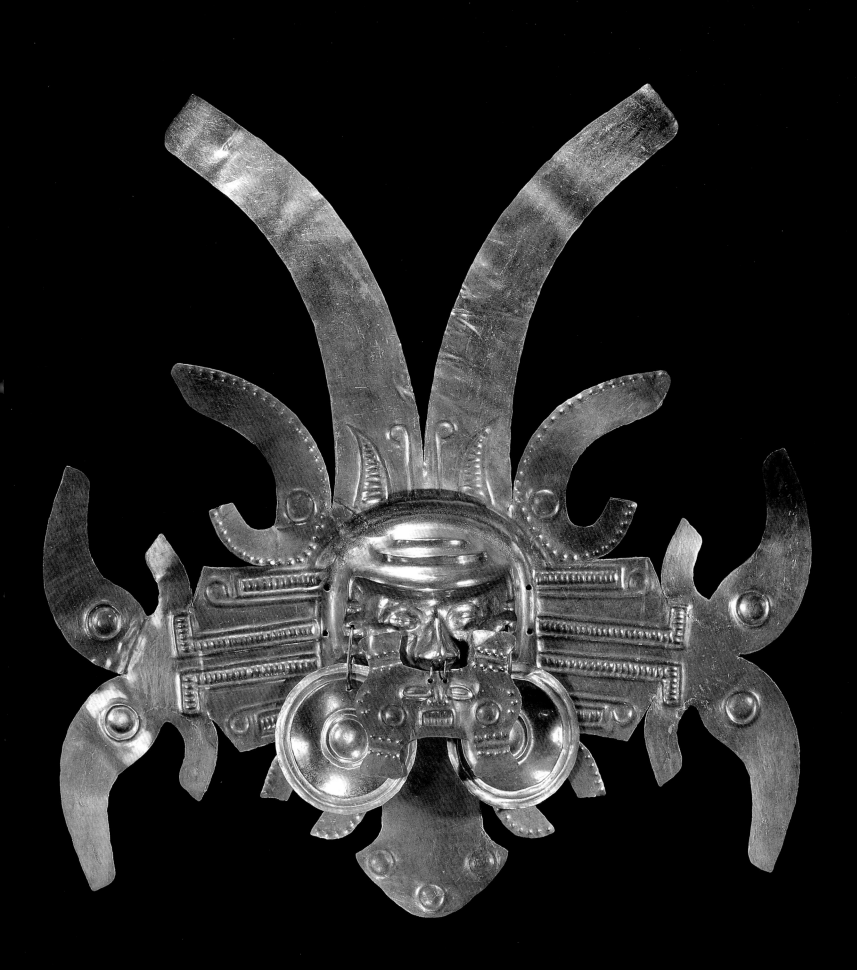

Diadem
24 cm
Darién, Cauca Valley
100 BC–1000 AD
Reg. O29383
Hammered and embossed gold
diadem with the form of a human face,
with forked crest-like feathers and
geometrical decorations.

Breastplate
26 x 27.5 cm
unknown
100 BC–1000 AD
Reg. O05196
The *caciques* of the Yotoco period of
Calima covered themselves with bright
gold sheets to allude to the Sun, the
divinity symbolising the origin and
renewal of life.

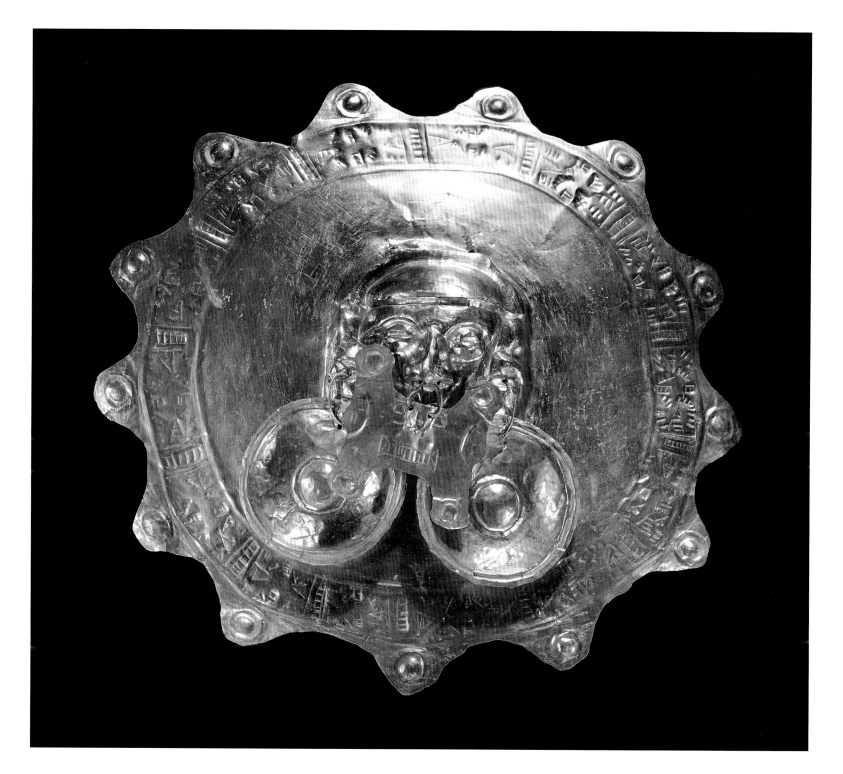

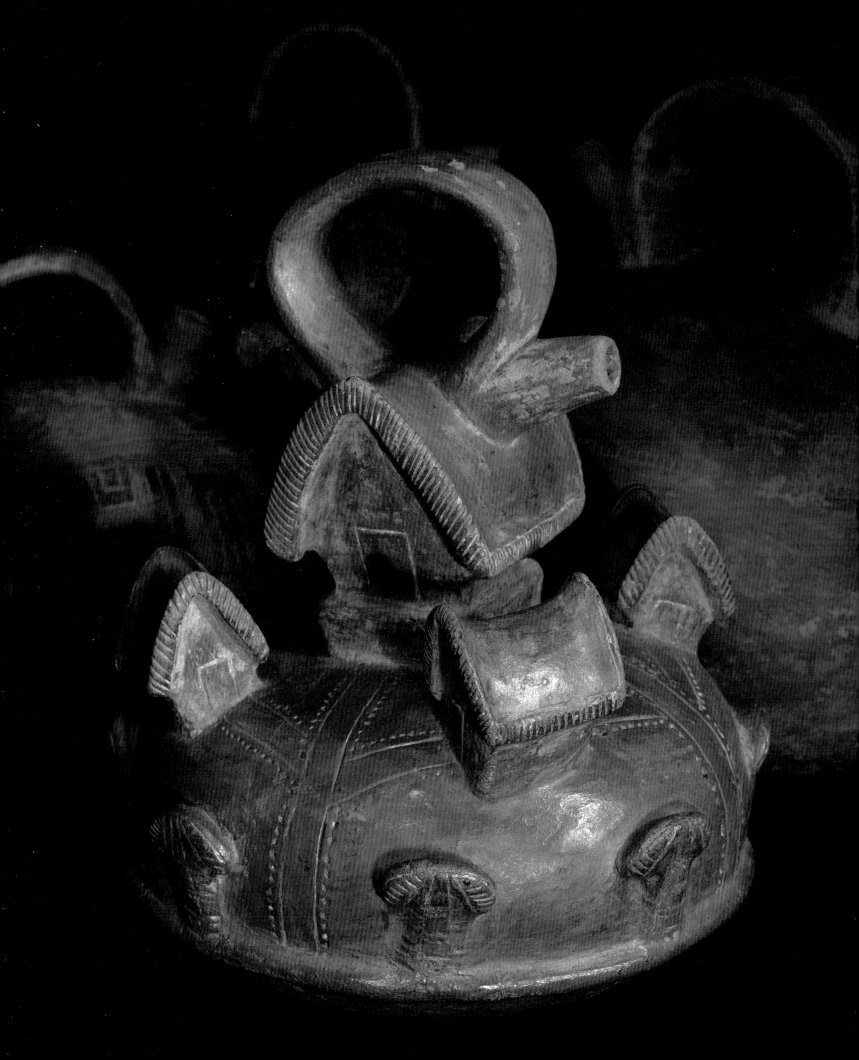

Alcarraza
21.3 x 18 cm
Restrepo, Cauca Valley
100 BC–1000 AD
Reg. C05620
This container, the purpose of which
was to hold fresh water, is the
representation of a village with houses
with rectangular plans and roofs with
two pitches, linked by paths. The Yotoco
Period: 100 BC–1000 AD

Vessel
11.4 x 7.8
Cauca Valley
1500 BC–100 BC
C06299
Representation of an individual carrying
a basket on his back, probably containing
exotic products for exchange. This is
also a man transformed into a bat,
carrying a bicephalous snake on his
head. Ceramic from the llama period:
1500 BC–100 BC.

Alcarraza
12.3 x 15.3 x 12.4 cm
Palmira, Cauca Valley
200 BC–200 AD
Reg. C13101
Earthenware vessel with the figure of an
opossum. The skill in the execution of its
hind limbs, its prehensile tail and its
characteristic of carrying its young inside
a pouch were qualities admired by the
members of this society.
Representations of this animal were also
common in metal objects. Malagana
Period: 200 BC–200 AD.

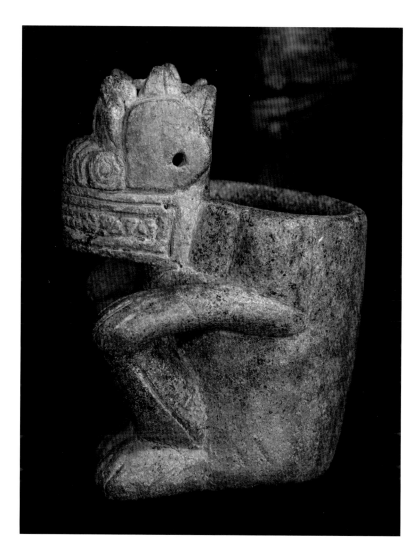

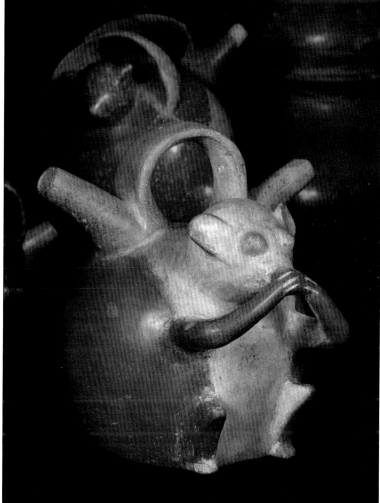

River Magdalena in the San Agustín
Region, Huila Department.
Photo: Rudolf.

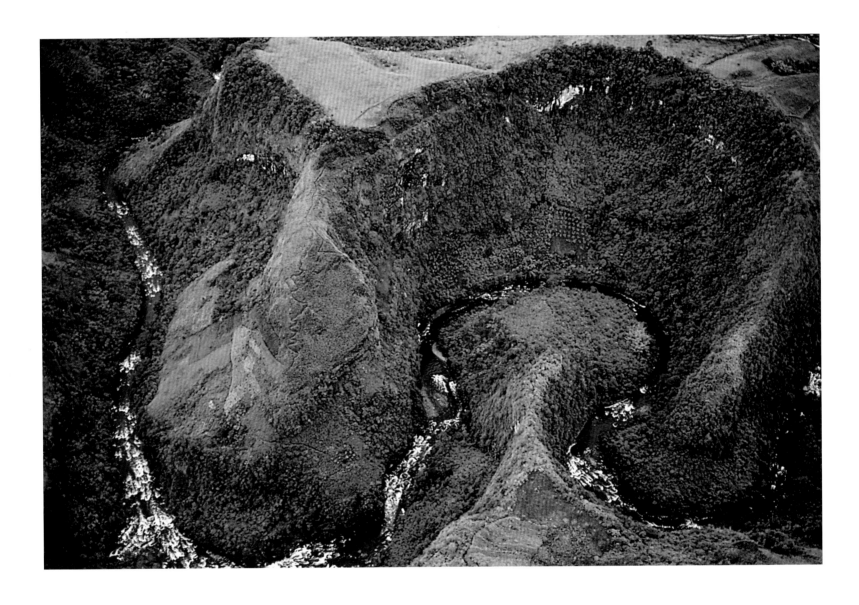

San Agustín

In prehispanic times the extensive region of Alto Magdalena, blessed by the great ecological diversity of its mountains and valleys, was part of the archaeological area of San Agustín. The numbers of inhabitants gradually increased over three periods of settlement. During the Formative Period, sedentary communities were established oriented towards agriculture, which produced utilitarian and ritual pottery, as well as some gold objects. In the Regional Classical Period, social hierarchisation developed; this was manifested in the construction of funerary monuments and stone statues in honour of leaders whose power apparently did not come from control of the economy but from religion.

This public expression today consists of more than five hundred figures located over an approximate area of 3,000 square kilometres. Predominant among them are anthropomorphic carvings of males with large heads, flattened noses, almond-shaped eyes, visible teeth, rectangular torsos and static postures; on occasions felines are found, which embody force and power, as well as other animals. Originally painted in various colours, in the sculptures it is the monumentality, the hieratic attitude, the symmetry and the attention to significant details that stand out.

Offerings of pottery and stone, wood and metal objects have been found in the funerary regalia. Pendants, plates, necklace beads, diadems, nose ornaments and cob-shaped coiled ear ornaments all stand out for their fineness and small format, all of which is in contrast with the monumental display of the funerary sculptures. Distinctive among these is the pendant in the shape of a winged fish—which was either cast or produced using the lost wax technique—that may have symbolised the union of two worlds.

During the Recent Period, the grand burials and the construction of stone monuments ceased, perhaps because the power based on economic control increased in importance, to the detriment of religion.

Temple, San Agustín archaeological
park, Huila Department.
Photo: Photographic Archive, Colombian
Institute of Anthropology and History.

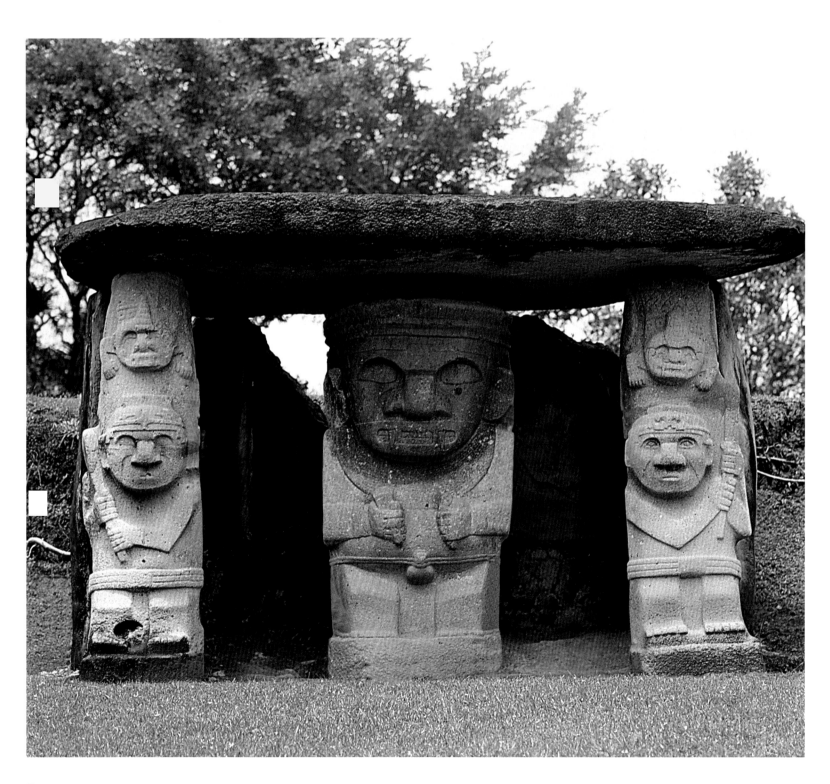

Map of the San Agustín archaeological
region.

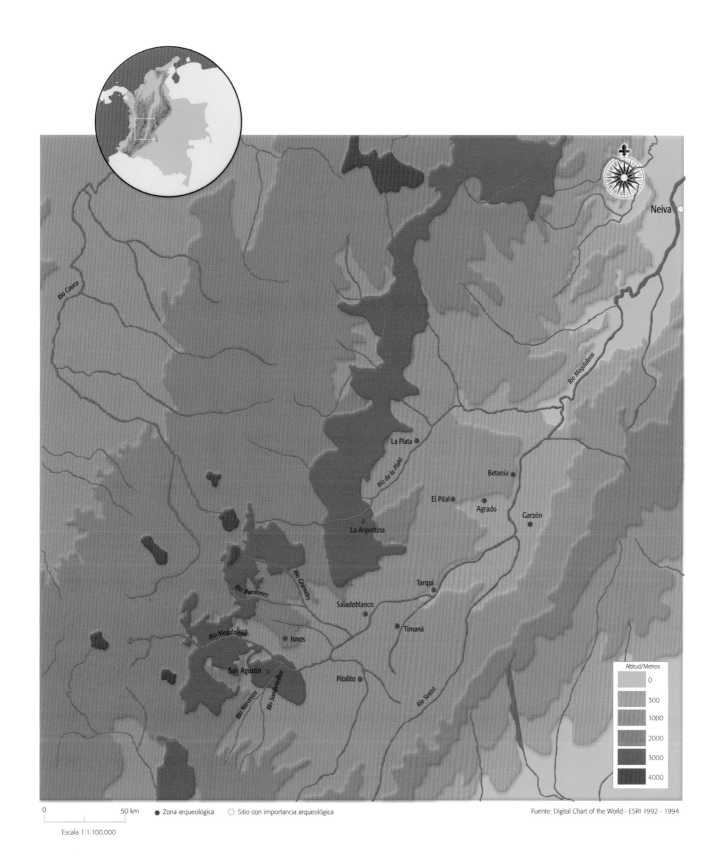

Neiva

La Plata

Betania

El Pital ● Agrado

Garzón

La Argentina

Tarqui

Saladoblanco

Timaná

Isnos

San Agustín

Pitalito

Río Cauca

Río Magdalena

Río de la Plata

Río Granates

Río Bordones

Río Magdalena

Río Naranjos

Río Sombrerillos

Río Suaza

Altitud/Metros

0
300
1000
2000
3000
4000

0 50 km ● Zona arqueológica ○ Sitio con importancia arqueológica

Escala 1:1.100.000

Fuente: Digital Chart of the World - ESRI 1992 - 1994

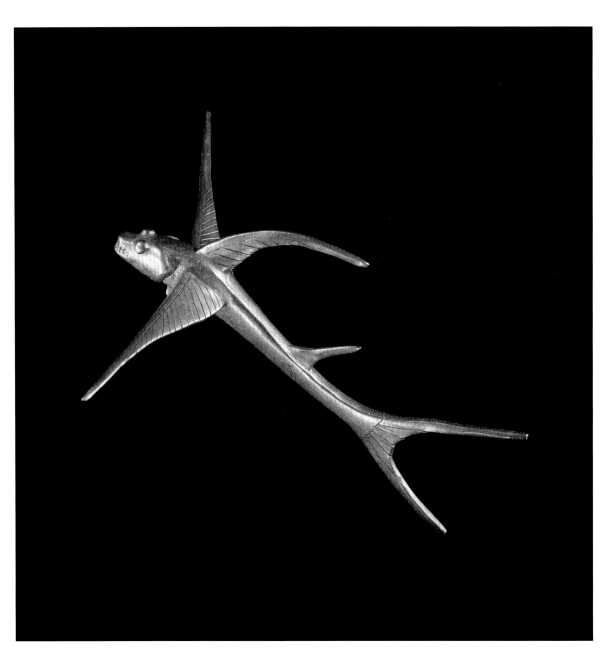

Pendant
3.1 x 9.7 x 8.8 cm
San Agustín, Huila
0–900 AD
Reg. O32924
This extraordinary pendant, cast in the form of a flying fish, suggests the mythical union of the two worlds of water and air. Fishes were not often represented in the prehispanic metalwork of Colombia.

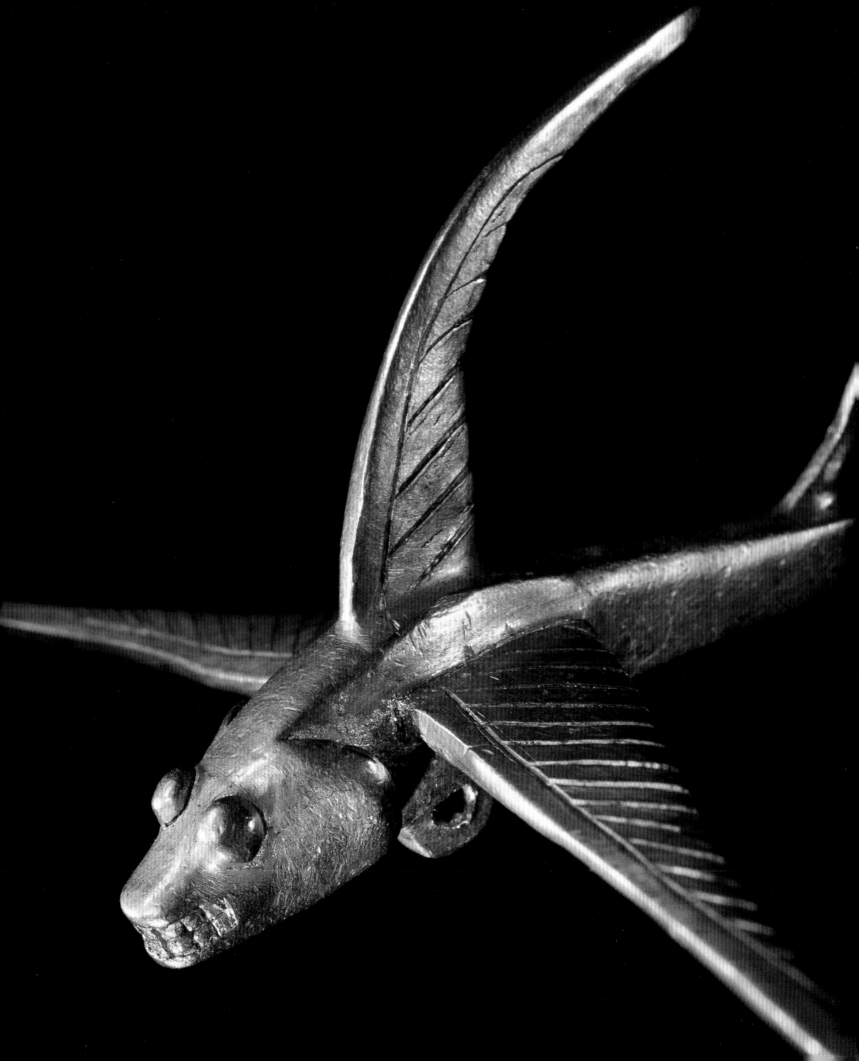

Diadem
30.5 x 35.2 cm
unknown
0–900 AD
Reg. O00112
Diadems like this adorned the foreheads
of the guardians and stone warriors that
guarded the monumental tombs of the
leaders of San Agustín. The power of the
jaguar was thus absorbed symbolically
by these characters.

Figure
3.5 x 1.5 cm
San Agustín, Huila
0–900 AD
Reg. O24251
Two embossed and assembled gold
sheets give form to this small male
human figure in a static position. Its
iconography is similar to the stone
sculptures found in the San Agustín
region.

Ear ornaments
6.7 x 3.1 cm
6.7 x 3.4 cm
Isnos, Huila
0–900 AD
Reg. O32871
Reg. O32872
Corncobs represented in gold alluded to
fertility. This pair of ear ornaments was
embossed on a model and then
assembled by pressure.

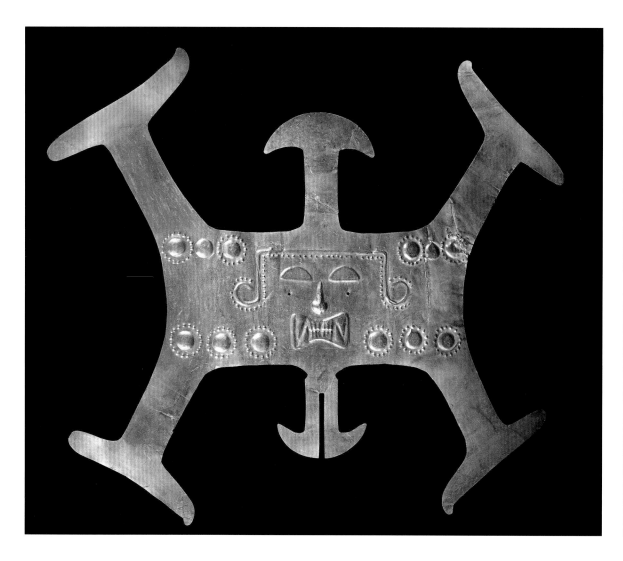

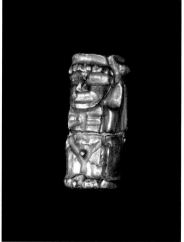

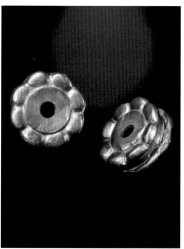

Necklace
1.2 x 0.5 cm
Isnos, Huila
0–900 AD
Reg. O32873
The monumentality of stone sculptures
contrasts with the smallness of this
pendant with no face and with
disproportionate hands, accompanied
by schematised birds.
On this occasion the goldsmiths
of San Agustín used the lost-wax casting
technique.

Alcarraza
7.7 x 15 x 12 cm
San Agustín, Huila
0–900 AD
C 12829
A small clay vessel in the form
of a ceremonial dwelling. Under large
feline-mouthed faces, its doors, located
at the ends, seem to be protected
by guardian beings.

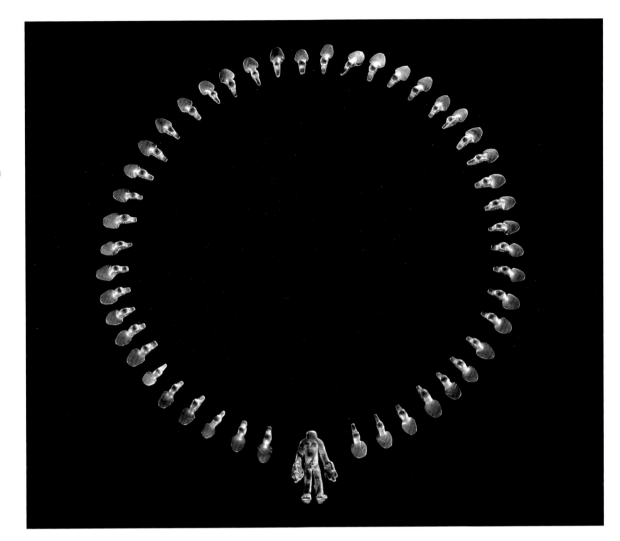

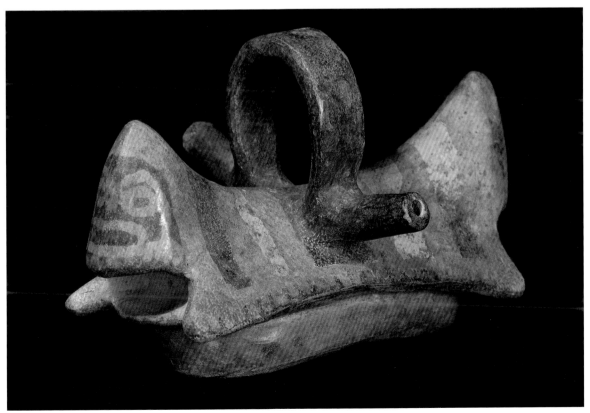

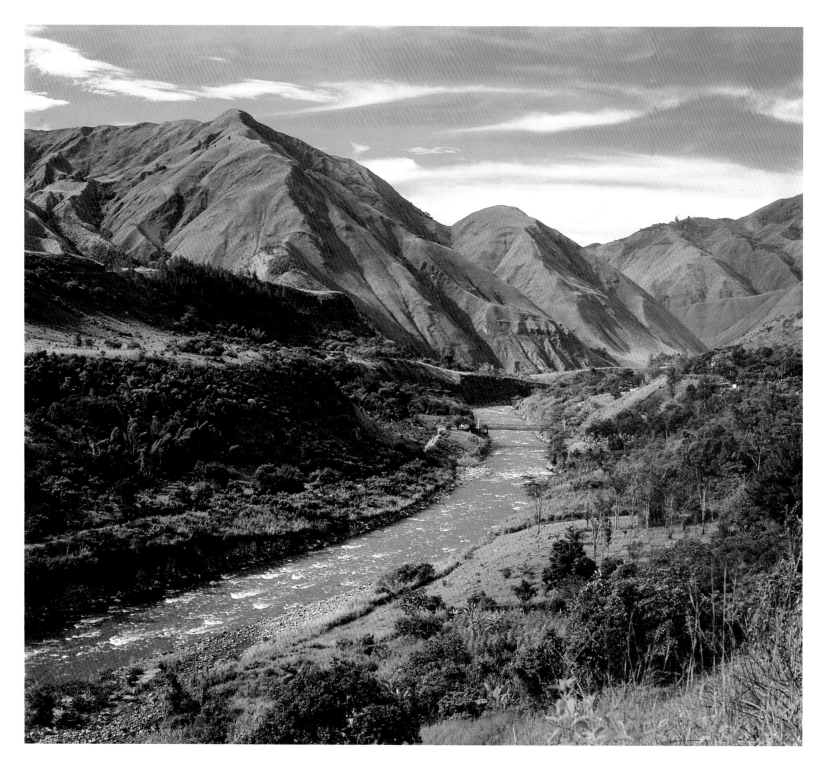

River Páez in the Tierradentro Region,
Cauca Department. Photo: Fabián Alzate.

Tierradentro

Due to the abrupt topography prevalent in the north-east of the department of the Cauca, the Spanish conquerors felt enclosed between mountains and so they gave the region the name by which it is still known today. Its occupation is divided into four distinct periods: Early, Middle, Late and Modern.

The people of Tierradentro developed very characteristic burial practices. On the summits of the mountains they carved underground mortuary chambers in volcanic rock, known as *hypogea*, of various types. The interiors of the more complex sepulchres, complete with spiral stairways, have geometrical paintings in the colours red, black and white. These imposing constructions were used for secondary burials, in which bones from a previous burial were placed definitively in high-quality ceramic urns.

In more modest burial sites, objects of hammered and embossed goldwork have been found, such as breastplates, bracelets and necklaces, in which the face of the jaguar predominates, as it does in some masks. Perhaps associated with the idea of transformation, one mask shows a human face with great realistic detail with embossed geometric decorations.

The people of Tierradentro also produced sculptures for ceremonial purposes that, despite having less detailed finishes, share basic characteristics with carved works from San Agustín in terms of symmetry, hieratic attitude and frontal orientation. The formal conception, modelling, colours and decoration of the pottery, consisting of *alcarrazas* (earthenware vessels) and other utilitarian and ritual recipients, such as a whistling vase, suggest that the communities of Tierradentro maintained cultural connections with the craftsmen of Cauca.

Cross section of a hypogeum
in Tierradentro.

Map of the Tierradentro archaeological
region.

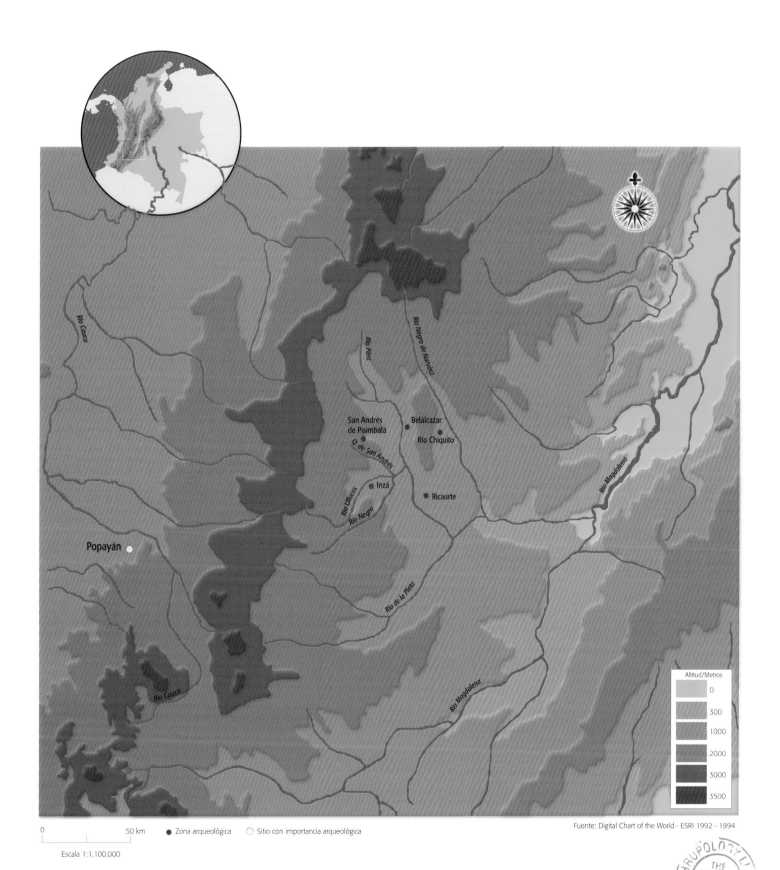

Altitud/Metros

	0
	300
	1000
	2000
	3000
	3500

0 50 km ● Zona arqueológica ○ Sitio con importancia arqueológica

Escala 1:1.100.000

Fuente: Digital Chart of the World - ESRI 1992 - 1994

Mask
8.7 x 12.7 cm
Ricaurte, Cauca
150 AD–900 AD
Reg. O28918
The metalwork of Tierradentro is highly
rare, for some unknown reason;
however, the few objects that are
known are masterful for their beauty and
rich iconography. This small mask very
realistically depicts the features of an
ancient face of Tierradentro. His face
painting undoubtedly identifies his clan
and lineage.

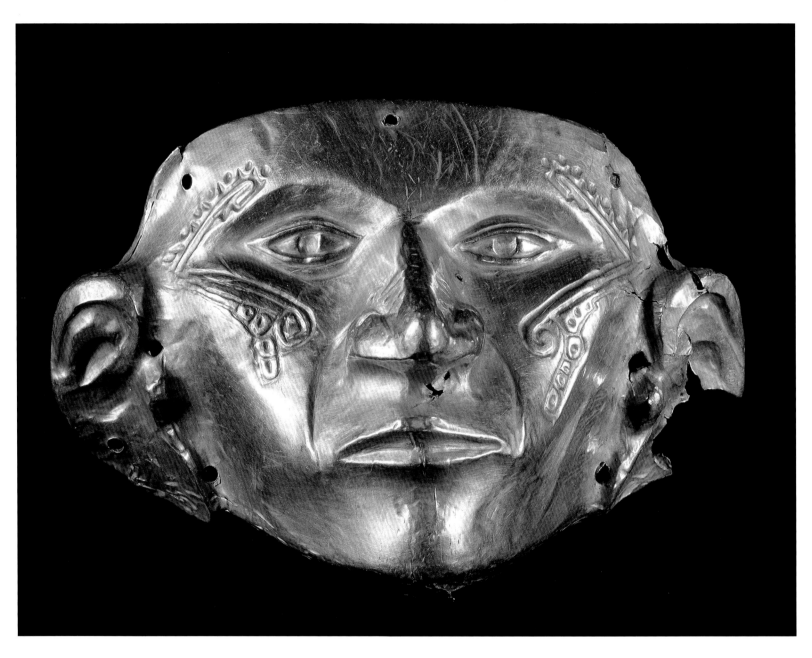

Mask
8.7 x 12.8 cm
El Pedregal, Inzá, Cauca
150 AD–900 AD
Reg. O07354
Special attributes such as cleverness, strength and ferocity make the jaguar an omnipresent animal in American mythology. This gold mask was undoubtedly part of a shaman's ritual paraphernalia.

Bracelet
5.4 x 8 cm
Río Chiquito, Cauca
150 AD–900 AD
Reg. O28443
The colourful design of this bracelet shows the features of a feline with a frog's body repeated over the whole outer surface of the bracelet in an interplay of complementary compositions. It was hammered and embossed in fine gold sheets and assembled by pressure.

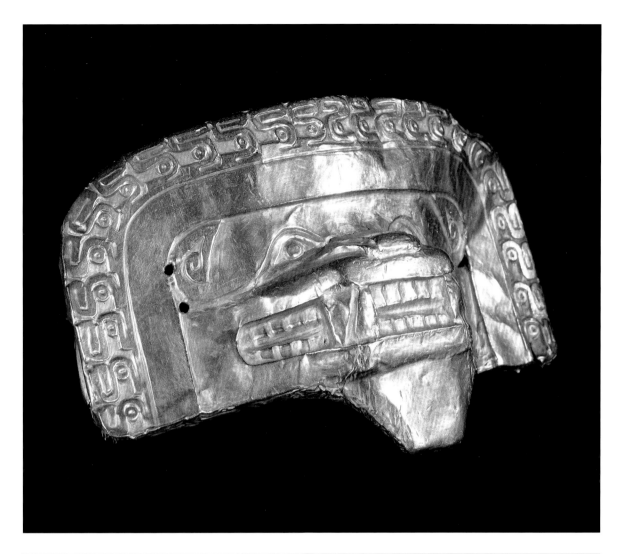

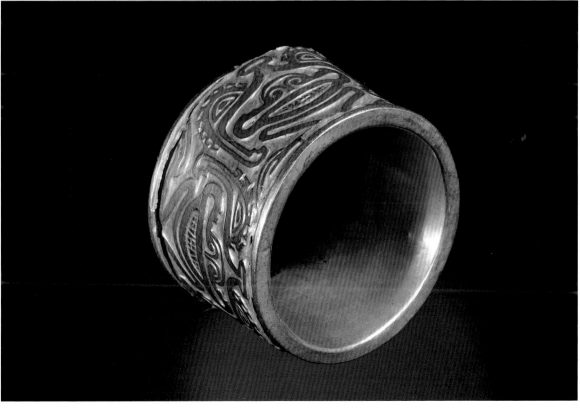

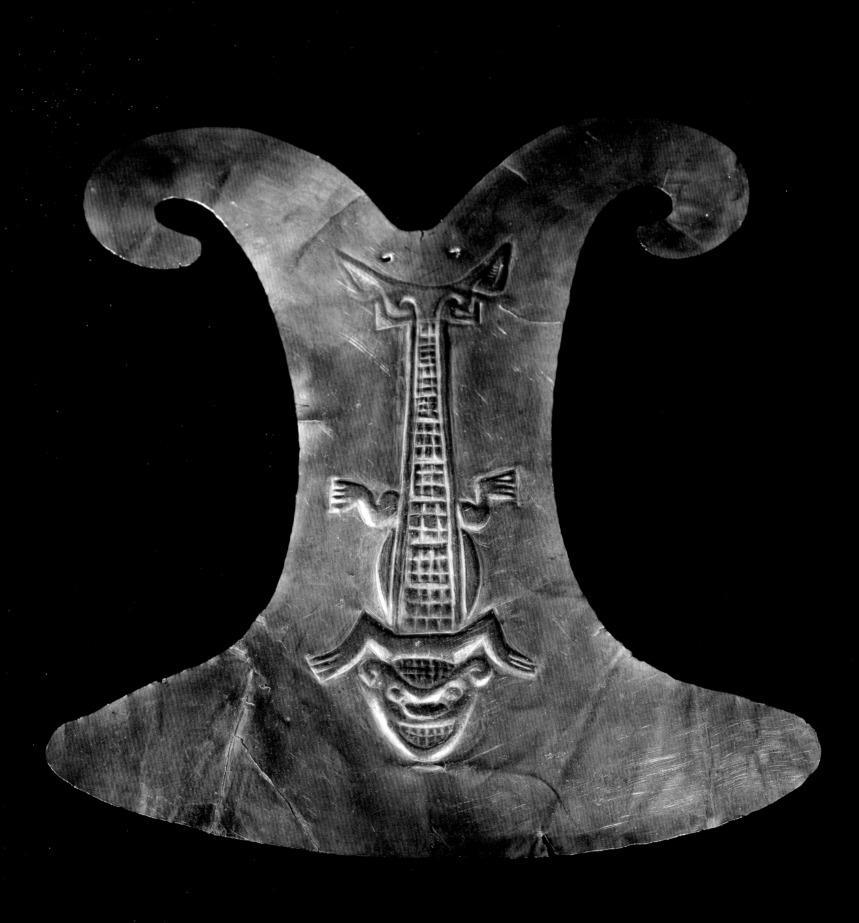

Breastplate
33 x 26.3 cm
Ricaurte, Cauca
150 BC–900 AD
Reg. O24969
With the figure of a cayman in the
centre, this breastplate covered the
wearer's chest. The rough texture of the
animal's skin has been faithfully captured
by the artist.

Alcarraza
15.7 x 14.5 cm
Río Chiquito, Cauca
150 AD–900 AD
Reg. C06292
A whistling vessel with the figure
of a man playing a Pan pipe.
The geometrical decoration of his body
is similar to those that cover the walls
of the hypogea of Tierradentro. X-ray has
enabled the various internal chambers of
this recipient, which enable it to be used
as a musical instrument, to be
discovered.

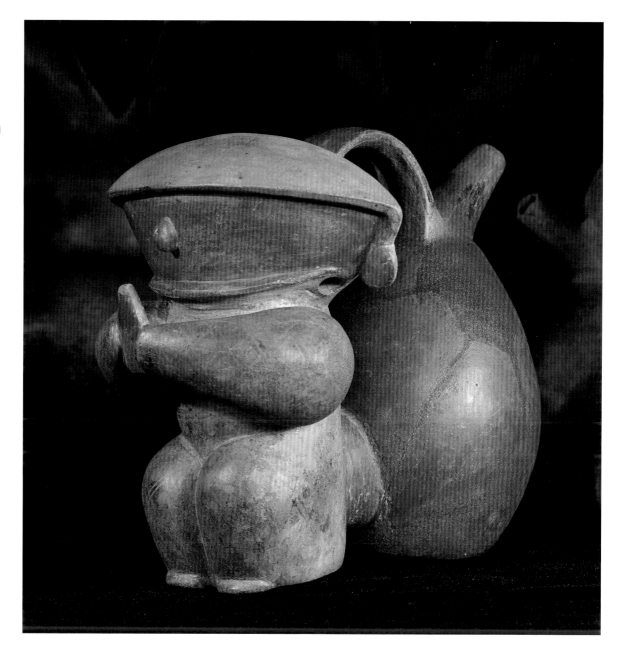

River Magdalena valley in the Tolima
Department. Photo: Rudolf.

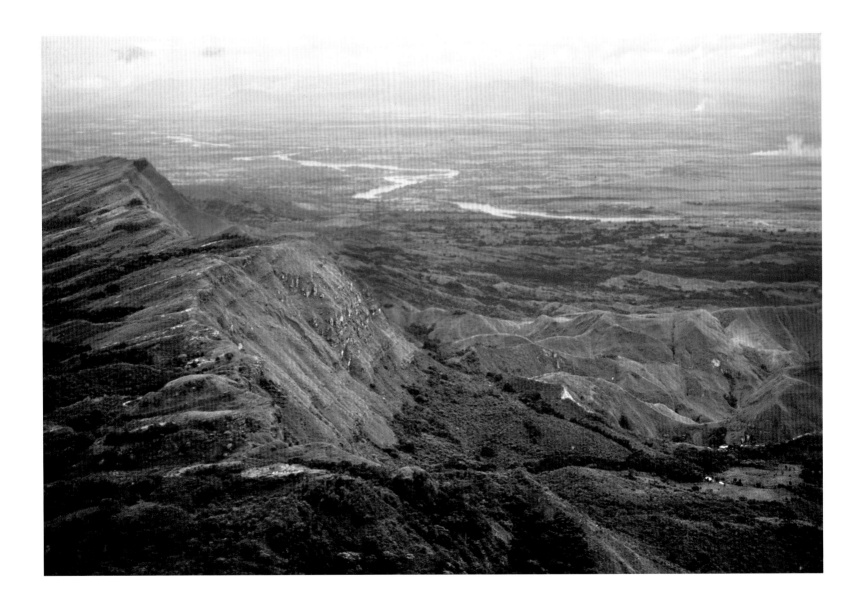

Tolima

The warm middle valley of the river Magdalena, which today includes the department of Tolima and the north of the department of Huila, was inhabited by groups of fishermen, hunters and gatherers. There, subsequently, lived farmers and potters who built terraces for dwellings and made ceramic pieces as well as outstanding metal objects.

The metalworking art of Tolima was intended to capture the phenomenon of shamanic transformation, as well as the magic inherent in the taking on of the attributes and powers of animals. It consists of two extensive groupings, each with great aesthetic power: the flat anthropo-zoomorphic figures, which allude to the flight of the shaman, and the three-dimensional ones, referring to mythical fauna. Belonging to the first group are breastplates and pendants in which, in the different variations, a man is transfigured into a bat, a bird or a jaguar; the tails, wings, ears, extremities and feathers of the respective animals are reduced until they become something akin to signs. The great imagination displayed by each object is balanced with a rigorous symmetry and an austere simplification of the forms, to the point that they almost seem to be ideograms.

The rich mythical fauna of Tolima took material shape in representations of insects, birds, fish, felines and caymans. Executed with varying degrees of naturalism and fantasy, they often combine several different figures in one.

The pottery also has references to the forms of plants; with time, the potters configured a number of regional styles and they created goblets, *alcarrazas* (earthenware vessels), pots and receptacles, decorated with incisions or painted with geometrical figures. These recipients were used during funeral practices, as were seats and urns with faces and human figures.

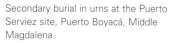

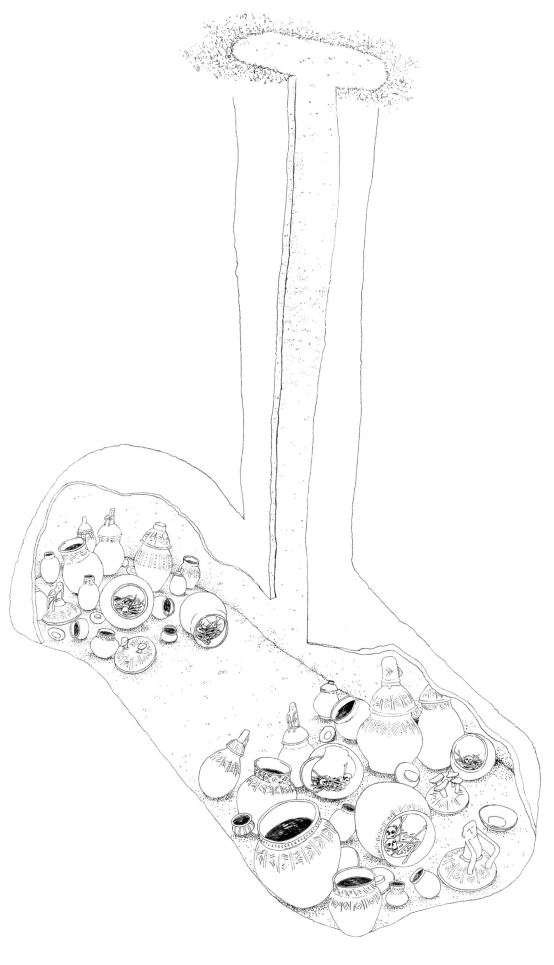

Map of the Tolima archaeological region.

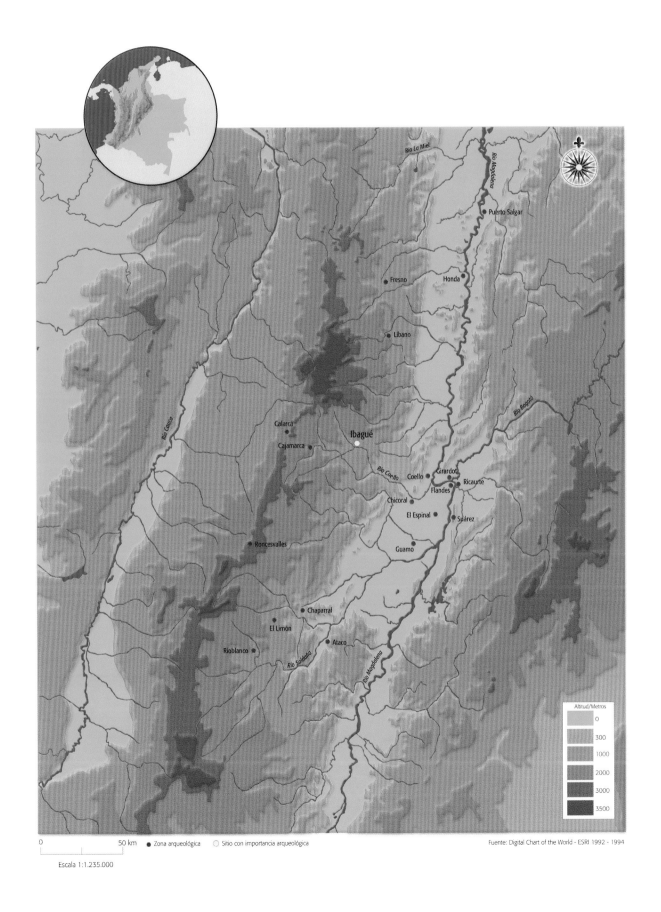

Río La Miel

Río Magdalena

Puerto Salgar

Fresno Honda

Líbano

Río Cauca

Río Bogotá

Calarcá

Ibagué

Cajamarca

Río Coello Coello Girardot
 Ricaurte
 Flandes
Chicoral
El Espinal Suárez

Roncesvalles

Guamo

Chaparral

El Limón

Rioblanco Ataco

Río Saldaña

Río Magdalena

Altitud/Metros
0
300
1000
2000
3000
3500

0 50 km ● Zona arqueológica ○ Sitio con importancia arqueológica

Fuente: Digital Chart of the World - ESRI 1992 - 1994

Escala 1:1.235.000

Breastplate
16 x 8.7 cm
unknown
0–500 AD
Reg. O06418
The wealth of the imagination of the goldsmiths of Tolima is captured in this breastplate, on which characteristics of man, jaguar and bat are combined, alluding to the man's transformation into an animal. This breastplate combines the techniques of casting, hammering and fretwork.

Breastplate
33.8 x 15.5 cm
Campo Hermoso, Ataco, Tolima
0–500 AD
Reg. O05834
An iconic figure of the prehispanic art of Colombia, this breastplate is the image of a schematised jaguar-man. It was cast in gold and hammered.

Breastplatees
Left to right and top to bottom
19.2 x 10.5 cm / 10.7 x 6.2 cm /
19.7 x 8.7 cm / 32 x 16.2 cm /
14.8 x 9.8 cm
unknown / unknown / Rioblanco, Tolima /
unknown / Corinto, Cauca
0–500 AD
Reg. O04662 / Reg. O06028 / Reg. O06235 / Reg. O06061 / Reg. O01222

A group of schematised breastplates. Breastplates with figures of men transformed with attributes of two of the symbolic animals most often represented in the prehispanic metalwork of Colombia: the jaguar and the bat.

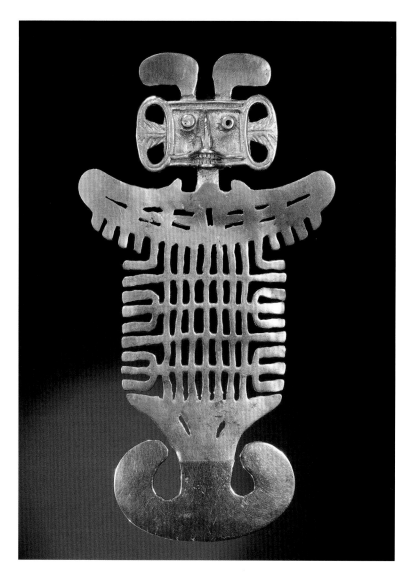

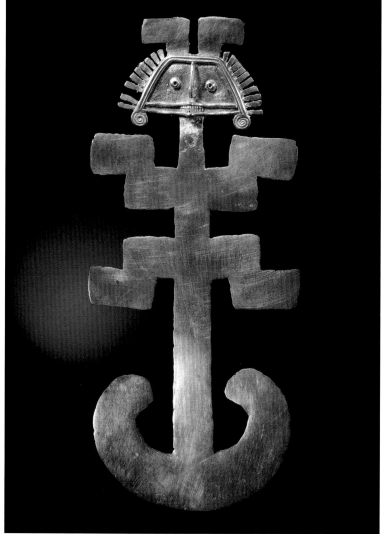

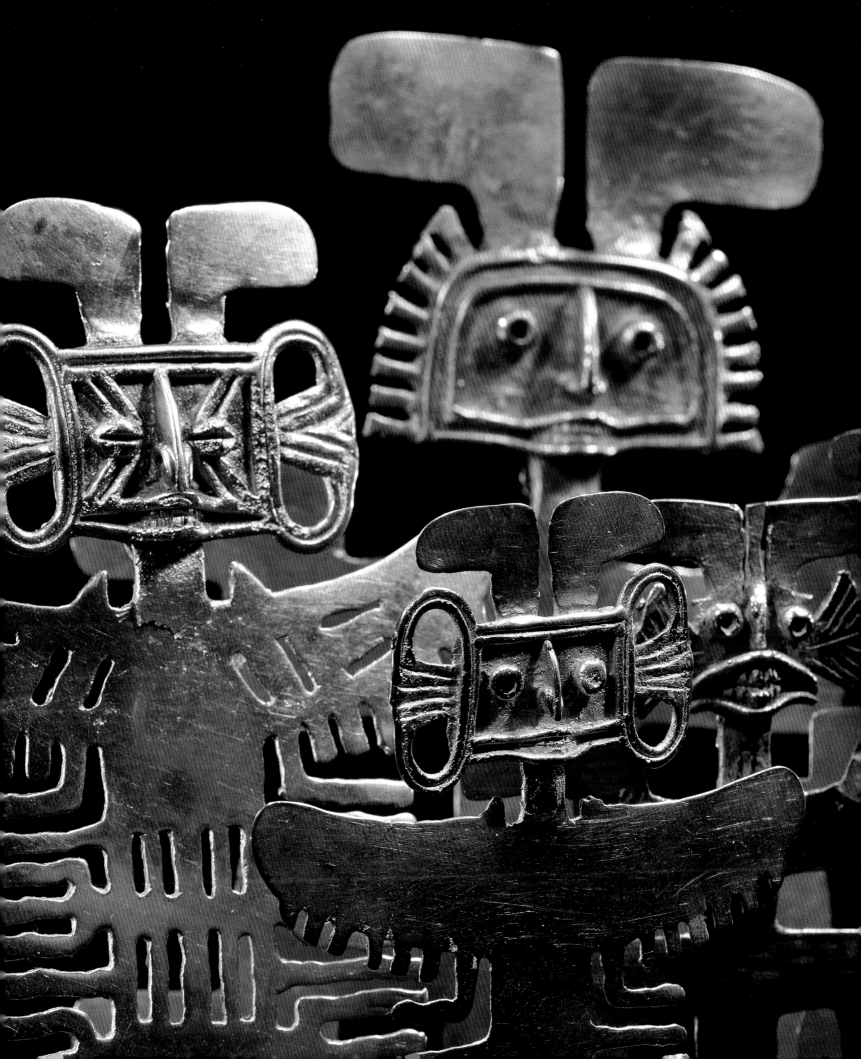

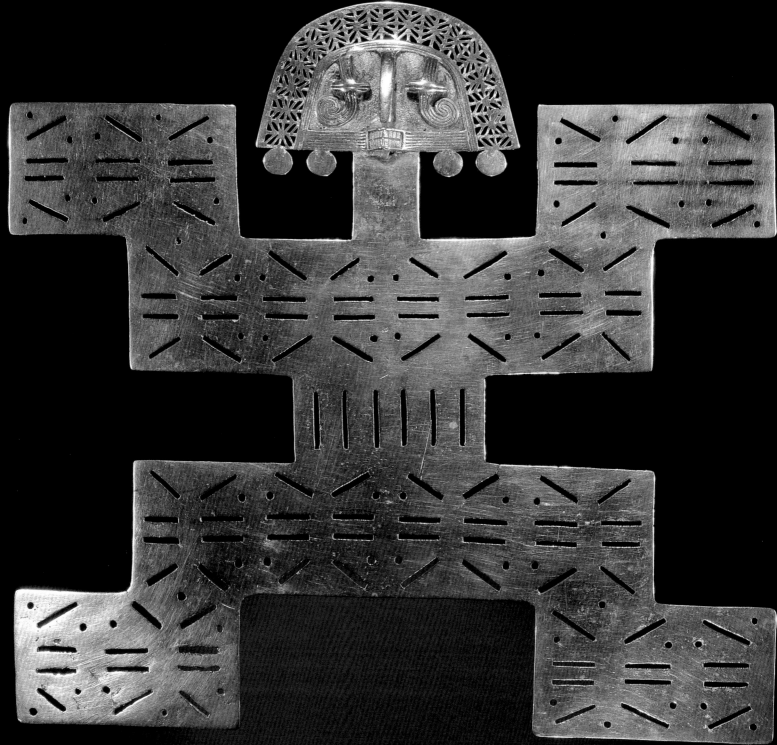

Breastplate
23.4 x 25.7 cm
El Dragón, Calarcá, Quindío
0–550 AD
Reg. O06029
The impeccable symmetry of its forms, the exact proportions of its measurements and its exquisite crafting make this breastplate a timeless masterpiece. Its discovery in the territory of Quimbaya indicates cultural relations with the inhabitants of that region.

Breastplate
18.8 x 11 cm
Chaparral, Tolima
0–550 AD
Reg. O05921
With the figure of a winged man with a jaguar's tail and jaws, this pendant was used as an emblem of power. Cast in gold using the lost-wax technique.

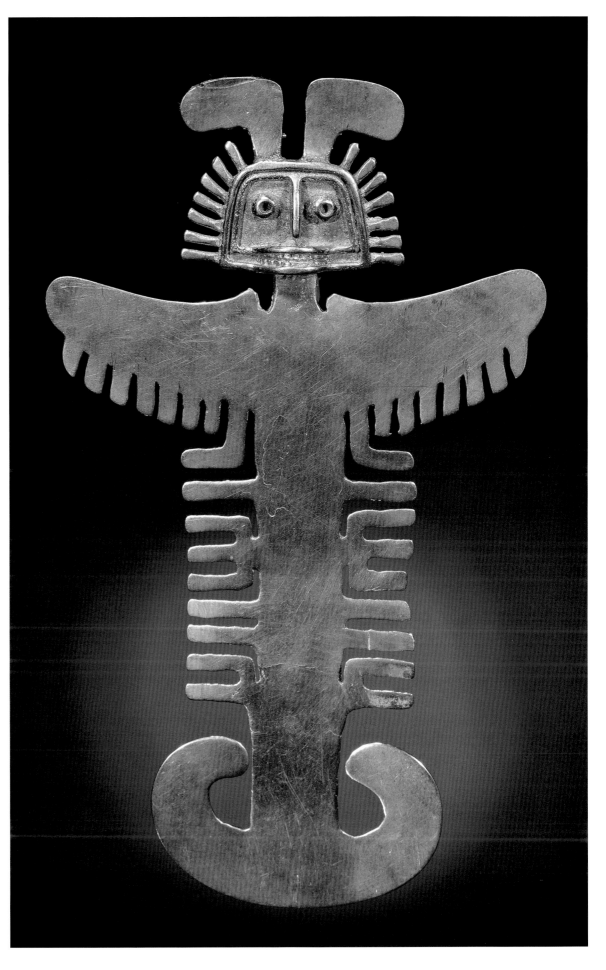

Ear pendants
5.5 x 8.3 cm
5.5 x 8.4 cm
Chaparral, Tolima
0–550 AD
Reg. O05931
Reg. O05932
The capacity to see the world upside-down and its mastery of darkness are special attributes that raise the bat to the level of a mythical animal. These ear pendants in the form of schematised bats were cast in gold and hammered.

Pendant
3.8 x 2 cm
unknown
0–550 AD
Reg. O01920
Pendants with features of birds, fish and insects form fantastic combinations of hybrid beings that allude to the notion of transformation associated with the shamanic thought of prehispanic societies. Made by casting gold.

Pendant
5.7 x 1.7 cm
Campo Hermoso, Ataco, Tolima
0–550 AD
Reg. O05871
This three-dimensional pendant, cast in gold, recreates the fantastic image of a feline carrying on its head and tail birds and insects that are characteristic of the baking-hot lands of the River Magdalena valley.

Bead necklace
3.1 x 2.8 cm
unknown
0–550 AD
Reg. O03683
Necklace beads with schematised human figures were common in the gold manufacturing regions of Calima, Malagana and Tolima. These pendants in particular allude to the rhythm and movement in dances and collective ceremonies.

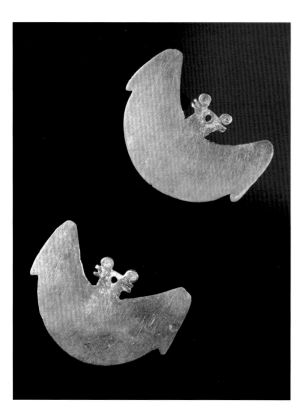 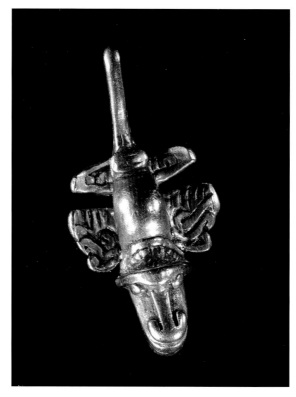

Urn
55.5 x 37.5 cm
Río La Miel
900 AD–1600 AD
Reg. C00835
Shaft tombs with lateral chambers with up to sixty burial urns, in which the exhumed bones of famous individuals were deposited, have been found in the riversides of the middle valley of the River Magdalena. The man who adorns the lid of this urn is decorated with small conch shell inlays.

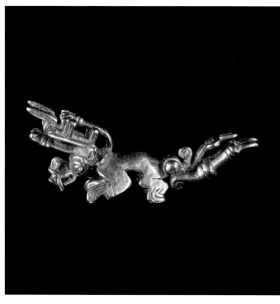 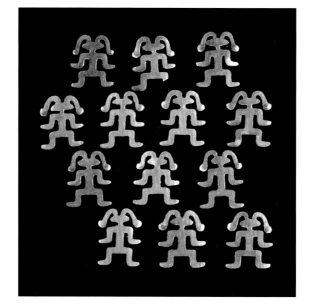

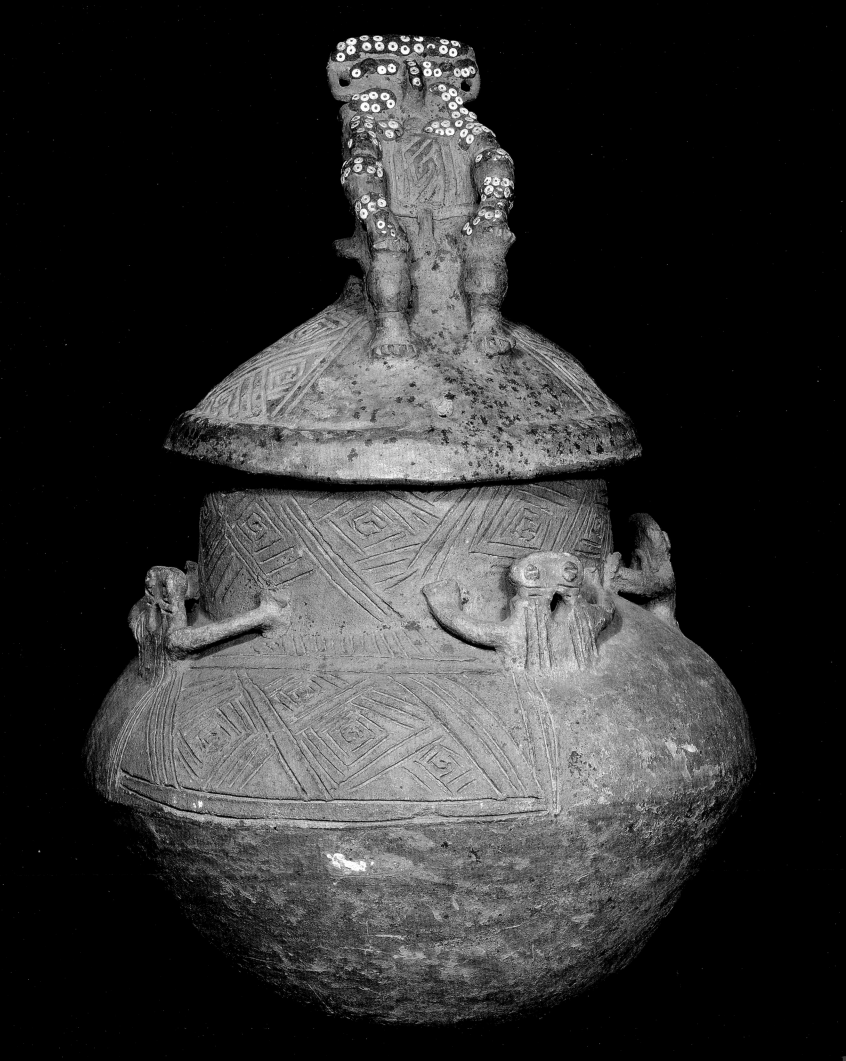

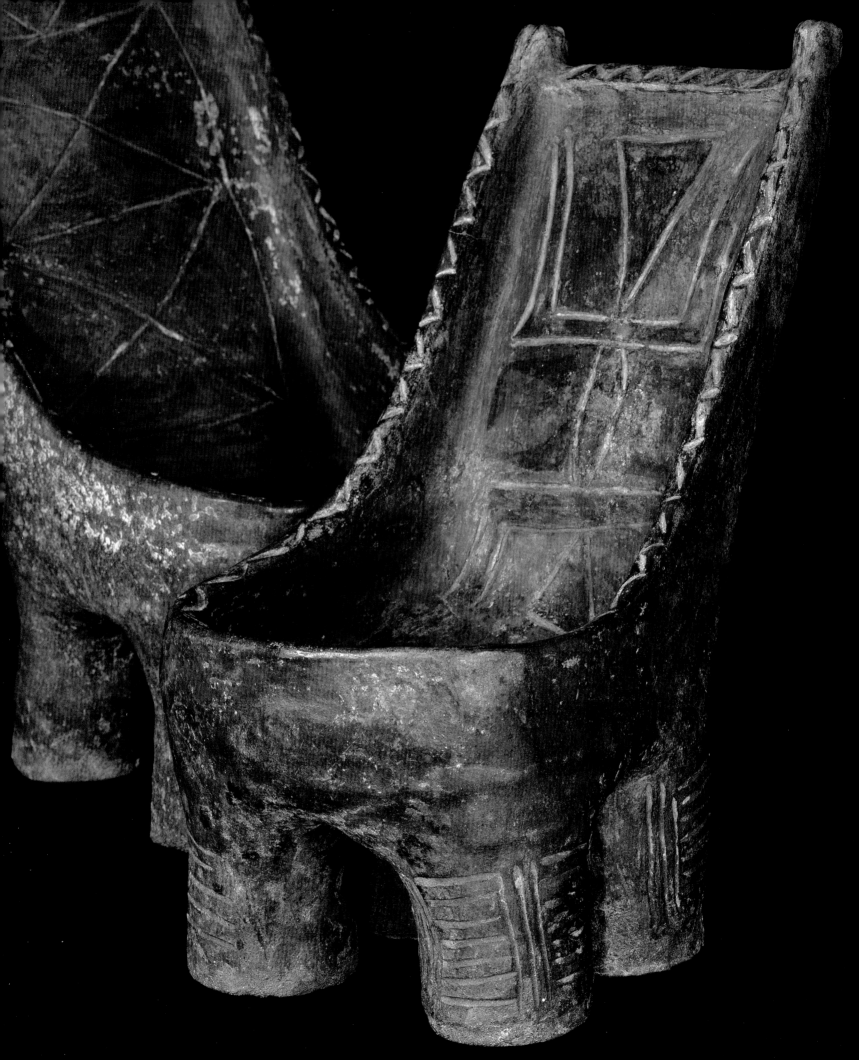

Seat
37.1 x 19.5 x 30 cm
Barroso, Guamo, Tolima
900 AD–1600 AD
Reg. C00849
As part of the regalia of the great
leaders, in the Tolima region burial chairs
of various sizes were buried that
reproduced human figures on their backs
with varying degrees of schematisation.
Frogs, lizards and snakes were also part
of the decorations of these chairs.

Goblet
25.8 x 16.1 cm
Llano Pelao, Espinal, Tolima
0–550 AD
Reg. C13404
The craftsmen of the Tolima region were
characterised by their decorating of
goblets and vessels for ceremonial use
with geometrical figures in contrasting
colours, undoubtedly as part of their rich
artistic expression, but also with a high
degree of symbolic content.

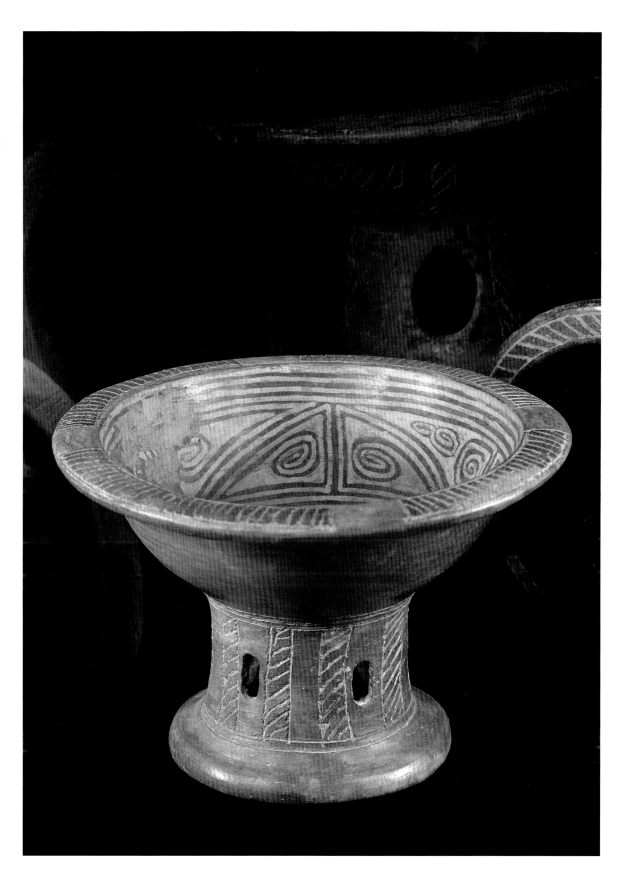

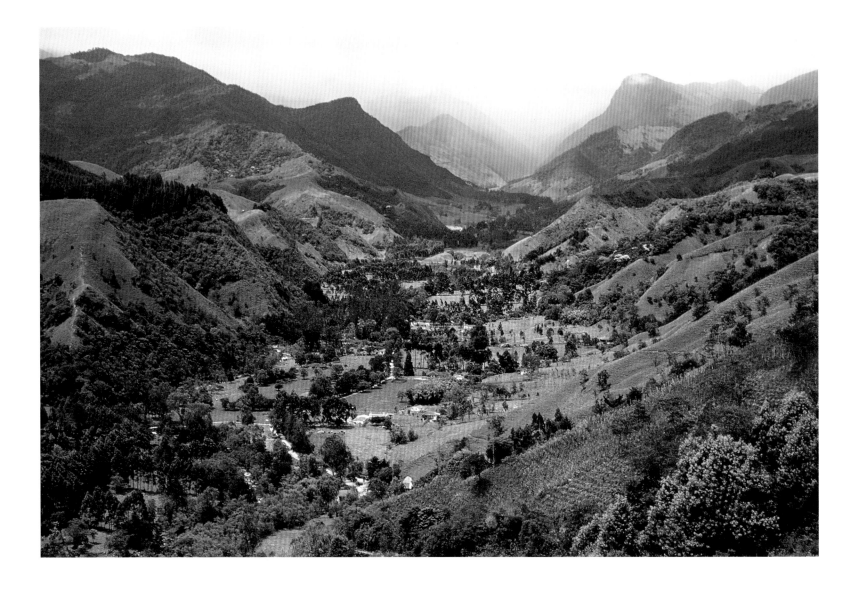

Quimbaya

Over the course of thousands of years the mountainous area of the Middle Cauca hosted various cultures. The societies of farmers, hunters and miners of gold and salt exchanged their surpluses and practised metalwork, which was developed over two periods, known as Early Quimbaya and Late Quimbaya.

During the Early period, the goldsmiths had recourse to complex technologies enabling them to produce works with considerable aesthetic sensitivity. Typical traits of these works were formal sobriety, reddish colours, and the brightness and smoothness of the surfaces. This production, which served as a source of prestige for the leading members of the communities, included adornments for the body such as mobile pendants that produced visual and sound effects, beads in the shape of human heads, breastplates, helmets, nose ornaments and stylised anthropomorphic and zoomorphic figures. The magnificent *poporos* (lime containers), some inspired by fruits and others by the human figure, supposedly expressed ideas on fertility and the life cycle. The lime sticks that complement them, are finished with complex figures with a shamanic character complete with abundant decorations and altered bodily proportions, perhaps for symbolic or expressive reasons. The representations of human figures have common characteristic features, such as rounded contours, triangular faces, thick torsos, half-closed eyes, nudity and the use of ligatures on the extremities.

During the Late Quimbaya period, which lasted until the Spanish Conquest, changes occurred in society, economy, aesthetics and metallurgy. Naturalism was replaced with geometry and schematisation. The production of various objects for the face, used by a larger number of people, began to predominate, and the manufacture of utensils for the consumption of coca was abandoned. Flat hammered and embossed surfaces with mythical motifs, rounded bodily contours and trapezoidal heads gained in importance. The potters made a wide variety of recipients with anthropomorphic figures, characterised by their high degree of abstraction.

Body painting.

Map of the Quimbaya archaeological region.

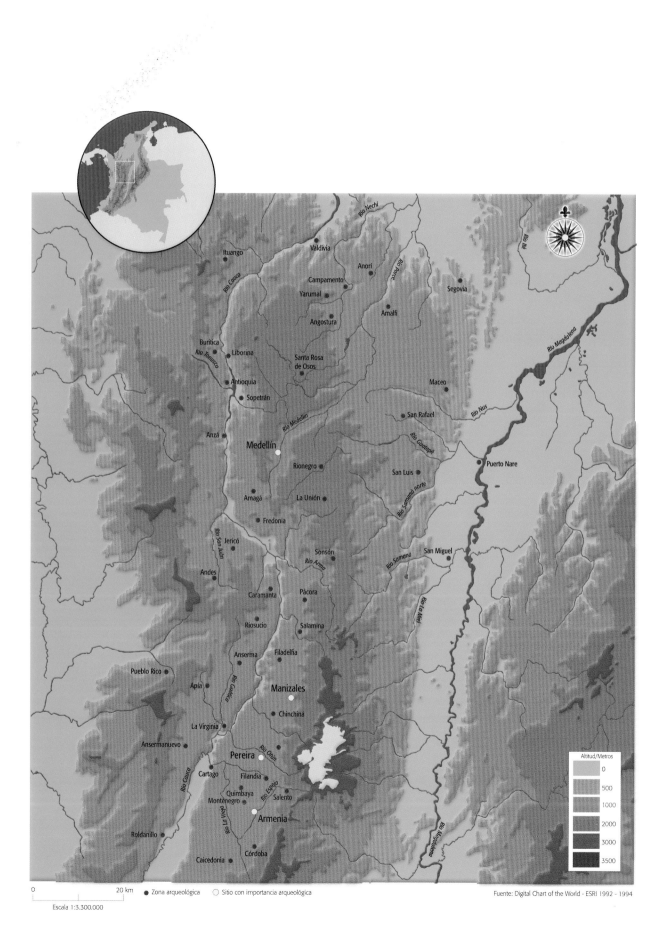

Río Nechí
Río Ité
Valdivia
Ituango
Anorí
Campamento
Yarumal
Segovia
Río Cauca
Río Porce
Angostura
Amalfi
Buritica
Liborina
Río Tonusco
Santa Rosa
de Osos
Maceo
Antioquia
Río Magdalena
Sopetrán
San Rafael
Río Nus
Anzá
Río Medellín
Medellín
Río Guatapé
Rionegro
Puerto Nare
San Luis
Amagá
La Unión
Río Samaná norte
Fredonia
Río San Juan
Jericó
Sonsón
Río Arma
San Miguel
Andes
Río Samaná
Río La Miel
Caramanta
Pácora
Riosucio
Salamina
Anserma
Filadelfia
Pueblo Rico
Apía
Río Cauca
Manizales
Chinchiná
La Virginia
Ansermanuevo
Pereira
Río Otún
Cartago
Filandia
Río Espejo
Quimbaya
Salento
Montenegro
Río Magdalena
Armenia
Río La Vieja
Roldanillo
Córdoba
Caicedonia

Altitud/Metros
0
500
1000
2000
3000
3500

0 20 km ● Zona arqueológica ○ Sitio con importancia arqueológica

Escala 1:3.300.000

Fuente: Digital Chart of the World - ESRI 1992 - 1994

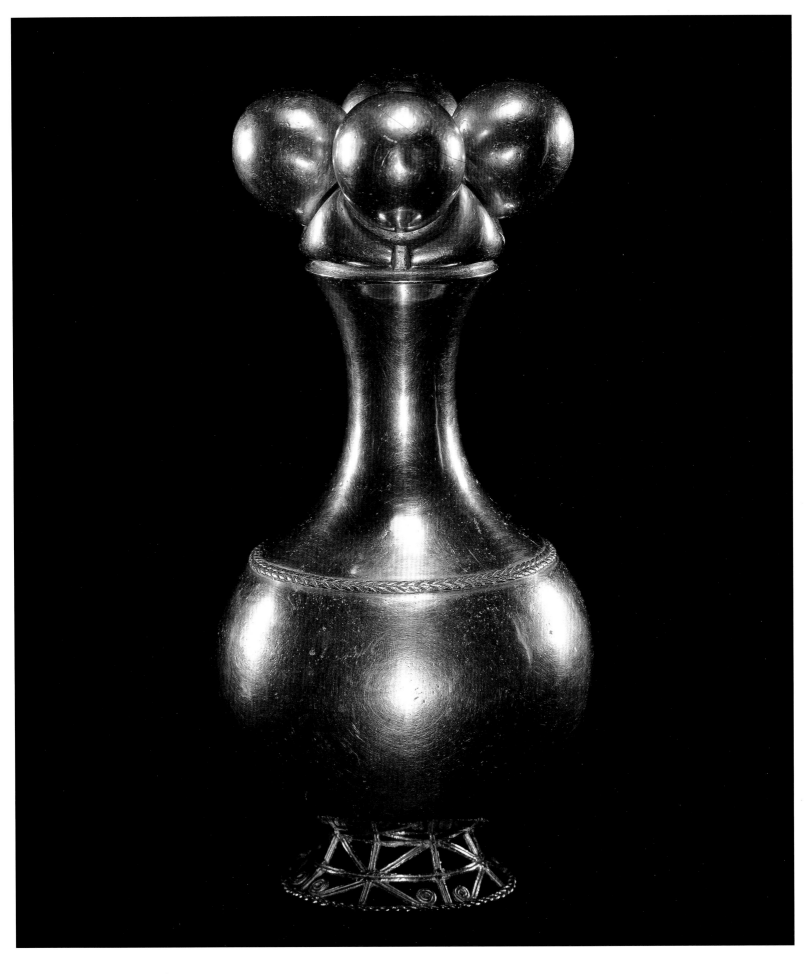

Lime container
23.5 x 11.4 cm
Loma de Pajarito, between Angostura
and Yarumal, Antioquia
0–600 AD
Reg. O00015
This *poporo*, with its harmonious
proportions and exquisite manufacture,
displays the mastery of the goldsmiths
of the Early Quimbaya period in their
handling of the lost-wax casting
technique with core. It was with this
piece that, in 1939, the collection of the
Banco de la República's Gold Museum
was begun.

Pendant
10 x 6.4 x 2 cm
Corinto, Cauca
0–600 AD
Reg. O00089
In the early goldwork of the Middle
Cauca there are frequently
representations of insects in
metamorphosis, such as this butterfly
chrysalis made of *tumbaga* using lost
wax casting.

Lime container
11 x 9.5 cm
Filandia, Quindío
0–600 AD
Reg. O00338
Inspired by the calabash and other
tropical fruits, the goldsmith created new
forms, such as this lime container made
of cast *tumbaga*. The reddish tone and
smooth and bright texture of its surface
are of surprising beauty.

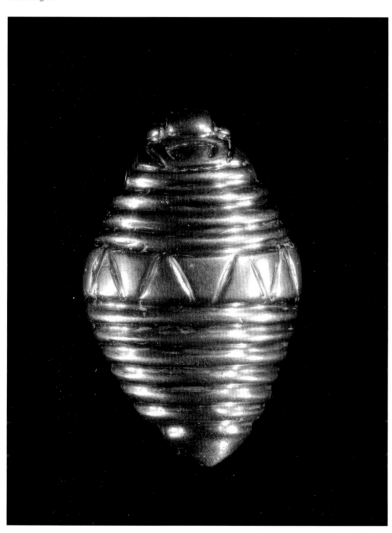

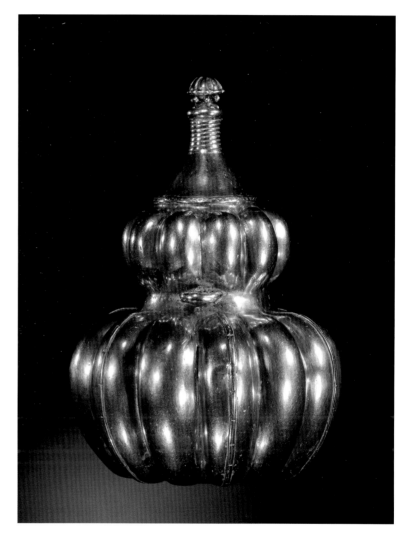

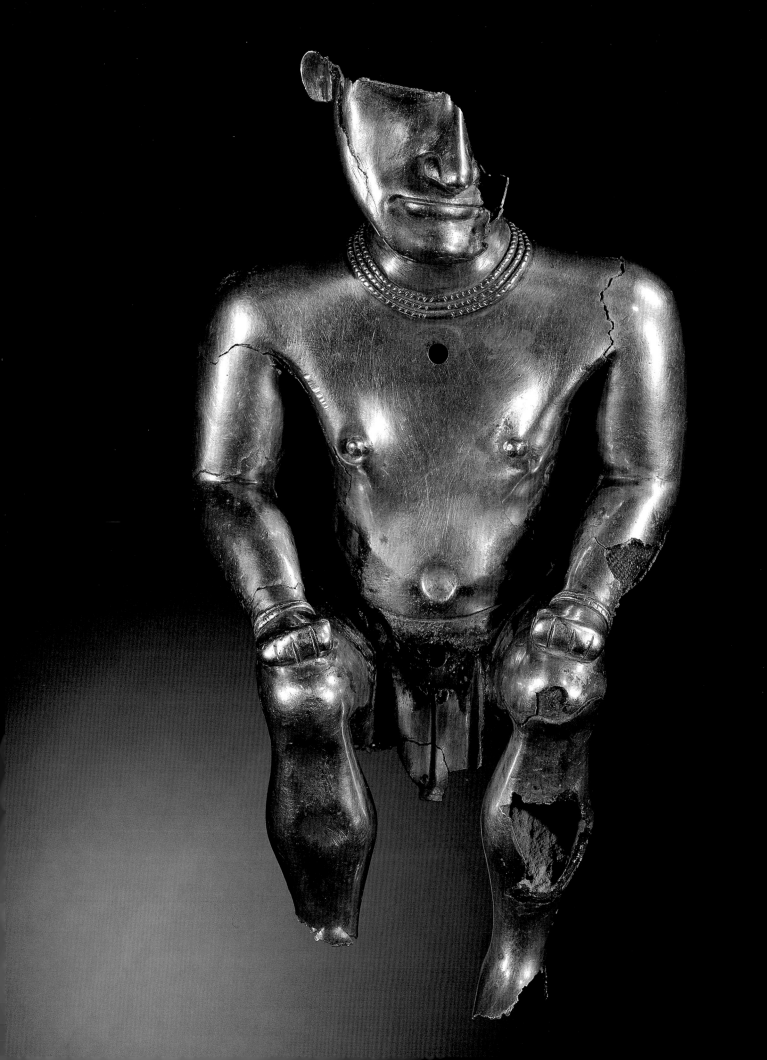

Lime container
24 x 11.8 x 7.2 cm
Pueblo Rico, Risaralda
0–600 AD
Reg. O00382
Although masters in the casting
technique with core, this *poporo* with
casting defects reveals the difficulties
the goldsmiths faced when casting large
objects with complex designs.

Lime container
16.7 x 8.6 cm
Roldanillo, Cauca Valley
0–600 AD
Reg. O02995
The goldsmiths of the Middle Cauca
made *poporos* in the shapes of women
and fruits that had bright reddish
surfaces, which probably symbolised
fertility. Cast in *tumbaga* using the
lost-wax method with core.

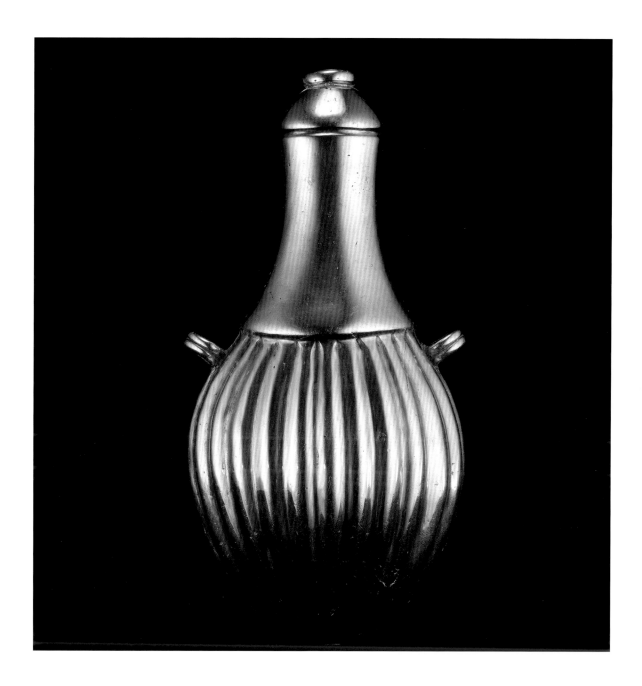

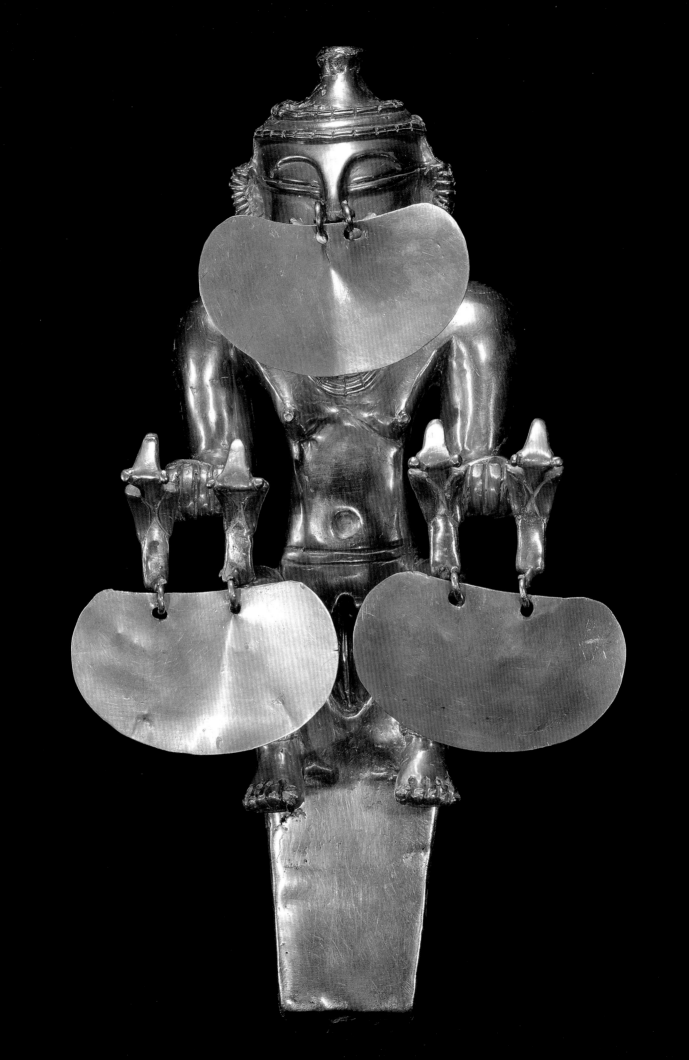

Lime container
27.1 x 11.8 cm
Puerto Nare, Antioquia
0–600 AD
Reg. O32852
In Quimbaya goldwork, the human
figures stand out for their realism,
nudity, well-built bodies and solemn
position, as can be appreciated in this
female *poporo* made of *tumbaga* with
a high gold content. Cast using the
lost-wax method with core.

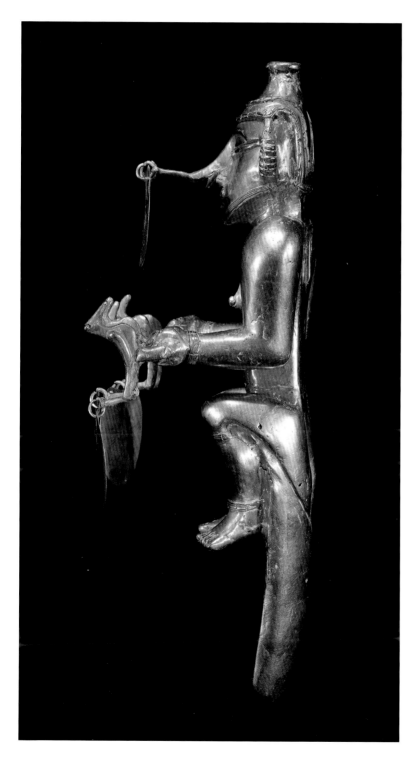
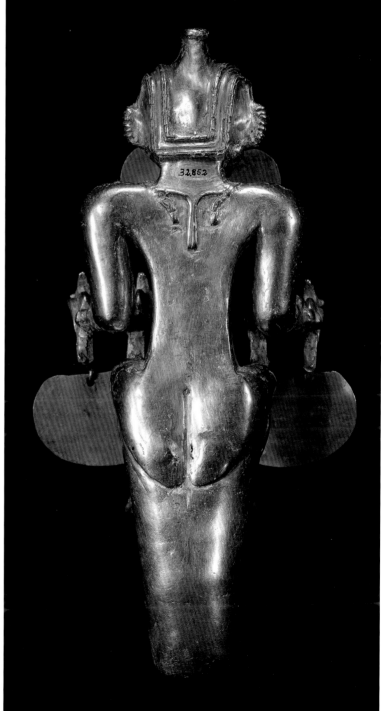

Container
29.3 x 13.4 cm
Puerto Nare, Antioquia
0–600 AD
Reg. O32857
A recipient in the shape of a *totuma*, a
small calabash-like fruit, with lid, used
to conserve the dried coca leaves.
These large containers were the
privilege of high-ranking individuals.
Cast using the lost-wax method with
tumbaga core.

Containers
Left to right
21.4 x 10.5 cm / 18 x 18.5 cm /
29.3 x 13.4 cm
Puerto Nare, Antioquia
0–600 AD
Reg. O32853 / Reg O32854 /
Reg. O32857
Large recipients such as these must
have been used by prestigious
individuals on special occasions.

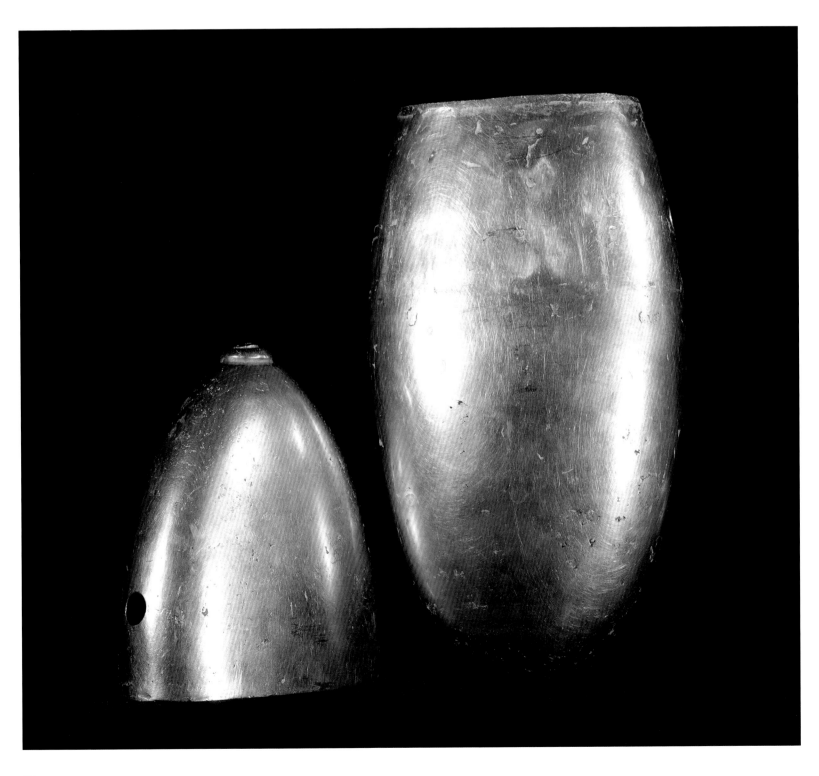

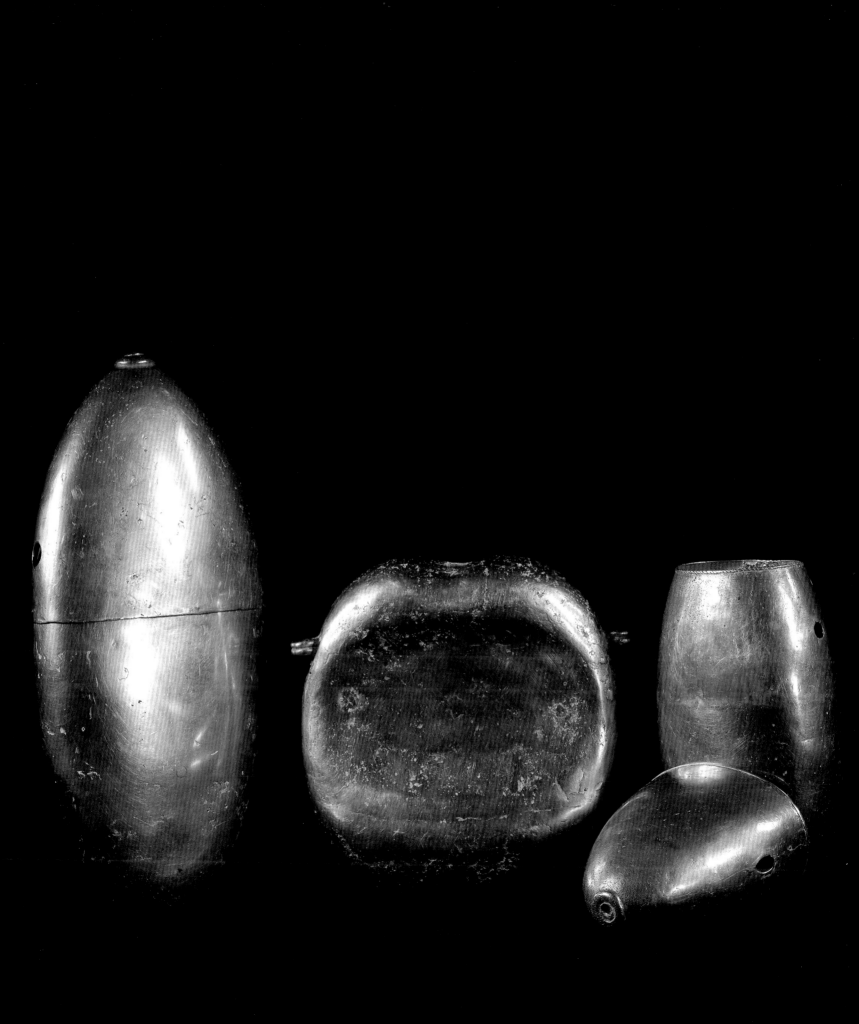

Helmet
11.2 x 19.1 cm
Puerto Nare, Antioquia
0–600 AD
Reg. O32933
Large helmets were used by Quimbaya leaders as visible emblems of their power. Hammered and embossed gold.

Lime container
24.5 x 7.2 cm
Tarazá, Antioquia
0–600 AD
Reg. O33160
The sobriety of the form and the purity of the surface of this *poporo*, made thousands of years ago, are remarkable. Its phallic shape alludes to the concept of fertility.

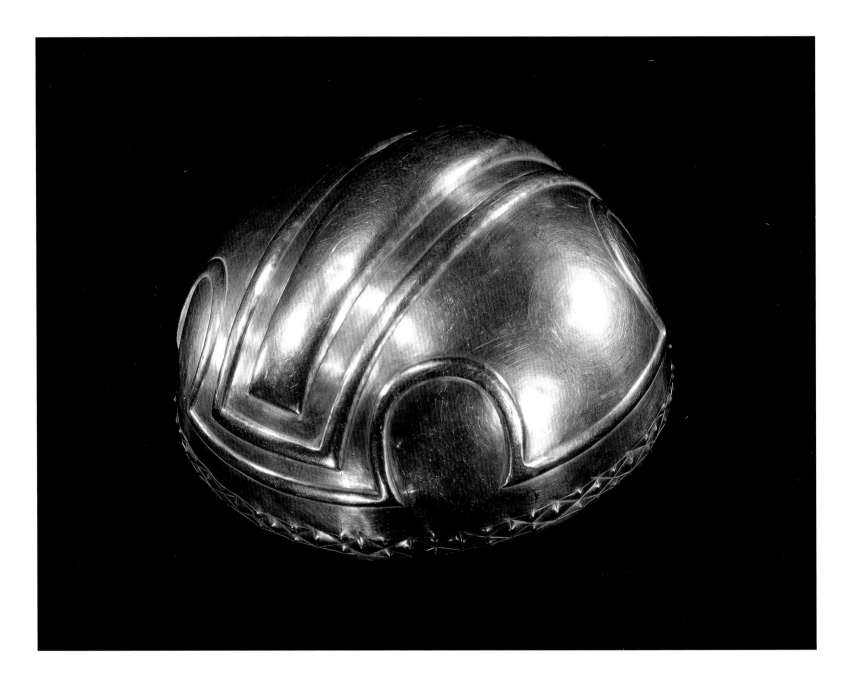

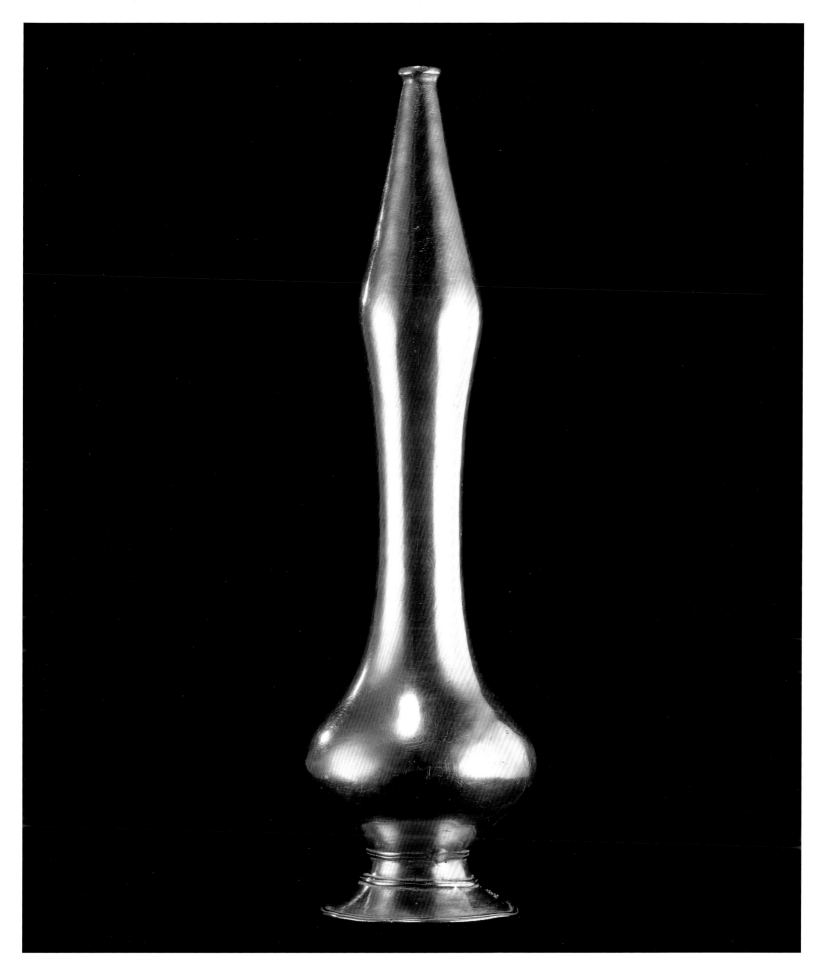

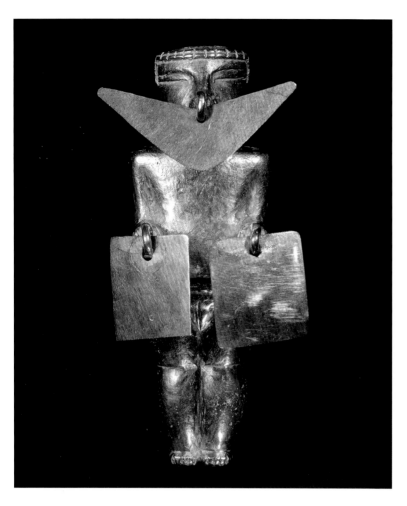

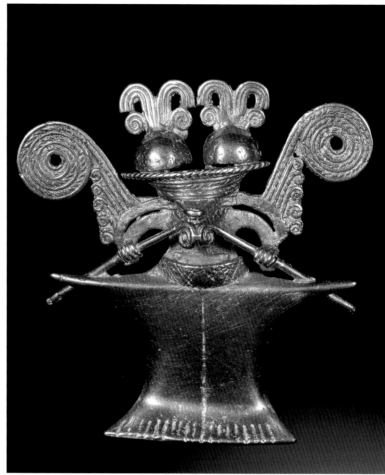

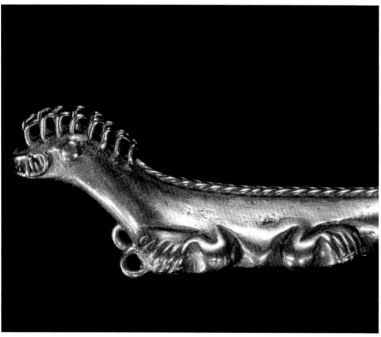

Pendant
8 x 2.8 cm
unknown
0–600 AD
Reg. O06516
Pendant in the form of a female human figure, adorned with an enormous nose ornament and pendant plates in her hands. The expression on her face reflects a meditative state.

Pendant
15 x 2.7 cm
unknown
0–600 AD
Reg. O06033
The depictions of animals in prehispanic goldwork are undoubtedly an attempt to represent the symbolic powers associated with them; in this iguana it is possible that reference is being made to the changes in its skin colour. Cast in *tumbaga* using the lost-wax method.

Pendant
7 x 7 cm
unknown
0–600 AD
Reg. O03492
Pendant in the form of a schematised human figure, complete with mask, feather head ornament and ceremonial staffs, the characteristic attire for a ritual. The wear and tear on the rings for hanging on the back is evidence of regular use.

Neck of lime container
17. 8 x 13.7 cm
Valdivia, Antioquia
0–600 AD
Reg. O03685
This neck of a *poporo* gourd with the figure of a man with enormous jaguar jaws stands out in the iconography of Early Quimbaya, characterised by the realism and sobriety of its forms. Made of *tumbaga* using the lost-wax technique.

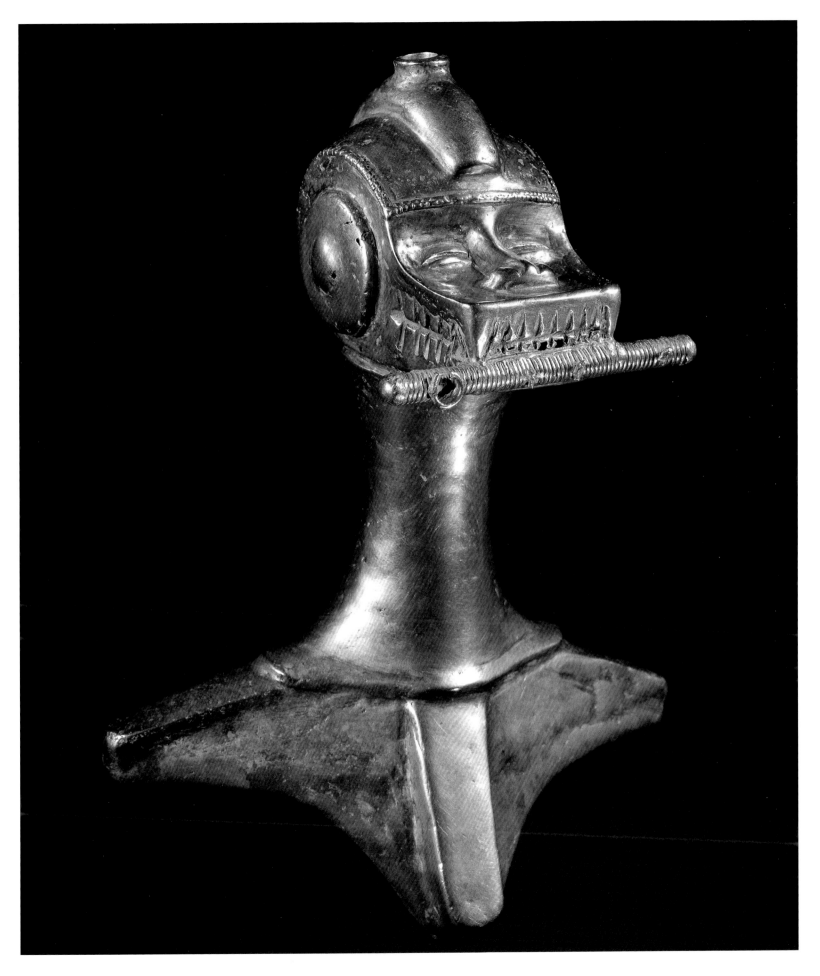

Lime container
15.9 x 8.9 cm
unknown
0–600 AD
Reg. O06443
Containers for lime like this are frequently seen suspended from the neck in gold figures coming from the Middle Cauca region that show characters of the elite sitting on benches. Cast in *tumbaga*, using the lost-wax method with core.

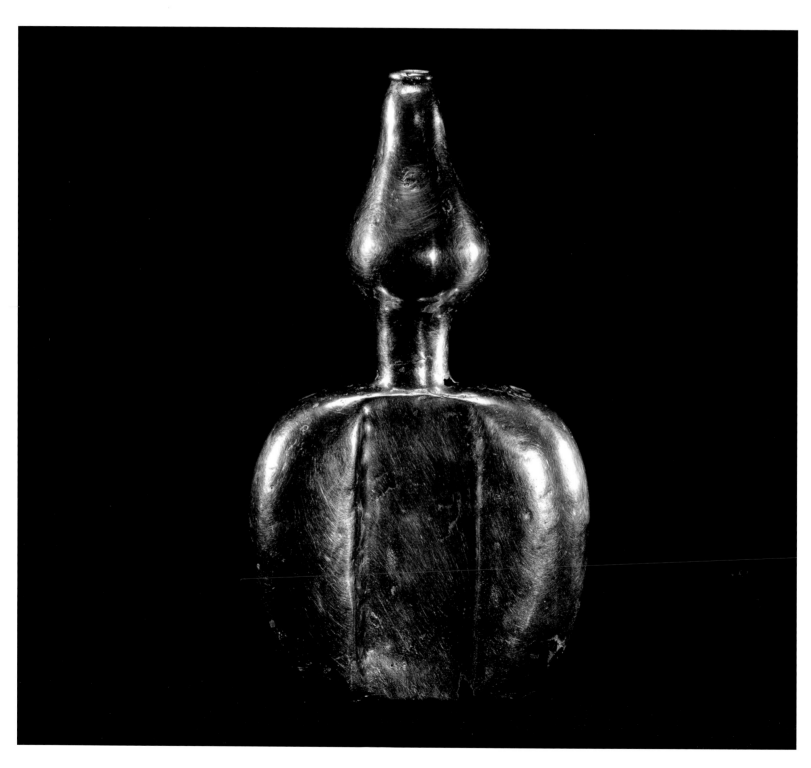

Pendant
11 x 13.5 cm
Trujillo, Cauca Valley
0–600 AD
Reg. O00340
Breastplate with the figure of an
individual adorned with diadem, nose
and ear ornaments, showing the gentle
face that is characteristic of this
goldwork. His schematised body is
covered with mobile plates that
produced visual and sound effects.

Pendant
4.7 x 3.8 x 1.6 cm
Jericó, Antioquia
0–600 AD
Reg. O00395
Land snails like this one, typical in the
goldwork of the Early Quimbaya period,
probably symbolised the cyclical
development of time. Pendant cast in
gold.

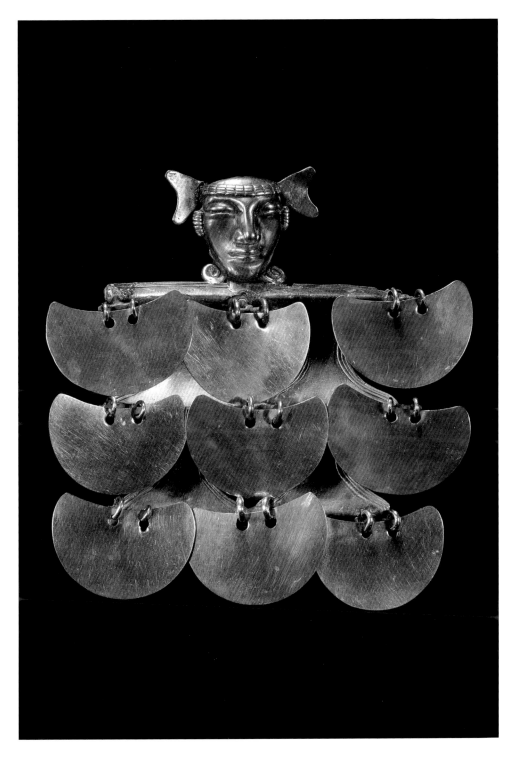

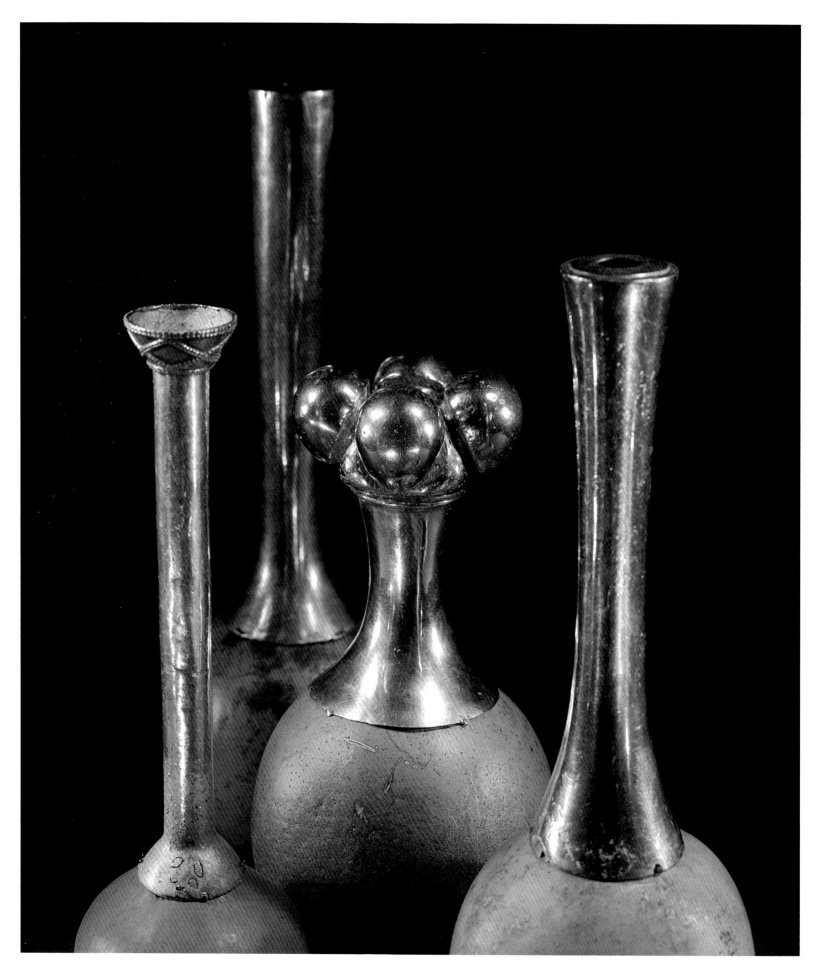

Necks of lime containers
Left to right
15.1 x 10.6 cm / 27.6 x 7.5 cm /
24 x 6.5 cm / 24.2 x 4.7 cm
Puerto Nare, Antioquia
0–600 AD
Reg.O32860 / Reg.O32861 /
Reg.O32862 / Reg.O32863
Necks of gourds for lime, made using
lost wax casting.

Crowns
Left to right
22.5 x 35.8 cm / 25.3 x 40.1 cm
Puerto Nare, Antioquia
0–600 AD
Reg. O32858 / Reg.O32859
This pair of diadems with decorations
that look like feathers were part of the
funerary regalia of high-ranking
individuals.

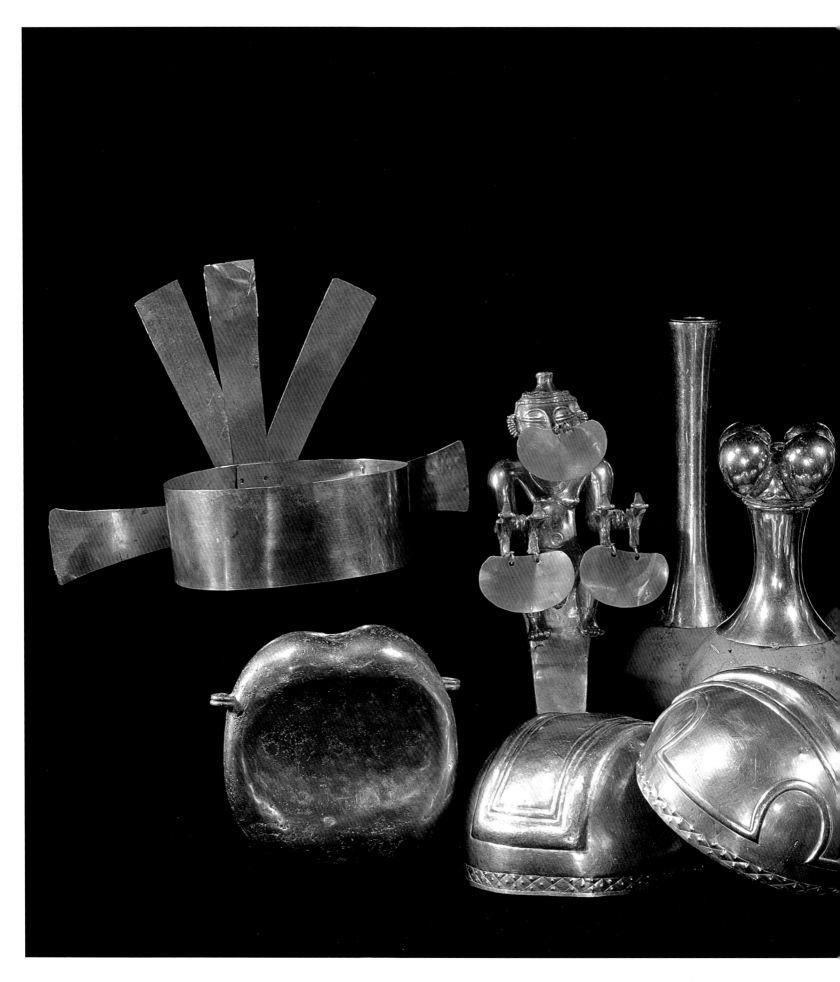

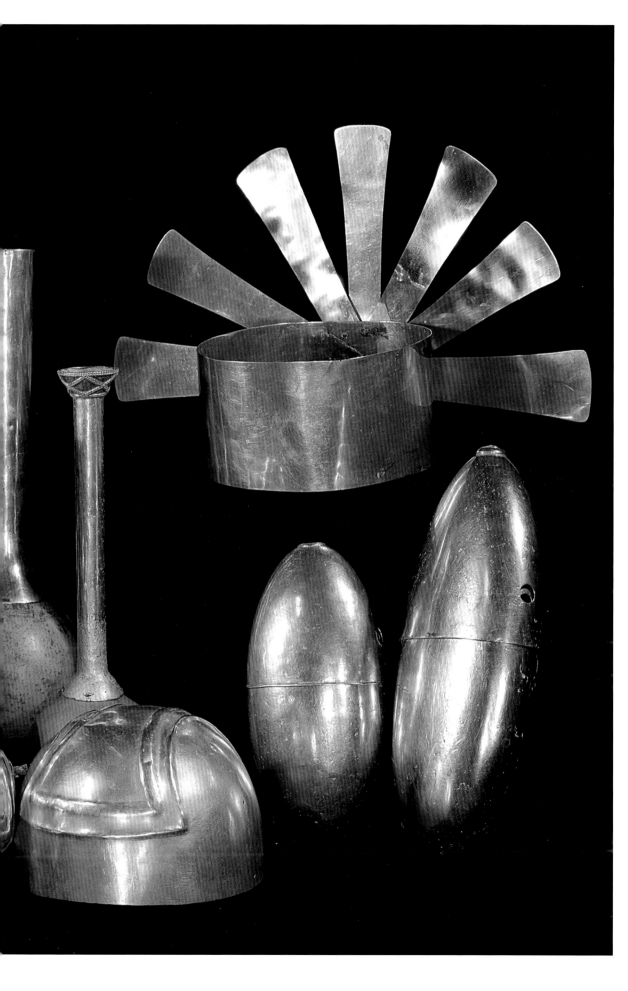

Quimbaya Treasure
Left to right and top to bottom
Crown / Neck of lime container / Neck of
lime container / Neck of lime container /
Neck of lime container / Lime container /
Crown / Container / Container / Helmet /
Helmet / Helmet / Container
25.3 x 40.1 cm / 15.1 x 10.6 cm /
27.6 x 7.5 cm / 24 x 6.5 cm /
24.2 x 4.7 cm / 27.1 x 11.8 cm /
22.5 x 35.8 cm / 29.3 x 13.4 cm /
21.4 x 10.5 cm / 10.8 x 19.4 cm /
11.2 x 19.3 / 9.8 x 18.8 / 18 x 18.5 cm
Puerto Nare, Antioquia
0–600 AD
Reg. O32859 / Reg. O32860 /
Reg. O32861 / Reg. O32862 /
Reg. O32863 / Reg. O32852 /
Reg. O32858 / Reg. O32857 /
Reg. O32853 / O32855 / O32933 /
O32856 / O32851
This group of objects, made by
hammering or casting with the lost-wax
method, was found in Puerto Nare,
Antioquia, part of the burial trousseaux
of distinguished individuals.

Vessel
20.5 x 40 cm
Antioquia, Antioquia
0–600 AD
Reg. C13360
Cinerary urn with mammiform
decoration alluding to fertility and rebirth.
Made of clay with brown engobe.

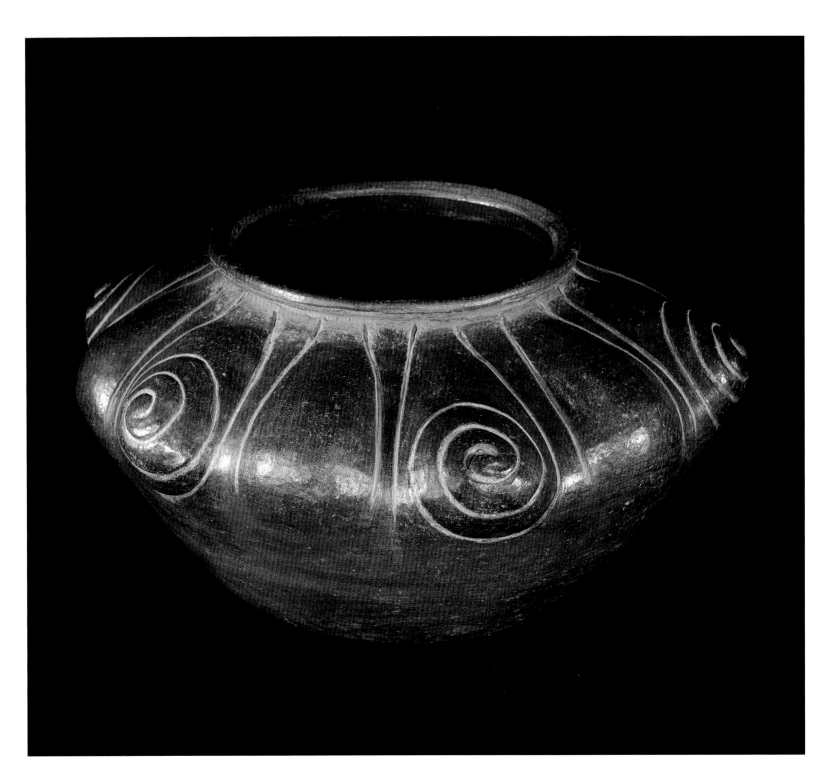

Ear ornaments
7 x 16 cm
8 x 14 cm
unknown
900 AD–1600 AD
Reg. O01727
Reg. O01728
Gold ear ornaments made by hammering starting from a wire from which a large number of triangular plates hang like birds in movement. Distinguishing features of the goldwork of the Late period were schematisation and geometrical designs.

Breastplate
14.1 cm
unknown
900 AD–1600 AD
Reg. O02797
Hammered gold breastplate, embossed with birds and geometrical figures. The wear and tear at the object's edges caused by intense use forced its owner to repair it with gold wire.

Breastplate
17.5 cm
Montenegro, Quindío
900 AD–1600 AD
Reg. O04688
In the decoration of Late Quimbaya, the schematised human figures with zoomorphic features allude to shamanic transformation. This hammered and embossed gold breastplate portrays a lizard-man.

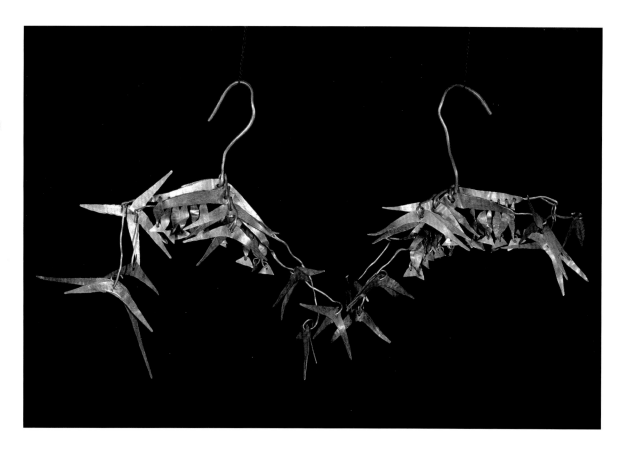

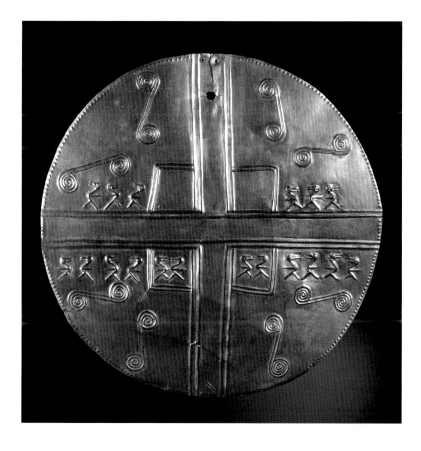

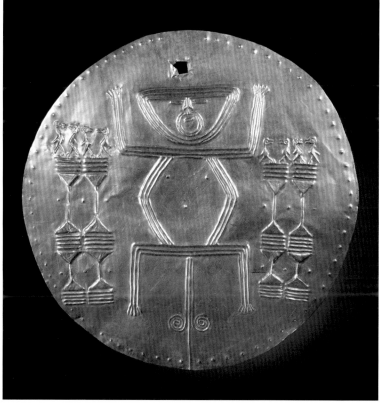

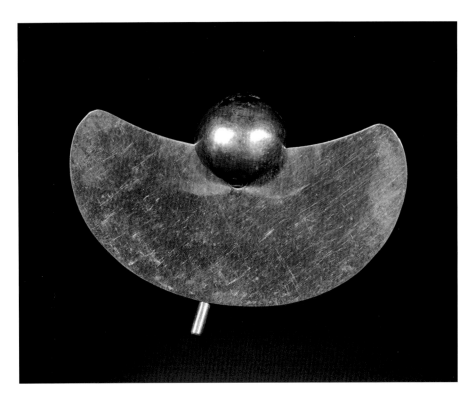

Ear ornament
4 x 5.7 cm
unknown
900–1600 AD
Reg. O00075
Used as an ear ornament, this decoration in the form of a hairpin with a pendant plate is characteristic of Late Quimbaya. Hammered *tumbaga*.

Sublabial ornament
10.2 x 10.2 cm
Pereira, Risaralda
900 AD–1600 AD
Reg. O02272
Decorations to be inserted into the nose, chin, cheekbones and ears were frequent in the Late period. This exquisitely symmetrical decoration hung from a hole opened under the individual's lower lip.

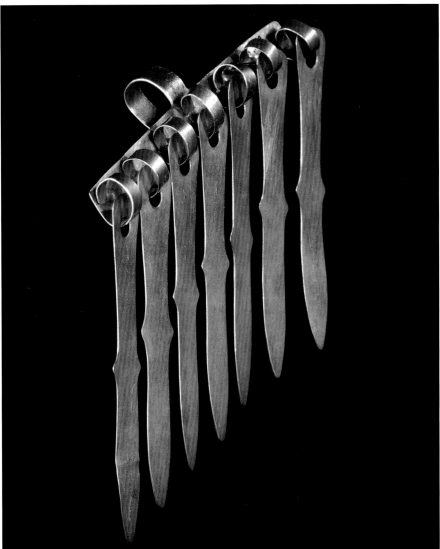

Pendant
30 x 6 cm
Restrepo, Cauca Valley
900 AD–1600 AD
Reg. O06811
Pendant in the form of a cayman.
The small spheres covering its body
represent the scales of its skin. Cast in
gold in approximately the year 900 AD.

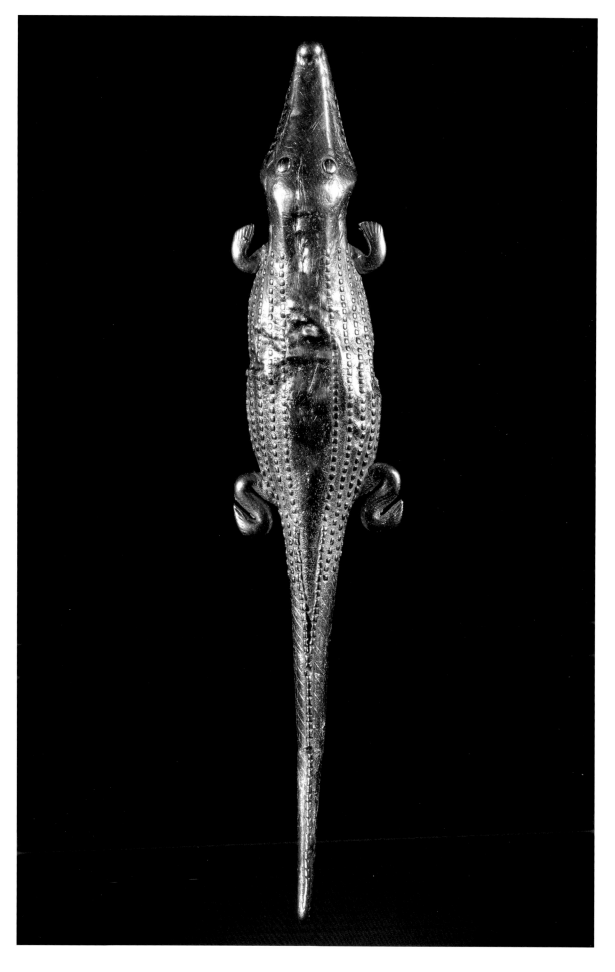

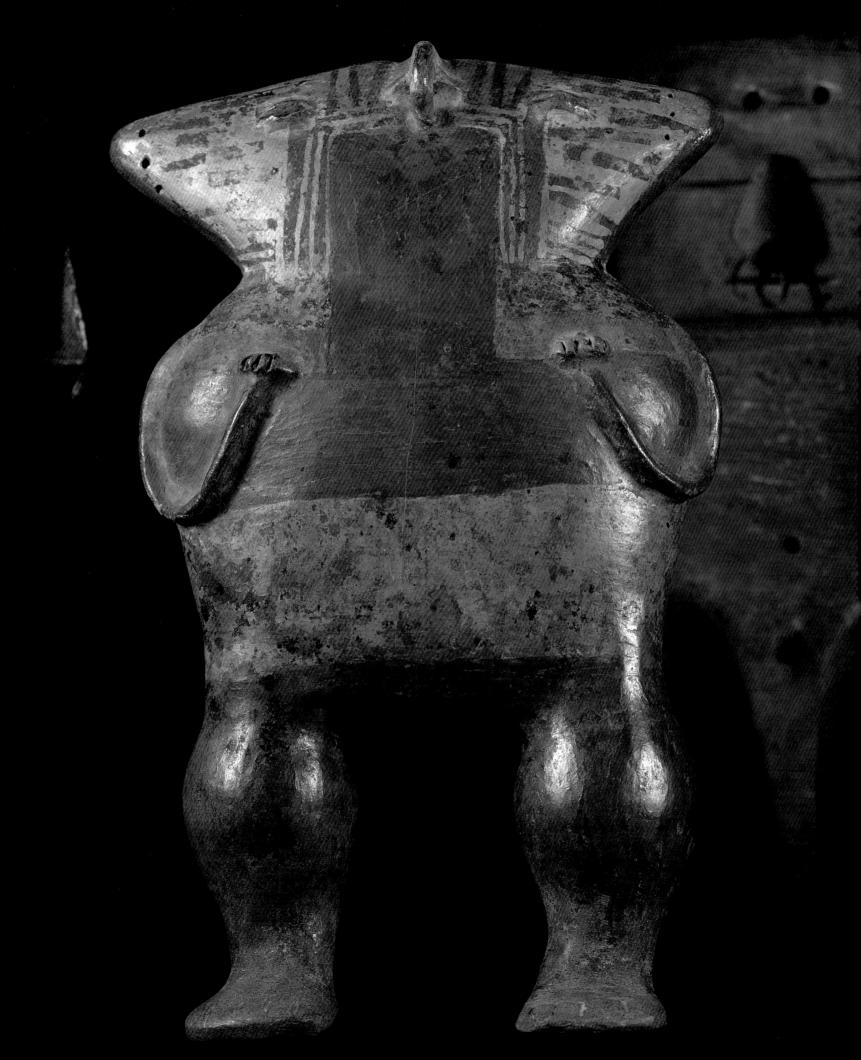

Figure
36 x 23.5 cm
Salamina, Caldas
900 AD–1600 AD
Reg. C00540
The potters of the Late period of the
Middle Cauca were characterised by
their development of stylised human
figures, decorated with face and body
painting, the significance of which was
possibly associated with social and
ethnic differentiation.

Figures
19.5 x 11.85 cm / 34.5 x 19.4 cm /
24 x 13.2 cm / 21 x 13 cm
unknown / Armenia, Quindío / El Edén,
Armenia, Quindío / El Edén, Armenia,
Quindío
900 AD–1600 AD
Reg. C00579 / Reg. C12596 /
Reg. C012606 / Reg. C012607
Group of shamans
Seated anthropomorphic figures
with body painting and carved face

decoration. The body postures and
rigidity of the faces of these characters
suggest meditation and trance-like states
in rites and ceremonies.

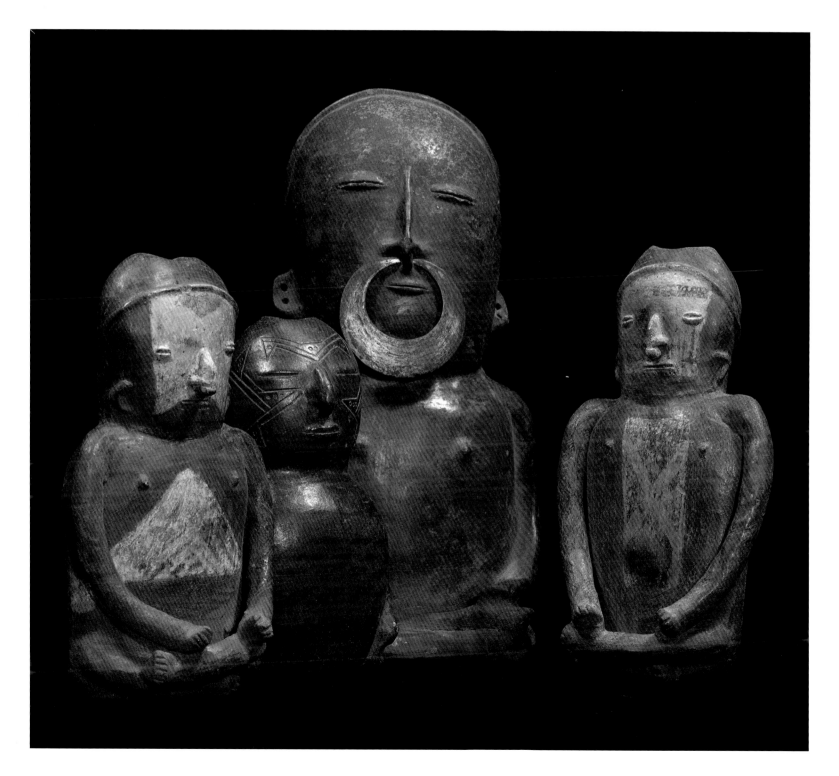

Map of the Cauca archaeological region.

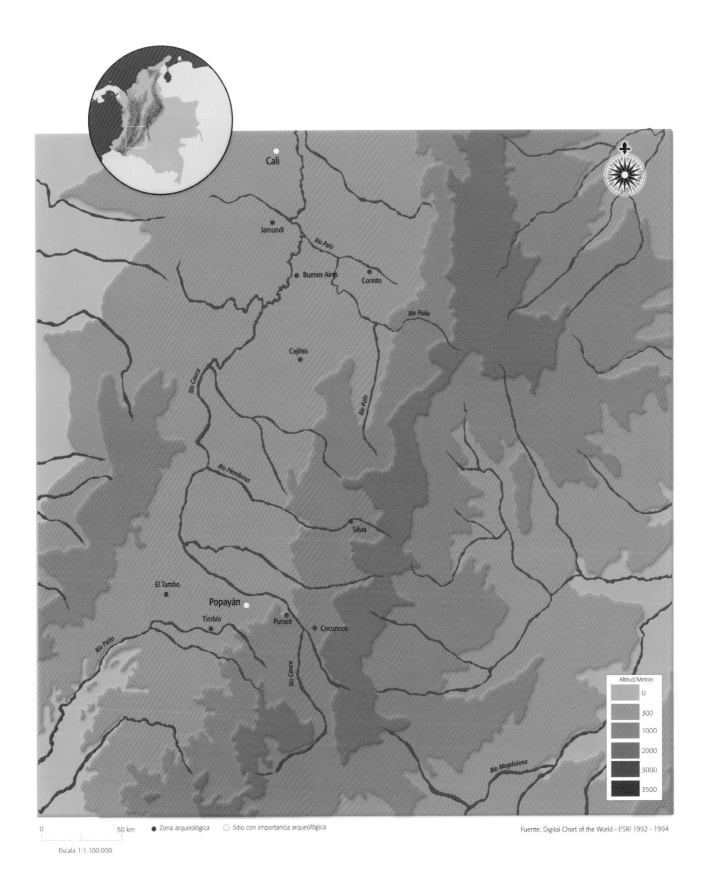

Cali

Jamundí

Río Palo

Buenos Aires

Corinto

Río Paila

Cajibío

Río Cauca

Río Palo

Río Piendamó

Silvia

El Tambo

Popayán

Timbío

Puracé

Coconuco

Río Patía

Río Cauca

Río Magdalena

Altitud/Metros

0
300
1000
2000
3000
3500

0 50 km ● Zona arqueológica ○ Sitio con importancia arqueológica

Fuente: Digital Chart of the World - ESRI 1992 - 1994

Escala 1:1.100.000

Cauca

L ocated in the area around Popayán at the base of the Central Andes, the archaeological area of Cauca has been very little investigated until now. The metalwork produced by these agricultural communities, apparently during a period after the first millennium AD, demonstrates great technical skill in lost wax casting and depletion gilding.

The group of objects known, which is smaller in number than the legacies left by other metalworking societies in Colombia, offers a magical universe that focuses on the iconography of transformation. There is also a series of objects worn on the body and others, rich in symbolism, used to modify physical appearance.

Of considerable size, the breastplates and pendants are generally flat, with the addition of three-dimensional figures. They have bilateral symmetry around their vertical axes and are generally shaped like man-birds with forked crests, aquiline bills or nose ornaments. They wear head ornaments, and have tails arranged in a semicircle and short wings open at the sides. In some cases this motif, which has been interpreted as a shaman transformed into a bird and in a trance state, is accompanied by auxiliary creatures.

With regard to the figures' attire, the following types are known: characteristic plaited nose ornaments fashioned out of small twisted rods, bead necklaces with frog figures, pendants, rattles and pins with various combinations of animal and human forms, which seem to express in miniature the transfiguration of the shaman and the powers acquired.

The pottery shows characters with altered anatomical proportions, painted faces and body adornments or shields with geometrical decorations; some are on stands, while others are standing or seated on benches.

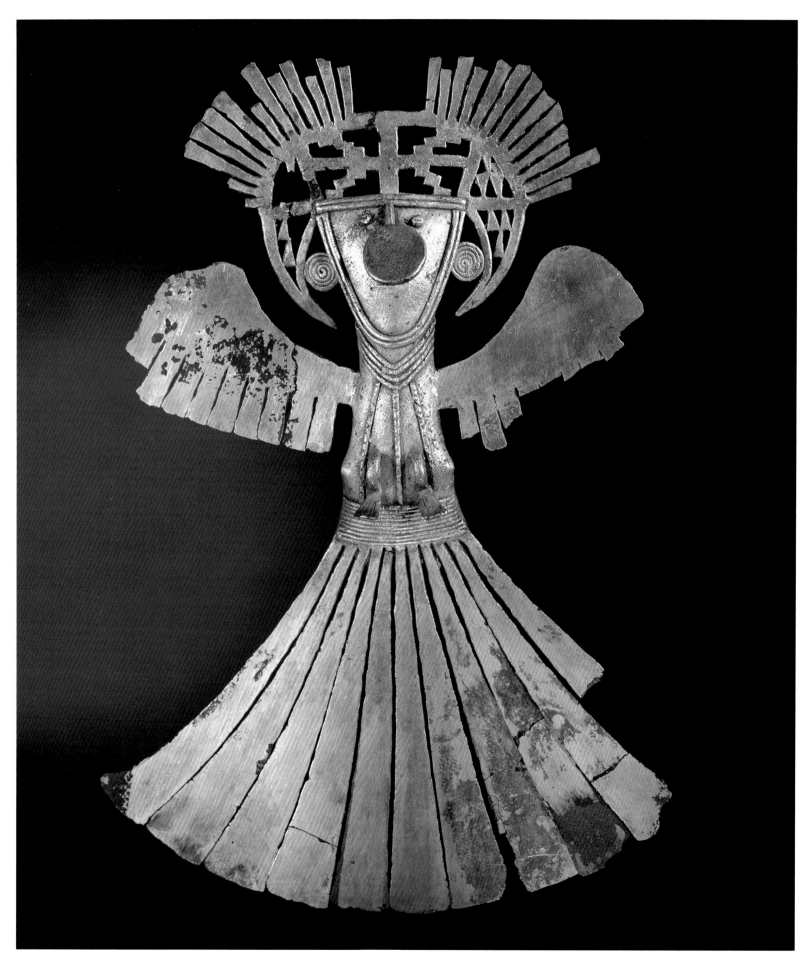

Breastplate
24 x 16.5 cm
Popayán, Cauca
1000 AD–1600 AD
Reg. O03038
Breastplate cast in *tumbaga* and gilded by depletion with the figure of a man-bird adorned with coiled nose ornament and fretwork head ornament. In the indigenous American cosmovision the shaman, assisted by the consumption of psychoactive plants, is transformed into a bird and flies symbolically to occult worlds, sources of power and knowledge.

Lime stick
7.4 x 1.5 cm
Quindío
1000 AD–1600 AD
Reg. O03106
This pin with a frog's body and bird's head suggests the opposition between the worlds of water and air, a common theme in indigenous symbolism. Cast in gold using the lost-wax technique.

Breastplate
16.5 x 12.2 x 2.1 cm
unknown
1000 AD–1.600 AD
Reg. O06414
Breastplate in the form of a man-bird with spread tail and forked head ornament, accompanied by fantastic animals. The representation of the shaman transformed into a bird is a recurring theme in Cauca iconography. Cast in *tumbaga* with a high gold content using the lost-wax method.

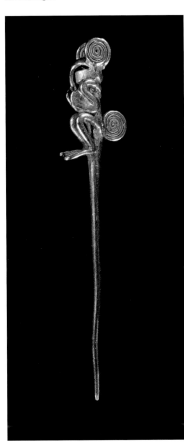

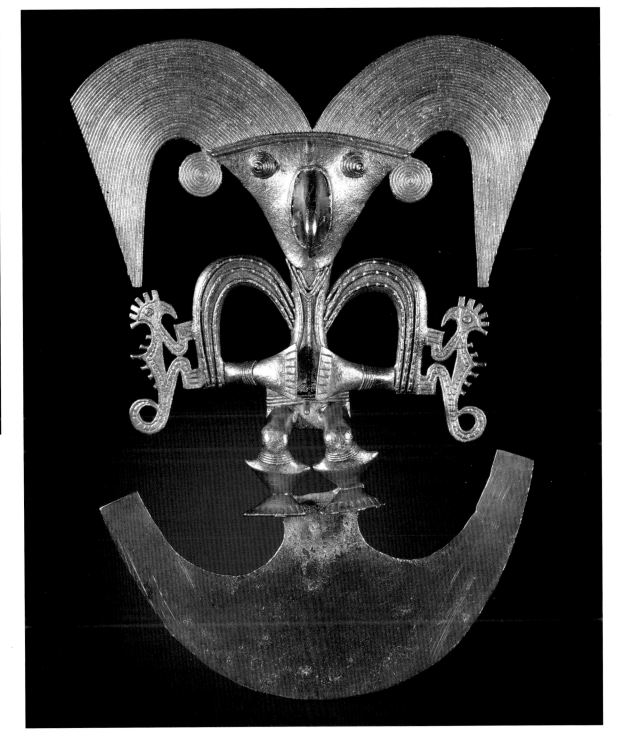

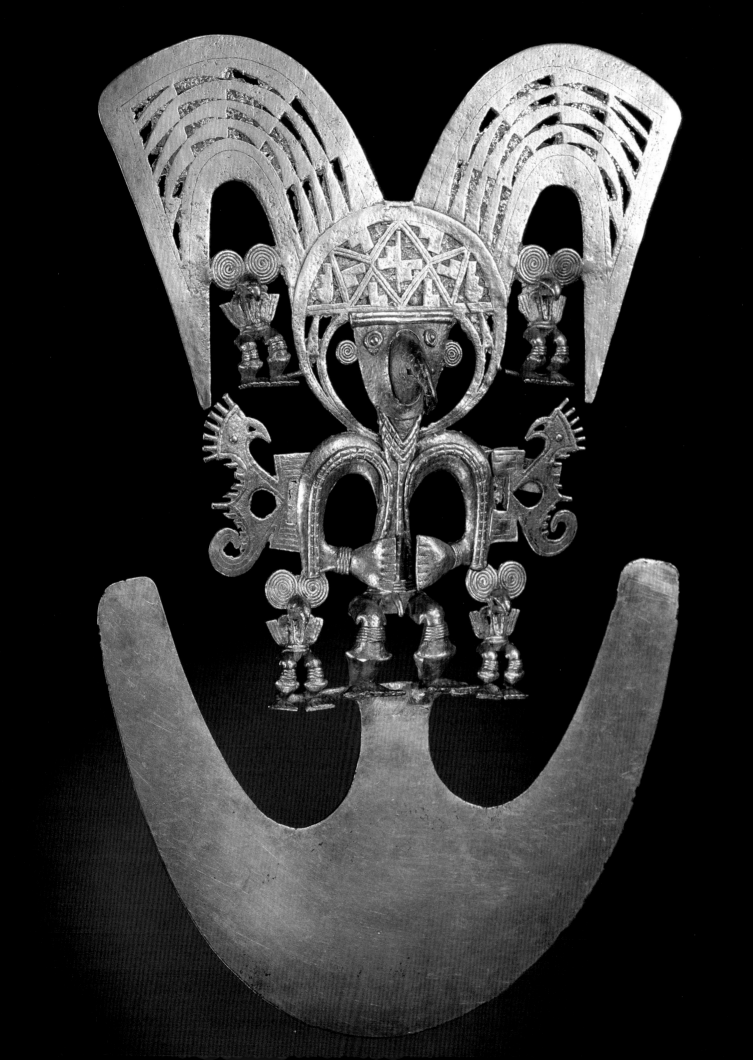

Breastplate
24 x 15.8 cm
Paletará, Puracé, Cauca
1000 AD–1600 AD
Reg. O07355
Of considerable size and made with
extraordinary skill, this breastplate
represents the static flight of the
shaman. The shaman and the
transformed beings that assist him have
calves deformed by the use of strong
ligatures, a practice with symbolic
connotations that still exists in some
indigenous societies of Colombia.

Breastplate
15.8 x 12.8 cm
Los Robles, Jamundí, Cauca Valley
1000 AD–1600 AD
Reg. O33481
Frequent in Cauca goldwork are
pendants with various combinations of
men, birds and frogs, as though the
intention was to combine the
characteristic elements of these worlds
in a single object.

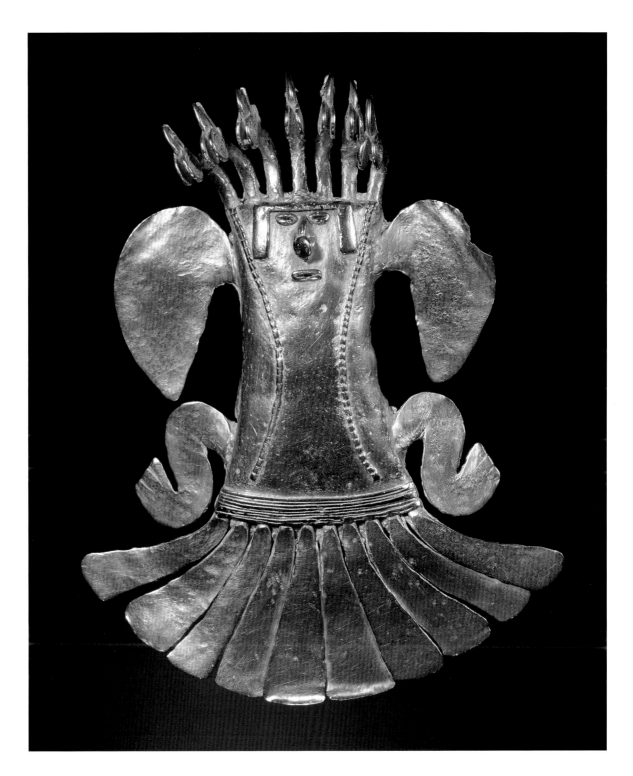

Breastplate
13.2 x 9.8 cm
Timbio-Cauca
1000 AD–1600 AD
Reg. O33824
Heart-shaped breastplates such as this,
undoubtedly associated with the same
symbolism, were worn as emblems by
the leaders of the gold crafting societies
of south-west Colombia. Cast *tumbaga*.

Breastplate
19.6 x 16.5 cm
Corinto-Cauca
1000 AD–1600 AD
Reg. O01221
Breastplate cast in *tumbaga* with the
schematised figure of the shaman
transformed into a bird. Cast *tumbaga*.

Figure
23 x 17.5 cm
unknown
1000 AD–1600 AD
Reg. C12697
In this figure, with exaggerated
anatomical proportions, adorned with a
necklace of large beads and coiled nose
ornament, the artist has resolved the
representation of the arms in a
surprising manner.

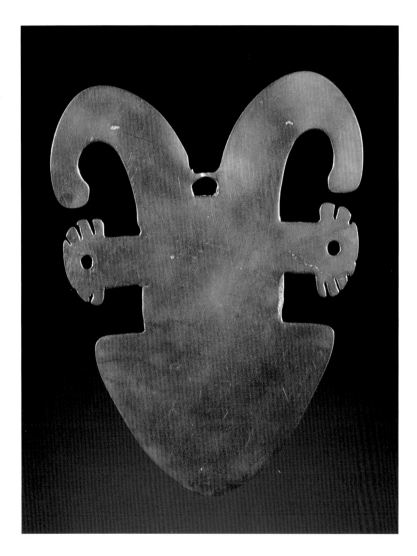

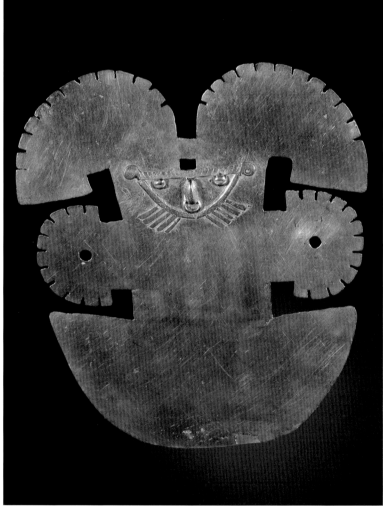

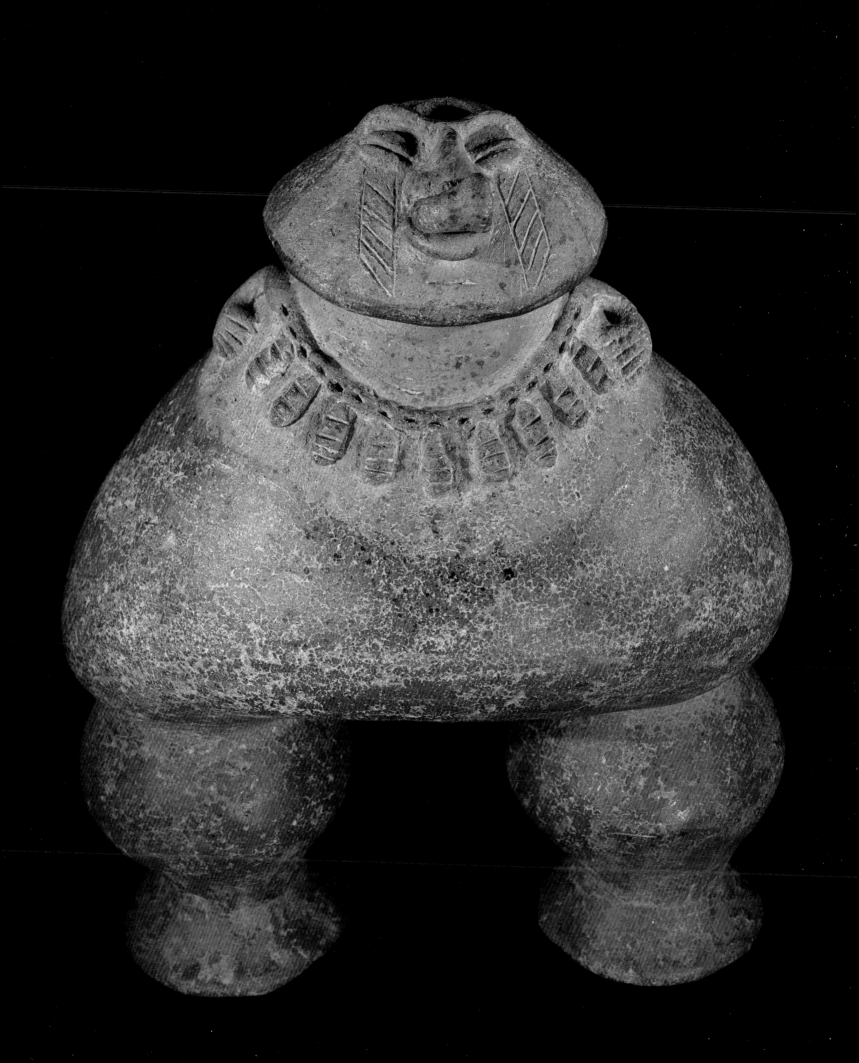

Momposina Depression,
plains of the Colombian Caribbean.
Photo: Diego Samper.

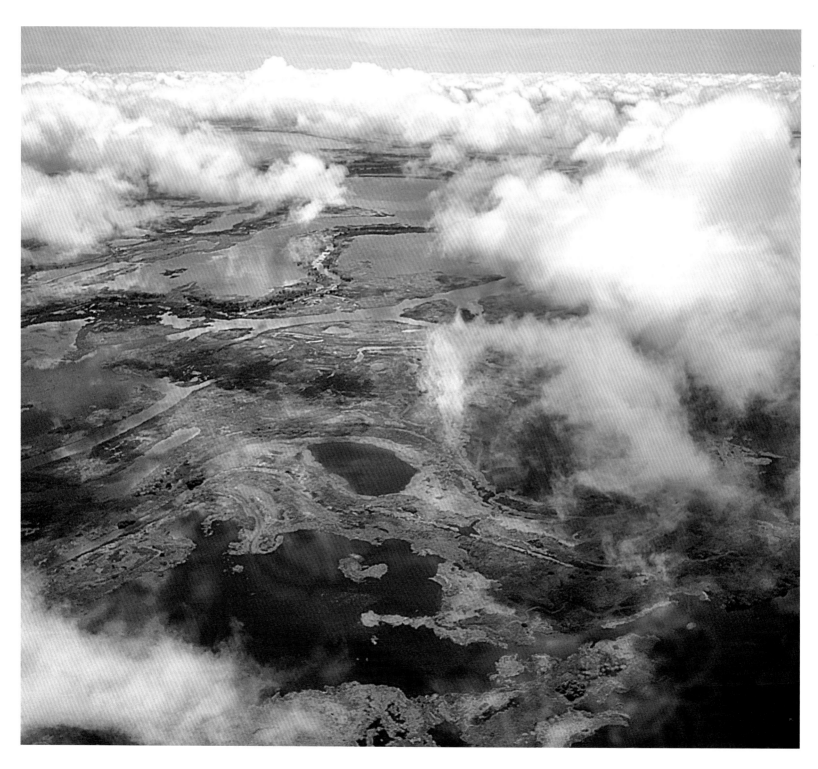

Zenú

The warm flood plains of the Colombian Caribbean were inhabited by groups of gatherers, hunters and potters. Subsequently, societies of farmers and goldsmiths constructed an extraordinary network of hydraulic drainage canals, which for more than a thousand years enabled them to control the floods and make use of extensive areas for dwelling, fishing and crop growing.

Textiles fulfilled a fundamental utilitarian and symbolic role. The network of canals may well have been understood as the weft on which living beings exist. A metaphor conceived in this way is found in the ear ornaments, constructed using the characteristic cast filigree and depicting a fabric surrounded by living beings. The exuberant regional fauna is depicted with realism in decorative baton tops, pendants, breastplates and facial ornaments in which the figure of the cayman is important, although jaguars, anteaters, various birds and allusions to crustaceans are also found.

The frequently found female figures, depicted with cloaks and painted or decorated bodies, are considered to be fertility symbols and reflect the social importance that women had; similar allusions may be contained in the mammiform breastplates.

In contrast with the metalwork of the flood plains, the metalwork produced around the San Jacinto mountain range and the lower part of the River Magdalena, which dates from a later period, shows a preference for the lost wax method of casting small ornamental objects made of *tumbaga*, using a large proportion of copper. These objects are naturalistic images of men, with musical instruments or benches, and local animals arranged in groups.

Everyday life and use of the canal
system in the River San Jorge.

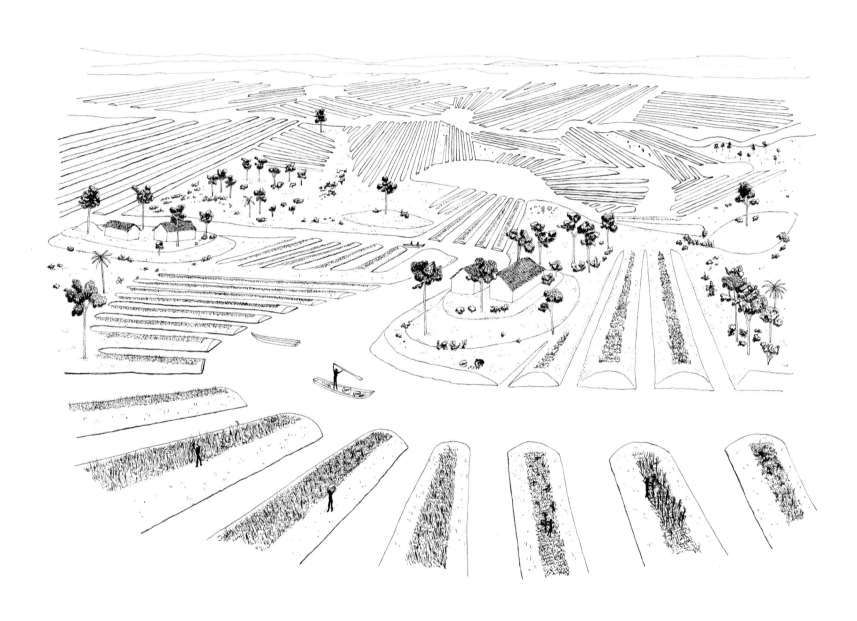

Map of the Zenú archaeological region.

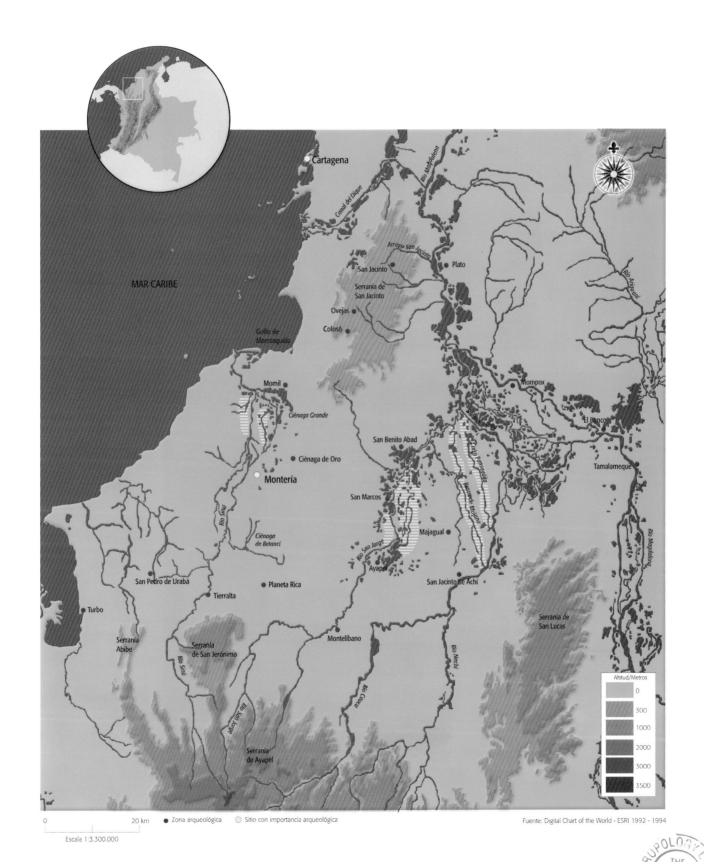

MAR CARIBE

Cartagena

Canal del Dique

Río Magdalena

Arroyo San Jacinto

San Jacinto
Plato

Serranía de
San Jacinto

Ovejas

Río Ariguaní

Colosó

Golfo de
Morrosquillo

Momil

Mompox

Ciénaga Grande

San Benito Abad

El Banco

Ciénaga de Oro

Caño Panseguita

Tamalameque

Montería

Brazo de Loba

Brazo de Mojana

San Marcos

Majagual

Río Sinú

Río San Jorge

Ayapel

Ciénaga
de Betancí

San Jacinto de Achí

San Pedro de Urabá

Planeta Rica

Serranía de
San Lucas

Tierralta

Turbo

Montelíbano

Río Nechí

Serranía
Abibe

Serranía
de San Jerónimo

Río Cauca

Río Sinú

Río Magdalena

Río San Jorge

Serranía
de Ayapel

Altitud/Metros

	0
	300
	1000
	2000
	3000
	3500

0 20 km ● Zona arqueológica ○ Sitio con importancia arqueológica Fuente: Digital Chart of the World - ESRI 1992 - 1994

Escala 1:3.300.000

ANTHROPOLOGY
THE
BRITISH
MUSEUM

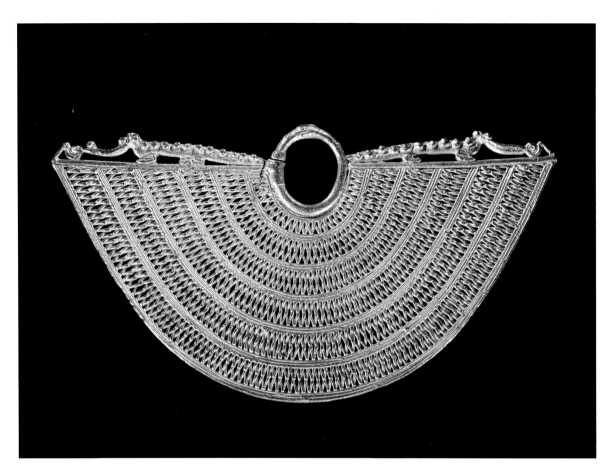

Ear ornament
5.4 x 10.3 cm
Córdoba
150 BC–1600 AD
Reg. O04295
In Zenú society the metaphor of woven fabric was present in the patterns of the drainage channels, the pottery and the goldwork, where the fabric of cast filigree produced ear ornaments, such as this, resting on which is a pair of caymans.

Horizontal baton top
6.4 x 15.4 cm
Majagual, Sucre
150 BC–1600 AD
Reg. O07505
Staffs of command, symbols of authority, were adorned with realistic representations of the fauna characteristic of the plains and muddy environments of the Caribbean. This top with a cayman was made of *tumbaga* with a high gold content in the second century AD.

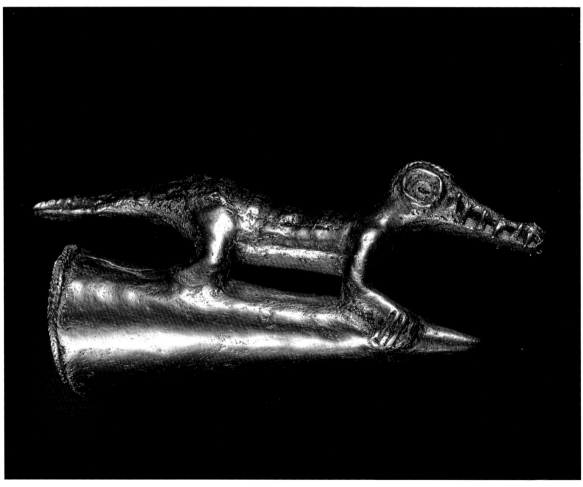

Baton top
11.3 x 9.7 cm
Majagual, Sucre
150 BC–1600 AD
Reg. O07503
Staff top in the form of an eagle's head.
This animal's high flight, the power of its
bill and its sharp gaze made it a being
with special attributes. Cast using the
lost-wax method with open core.

Horizontal baton top
7.8 x 9.9 cm
Majagual, Sucre
150 BC–1600 AD
Reg. O07504
The most ancient goldwork in Zenú is
ostentatious and elaborate. In this
bicephalous staff top, the goldsmith
took pains to represent the details of
the deer's antlers. Cast *tumbaga* with
a high gold content.

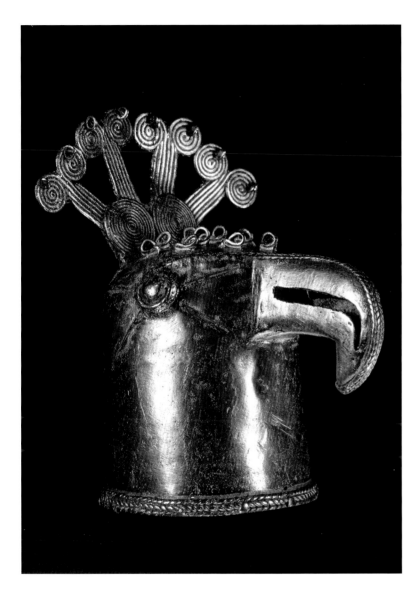

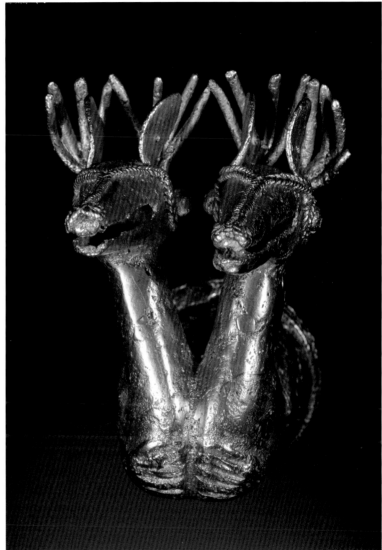

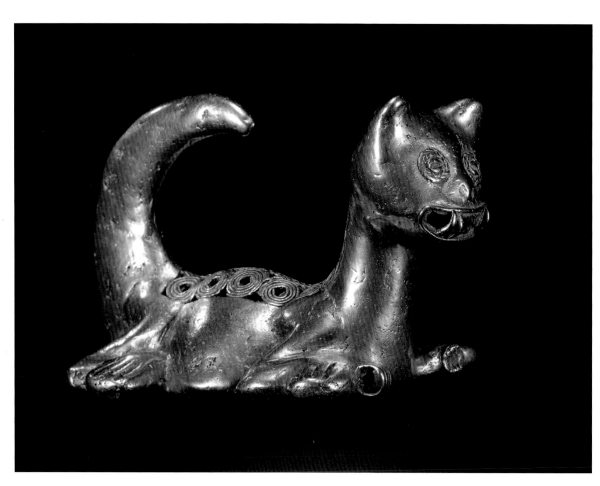

Pendant
7.5 x 12.2 cm
El Banco, Magdalena
310 AD–390 AD
Reg. O17191
Pendant in the form of a feline with a raised tail. The Zenú fauna represented by goldsmiths, potters and craftsmen of conch shells are characterised by their gentle attitudes and lack of aggressive expressions.

Ear ornaments
7.6 x 13.6
7.6 x 13.4
San Marcos, Sucre
150 BC–1600 AD
Reg. O33191
Reg. O33192
The design of these cast filigree ear ornaments is one of the most renowned features of the goldsmith's art of prehispanic Colombia. First made using fine threads of beeswax and later cast in *tumbaga* using the lost-wax method.

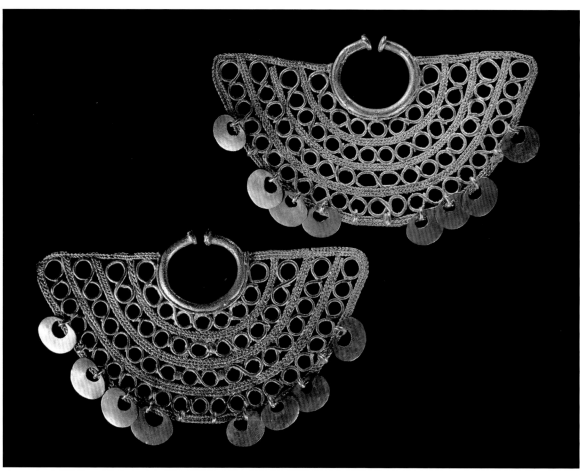

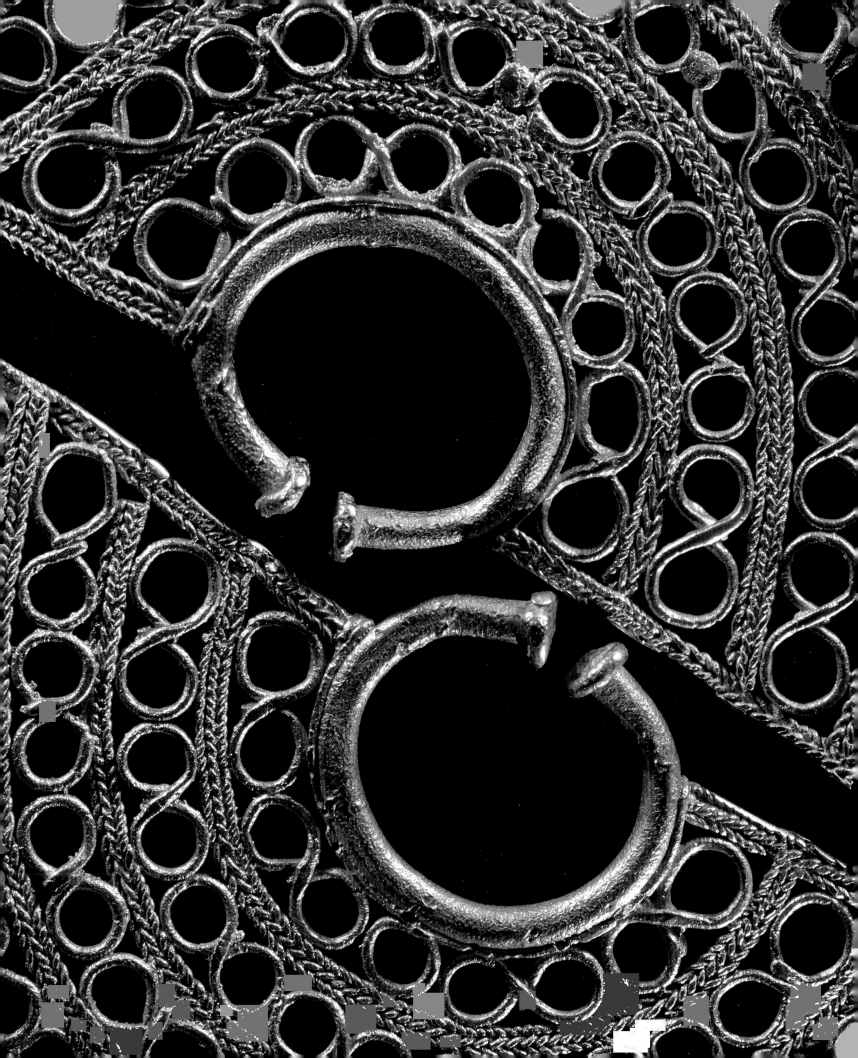

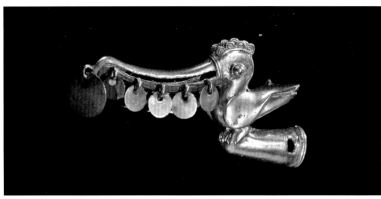

Horizontal baton top
4.5 x 2.7 cm
Córdoba
1210 AD–1350 AD
Reg. O33449
In the twelfth century AD, when this staff top was made, the goldsmiths of Zenú were continuing an already age-old tradition of representing the fauna of their region in metal objects with a high gold content.

Pendant
19.2 x 6.5 x 3.3 cm
San Marcos, Sucre
150 BC–1600 AD
Reg. O33624
Pendant in the form of a fish, a type of catfish known locally as *coroncoro*. The creature's scales and fins were shaped starting from geometrical lines and designs. Cast *tumbaga*.

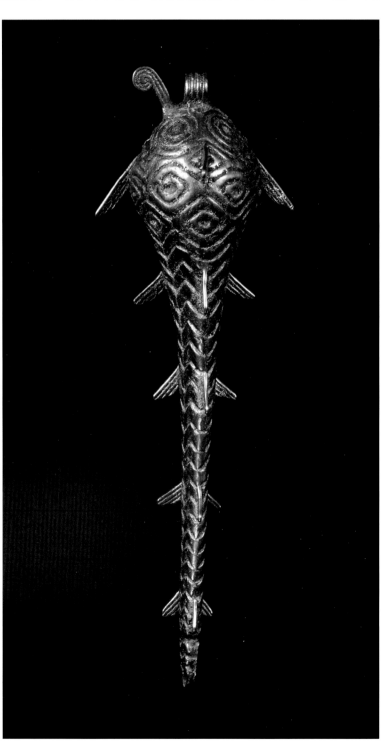

Pendant
7.5 x 11.6 cm
Coloso, Sucre
900 AD–1600 AD
Reg. O33632
The amphibious way of life of the populations that inhabited the lakeside and riverside environments of the Caribbean was captured by the goldsmiths in pendants with human heads and bodies of crustaceans or fishes. *Tumbaga* with a high gold content cast using the lost-wax technique.

Pendants
Left to right
9.8 x 5.5 cm / 11.1 x 7.1 cm /
6.2 x 3.7 cm / 9.2 x 6.8 cm
Colosó, Sucre / Montelíbano, Córdoba /
unknown / Colosó, Sucre
150 BC–1600 AD
Reg.O22334 / Reg.O32696 /
Reg.O06025 / Reg.O21333
Amphibious men with a high degree of schematisation and forked head ornaments were made of metal, conch shell and bone from the first centuries AD until the Spanish conquest. Pendants cast in gold and *tumbaga*.

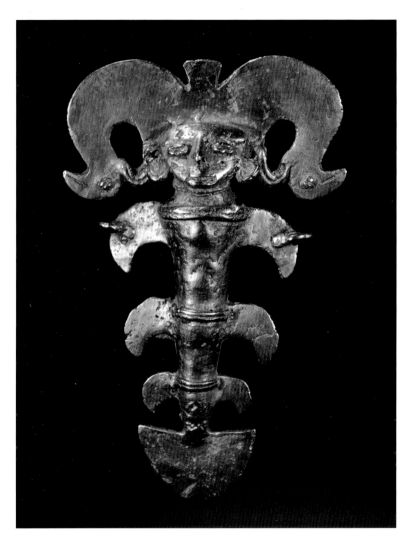

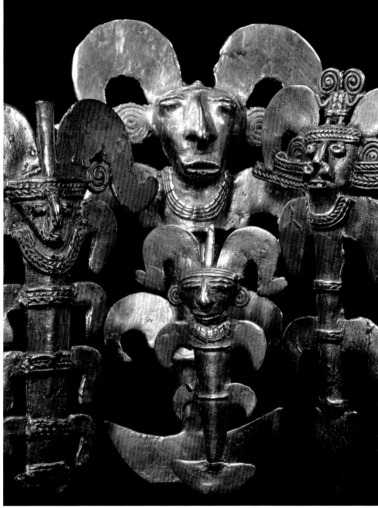

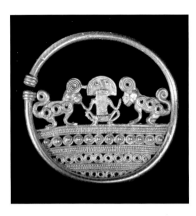

Ear ornament
5.2 x 5.5 cm
Colosó, Sucre
900 AD–1600 AD
Reg. O19963
Circular ear ornament decorated with spirals and the figure of a human flanked with felines. Gold with the cast filigree technique.

Breastplate
21.7 cm
unknown
150 BC–1600 AD
Reg. O29440
Large gold hammered and embossed mammiform breastplates highlight the political and religious power achieved by women in this society.

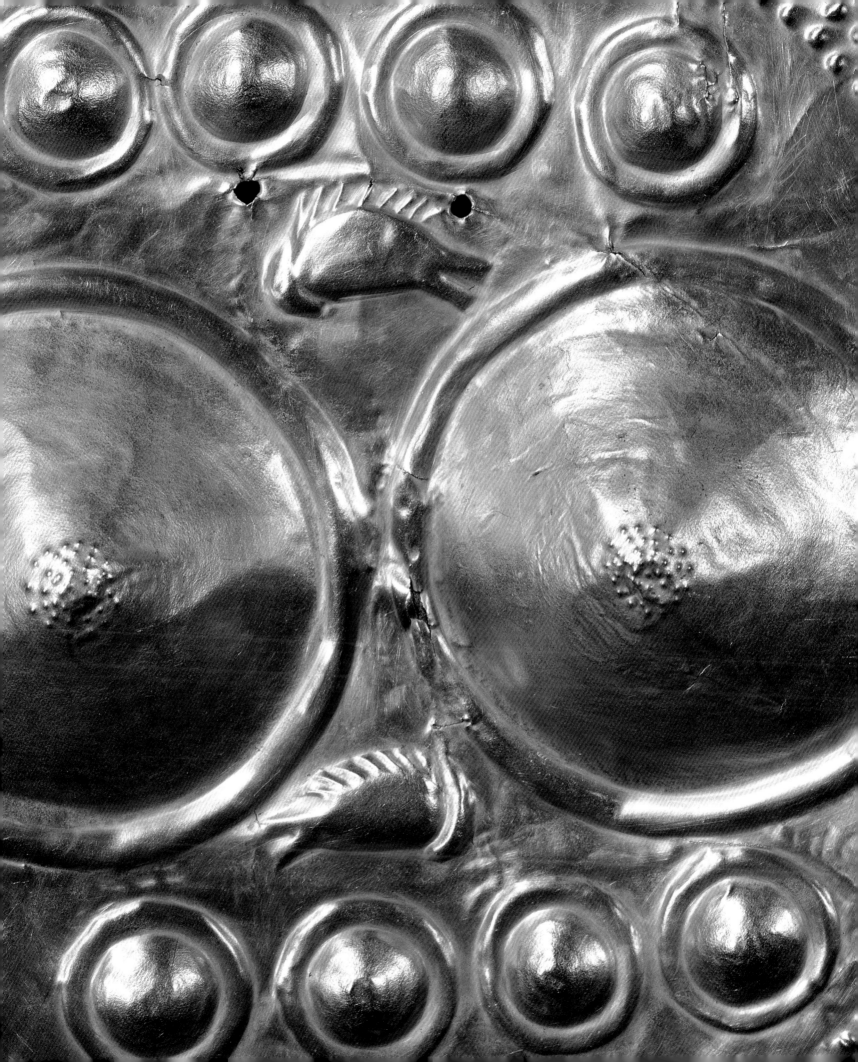

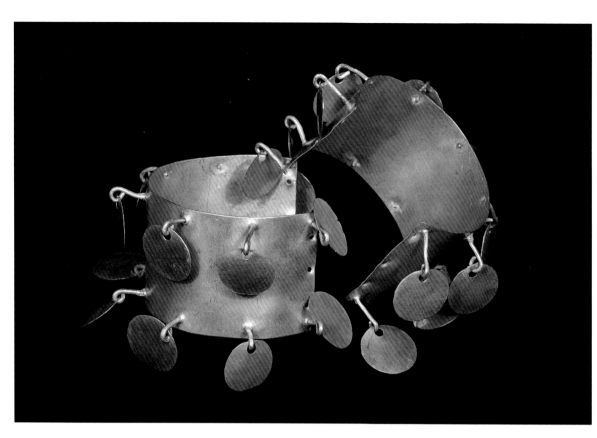

A breastplate, a nose ornament, a pair of bracelets and a "*cubresexo*" (codpiece) make up the so-called "Regalia of Planeta Rica". Found under a large burial mound, these objects were part of the regalia with which a high-ranking individual was buried. The absence of traces of use leads us to suppose that these objects were manufactured exclusively to adorn the deceased after his death.

Bracelets
6 x 4.1 cm
5.3 x 4.1 cm
Planeta Rica, Córdoba
150 BC–1600 AD
Reg. O33163
Reg. O33164

Nose ornament
3.7 x 18.3 cm
Planeta Rica, Córdoba
150 BC–1600 AD
Reg. O33165

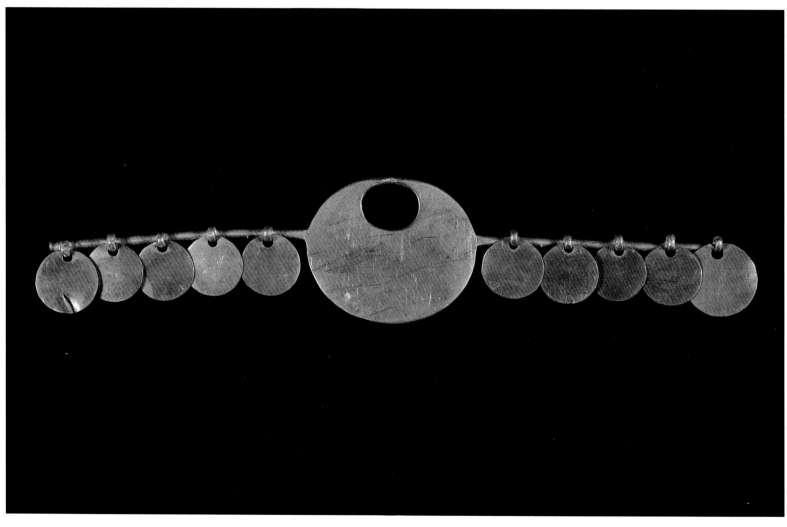

Codpiece
6.7 x 11.9 cm
Planeta Rica, Córdoba
150 BC–1600 AD
Reg.O33162
In contrast with most of the men, who
wore conch shell codpieces, the
individual buried with this attire had the
privilege of taking a *cubresexo* of
excellent design and craftsmanship on
his journey through the world beyond.

Breastplate
20.8 x 14.9 cm
Planeta Rica, Córdoba
150 BC–1600 AD
Reg. O33161
In the shape of a heart, this item is
decorated with a number of pendant
plates that produced an extraordinary
interplay of light and sound.

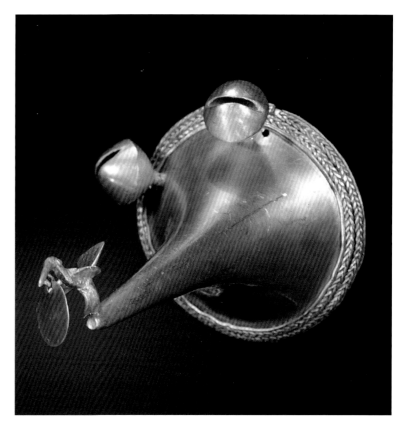

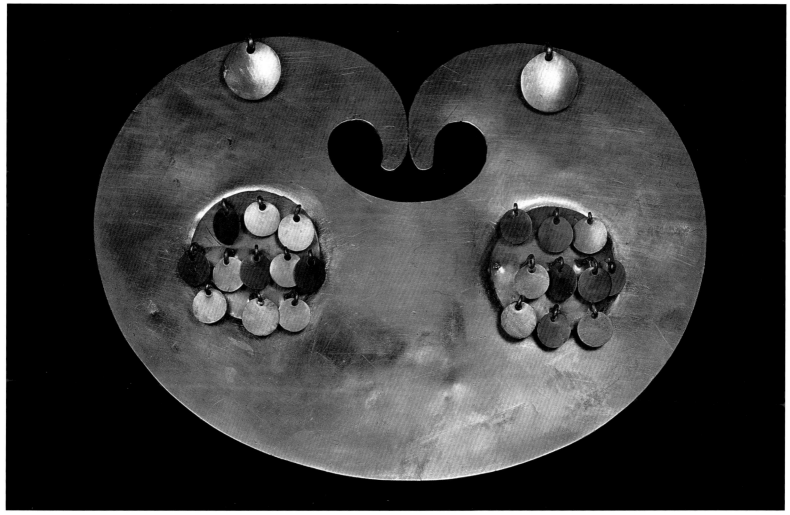

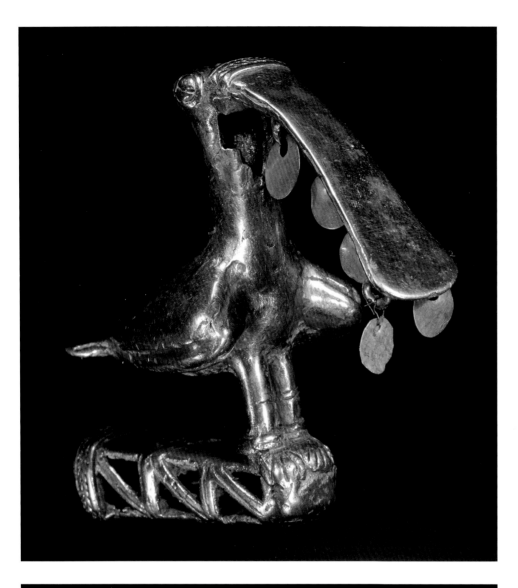

Baton top
8.9 x 10.6 cm
unknown
640 AD
Reg. O06444
A masterpiece of Zenú goldwork, this staff top in the form of a spoonbill was made of *tumbaga* in the seventh century AD. This bird, common in humid and muddy areas, was one of the animals most often represented by the goldsmiths of the region.

Ear ornaments
6.2 x 8 cm
6.1 x 7.8 cm
unknown
150 BC–1600 AD
Reg. O16820
Reg. O16821
The design of this pair of ear ornaments evokes the fabric of the *vueltiados* hats. These were made of plant fibres and have been used since prehispanic times on the plains of the Caribbean.

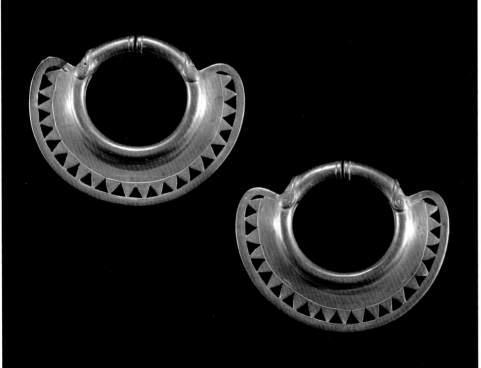

Pendant
5.4 x 7.3 cm
unknown
150 BC–1600 AD
Reg. O33141
Bells and pendants such as this, in the form of a human head with realistic faces adorned with ear ornaments and complex head ornaments, were made by casting *tumbaga* with a high gold content using the lost-wax method with core.

Nose ornament
6.4 x 9.4 cm
Sucre
150 BC–1600 AD
Reg. O29228
In this nose ornament, crafted in hammered gold, two birds are joined by their beaks to form an attractive design.

Baton top
4.8 x 7 cm
unknown
150 BC–1600 AD
Reg. O30227
In this staff top, the figure of a musician with hat, nose ornament and enormous ear ornaments plays the trumpet and maracas. The attention is drawn to his enormous hunched back. Cast in *tumbaga* by the lost-wax method with core.

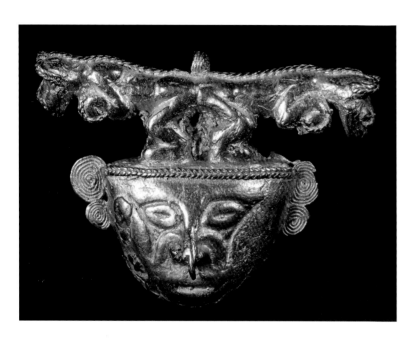

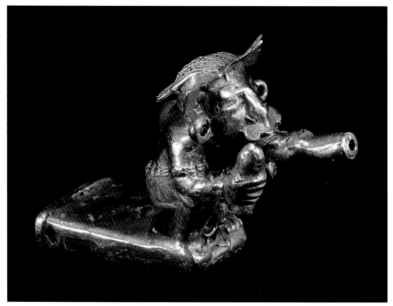

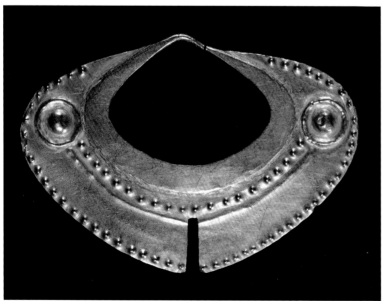

Pendant
43.3 x 7.1 cm
Montería, Córdoba
150 BC–1600 AD
Reg. O33035
Note the astonishing degree of
stylisation achieved by the Zenú
goldsmiths in this decoration with
descending prolongations made of
hammered gold.

Baton top
11.3 x 8.2 cm
Planeta Rica, Córdoba
150 BC–1600 AD
Reg. O33147
Staff top in the form of a crustacean's pincer. The "eight"-shaped cast filigree decoration of this object was common in the design of Zenú goldwork. Cast gold.

Breastplate
7.1 x 5.1 cm
unknown
150 BC–1600 AD
Reg. O06054
Only if we look at this object in detail can we see the shape and fins of a fish adorned with multiple spirals. A pendant cast in *tumbaga* using the lost-wax method.

Breastplate
14.5 x 14.1 cm
Ayapel, Córdoba
150 BC–1600 AD
Reg. O33752
Breastplate in the shape of a bird with tail and wings spread; a recurrent theme in the iconography of Tairona, Urabá, Zenú and Lower Central America. Cast gold.

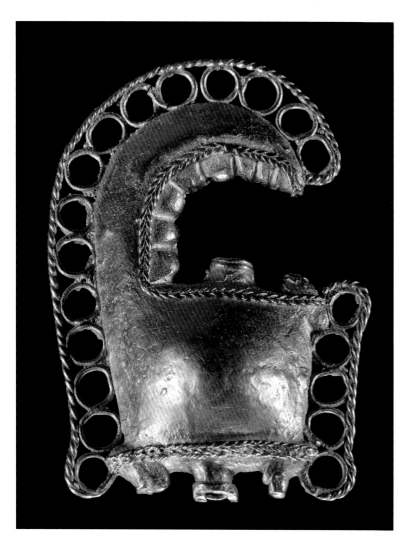

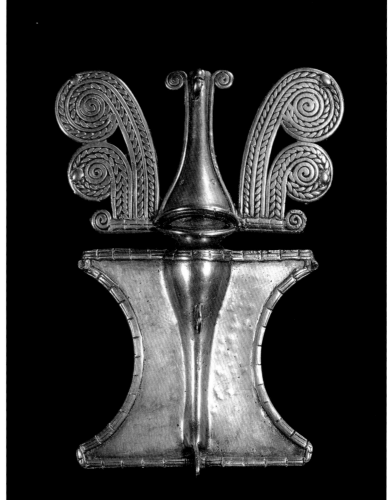

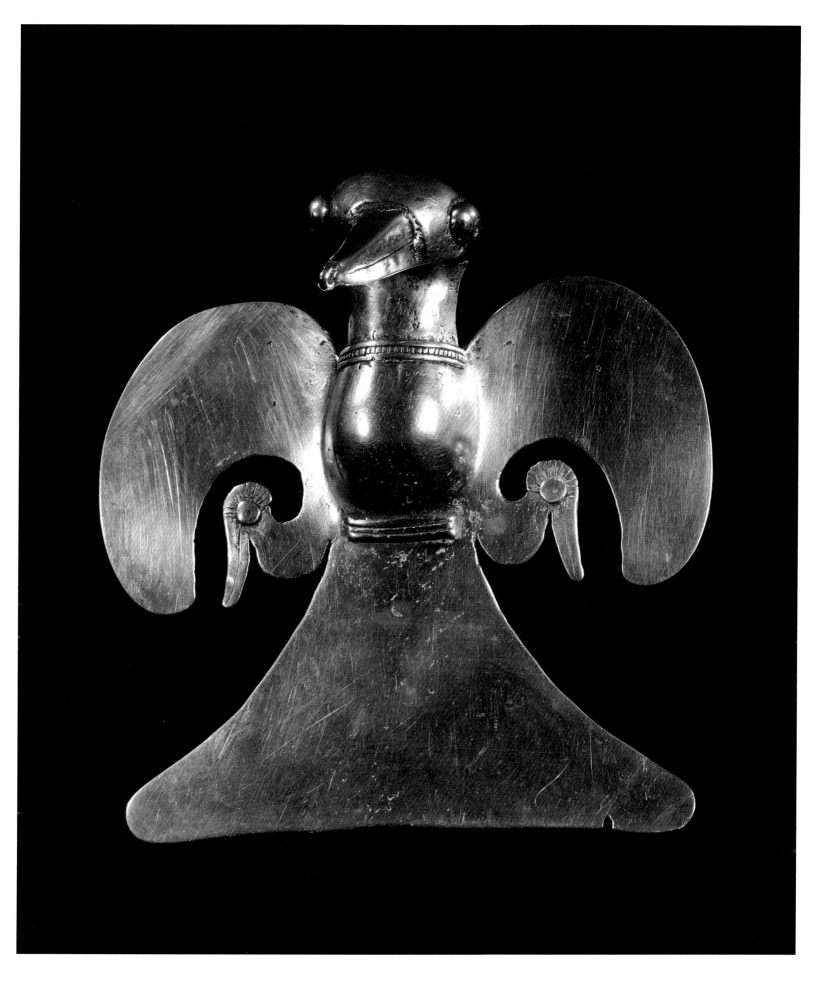

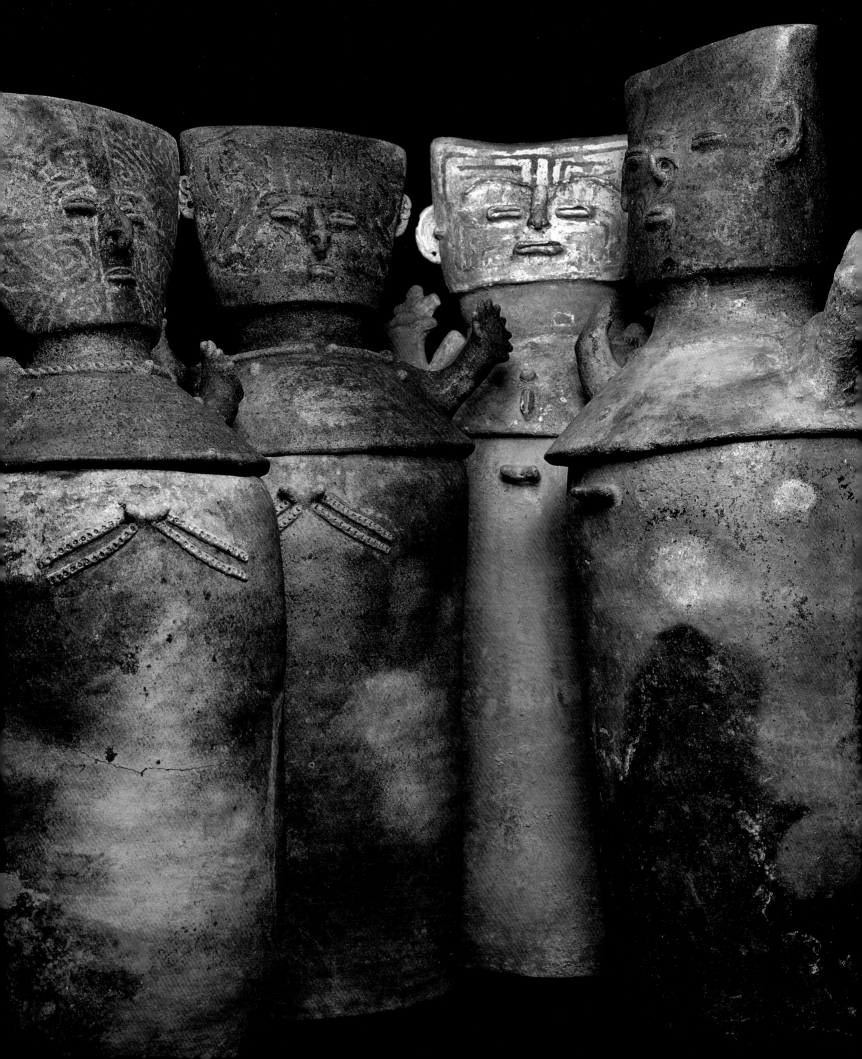

Urns
Left to right
70.4 x 30.5 cm / 72.7 x 37 cm /
78 x 27 cm / 77.1 x 42 cm
Tamalameque, Cesar
1300 AD–1600 AD
Reg. C02035 / Reg. C02436 /
Reg. C11124 / Reg. C02435
Group of Tamalameque urns
Burial urns with lids; the human figure
that adorns the urn undoubtedly
represents the deceased inside it.
These items have been found in large
groups in cemeteries consisting of
tombs with shafts and lateral chambers.

Figure
24.3 x 18.2 cm
Zambrano, Bolívar
unknown
Reg. C04552
From ancient times the various
populations of the plains of the
Caribbean moulded female figures in
clay, undoubtedly as a metaphor of
fertility.

Figure
27 x 11.8 x 7 cm
San Pedro de Urabá, Antioquia
unknown
Reg. C12595
On their arrival in 1533, the Spaniards
witnessed the social and political
importance exercised by the women of
the Zenú culture. This female figure
shows a woman richly adorned with
skirt, body painting and spool-shaped ear
ornaments.

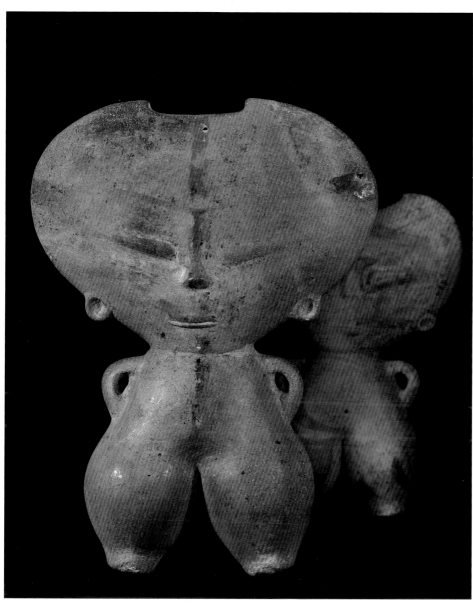

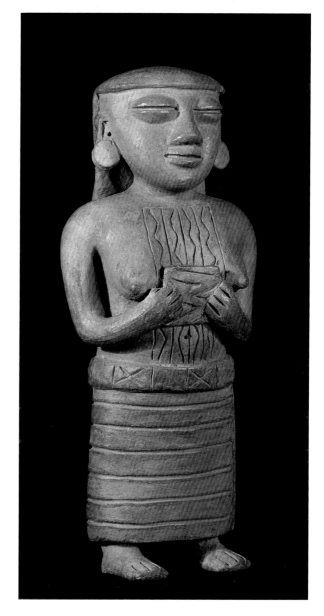

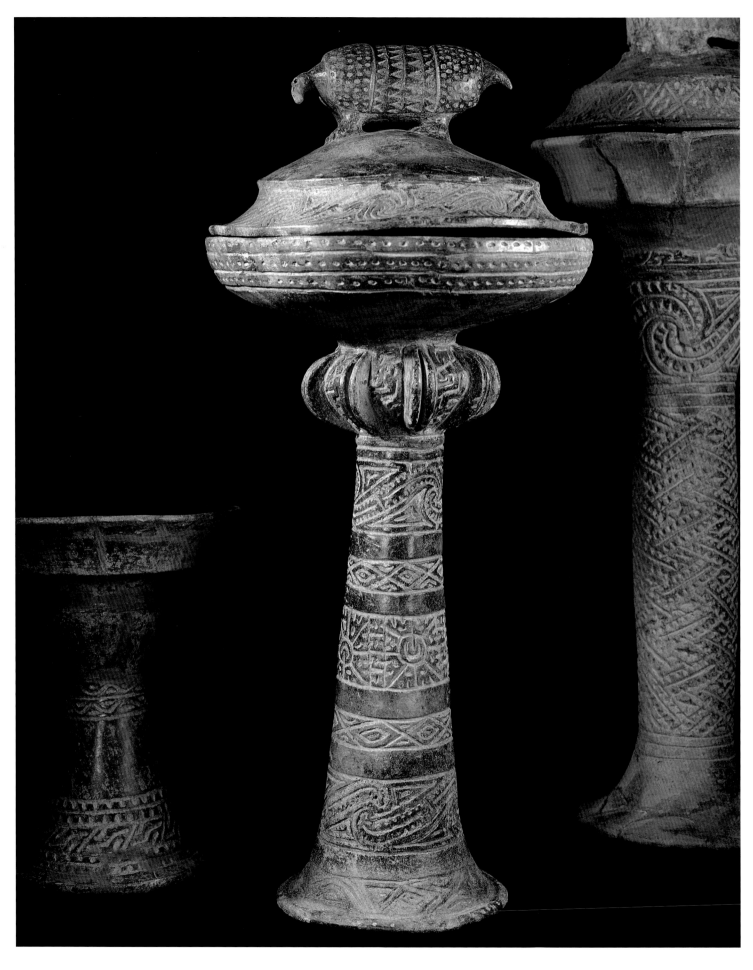

Goblet
65 x 30.5 cm
Ciénaga de Betancí, Córdoba
unknown
Reg. C12822
The colourful decoration carved on this pedestal goblet is in contrast with the stylisation of its form. Attractive ceramic vessels were deposited as offerings in huge burial mounds.

Figure
20.1 x 25.1 cm
San Marcos, Sucre
unknown
Reg. C13108
Large numbers of clay women have been found under burial mounds as part of the regalia of female chieftains and high-ranking women of the Zenú society.

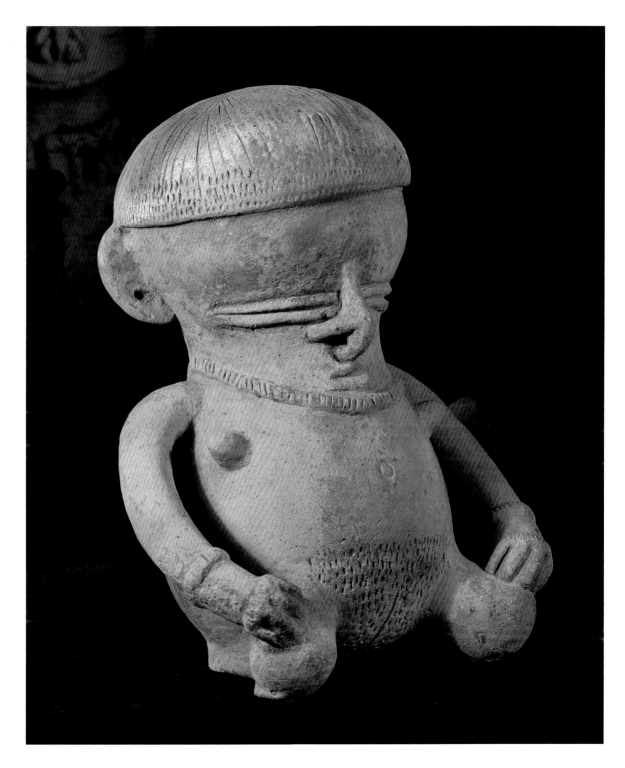

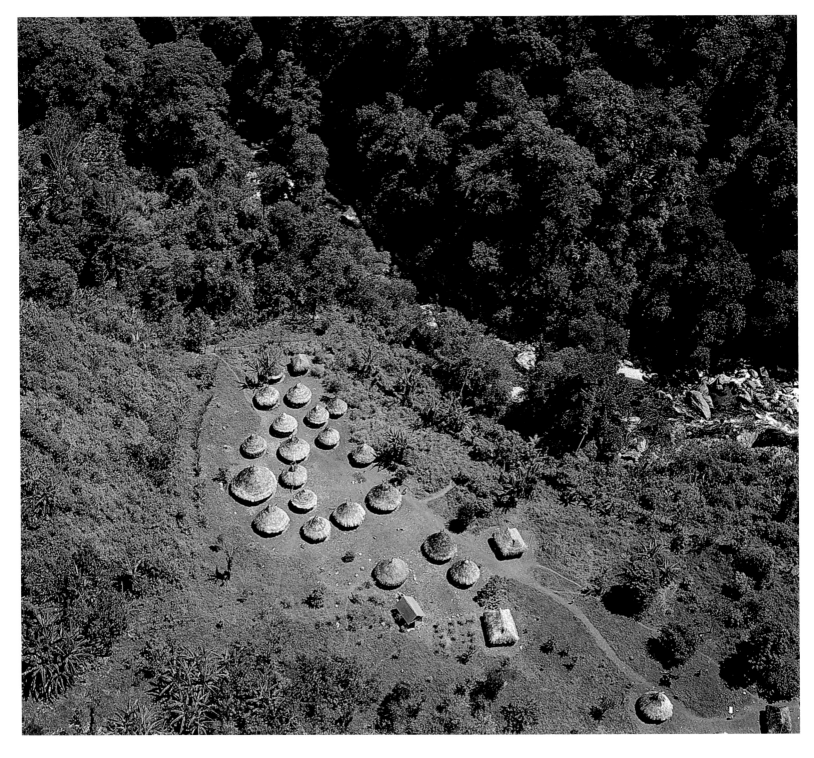

Tairona

An area of great biological and climatic diversity, the Sierra Nevada de Santa Marta was inhabited for two long periods: Nahuange and Tairona. In the Nahuange period, the subsistence of the farmers, fishermen and artisans was provided by the resources of the coast and the art objects they produced were realistic. The size of their jadeite plates and pendants, of which the source of the material is unknown, was outstanding. In metalwork, hammered *tumbaga* and highly polished surfaces were prevalent, while characteristic motifs were pendants in the form of frogs, birds with long beaks, and emblematic breastplates for personal adornment. Particularly distinctive were the figures of enigmatic females and individual shamans, richly adorned with masks, head ornaments and symbols of power. In addition to utilitarian pottery and musical instruments, such as *ocarinas* (oval flute-like wind instruments), the potters manufactured special objects to accompany the dead on their journey to the world beyond, adorned with figures of birds, felines, snakes and figures wearing masks.

During the Tairona period, power was in the hands of an elite of shamans and expansion occurred towards the high regions, where outstanding engineering works and architecture were built with flagstones. The naturalism in the representations evolved towards a figuration typical of shamanism: human and animal features were mixed together in a single object, including ornaments and symbols. The emblematic figures of bat-men, jaguar-men and birds with open wings excel for their technical and artistic quality, as well as for their mysterious symbolism. Stone bead necklaces, manufactured in large quantities, were used as offerings. The iconographic and symbolic wealth of Tairona seems to express a close connection between power and the supernatural.

Map of the Tairona archaeological region.

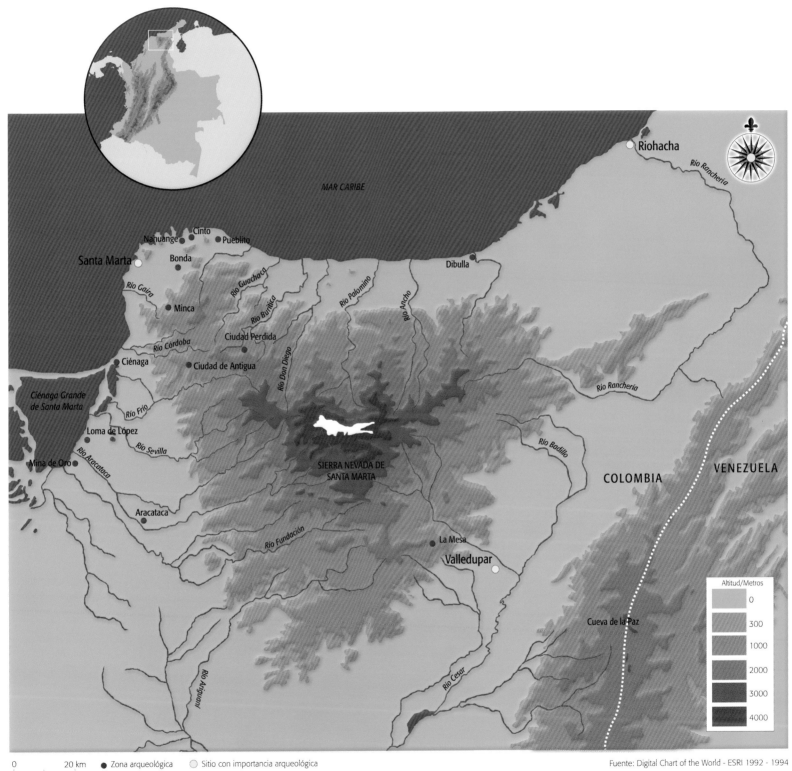

MAR CARIBE

Riohacha

Río Ranchería

Cinto
Nahuange Pueblito
Santa Marta Bonda
Río Gaira Río Guachaca Dibulla
Río Buritaca Río Polomino Río Ancho
Minca
Río Córdoba Ciudad Perdida
Ciénaga Ciudad de Antigua
Río Don Diego
Río Ranchería
Ciénaga Grande
de Santa Marta Río Frío
Loma de López Río Badillo
Río Aracataca Río Sevilla
Mina de Oro COLOMBIA VENEZUELA
SIERRA NEVADA DE
SANTA MARTA

Aracataca

Río Fundación

La Mesa
Valledupar

Río Ariguaní

Cueva de la Paz

Río Cesar

Altitud/Metros
0
300
1000
2000
3000
4000

0 20 km ● Zona arqueológica ○ Sitio con importancia arqueológica

Fuente: Digital Chart of the World - ESRI 1992 - 1994

Escala 1:1.700.000

Breastplate
13.8 cm
Río Palomino, Santa Marta, Magdalena
200 AD–900 AD
Reg. O16146
In the mythology of the indigenous
peoples of the Sierra Nevada de Santa
Marta, this character represents the
humanised sun travelling across the
celestial vault, in a bunk or hammock
that often takes the form of a snake.
Hammered and embossed *tumbaga*
breastplate.

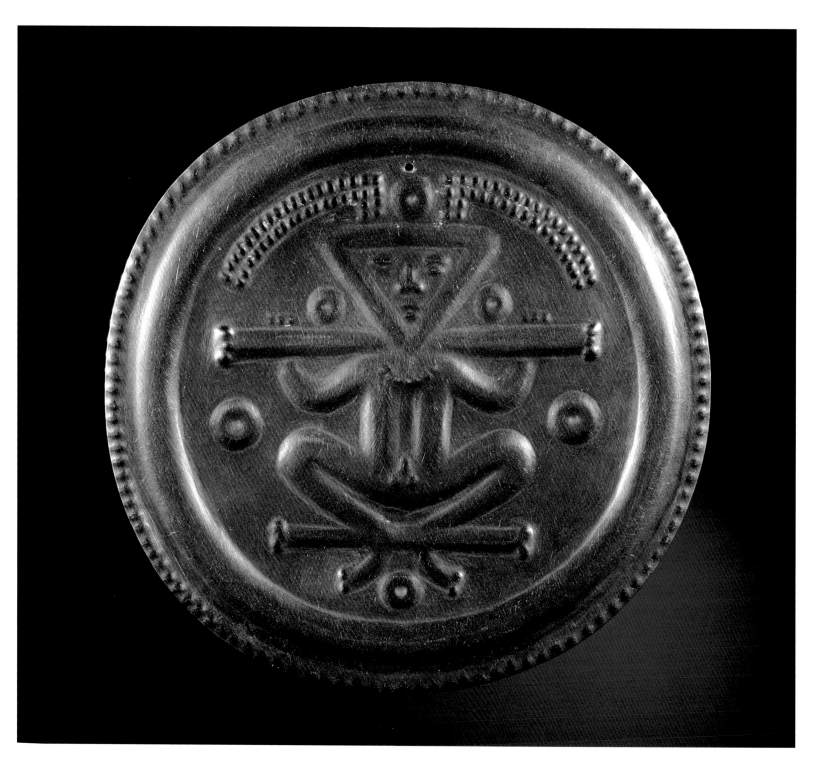

Application
12.4 x 13.9 cm
Minca, Santa Marta, Magdalena
200 AD–900 AD
Reg. O15451
An application for cloth. The central
character, taken on a walk by mythical
beings, has a huge head ornament that
terminates in two fork-tongued snakes, a
frequent motif in the iconography of the
Tairona period.

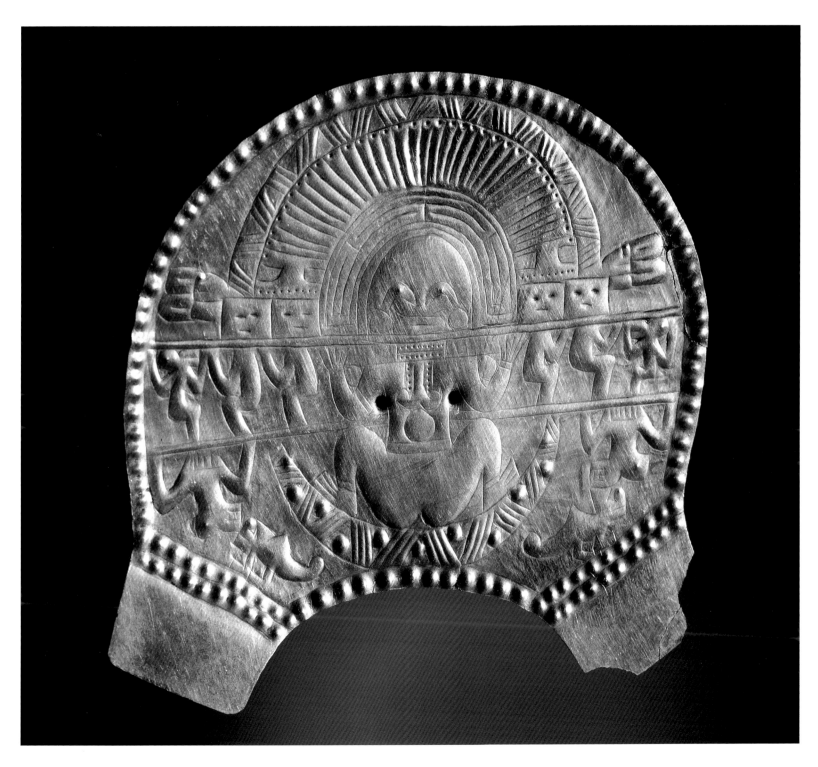

Breastplate
9.5 x 11.9 cm
Río Palomino, Santa Marta, Magdalena
900 AD–1600 AD
Reg. O16584
Breastplate with the form of a man with a bat mask and large head ornament of feathers shaped like spirals and birds. In indigenous thought, the bat is associated with darkness and the nocturnal world. Cast in *tumbaga* using the lost-wax technique.

Breastplate
10.6 x 11.3 cm
Ciénaga, Magdalena
900 AD–1600 AD
Reg. O16300
In the Tairona period, the society was governed by an elite of shamans who exercised powers over society, nature and the cosmos. This pendant in the form of a man-bat is undoubtedly the representation of one of these leaders. Gilded cast *tumbaga*.

Nose ornament
7.1 x 9 cm
Minca, Santa Marta, Magdalena
900 AD–1600 AD
Reg. O12792
This cast filigree nose ornament is reminiscent of the butterflies that inhabit the valleys and mountains of the Sierra Nevada. We do not know what the significance of this was for its author.

Ear ornaments
4.2 x 7.8 cm
4.3 x 7.7 cm
Magdalena
900 AD–1600 AD
Reg. O13693
Reg. O13694
Two snakes with forked tongues decorate the borders of each of these ear ornaments, cast in *tumbaga* using the lost-wax method.

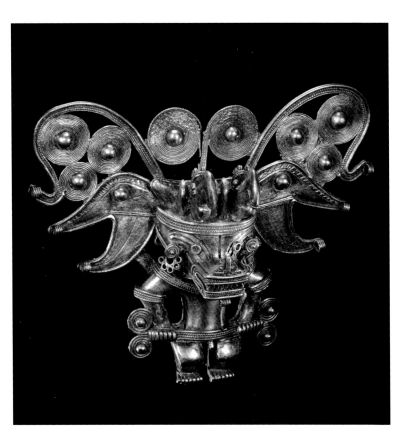

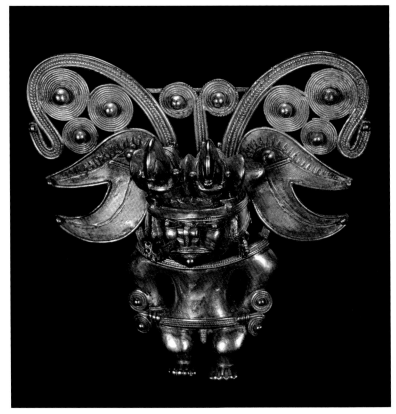

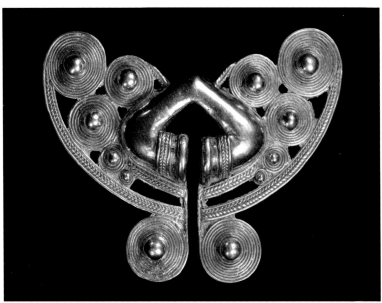

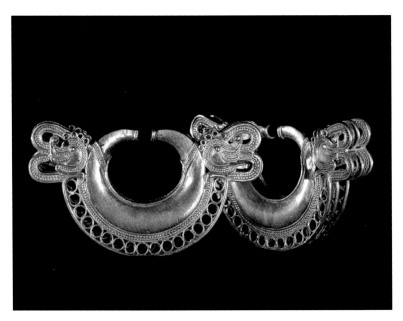

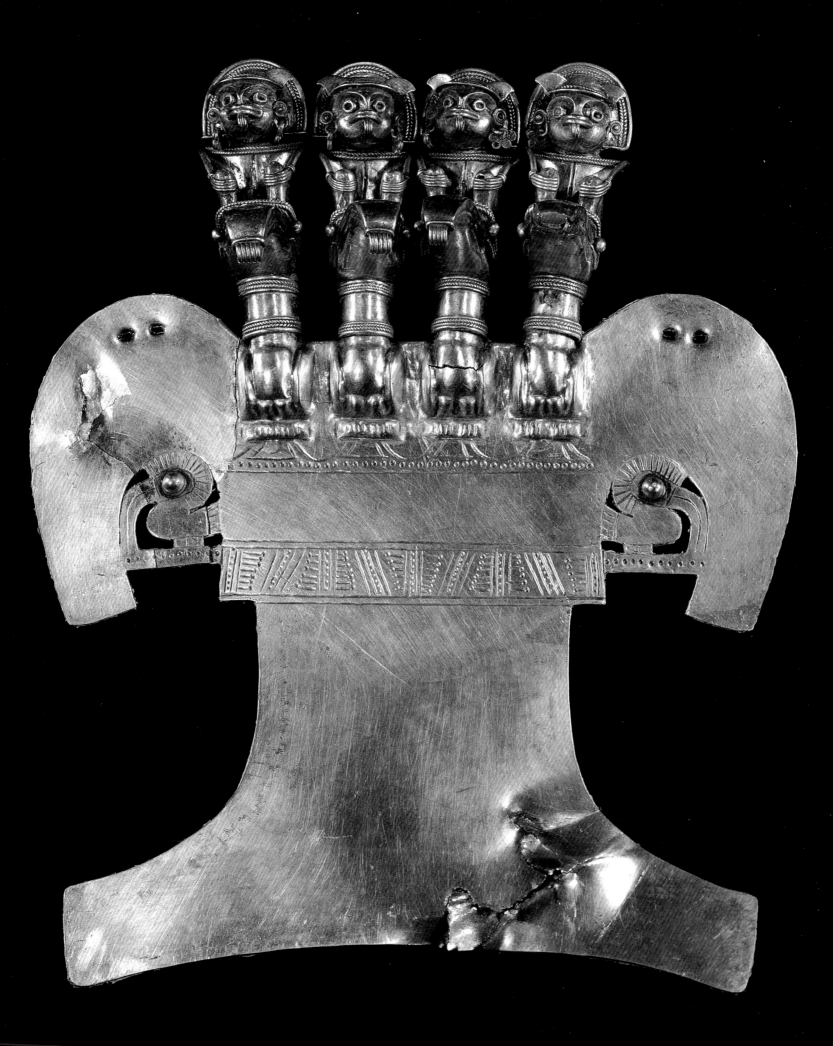

Page 191
Breastplate
20.5 x 18.2 cm
Ciénaga, Magdalena
900 AD–1600 AD
Reg. O12943
Four man-bats resting on birds adorn the body of a larger bird. Pieces similar to this have been found in Muisca territory, undoubtedly evidence of the cultural and linguistic relationship between these societies. Gilded cast *tumbaga*.

Breastplate
13.6 x 11.7 cm
Ciénaga, Magdalena
200 AD–900 AD
Reg. O16791
Breastplate from the Nahuange period in the form of a bird with spread wings. Interpreted as the static flight of the shaman, this symbol was represented from the first centuries AD by the gold crafting societies of the north of Colombia and Lower Central America.

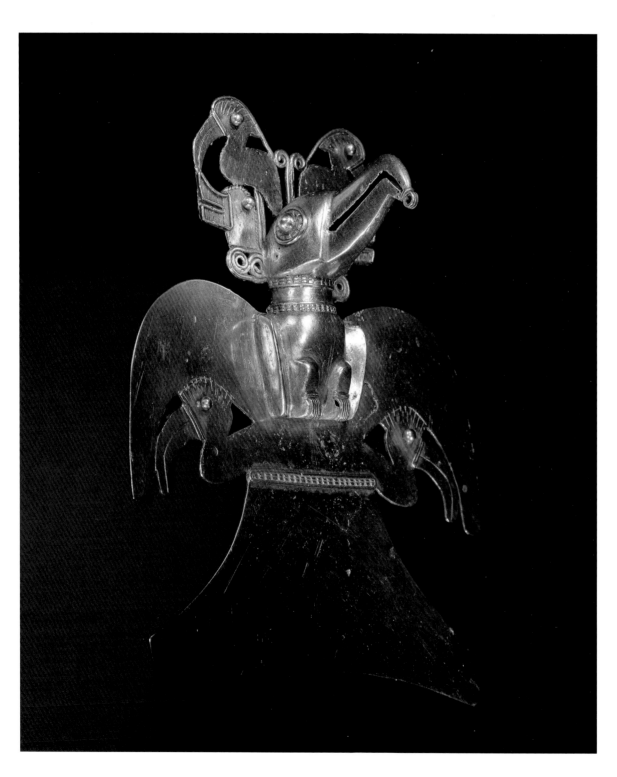

Pendant
18 x 5.2 x 3.4 cm
Río Don Diego, Santa Marta, Magdalena
900 AD–1600 AD
Reg. O20067
A hybrid pendant combining the forms of
the snail and the snake. In the thought
of the current indigenous inhabitants of
the Sierra Nevada de Santa Marta, these
animals are symbols of the male sex and
associated with fertility. Cast in *tumbaga*
using the lost-wax method with core.

Pages 194-195
Belt
13.2 x 53.2 cm
Río Don Diego, Santa Marta, Magdalena
900 AD–1600 AD
Reg. O30198
Two enormous snakes' heads with
forked tongues furrow the face of a
character, while two serene herons rest
on each side. Hammered and embossed
gold belt.

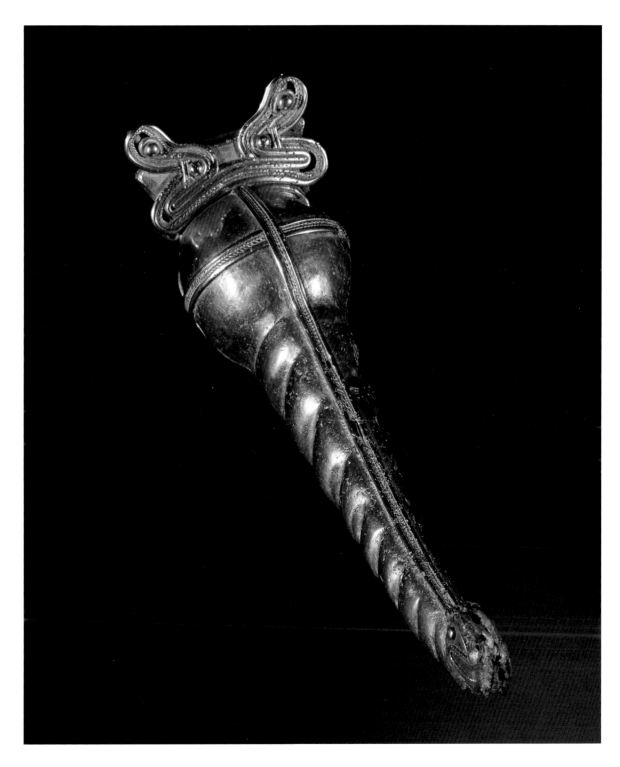

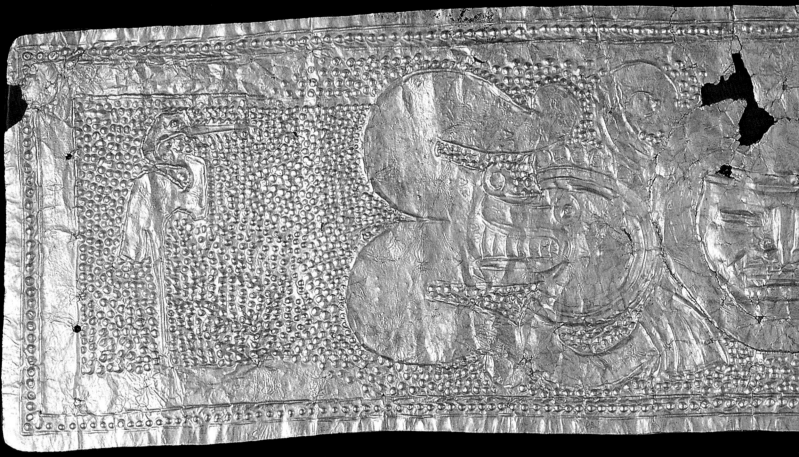

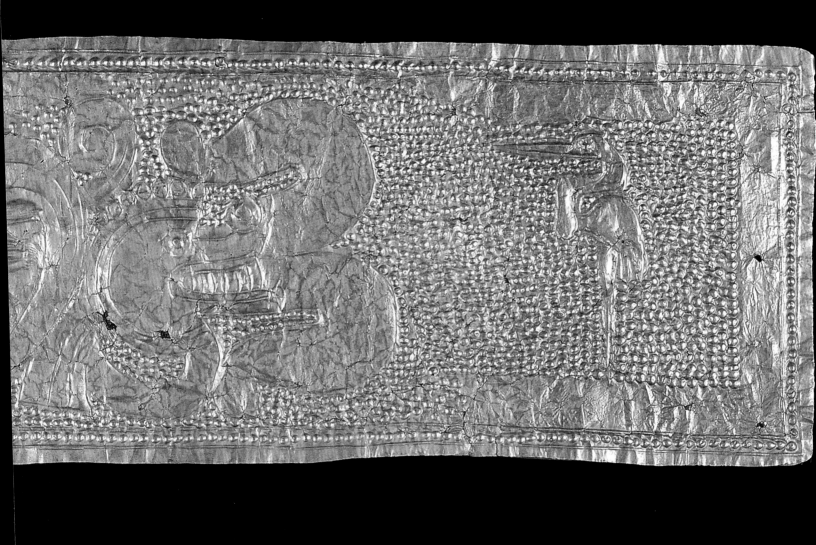

Pendant
7.1 x 5.8 cm
Río Don Diego, Santa Marta, Magdalena
900 AD–1600 AD
Reg. O30199
Pendants, associated with the same
symbolism, with schematised figures of
men adorned with masks, staffs and
attractive head ornaments, were
widespread in prehispanic Colombia.
Gilded *tumbaga* cast using the lost-wax
method.

Pendant
7.2 x 5.9 cm
Santa Marta, Magdalena
900 AD–1600 AD
Reg. O11795
The size of this object does not illustrate
the force and power of this character.
In this pendant in the form of a man-bat,
the double tubular nose ornament raises
the nose, the visor with decorations
hints at the ears and the sublabial
decoration simulates an animal's muzzle.
Gilded cast *tumbaga*.

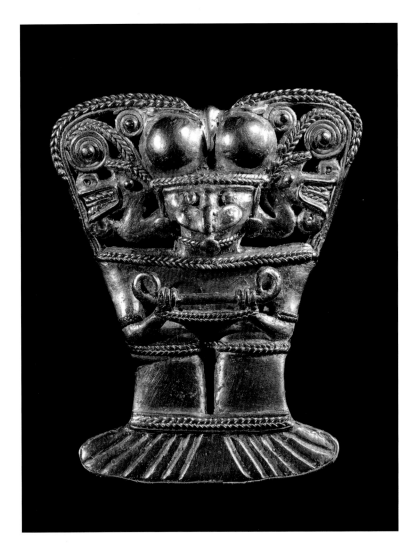

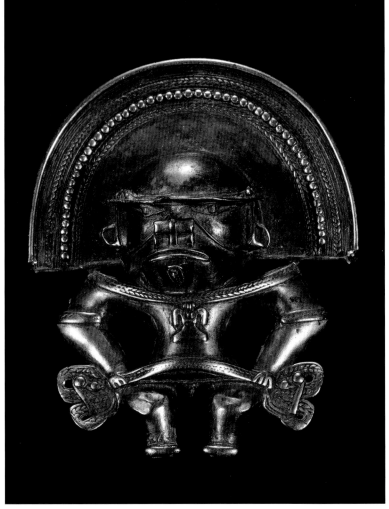

Object
11.4 x 7 cm
Minca, Santa Marta, Magdalena
900 AD–1600 AD
Reg. O12268
A tray for the ritual use of hallucinogens,
with a top in the form of a bird-man
guarded by jaguars. Gilded cast
tumbaga.

Breastplate
12.3 x 9.3 cm
unknown
900 AD–1600 AD
Reg. O23820
Breastplate with a number of birds, cast
in *tumbaga* by the lost-wax technique.
Its colourful design is typical of Late
Tairona goldwork.

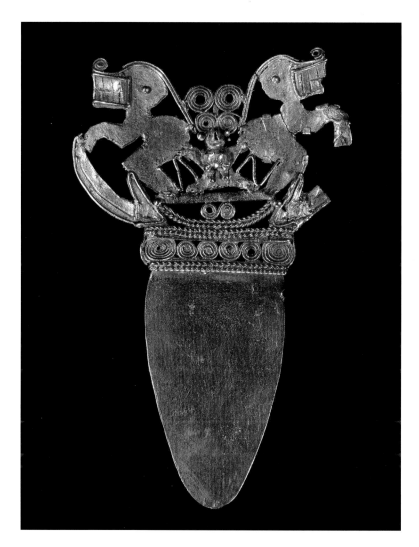

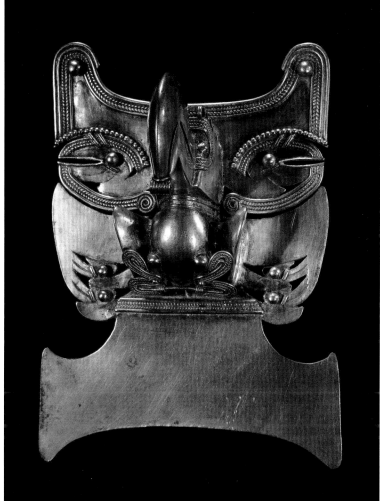

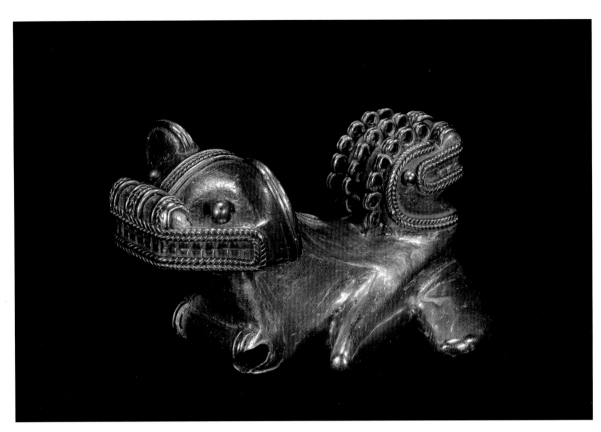

Pendant
5.6 x 5 cm
Ciénaga, Magdalena
900 AD–1600 AD
Reg. O12563
With a frog's body, a jaguar's head and a snake's tail, this extraordinary pendant must have had a profound symbolic content for its owner. It was cast using the lost-wax method with a *tumbaga* core and then gilded by depletion.

Breastplates
10.6 x 11.3 cm / 9.5 x 11.9 cm
Ciénaga, Magdalena / Río Palomino, Santa Marta, Magdalena
900 AD–1600 AD
Reg. O16300 / Reg. O16584
By the use of adornments and head ornaments, the Taironas modified their appearance and acquired the appearance of animals.

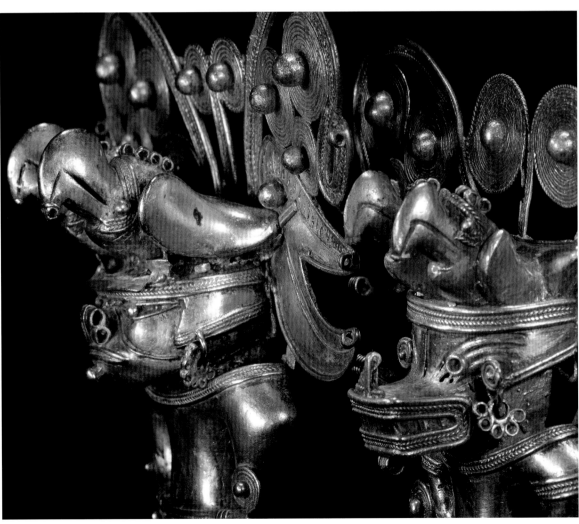

Vessel
11.5 x 22 x 11.2 cm
unknown
900 AD–1600 AD
Reg. C00738
This vessel transports us back to an
ancient place in which masked
individuals congregated to conduct
sacred rites and ceremonies.
This practice is still common among the
indigenous peoples of the Sierra Nevada
de Santa Marta.

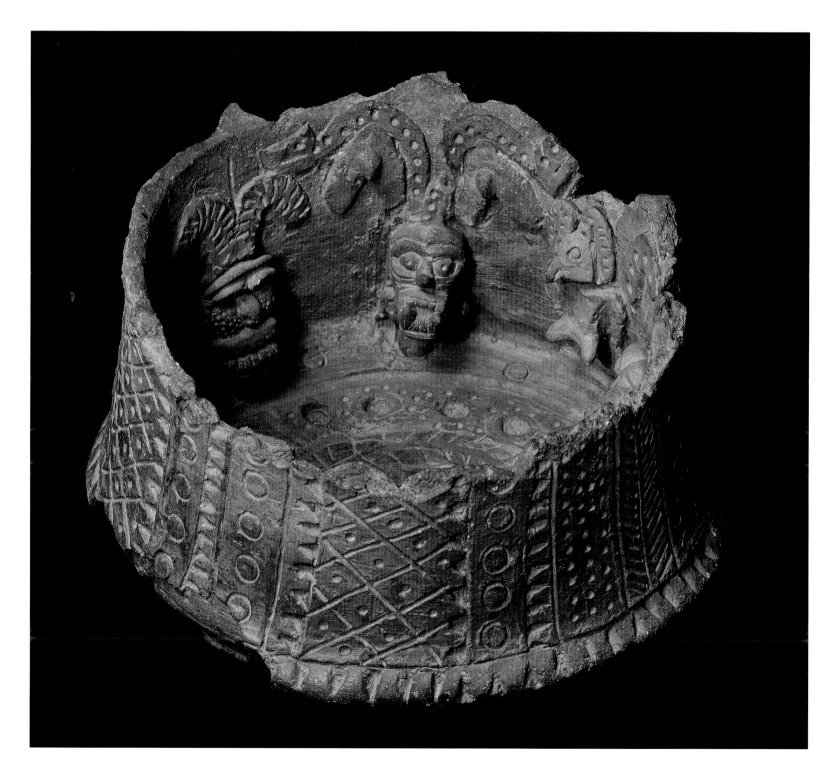

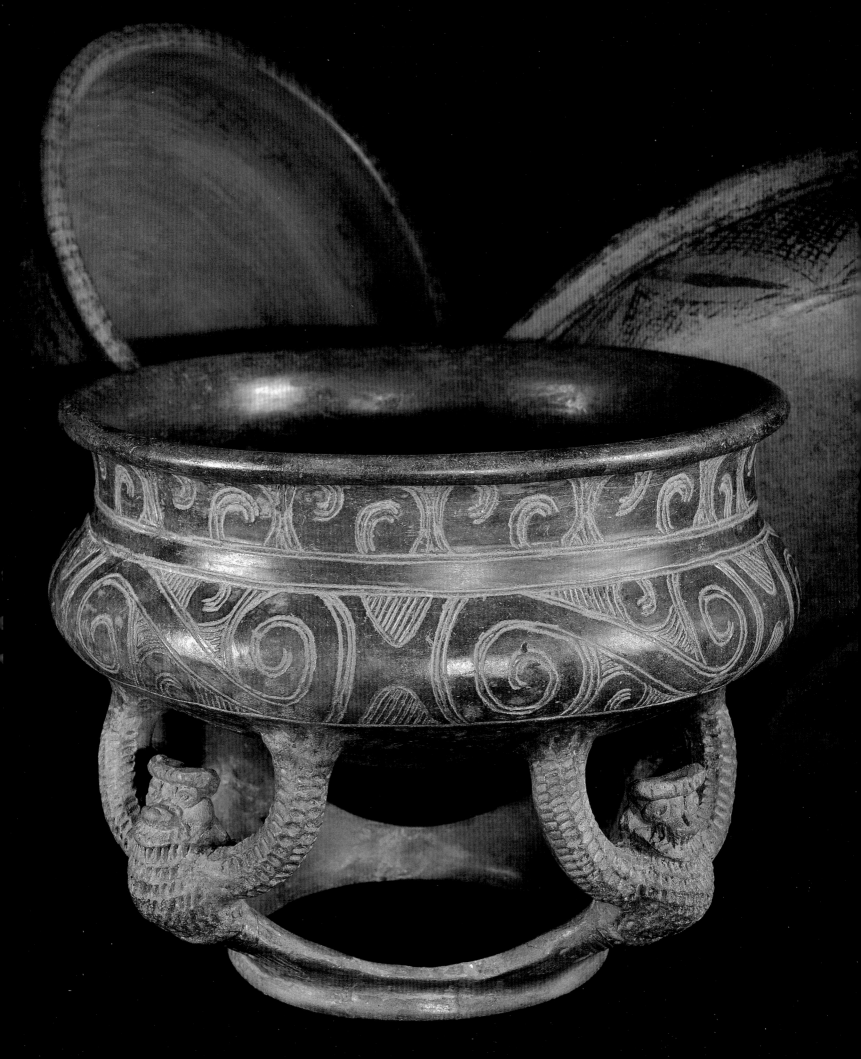

Vessel
19.5 x 26.3 cm
unknown
200 AD–900 AD
Reg. C05615
Four mythical beings, like Atlases, support the world, symbolised in this vessel with geometrical decorations.

Baton top
6.8 x 5.3 cm
unknown
900 AD–1600 AD
Reg. H00123
Staff top carved in bone with the scene of a jaguar-man carrying a man tied by the feet on his back. A bird pecks at the masked man's cranium. Small objects such as this one, carved in bone, reveal the complex cosmovision of the ancient inhabitants of the Sierra Nevada de Santa Marta.

Breastplate
10.1 x 11.4 cm
Magdalena
200 AD–900 AD
Reg. H00141
This bone breastplate depicts a distinguished figure from the Nahuange mythical world, who, thanks to his prestige, had the privilege of bearing a bird on his chest.

Pendant
4.2 x 11.7 cm
unknown
200 AD–900 AD
Reg. K00388
A pendant with carved decoration made with the core of a marine shell. The curvature of the beak leads us to believe it is a Magnificent Frigatebird (*Fregata magnificens*).

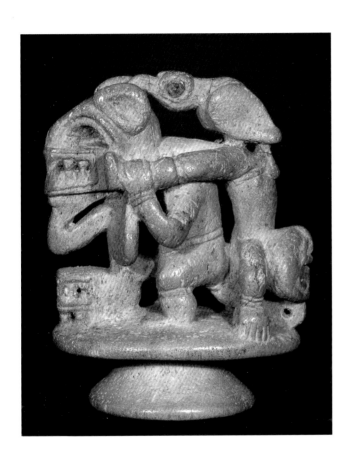

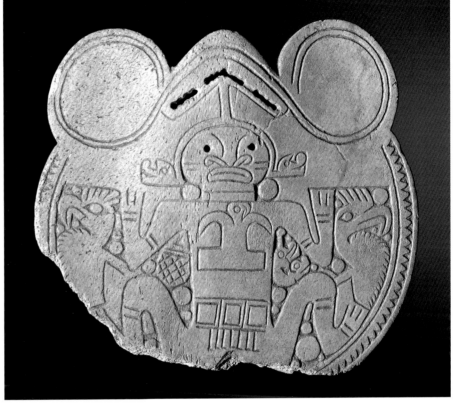

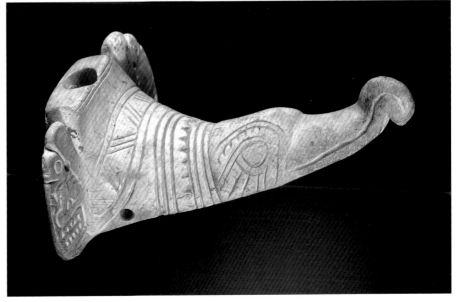

Axe
10.9 x 29.4 x 2.1 cm
Minca, Santa Marta, Magdalena
900 AD–1600 AD
Reg. L00042
Fragile and not showing any signs
of use, this stone axe was not a weapon
or a tool, but an insignia of power
for the leaders of the Sierra Nevada
de Santa Marta.

Batons
33 x 5.8 x 1.8 cm / 59.6 x 7.5 x 2 cm /
28.5 x 3.8 x 1.1 cm / 56 x 7.4 x 2 cm
unknown / Bonda, Santa Marta,
Magdalena / Dibulla, Riohacha, Guajira /
Minca, Santa Marta, Magdalena
900 AD–1600 AD
Reg. L00867 / Reg. L00810 /
Reg. L01093 / Reg. L00697
Set of stone staffs.
The mythology of the indigenous
peoples that currently occupy the Sierra
Nevada de Santa Marta tells that before
the Sun appeared, the world was made
of stone. As a consequence, when old
people die they turn into stone, as they
return to the mythical time. Staffs are
insignias of power.

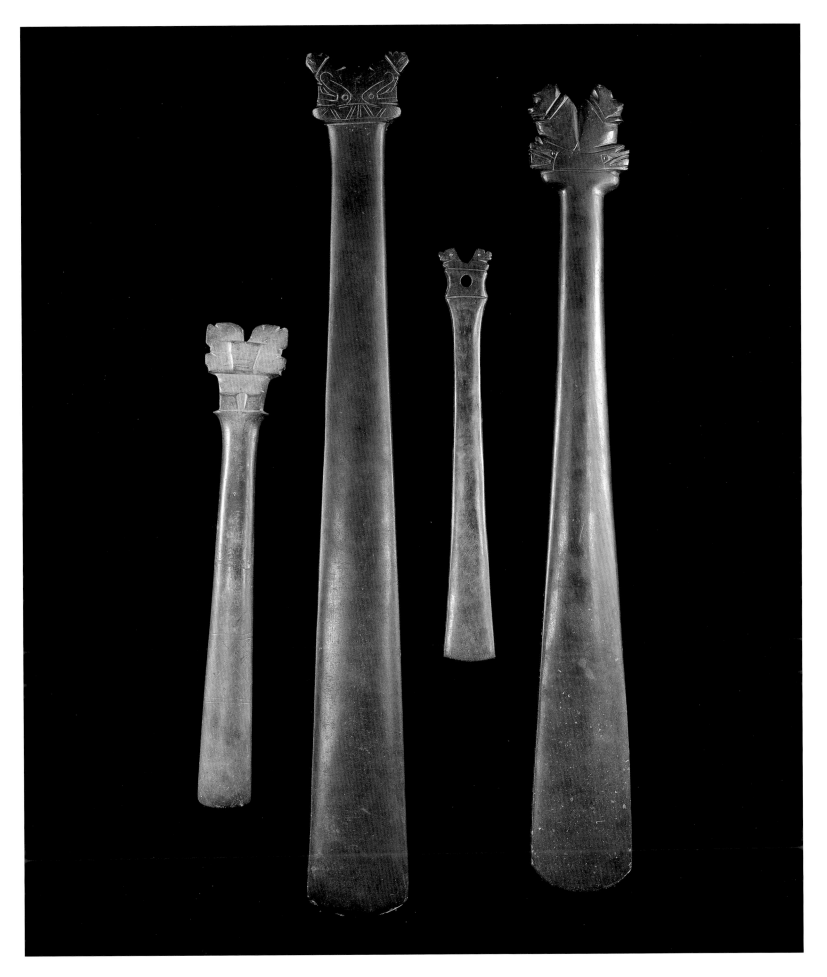

Savanna of Bogotá from the high
moor of Tablazo, in the Cundinamarca
Department. Photo: Fabián Alzate.

Muisca

The inter-Andean highlands and valleys of the Eastern Andes were occupied by hunters and gatherers who progressively adopted agriculture and pottery. Later on, people speaking the Chibcha language arrived from Central America. The peoples that were part of the archaeological area of the Eastern Cordillera developed different ways of living but maintained relations and shared forms of expression and conceptions of the world.

On the basis of the iconography, area of influence, context of use and production techniques, three styles may be distinguished. In Nuclear Muisca, at the centre of the region, the figures of birds and human representations with eyes and mouth in the shape of a "coffee bean" are prevalent. The Complex Western style, from the western and southwestern slopes of the mountain range, is characterised by very elaborate anthropomorphic motifs in its decorations. The Simple Hammered style refers to simple objects for use on the face and body, produced by hammering, in which circular and half-moon forms are frequent.

Metal fulfilled a fundamental role in the religious world of the Muiscas, who considered it a male principle necessary to fecundate the earth. Two large groups of objects made from metal were, first, adornments employed by the leaders as signs of authority and religious knowledge, and, second, votive figures. With the latter—produced in various forms, colours and sizes, then placed in special ceramic containers that were deposited in caves, lagoons and temples alongside other offerings—they sought to maintain the balance of the world symbolically. The offerings are generally flat and triangular, and show—using schematised features—caciques, warriors, women and animals, as well as small everyday objects, various scenes and rituals.

The Muiscas perfected weaving techniques, colouring their fabrics with mineral and plant pigments. They used mummification, with which they sought to perpetuate the unifying figures of their leaders and to maintain close links with their ancestors.

Map of the Muisca archaeological region.

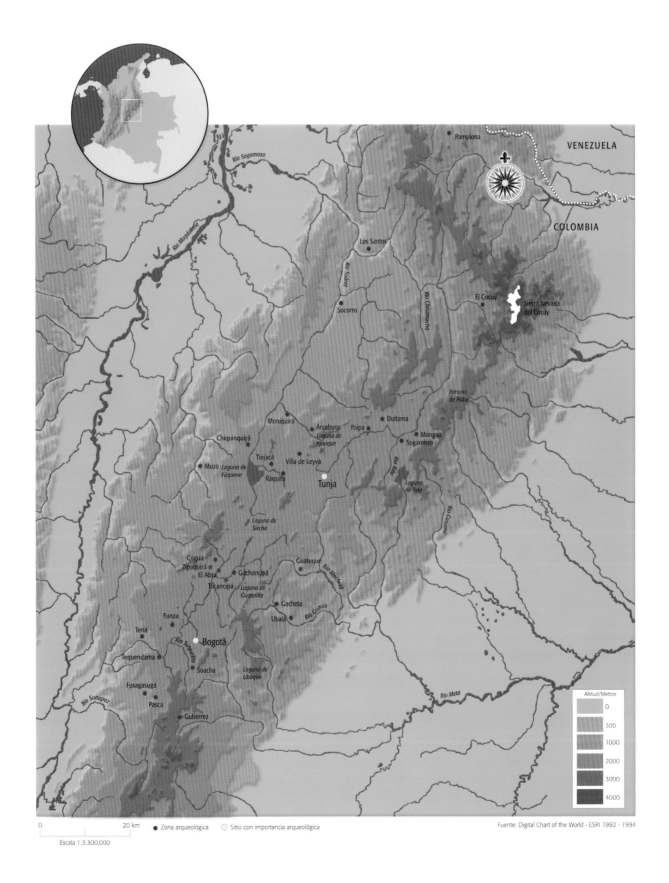

VENEZUELA

COLOMBIA

Pamplona

Rio Sogamoso

Rio Magdalena

Los Santos

Rio Suárez

El Cocuy

Sierra Nevada
del Cocuy

Socorro

Rio Chicamocha

Páramo
de Pisba

Duitama

Moniquirá
Arcabuco Paipa
Chiquinquirá Laguna de
Iguaque Mongua
Sogamoso

Tinjacá
Muzo Laguna de Villa de Leyva Rio Tota
Fúquene Laguna
Ráquira de Tota

Tunja

Rio Casanare

Laguna de
Siecha

Cogua Guatequé Rio Machetá
Zipaquirá Gachancipá
El Abra
Tocancipá Laguna de
Guatavita

Gacheta
Ubalá Rio Guavio
Funza
Tena

Bogotá Rio Tunjuelito

Tequendama Soacha Laguna de
Ubaque

Fusagasugá Rio Meta
Rio Sunapaz
Pasca
Gutierrez

Altitud/Metros

0
300
1000
2000
3000
4000

0 20 km ● Zona arqueológica ○ Sitio con importancia arqueológica Fuente: Digital Chart of the World - ESRI 1992 - 1994

Escala 1:3.300.000

207

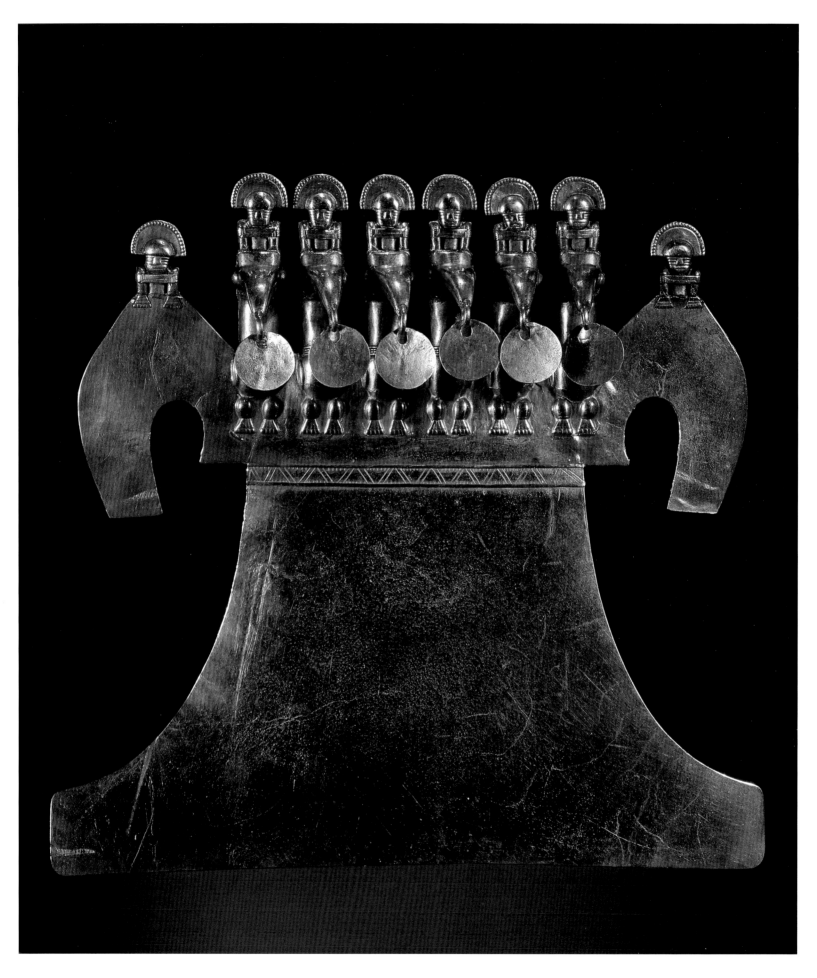

Breastplate
21 x 22.5 cm
Guatavita, Cundinamarca
600 AD–1600 AD
Reg. O01253
This winged breastplate, similar in
iconographic terms to those found in the
Sierra Nevada de Santa Marta, reveals
a mythical view of the world shared
by these Chibcha-speaking societies.
Its fine finish, in cast *tumbaga*,
is noteworthy.

Votive figure
5.3 x 5 cm
Gachancipá, Cundinamarca
600 AD–1600 AD
Reg. O06787
A votive object in the form of a mask,
cast in gold.

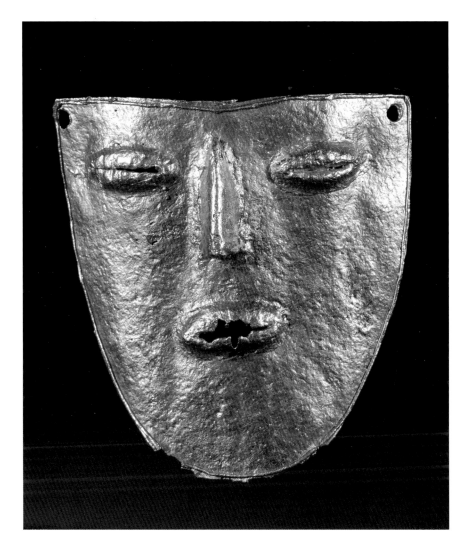

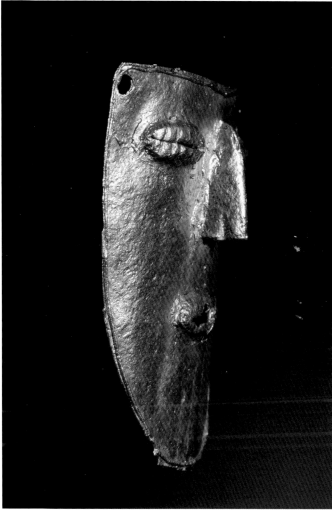

Diadem
6.5 x 22.8 cm
Sogamoso, Boyacá
600 AD–1600 AD
Reg. O19535

Ear ornaments
11.1 x 12.2 cm
11.2 x 13. 2 cm
Sogamoso, Boyacá
600 AD–1600 AD
Reg. O19536
Reg. O19537
Belonging to an individual of high rank,
this regalia cast in gold was found in
Sogamoso, a place of pilgrimage for
Muisca society, renowned for its Temple
of the Sun.

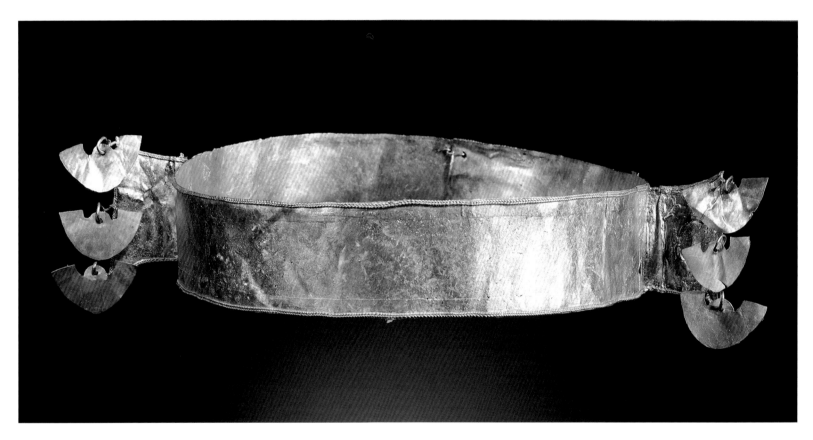

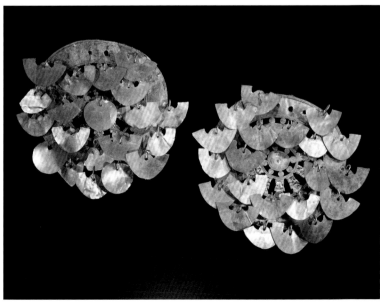

Breastplate
11 x 11.9 cm
Chiquinquirá, Boyacá
1040 AD–1120 AD
Reg. O33772
The absence of gold mines in the
Altiplano was no obstacle to the Muisca
goldsmiths. They were able to create
large, attractive ornaments from this
metal by trading with neighbouring
lands. A winged breastplate cast in gold.

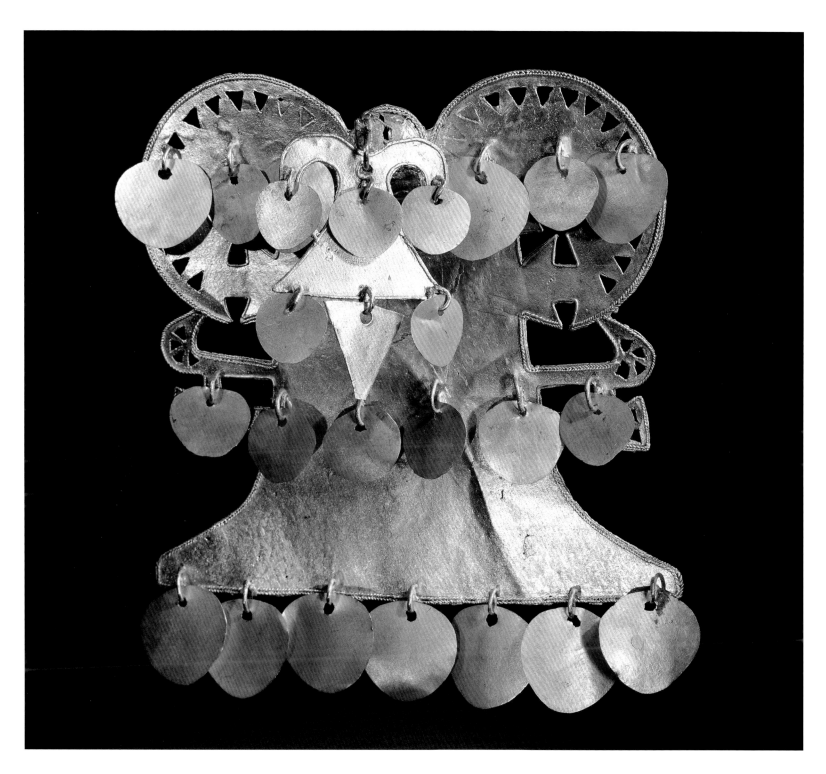

Votive figure
10.2 x 19.5 x 10.1 cm
Pasca, Cundinamarca
600 AD–1600 AD
Reg. O11373
A votive raft staging the ceremony
of El Dorado. To take up his rightful
position, the heir to the Muisca
chiefdom covered his body with
powdered gold and, accompanied by his
people, threw gold and emeralds into
the water as an offering to the gods.

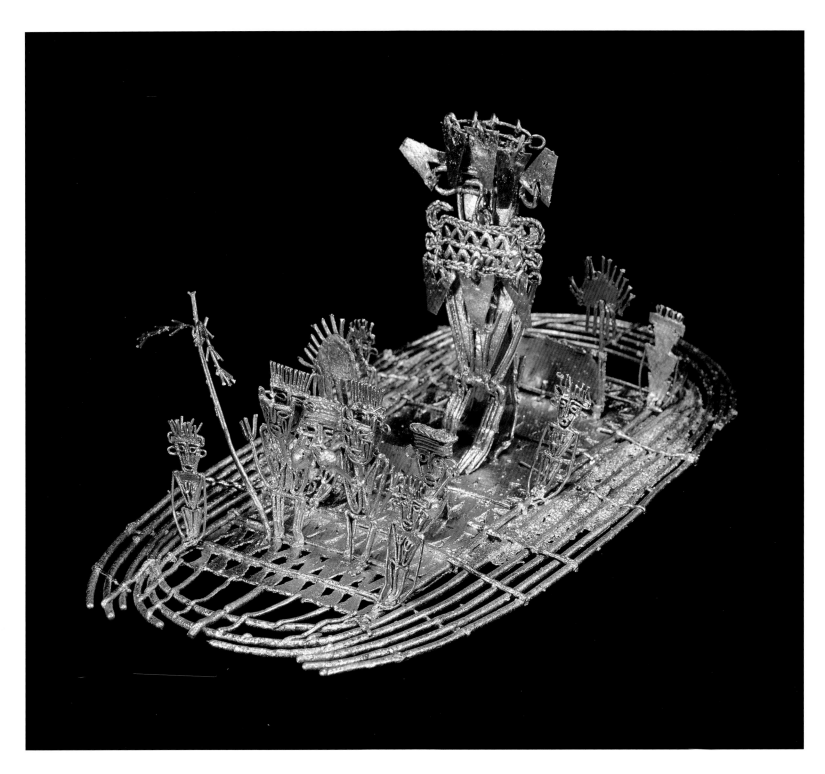

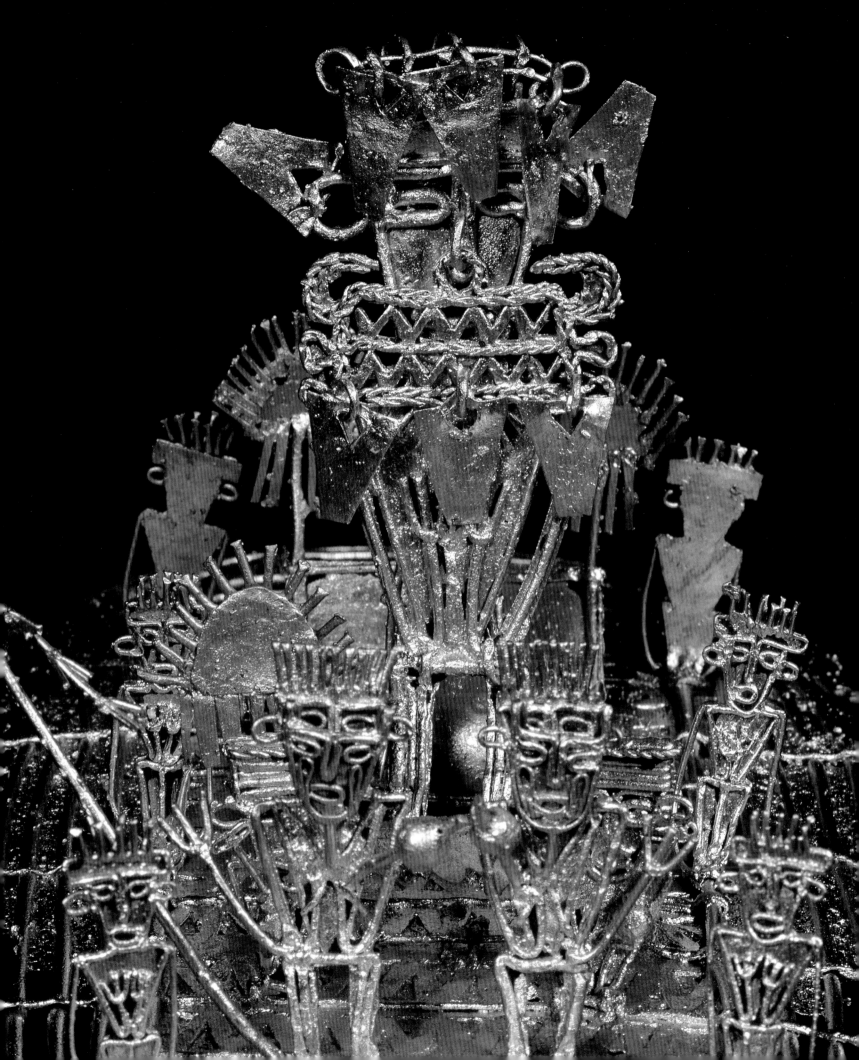

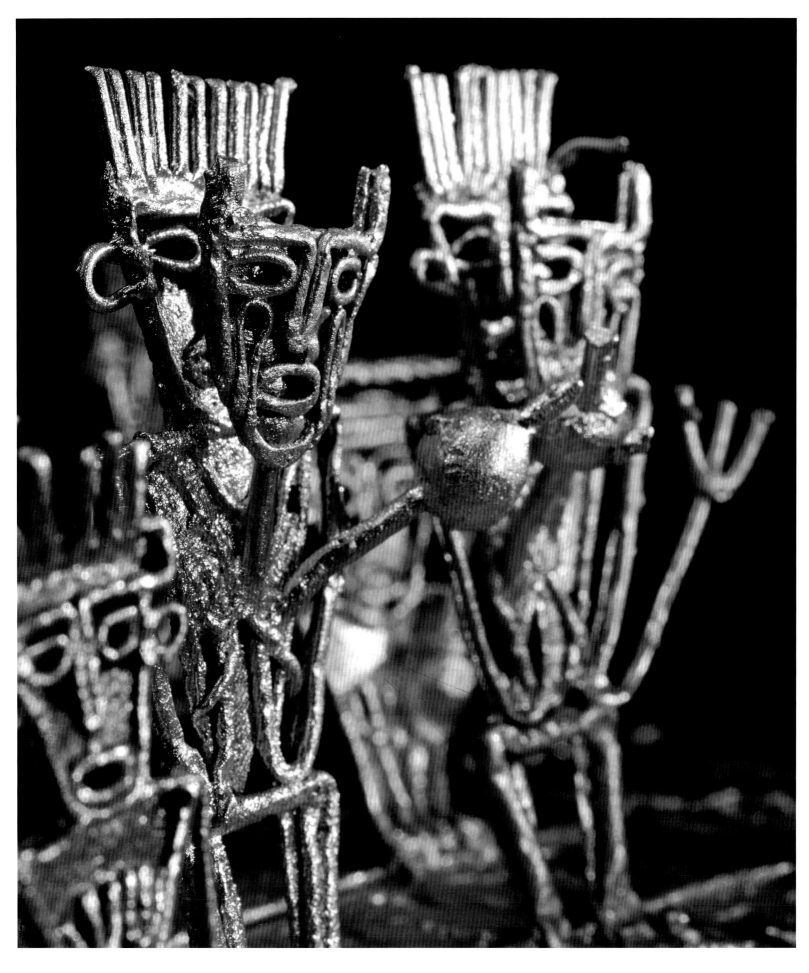

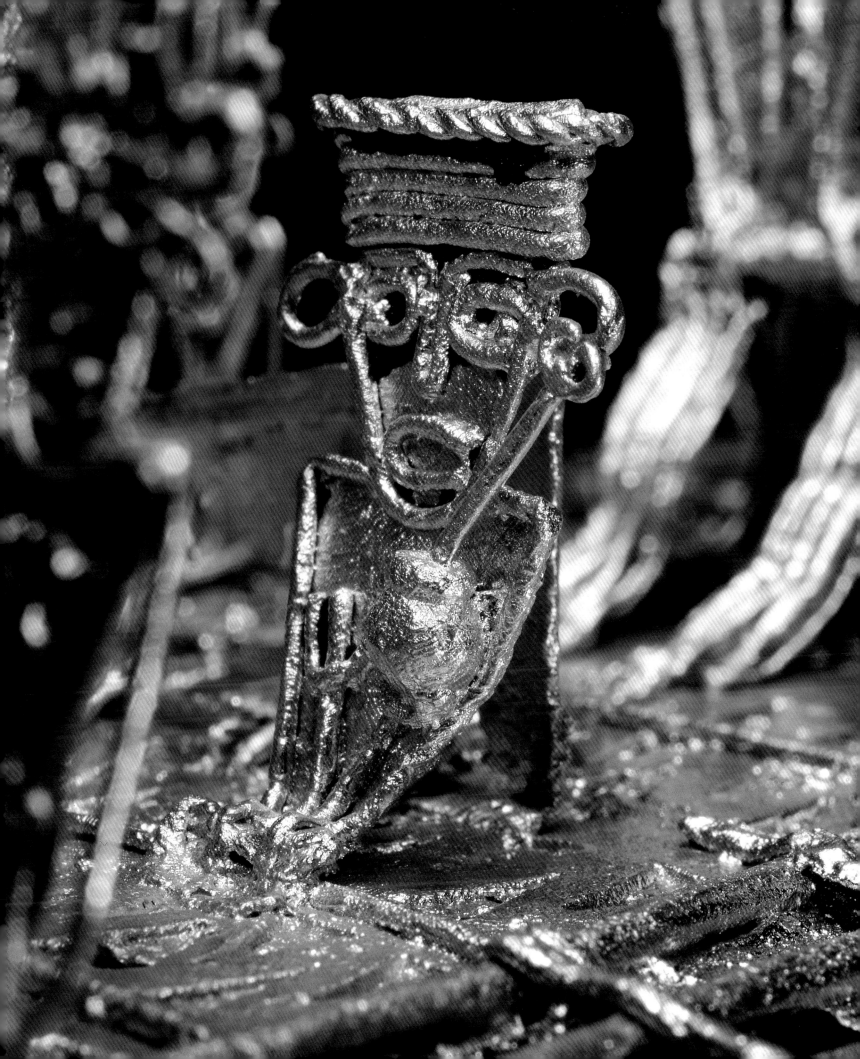

Votive figure
8 x 4.2 cm
Guatavita, Cundinamarca
600 AD–1600 AD
Reg. O06755
A votive figure in the form of a warrior
adorned with items for battle. His sharp
teeth would seem to represent his
ferocity and courage. Made of *tumbaga*
by lost wax casting.

Votive figure
6.9 x 2 cm
600 AD–1600 AD
Reg. O06591
A votive figure with the representation
of a sexual scene, probably associated
with fertility, a permanent theme of
rogation among indigenous societies to
their gods. Cast *tumbaga*.

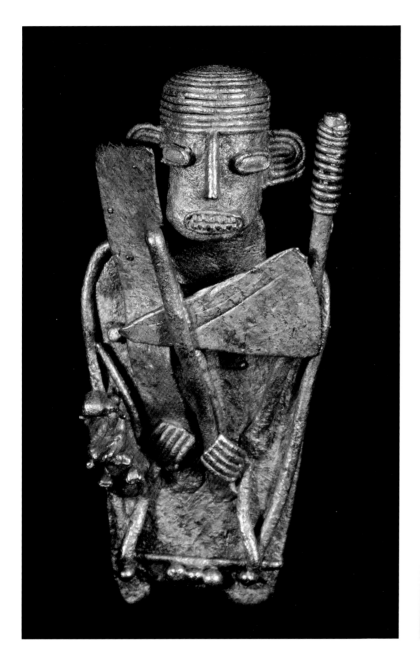

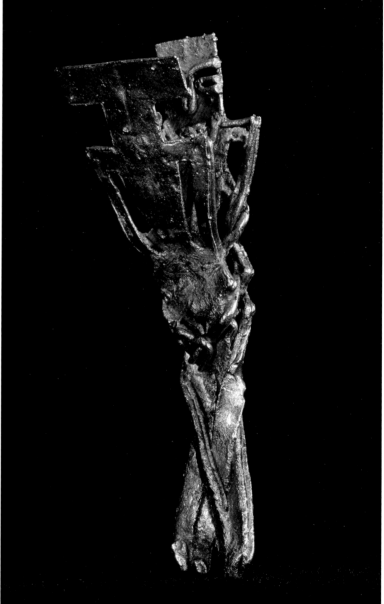

Votive figure
8.4 x 2.5 cm
unknown
600 AD–1600 AD
Reg. O04678
Muisca goldwork was characterised by
emphasis on the production of votive
figures. This work was conducted under
the supervision of the priests, who were
responsible for making the offerings in
sacred sites. A votive figure associated
with maternity. Cast *tumbaga*.

Votive figure
11.9 x 3.2 cm
unknown
600 AD–1600 AD
Reg. O00296
Perhaps as a symbol of courage, the
güechas, or warrior Muisca, shaved their
heads. This *tunjo* represents a victorious
warrior with bow, arrows and his
enemy's head as a trophy.

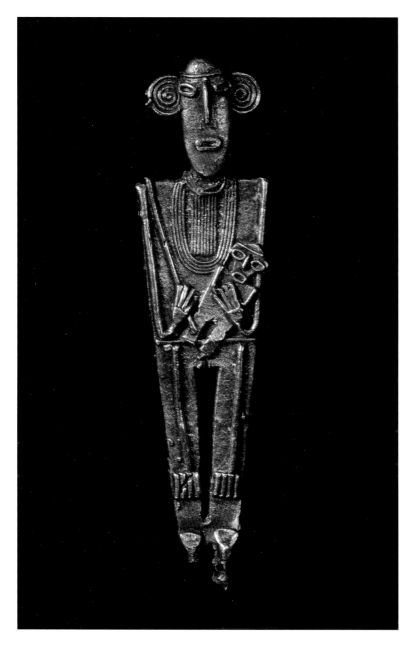

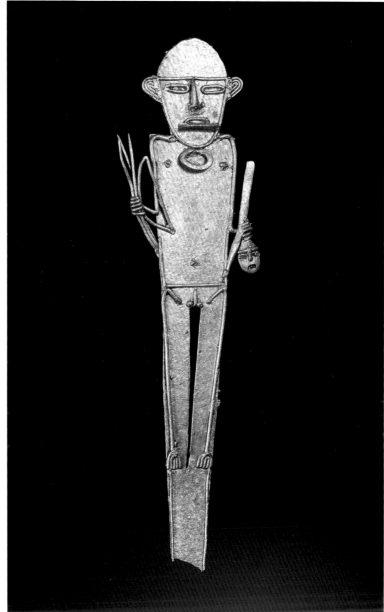

Votive figure
8.3 x 22.6 cm
Pasca, Cundinamarca
600 AD–1600 AD
Reg. O11374
This object, with the representation of a
high-ranking chieftain, was part of the
group of offerings in which, hundreds of
years ago, a Muisca placed the Muisca
Raft. Cast gold.

Votive figure
9.1 x 5.7 x 6.4 cm
Fusagasugá, Cundinamarca
600 AD–1600 AD
Reg. O32866
A votive object in the form of a *cercado*
with the figure of a bicephalous man
symbolising the dual character of the
power exercised by Zipa and Zaque,
supreme *caciques* of Muisca society.

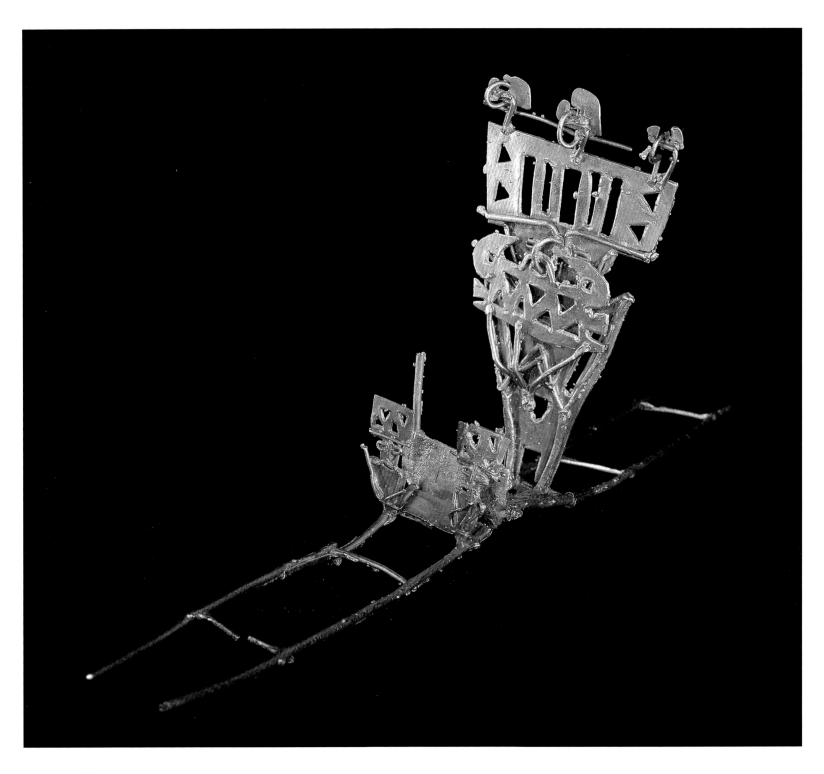

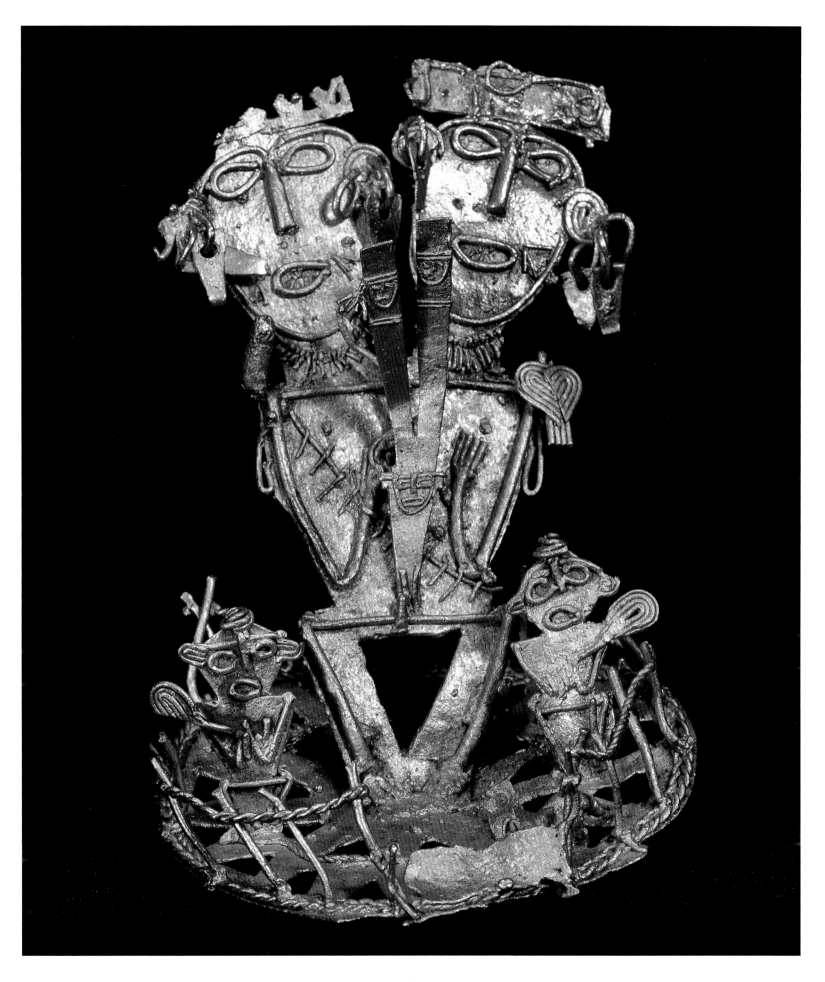

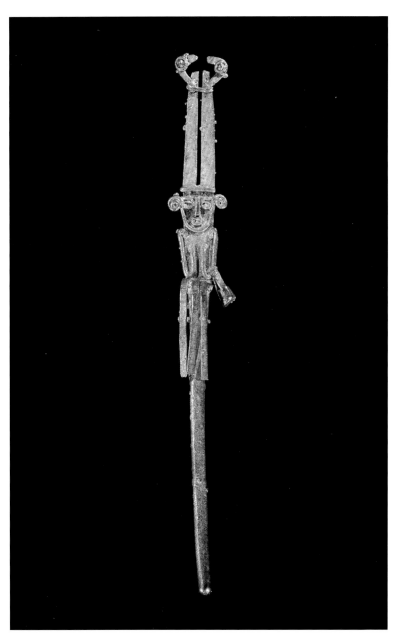

Votive figure
12.4 x 1.4 cm
unknown
600 AD–1600 AD
Reg. O29286
The Muisca offered the gods blood
collected in human sacrifices. Votive
representation of a human sacrifice, cast
in *tumbaga*.

Blowpipe
1.9 x 17.3 cm
Cogua, Cundinamarca
600 AD–1600 AD
Reg. O24559
In prehispanic societies, war had
a generally ritual nature. A sling
or blowpipe with a hook in the form
of a human head, cast in *tumbaga*
by the lost-wax technique with core.

Breastplate
15 x 14.5 cm
Chiquinquirá, Boyacá
1040 AD–1120 AD
Reg. O33771
Unquestionably of Muisca style, this
breastplate in the form of a bird with
spread wings is similar in iconographic
terms to those of Zenú, the Sierra
Nevada de Santa Marta and Lower
Central America. Cast in gold by lost
wax.

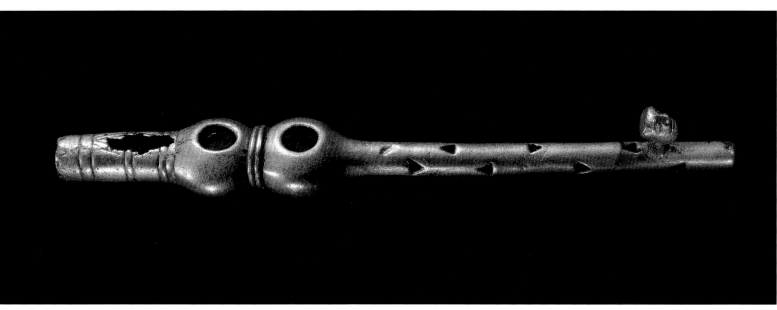

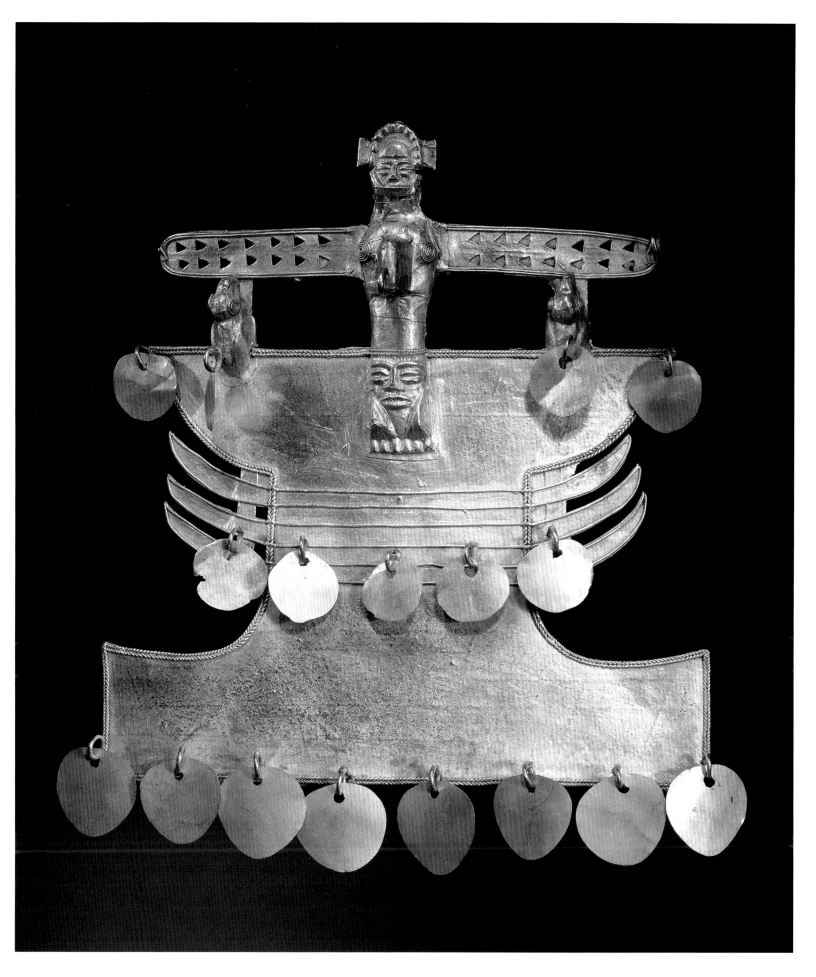

Votive figure
5.7 x 10 cm
unknown
1160 AD
Reg. O01115
This extraordinary figure with the form of a feline adorned with ear ornaments and crest of feathers shows the rough finish and limited polish of Muisca objects for offerings. Its face apparently still has residues of a resin or greasy substance offered in the temples. Cast using the lost-wax method with *tumbaga* core.

Votive figure
2.3 x 8.2 x 8.2 cm
Soacha, Cundinamarca
600 AD–1600 AD
Reg. O32884
Votive offering in the form of a feline. The objects offered were generally human and animal figurines popularly known as *tunjos*. Cast gold.

Votive figure
5.4 x 1.7 x 3 cm
Cundinamarca
600 AD–1600 AD
Reg. O33078
A votive object in the form of a deer, made by casting with the lost-wax method with core. The geometrical design covering its body is similar to that of certain cotton textiles.

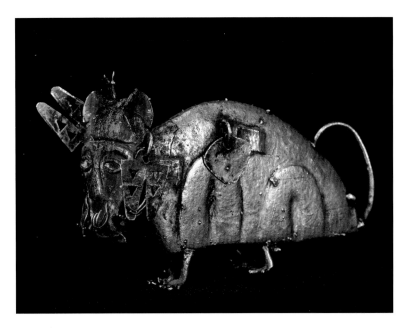

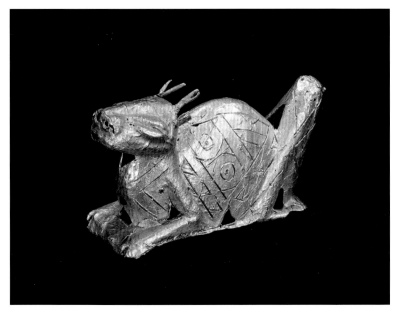

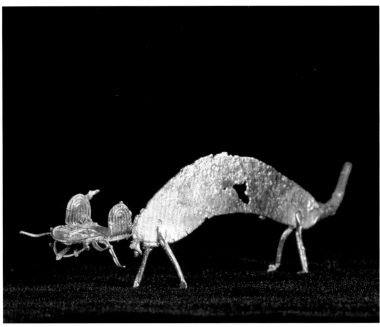

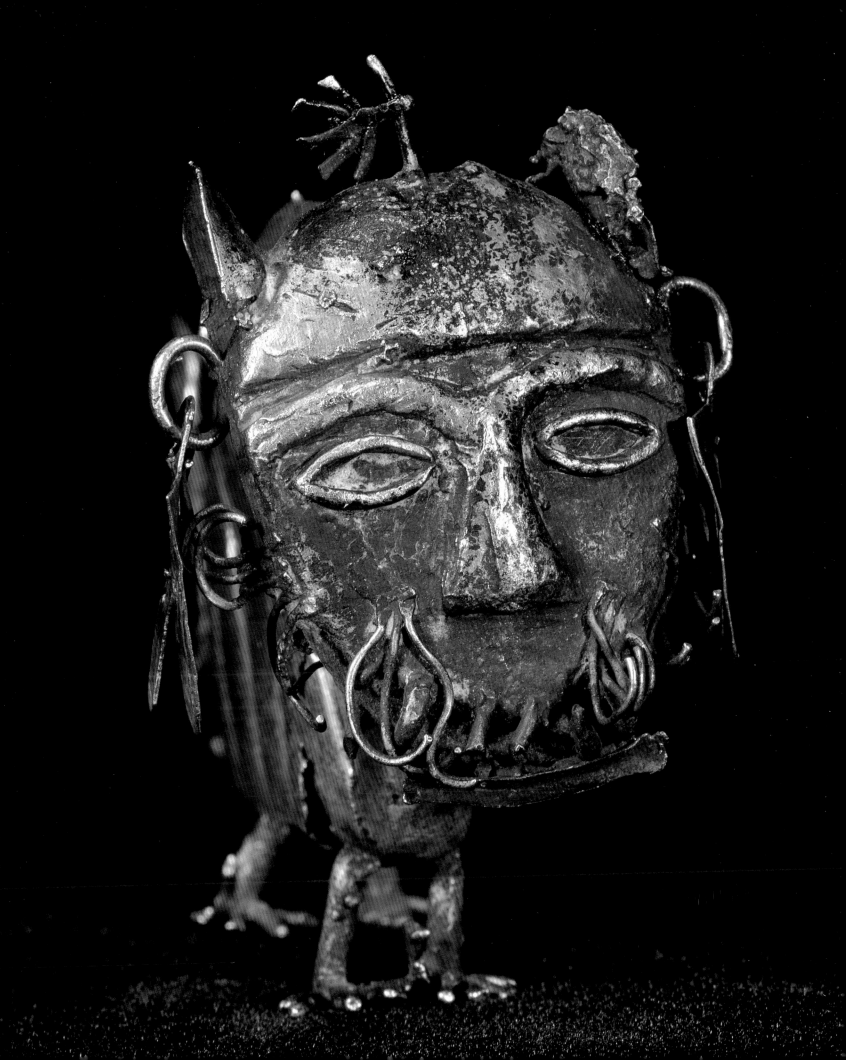

Breastplate
15.4 x 11.9 cm
Boyacá
600 AD–1600 AD
Reg. O08512
Gold breastplate with the schematisation
of a winged man with head ornament
simulating the rays of the sun and
multiple plates that glint in the light.
Muisca goldsmiths were experts in the
art of lost-wax casting.

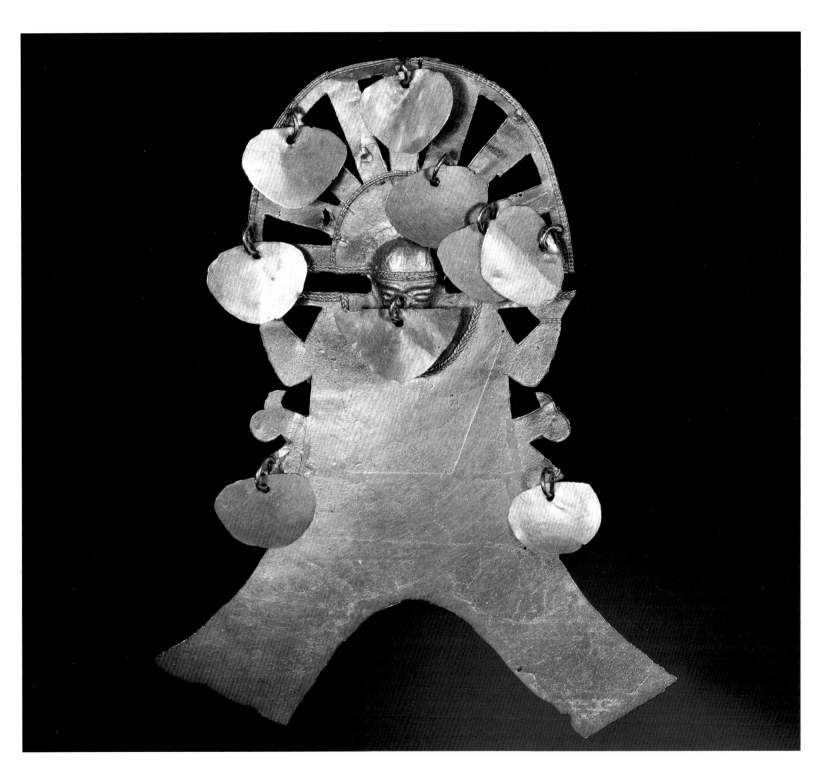

Votive figures
Top to bottom and left to right
10.6 x 7 cm / 8 x 6 cm / 7.5 x 6 cm /
6.7 x 56 cm / 4.7 x 6 cm / 6.5 x 4.5 cm
unknown / unknown / Muzo, Boyacá /
Arcabuco, Boyacá / unknown / unknown
600 AD–1600 AD
Reg. O00086 / Reg. O03044 /
Reg. O01248 / Reg. O00154 /
Reg. O05295 / Reg. O01864

To meditate, Muisca chieftains or
shamans adopted a receptive position
that the current indigenous groups liken
to a basket in which the Universe
is contained.

Pages 226–227
Votive group
Top to bottom and left to right
17.8 x 4.7 x 1 cm / 13 x 4.6 cm /
15.3 x 4.8 x 0.7 cm / 4.5 x 5.9 x 1 cm /
3 x 4.3 x 10.5 cm / 8.4 x 4 cm
Gutiérrez, Cundinamarca
1320 AD–1400 AD
Reg. O33904 / Reg. O33905 /
Reg. O33903 / Reg. O33902 /
Reg. O33900 / Reg. O33901
Gutiérrez Group
The lack of gold deposits in the Altiplano
forced Muisca goldsmiths to obtain it by
trade with their neighbours the Panche
and the Muzo. This group of objects,
made by casting high purity gold, was
found in the same tomb as part of the
offering of an important individual.

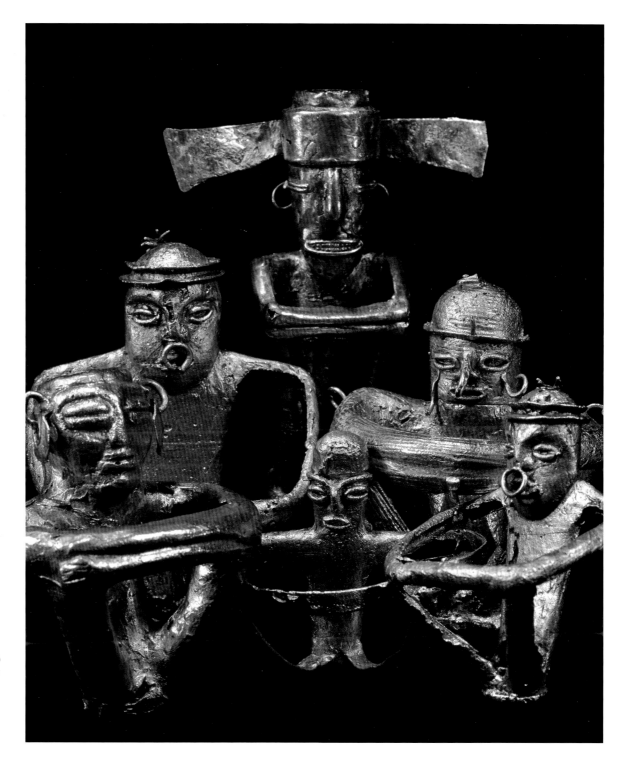

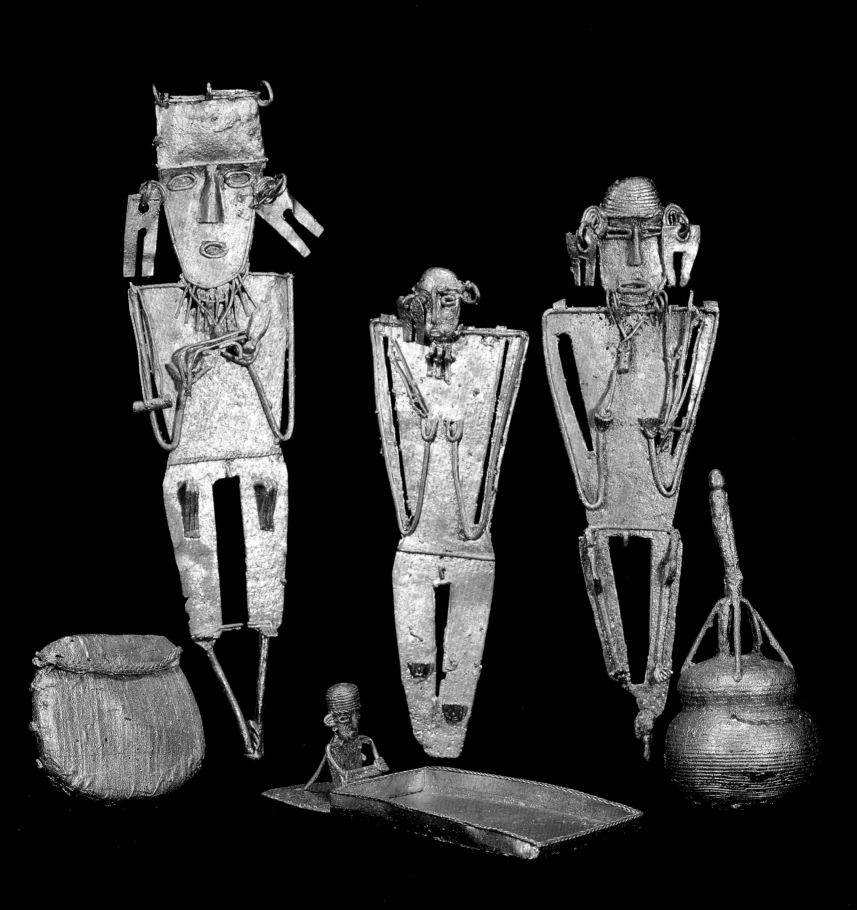

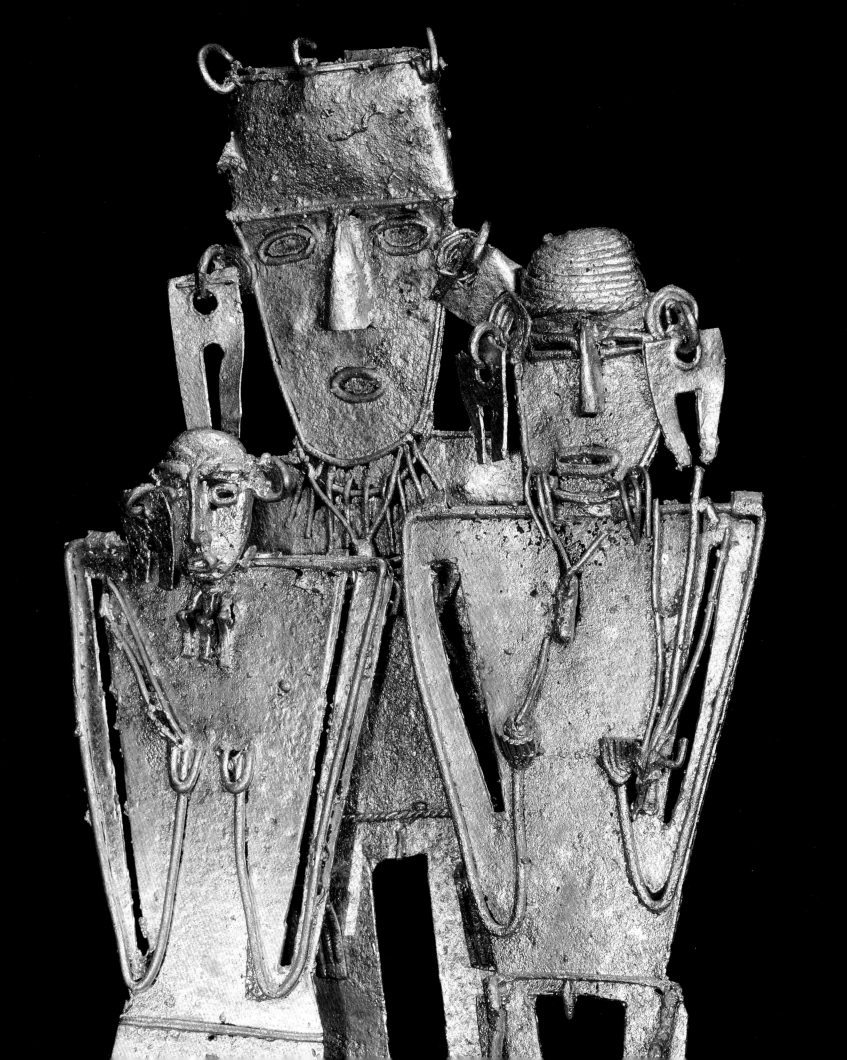

Nose ornament
14.6 x 18.9 cm
Boyacá
600 AD–1600 AD
Reg. O33882
This nose ornament with fretwork
decoration and design of birds
with facing beaks transformed the face
of an important figure. Cast in *tumbaga*
using the lost-wax method.

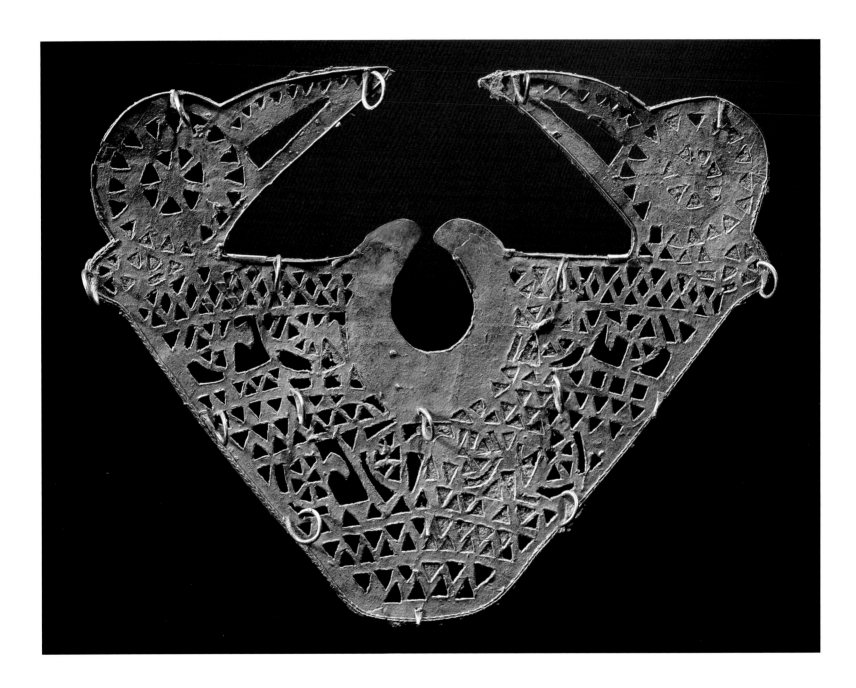

Ear ornaments
9.2 cm
9 cm
Chiquinquirá, Boyacá
1040 AD–1120 AD
Reg. O33767
Reg. O33768
The skill of Muisca goldsmiths is captured in this pair of pendant ear ornaments that personify the rays of the sun. Gold cast with the filigree technique.

Votive figure
7.9 x 2.9 cm
Pisba, Boyacá
1420 AD–1620 AD
Reg. O25663
Fine threads of cast gold simulate the cloth with which a personality was covered at the moment of his mummification. This votive object was part of the burial regalia of a Muisca priest mummified in the eighteenth century.

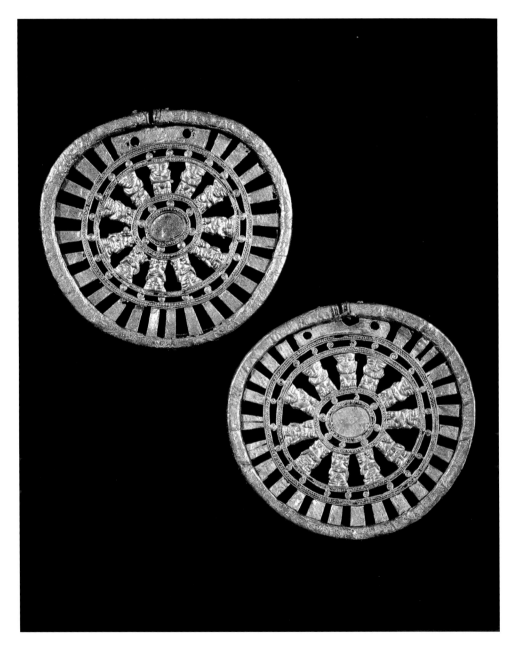

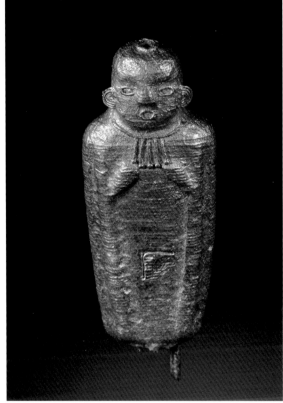

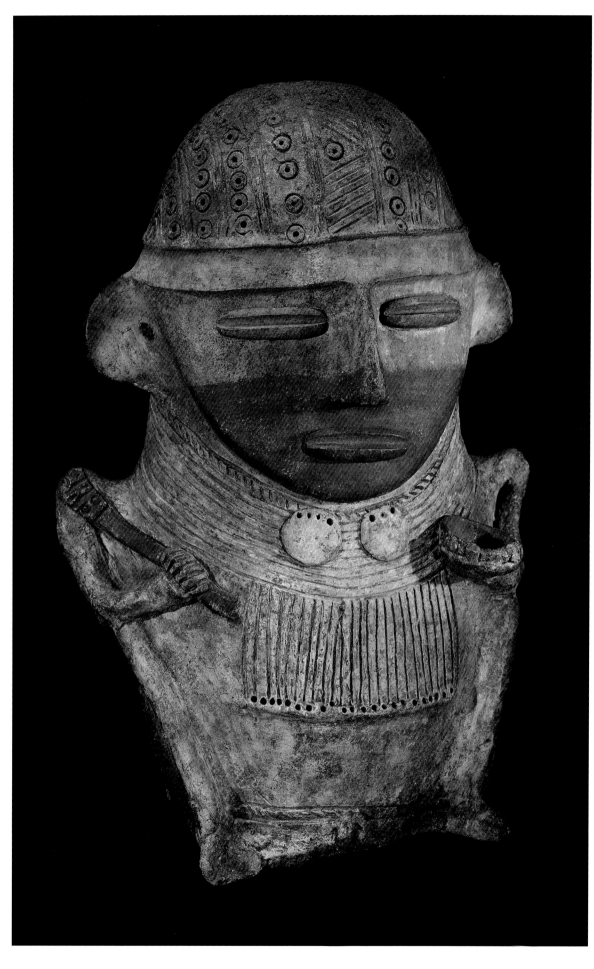

Offering holder
37.5 x 26.5 cm
unknown
600 AD–1600 AD
Reg. C12799
Objects like this were deposited by the priests in sacred places such as caves and lagoons. The offerings deposited there consisted of a group of objects, not all made of metal, in which a basic idea associated with a specific rogation was repeated. Ceramic offering holder.

Mummy
75 x 65 cm
Pisba, Boyacá
1520 AD
Reg. D00009
Mummification was a form of burial characteristic of Muisca leaders and priests. This mummy was found in a cave in the high moor of Pisba, Boyacá, along with gold, ceramic and textile offerings.

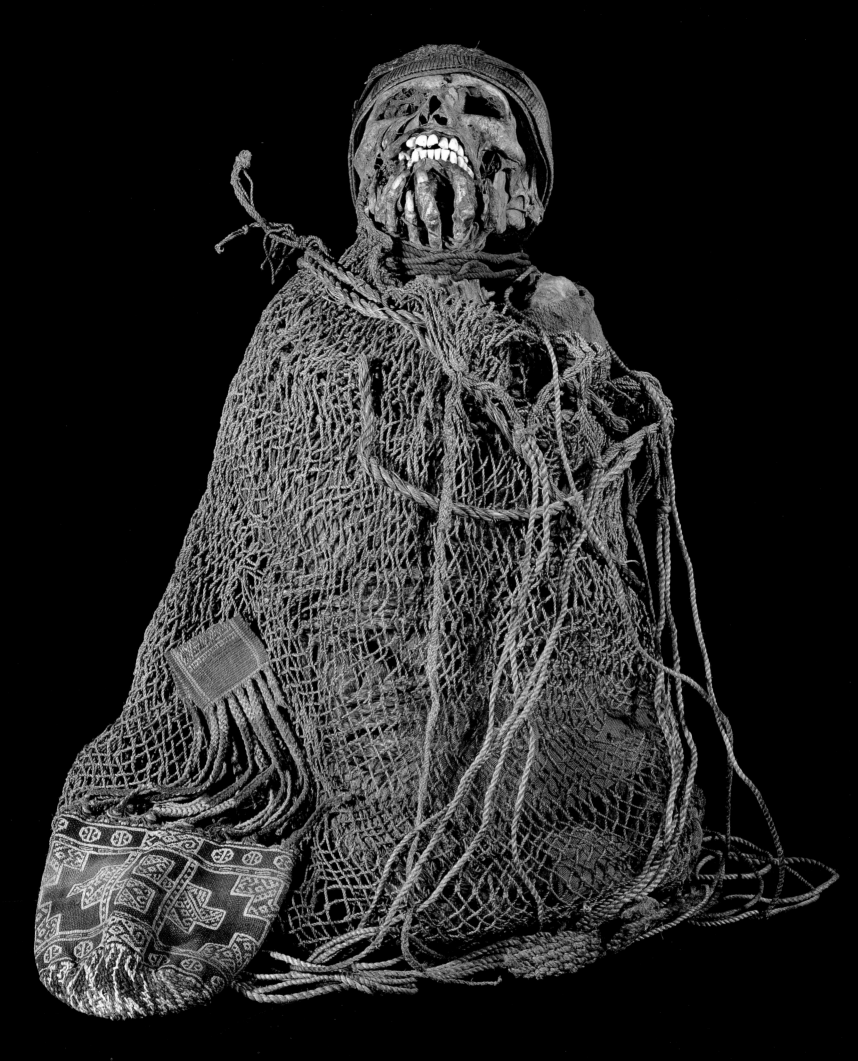

Fragment of blanket
35 x 59.5 cm
Santander
unknown
Reg. T00054
More than gold, the tributes most
appreciated by the Muisca chieftains
were woven cotton blankets. Coloured
with fine plant dyes, the few textiles
that are still conserved are astonishing
for the beauty of their designs and the
techniques used in their manufacture.

Inlet to the north of Titumate, in the
Chocó Department. Photo: Rudolf.

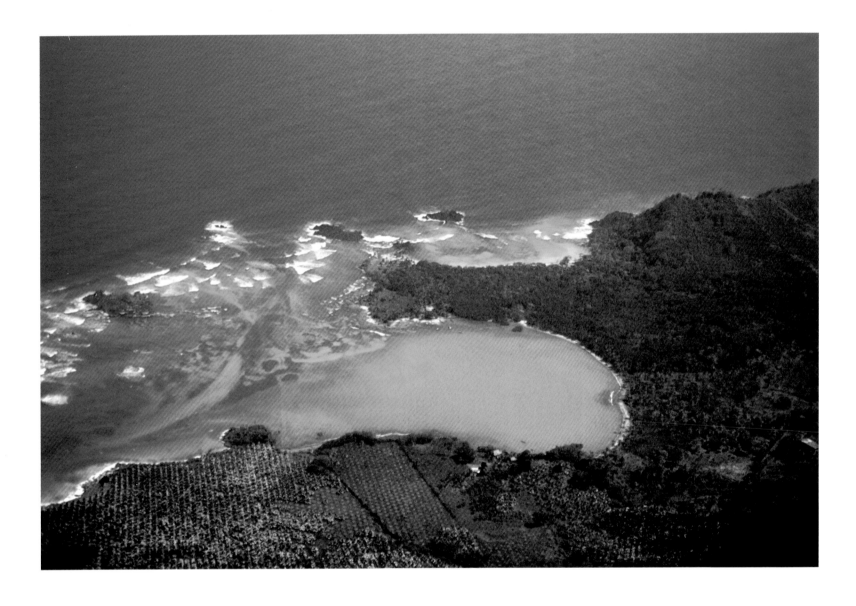

Urabá and Chocó

The communities that settled in the Gulf of Urabá and in the north of the Colombian Pacific Coast—which have been very little studied to date—occupied territories that, thanks to their geographical location and proximity to sea and river routes, enabled them to increase their sources of subsistence, exploit rich gold deposits and maintain active commercial relations and cultural exchanges with groups from the interior of the country and Central America.

These influences are manifested in various visual elements and in the adoption of goldwork and pottery techniques. In the case of Urabá, various iconographic motifs with influences from the archaeological areas of Zenú, Tairona and Quimbaya appear. These same influences can be identified in the case of Chocó, together with those from Central American societies. The presence of Chocó objects in the plains of the Caribbean was probably the result of economic and cultural exchange activities.

The two areas had in common the use of the spiral as a symbol, either as a single motif or as a complementary element in decorating metal objects; they also shared the creation of various combinations of anthropomorphic and zoomorphic figures. Despite these common aspects, characteristics exist that make it possible to speak of individual styles. This is the case of the female representations in the imagery of Urabá, which, with their typical broad shoulders and swollen extremities, were perhaps icons of fertility. The zoomorphic pendants, on the other hand, express a peculiar mythical fauna. In Chocó distinctive elements are the anthropomorphic motifs that refer to transformation into birds, and the symbolic breastplates with figures of birds with several heads.

Iconography of spirals in the goldwork of Urabá.

Map of the Urabá–Chochó archaeological region.

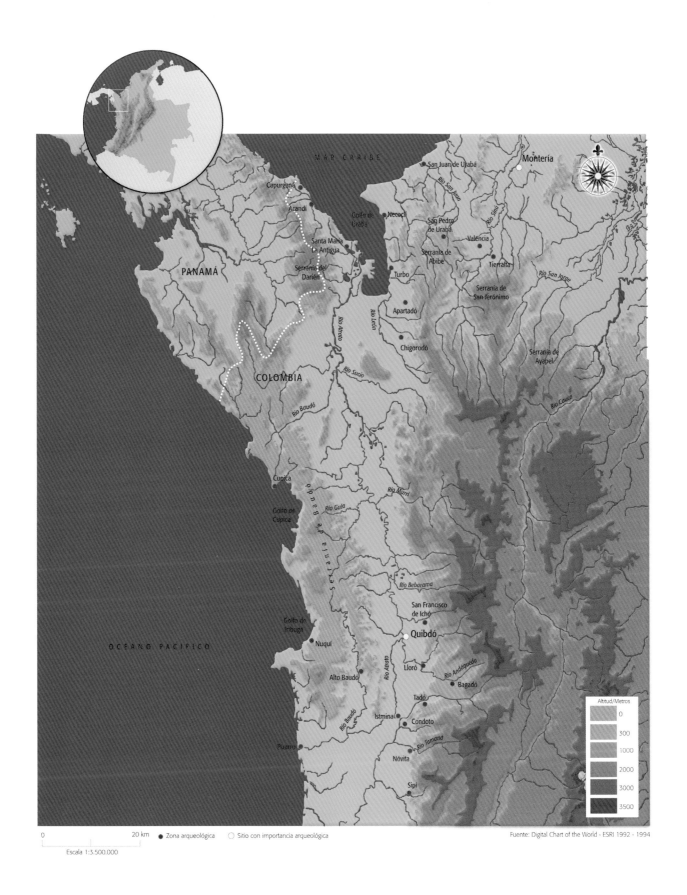

MAR CARIBE

San Juan de Urabá

Montería

Capurganá

Acandí

Golfo de Urabá

Necoclí

San Pedro de Urabá

Valencia

Santa María La Antigua

Serranía de Abibe

Río Sinú

Río San Juan

PANAMÁ

Serranía del Darién

Turbo

Tierralta

Río San Jorge

Serranía de San Jerónimo

Río León

Apartadó

Río Atrato

Serranía de Ayapel

COLOMBIA

Chigorodó

Río Sucio

Río Cauca

Río Baudó

Cupica

Serranía de Baudó

Golfo de Cupica

Río Guía

Río Murri

Río Bebarama

San Francisco de Ichó

Golfo de Tribugá

Quibdó

OCÉANO PACÍFICO

Nuquí

Lloró

Río Andágueda

Alto Baudó

Bagadó

Tadó

Río Atrato

Istmina

Condoto

Río Baudó

Pizarro

Río Tamaná

Nóvita

Sipí

Altitud/Metros

0
300
1000
2000
3000
3500

0 20 km ● Zona arqueológica ○ Sitio con importancia arqueológica

Escala 1:3.500.000

Fuente: Digital Chart of the World - ESRI 1992 - 1994

237

Breastplate
6.3 x 10.8 cm
San Pedro de Urabá, Antioquia
ca. 500 AD
Reg. O32303
Breastplates with divergent spirals were
common in the archaeological regions
of Zenú, Tairona, Urabá and Lower
Central America. The spiral is frequently
related symbolically with the
development of time.

Pendant
4.7 x 3.9 cm
San Pedro de Urabá, Antioquia
ca. 500 AD
Reg. O32333
A pendant in the form of a man-bird.
The similarity between this face
and those of Early Quimbaya suggests
relations between these societies.

Breastplate
11.9 x 9 cm
San Pedro de Urabá, Antioquia
ca. 500 AD
Reg. O32654
A beautiful bird with spread wings and
tail, with a head ornament of spirals,
is concealed behind a set of metal plates
that produced shine and movement.
Gold cast using the lost-wax technique
and hammered.

Lime container
14.3 x 6 cm
San Pedro de Urabá, Antioquia
ca. 500 AD
Reg. O33041
Used to contain the lime extracted from
burnt and crushed shells that was mixed
with coca leaves, this *poporo* is shaped
like a calabash. The reddish tone of its
surface shows the high copper content
used in the alloy and is associated
symbolically with the female and fertility.

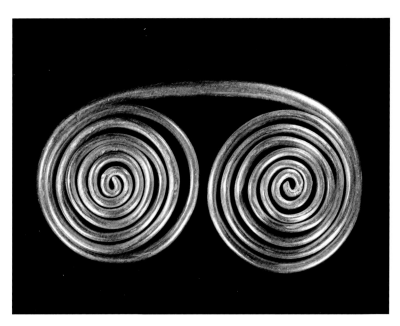

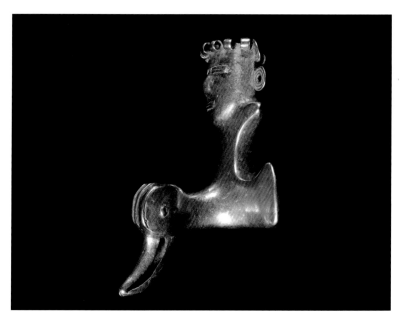

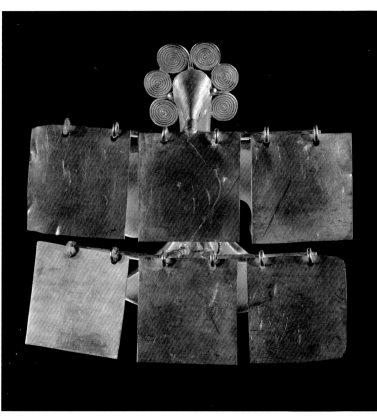

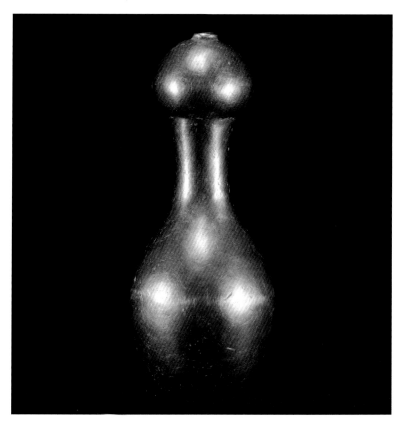

Pendant
11.4 x 3.4 cm
San Pedro de Urabá, Antioquia
200 AD
Reg. O33264
In this pendant in the form of a
spoonbill, cast in gold by the lost-wax
method, the degree of schematisation
achieved by the artist when shaping the
body of the bird is astonishing.

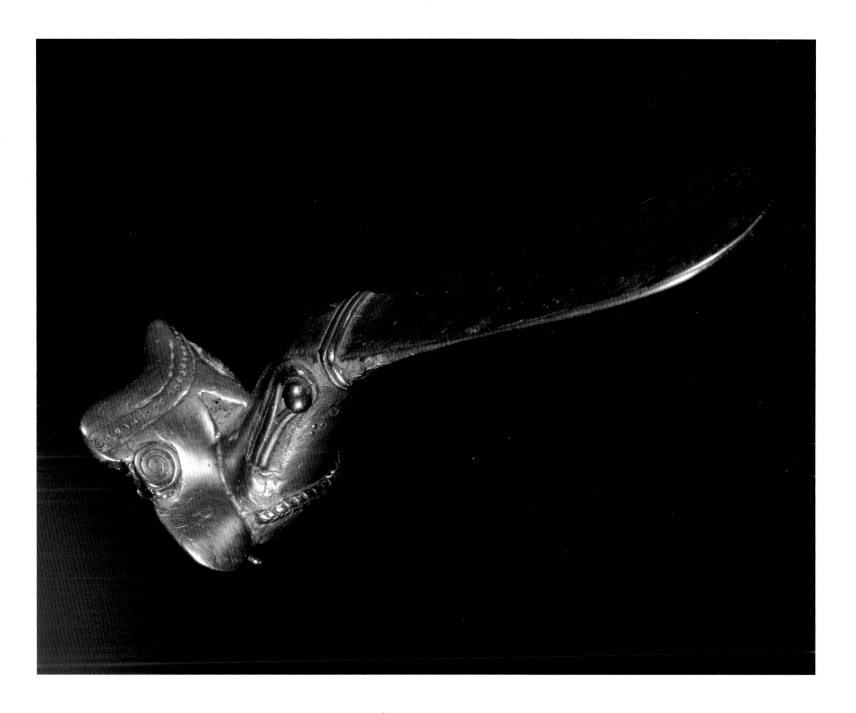

Pendant
8.5 x 4.3 cm
ca. 500 AD
La Playa, Acandí, Chocó
Reg. O33381
Pendant in the form of a man with
fish fins and tail cast in *tumbaga*
with a high copper content.

Pendant
5.8 x 2.7 x 1.2 cm
Turbo, Antioquia
ca. 500 AD
Reg. O33823
In Urabá female figures of remarkable
realism were common, with wide
shoulders and wide hips to allude to
fertility. This gilded *tumbaga* pendant
was cast using the lost-wax method
with core.

Figure
29 x 17.5 cm
Córdoba
ca. 500 AD
Reg. C13238
Female figure adorned with spool-
shaped ear ornaments. The design of
her face and body painting must have
had a significance that is unknown to us.

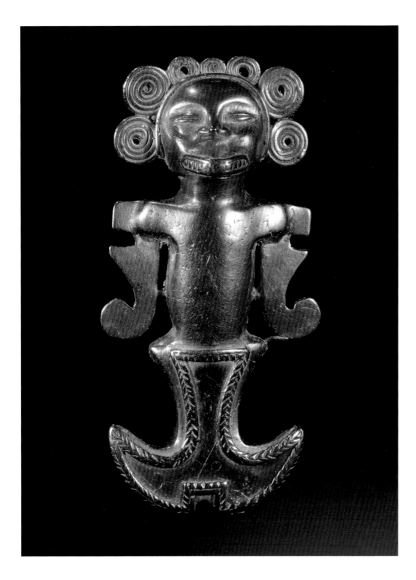

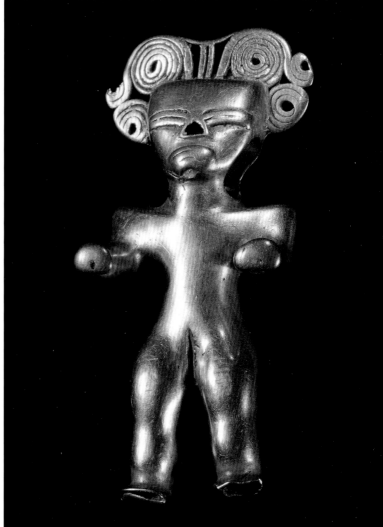

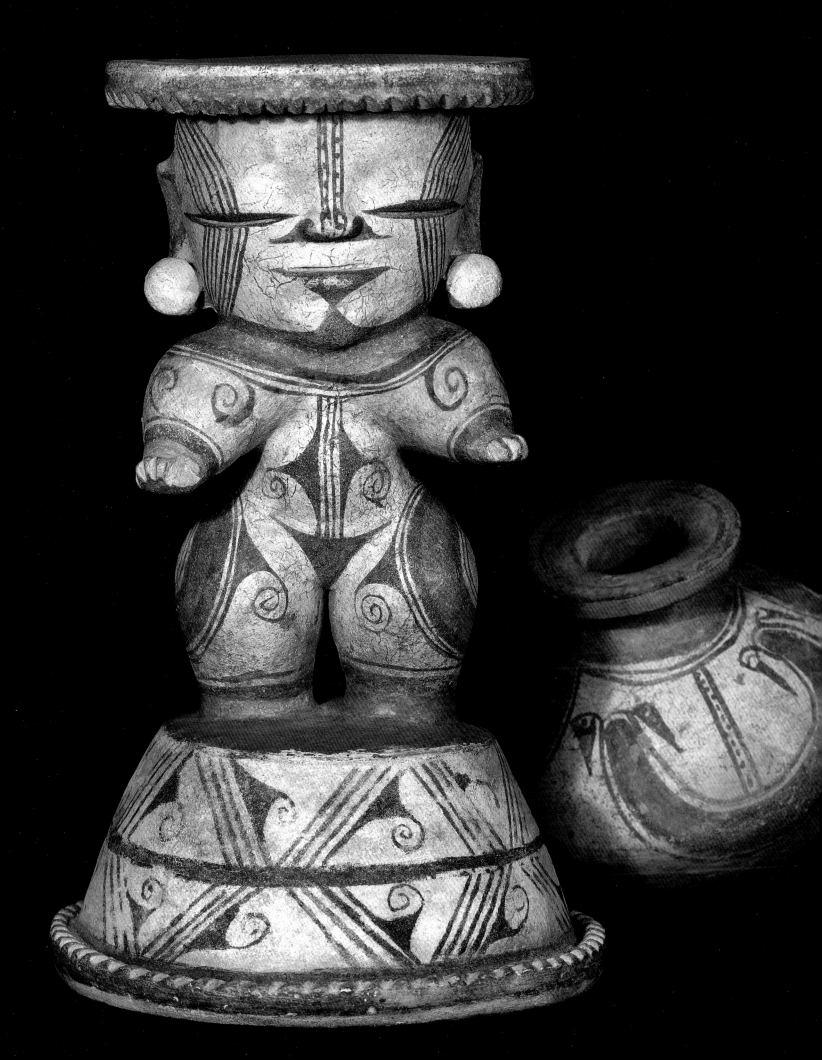

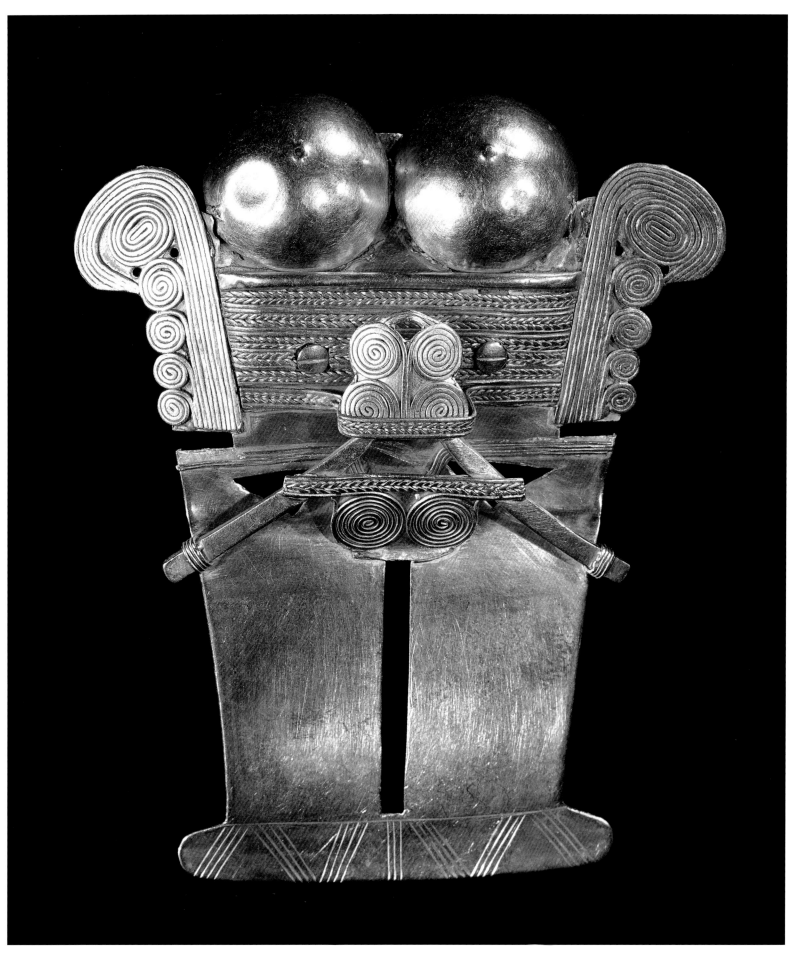

Pendant
17 x 14.2 cm
unknown
unknown
Reg. O06030
Breastplate with the figure of
a schematised man with staffs and
spiral ornaments. Cast in gold using
the lost-wax technique. The eyes
and staffs, made separately, were joined
to the figure using the welding
technique.

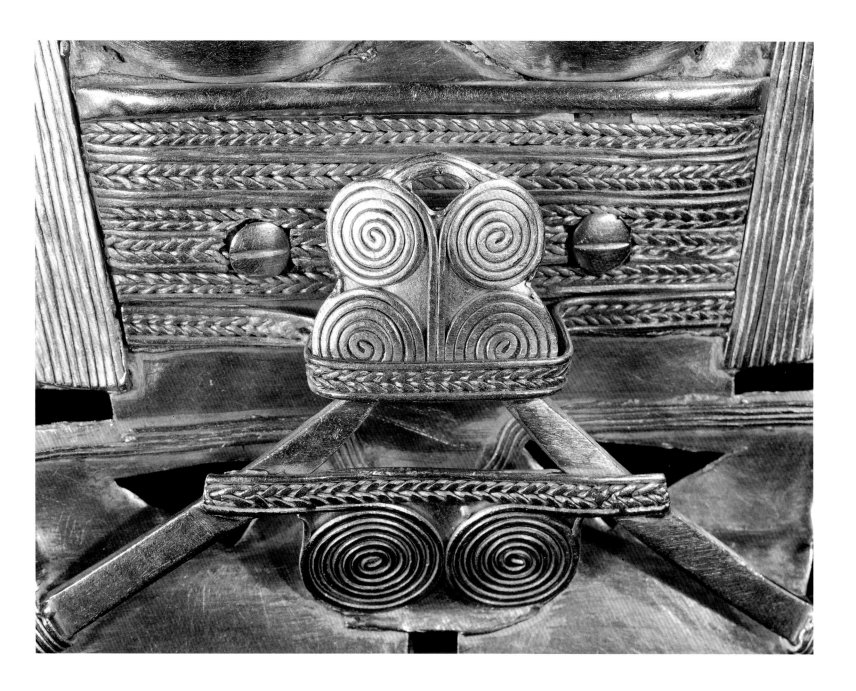

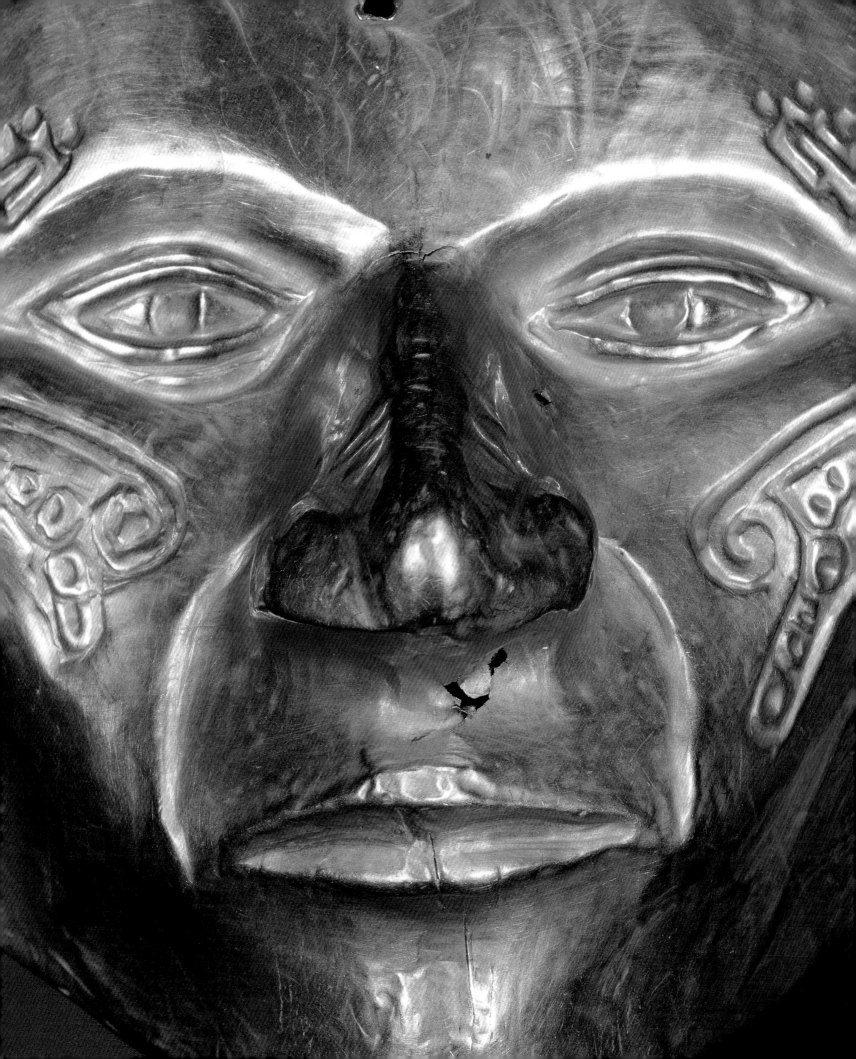

Pre-Hispanic Metalworking and Goldwork Techniques

Prehispanic metalworking and goldwork techniques

Metalworking technology

The technology associated with the working of metals is a body of knowledge, skills, tools and working forms employed by a society to produce useful objects, starting with the materials offered by nature. This technology gradually developed in prehispanic Colombia starting from the tradition that spread from the Central Andes of South America, and from the inventions and innovations that each local community gradually incorporated.

For this reason, we think that the prehispanic metalworking technology of Colombia is composed of two sets of aspects: one that is common and general for the whole territory, and another that is particular and specific for each geographical area. The common aspects include forms of mining, metal alloys and manufacturing and finishing techniques that were known by all the communities of goldsmiths in all periods. The particular and specific aspects appear as developments and refinements and are isolated phenomena characteristic of given times or areas.

The first stage of any metalworking process is, of course, obtaining the raw materials by mining. Most of the gold that was used in the prehispanic time was obtained in alluvial deposits, that is to say, in riverbeds and gorges that intersect gold-bearing veins. The basic technique consist-

ed in the manual washing of the sands using wooden washing pans to separate the gold particles, as is still done today in many regions. Certain improvements were made to this basic technique, such as digging channels to deviate the currents, and building dikes and pools for washing sands. Evidence of works of this type has been found in the Buriticá site, in the department of Antioquia.

The mining of gold in vein deposits was less frequent and seems to have occurred almost exclusively in those areas where there were no alluvial deposits or when veins relatively close to the surface were found. In these cases it was necessary to excavate galleries and tunnels; according to the information that was gathered at the time of the Conquest, these galleries and tunnels were often narrow and vertical, so that their exploitation required great physical effort. Copper always had to be obtained from deposits that contained it in variable quantities; the process included the grinding of minerals, mixing with reducing and founding agents, and at least two stages of founding that enabled metallic copper, purified or alloyed with gold, to be obtained.

Most of the metal objects from that era were made of gold and copper alloy, known as *tumbaga* or *guanín* (the quantities of the two metals

Lost-wax casting:

1. The goldsmith carves the design of the bead or pendant into a mould of clay and ground charcoal.

2. On top he places a thin sheet of beeswax, which he cuts with the shape of the piece; he carves and applies the external details.

3. Then he adds a wax funnel, through which the metal is to be poured.
He covers the whole object with a layer or mould of clay.

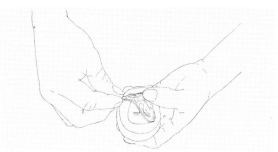
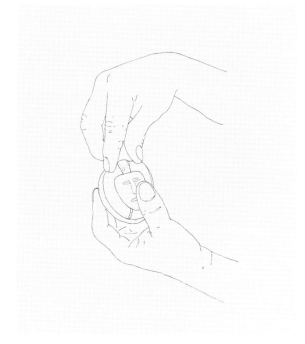

4. He cuts the funnel and polishes the surface with fine sand or other materials.

5. Once the mould is dry, it is heated to extract the wax from inside it.

6. The goldsmith melts the metal in a ceramic or coal refractory recipient, placed among the embers in a ceramic oven, stoking the fire.

7. He pours the liquid metal into the hot mould.

8. He cools the mould with water and when it breaks, due to the abrupt temperature change, the piece is extracted.

9. He cuts the funnel and polishes the surface with fine sand or other materials.

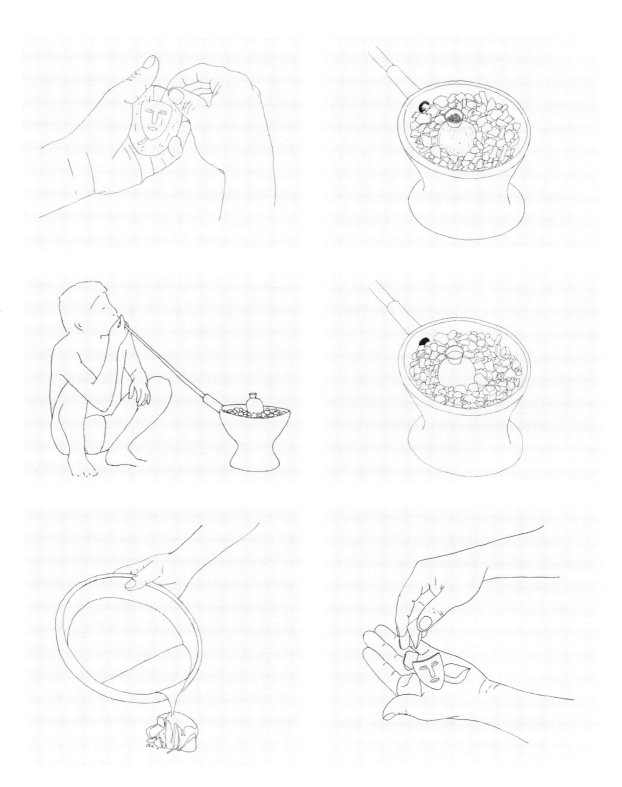

1. To manufacture hammered objects, the goldsmith takes a gold ingot, places it on a stone anvil and hits it with a hammer till he obtains a sheet.

2. With hammering, the metal becomes hard and brittle; to recover its malleability, the goldsmith performs the "annealing" or heating of the sheet till it becomes red hot at the point where he stokes the fire.

3. He immerses the sheet in water to cool it and hammers it again.

4. Once he obtains the desired size of the sheet, he cuts it with a hammer and chisel.

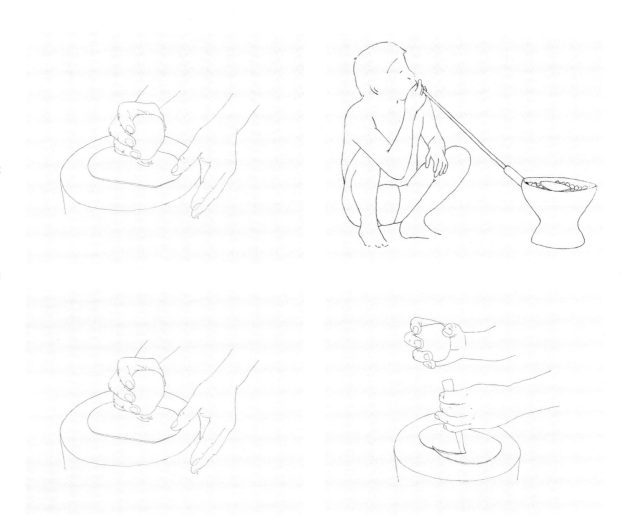

were variable), together with small quantities of silver, which appears naturally associated with alluvial gold. Another significant amount of metal objects were made starting from alluvial gold, without the addition of copper, so, apart from the gold, they only contain small quantities of silver or platinum.

The exceptions are the use of pure or almost pure copper, a practice that occurred in the Altiplano de Nariño, in the middle valley of the Cauca, in the plains of the Atlantic coast and in the Eastern Andes; the use of platinum by means of the process known as sintering, on the Pacific Coast; stanniferous and arsenic bronze and silver, pure or almost pure, specifically in the Altiplano de Nariño.

The basic options of production are casting and hammering. The former involved the smelting of metals or alloys in ceramic ovens, and the latter the thinning of ingots until sheets were obtained by means of hammering on stone anvils. One technique or the other predominated in each geographical area, without this meaning that these emphases determined the configuration of styles. It seems likely that, rather than being at-

tached to one option or another, the goldsmiths selected the technique or combination of techniques in which they were most skilful from all the areas and periods, and which best suited their purposes.

On this common base of manufacturing techniques, the following local developments occurred: the lost wax technique of casting, which used a core and supports to produce hollow pieces, one of the outstanding features of Early Quimbaya metallurgy; the use of stone moulds to make identical wax moulds and cast a series of identical motifs using the lost wax technique, as occurred among the Muiscas of the Eastern Cordillera; and the use of complex assemblies to produce three-dimensional pieces from sheets and cast parts, which was practised in the middle Cauca valley and in the Sierra Nevada de Santa Marta.

A large proportion of the pieces made of *tumbaga* received a surface treatment known as depletion gilding. The first step in this process consists in heating up the piece in an oxidising atmosphere, causing the oxidation of the copper present in the alloy; the following step consists in

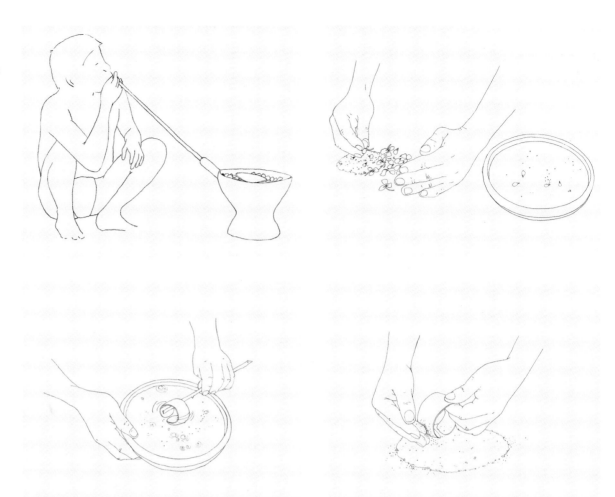

washing the piece in an acid bath to remove the oxides. The gold, being more resistant to corrosion, remains unaffected. By repeating the process several times, the alloy on the surface is enriched in gold and the colour changes considerably.

A significant development of this basic procedure, known as *raspado zonificado* (zoned scraping), took place in the Altiplano de Nariño. This refinement involved the selective scraping of areas of the surface after the oxidation of the copper to obtain designs in two different colours, with polishing and attacking with acids to produce rough textures. In the same region the goldsmiths gilded the pieces by founding a thin layer of gold onto a *tumbaga* or copper surface. In other areas, pieces of copper were lined with thin gold sheets and stuck together with resins.

The most distinctive of the various ornamental techniques is embossing, which was achieved by pressing and hitting on both sides of the metal sheet with chisels and punches. A local technique, known as granulation, characteristic of the Pacific Coast and in the Cauca Valley, involved welding small gold spheres to form decorations in relief. Weldings other than granulation

were very scarce; there are a few welded pieces in the Altiplano de Nariño, the Pacific Coast and the Sierra Nevada de Santa Marta.

Even though it is not possible to speak of a major technological development nor of a widespread diffusion of local innovations, it is possible to state that the prehispanic goldsmiths achieved a high degree of mastery of relatively simple techniques. Thanks to this master craftsmanship they produced admirable pieces, the replication of which is still a challenge today even for jewellers using the most modern metalworking techniques.

Chronology

Roberto Lleras Pérez

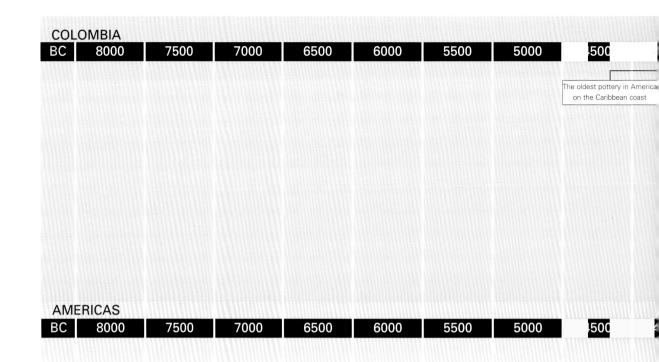

COLOMBIA

BC	8000	7500	7000	6500	6000	5500	5000	4500

The oldest pottery in America
on the Caribbean coast

AMERICAS

BC	8000	7500	7000	6500	6000	5500	5000	4500

OLD WORLD

BC	8000	7500	7000	6500	6000	5500	5000	4500	4

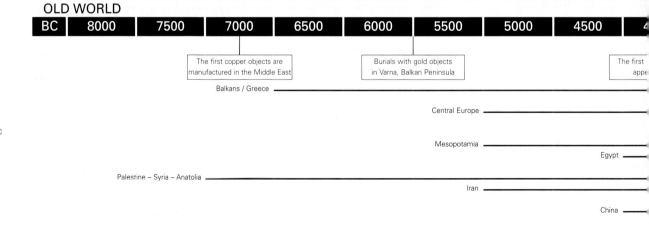

The first copper objects are
manufactured in the Middle East

Burials with gold objects
in Varna, Balkan Peninsula

The first
appe

Balkans / Greece ⎯⎯⎯⎯⎯⎯⎯

Central Europe ⎯⎯⎯⎯⎯⎯⎯

Mesopotamia ⎯⎯⎯⎯⎯⎯⎯

Egypt ⎯⎯

Palestine – Syria – Anatolia ⎯⎯⎯⎯⎯⎯⎯

Iran ⎯⎯⎯⎯⎯⎯⎯

China ⎯⎯

Note: In the Old World, when large regions are considered and not specific cultures, we find a continuity between archaeological traditions and historical ones; for this reason, dates of conclusion are not indicated. In these large areas the metalworking tradition continues to the present day.

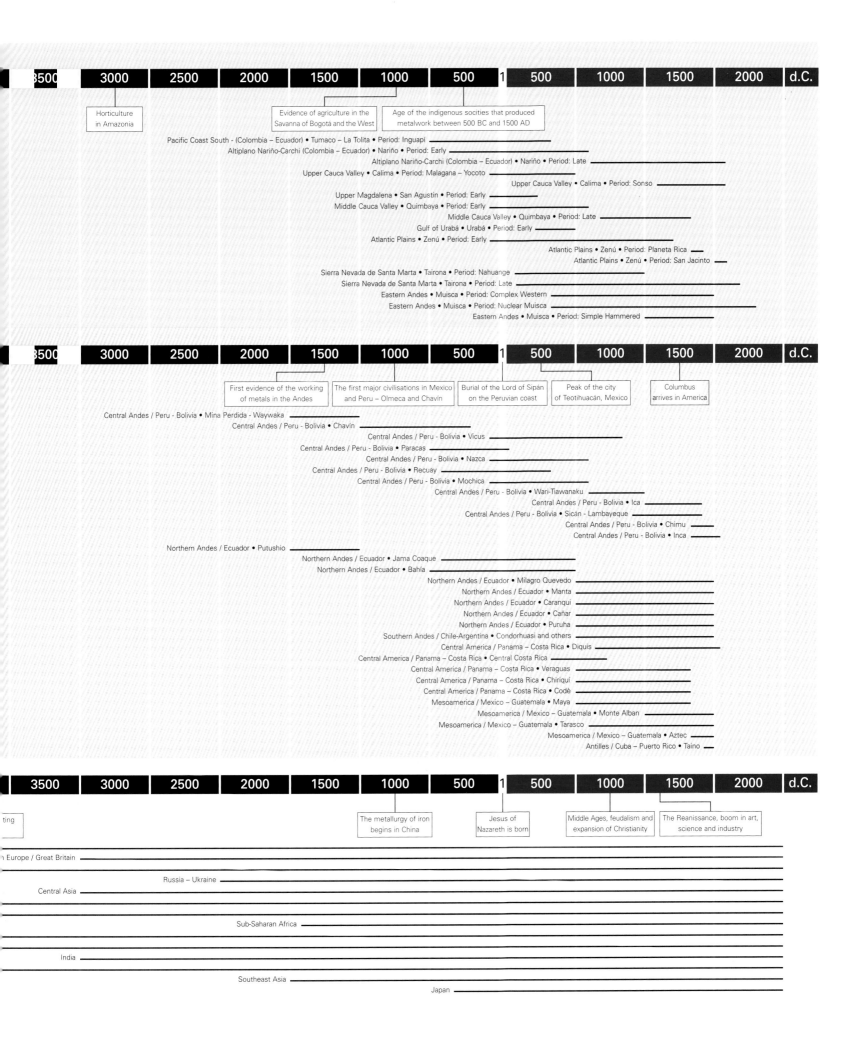

Timeline 1

3500 | 3000 | 2500 | 2000 | 1500 | 1000 | 500 | 1 | 500 | 1000 | 1500 | 2000 | d.C.

Horticulture in Amazonia

Evidence of agriculture in the Savanna of Bogotá and the West

Age of the indigenous socities that produced metalwork between 500 BC and 1500 AD

- Pacific Coast South - (Colombia – Ecuador) • Tumaco – La Tolita • Period: Inguapí
- Altiplano Nariño-Carchi (Colombia – Ecuador) • Nariño • Period: Early
- Altiplano Nariño-Carchi (Colombia – Ecuador) • Nariño • Period: Late
- Upper Cauca Valley • Calima • Period: Malagana – Yocoto
- Upper Cauca Valley • Calima • Period: Sonso
- Upper Magdalena • San Agustín • Period: Early
- Middle Cauca Valley • Quimbaya • Period: Early
- Middle Cauca Valley • Quimbaya • Period: Late
- Gulf of Urabá • Urabá • Period: Early
- Atlantic Plains • Zenú • Period: Early
- Atlantic Plains • Zenú • Period: Planeta Rica
- Atlantic Plains • Zenú • Period: San Jacinto
- Sierra Nevada de Santa Marta • Tairona • Period: Nahuange
- Sierra Nevada de Santa Marta • Tairona • Period: Late
- Eastern Andes • Muisca • Period: Complex Western
- Eastern Andes • Muisca • Period: Nuclear Muisca
- Eastern Andes • Muisca • Period: Simple Hammered

Timeline 2

3500 | 3000 | 2500 | 2000 | 1500 | 1000 | 500 | 1 | 500 | 1000 | 1500 | 2000 | d.C.

First evidence of the working of metals in the Andes

The first major civilisations in Mexico and Peru – Olmeca and Chavín

Burial of the Lord of Sipán on the Peruvian coast

Peak of the city of Teotihuacán, Mexico

Columbus arrives in America

- Central Andes / Peru - Bolivia • Mina Perdida - Waywaka
- Central Andes / Peru - Bolivia • Chavín
- Central Andes / Peru - Bolivia • Vicus
- Central Andes / Peru - Bolivia • Paracas
- Central Andes / Peru - Bolivia • Nazca
- Central Andes / Peru - Bolivia • Recuay
- Central Andes / Peru - Bolivia • Mochica
- Central Andes / Peru - Bolivia • Wari-Tiawanaku
- Central Andes / Peru - Bolivia • Ica
- Central Andes / Peru - Bolivia • Sicán - Lambayeque
- Central Andes / Peru - Bolivia • Chimu
- Central Andes / Peru - Bolivia • Inca
- Northern Andes / Ecuador • Putushio
- Northern Andes / Ecuador • Jama Coaque
- Northern Andes / Ecuador • Bahía
- Northern Andes / Ecuador • Milagro Quevedo
- Northern Andes / Ecuador • Manta
- Northern Andes / Ecuador • Caranqui
- Northern Andes / Ecuador • Cañar
- Northern Andes / Ecuador • Puruha
- Southern Andes / Chile-Argentina • Condorhuasi and others
- Central America / Panama – Costa Rica • Diquis
- Central America / Panama – Costa Rica • Central Costa Rica
- Central America / Panama – Costa Rica • Veraguas
- Central America / Panama – Costa Rica • Chiriquí
- Central America / Panama – Costa Rica • Codè
- Mesoamerica / Mexico – Guatemala • Maya
- Mesoamerica / Mexico – Guatemala • Monte Alban
- Mesoamerica / Mexico – Guatemala • Tarasco
- Mesoamerica / Mexico – Guatemala • Aztec
- Antilles / Cuba – Puerto Rico • Taino

Timeline 3

3500 | 3000 | 2500 | 2000 | 1500 | 1000 | 500 | 1 | 500 | 1000 | 1500 | 2000 | d.C.

The metallurgy of iron begins in China

Jesus of Nazareth is born

Middle Ages, feudalism and expansion of Christianity

The Reanissance, boom in art, science and industry

- ...ting
- ...n Europe / Great Britain
- Russia – Ukraine
- Central Asia
- Sub-Saharan Africa
- India
- Southeast Asia
- Japan

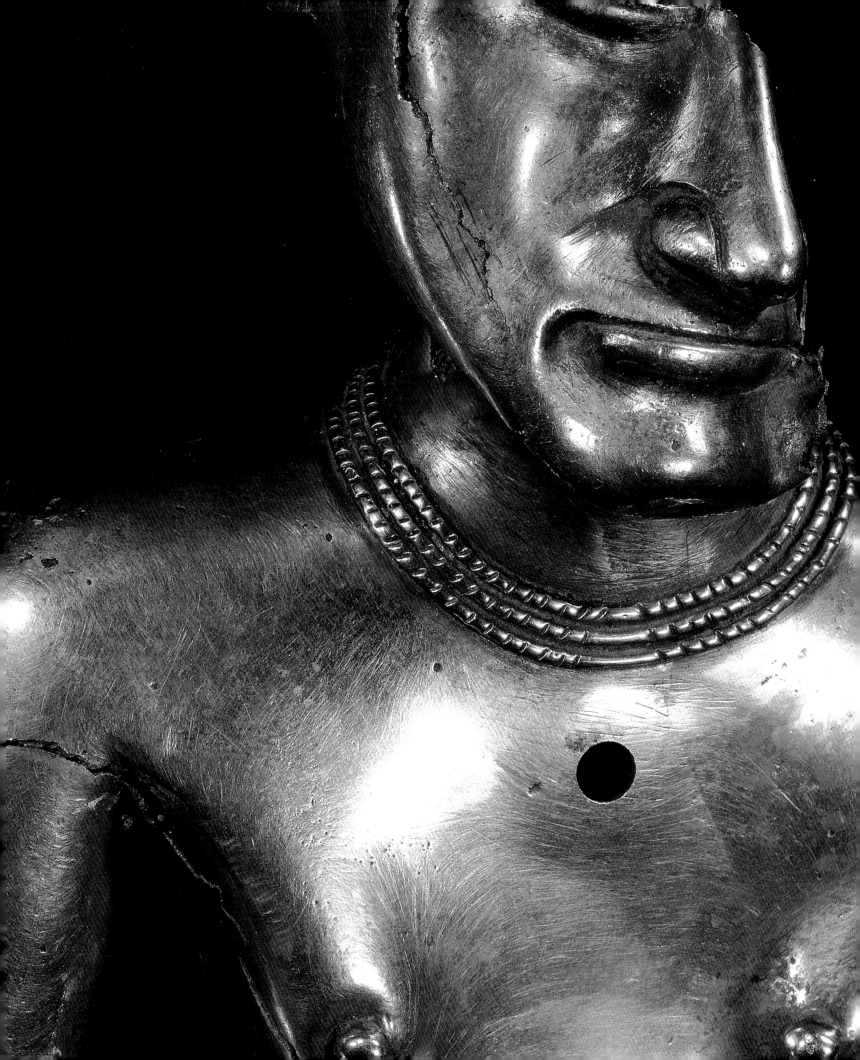

Colombian Indigenous Peoples Today

Colombian indigenous peoples today

The indigenous population of Colombia numbers some 700,000 people and currently represents around 1.5% of the country's total population. Located in relatively isolated areas, they comprise around eighty groupings that speak sixty-four aboriginal languages and some three hundred dialect forms.

The largest community is that of Los Paeces in the department of Cauca, followed in demographic importance by the Wayúu, who inhabit La Guajira. Other groups are the Cunas and the Emberas, located in the rainforests of the west, the peoples of Nariño, to the south, the various ethnicities of Amazonia, the Wiwas, Kogis and Arhuacos of the Sierra Nevada de Santa Marta, the Cunas on the frontier with Panama and the Baríes, who live on the frontier with Venezuela.

Their ways of life are based on a profound knowledge of and respect for the environment. This knowledge and their means of subsistence are based to a large extent on the traditions of their ancestors. The cultivation of yucca, maize and beans, hunting and fishing, are legacies that are in conflict with modifications due to the introduction of "Western" forms of production and labour.

The symbolic and religious practices of today, which are either in the process of transformation or, in many cases, in danger of extinction, have prolonged the age-old customs over time. The shaman—which can be either a man or a woman—maintains the ability to come into contact with the supernatural world by means such as fasting, meditation, or the consumption of substances obtained from sacred plants, such as tobacco, coca, yage and yopo. They retain the use of masks, batons, rattles and other ritual instruments.

Body and face painting, the use of necklaces, earrings and nose ornaments, the art of *plumarios* (feather adornments) and initiation rites remain as millennial practices involving transformation and communication with other worlds. Music is present in community ceremonies and festivals. The cult of the dead and, in particular, secondary burials propitiate the entry of the deceased into the world of the ancestors, from where they fulfil functions as protectors of their communities.

At the present time artisan goldwork still exists, albeit precariously, in Barbacoas (Nariño), Mompox (Bolivar), Condoto and San José (Chocó), where it is practised by Afro-Colombian craftsmen. During the Conquest, the hard labour in the mines was performed by black slaves, who replaced the natives, with the latter losing contact with the traditions of their ancestors. Their techniques and some symbols came into the hands of black craftsmen, who enriched this tradition with Spanish and African influences. In Mompox, goldwork designs of the Zenú style and delicate filigree work still survive. The metalwork of Chocó, executed with coins or using aluminium from objects in the home, has African influences; in Nariño there are traces of the religious art of the Colonial Period. Zoomorphic figures, designs based on stylised flowers, crucifixes, reliquaries and various geometrical motifs today represent traces of the original prehispanic creative genius, that has since been affected by multiple influences.

Ingano musicians of the Sibundoy Valley, Putumayo, 1947 (Lothar Petersen. ICANH Archive).

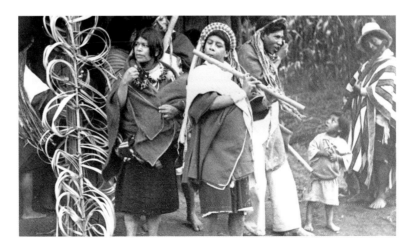

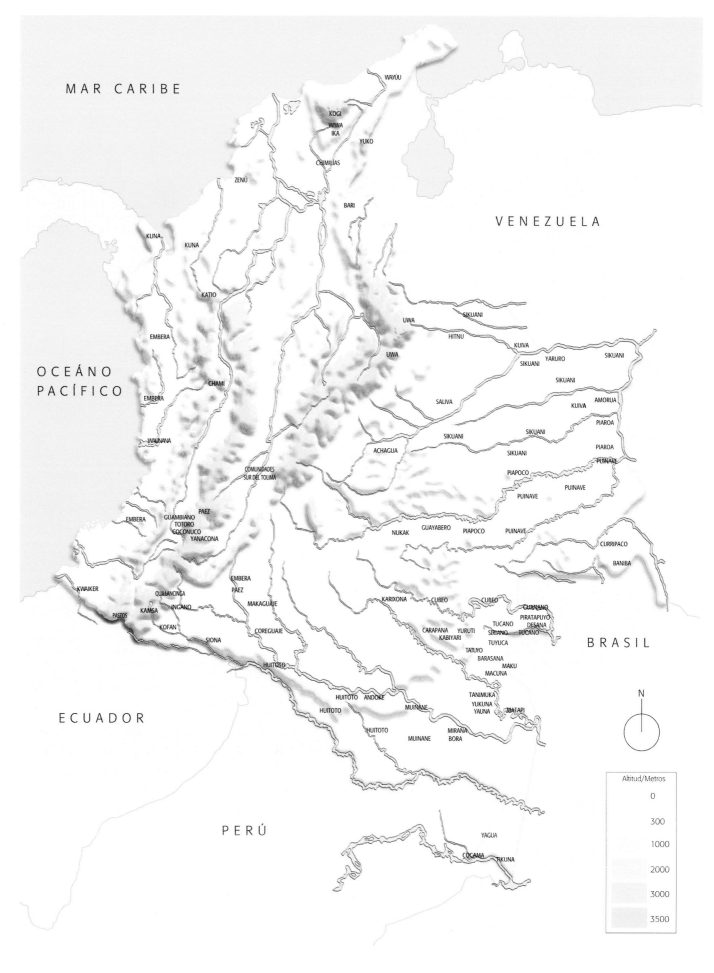

MAR CARIBE

WAYÚU

KOGI
WIWA
IKA
YUKO

CHIMILÍAS

ZENÚ

BARI

VENEZUELA

KUNA

KUNA

KATIO

UWA SIKUANI

HITNU

KUIVA

OCEÁNO
PACÍFICO

EMBERA

UWA SIKUANI YARURO SIKUANI

SIKUANI

EMBERA

CHAMI SALIVA KUIVA AMORUA

PIAROA

WAUNANA SIKUANI PIAROA

ACHAGUA SIKUANI PUINAVE

SIKUANI

COMUNIDADES PIAPOCO
SUR DEL TOLIMA PUINAVE PUINAVE

PAEZ
GUAMBIANO CURRIPACO
EMBERA TOTORO NUKAK GUAYABERO PIAPOCO PUINAVE
COCONUCO
YANACONA BANIBA

KWAIKER KARIXONA CUBEO CUBEO
QUILLANCINGA GUANANO
KAMSA PIRATAPUYO
PASTOS INGANO EMBERA TUCANO DESANA
KOFAN PAEZ CARAPANA YURUTI SIRIANO TUCANO
 MAKAGUAJE KABIYARI TUYUCA BRASIL
SIONA TATUYO
 COREGUAJE BARASANA
 MAKU
HUITOTO MACUNA

HUITOTO ANDOKE TANIMUKA
HUITOTO MUINANE YUKUNA MATAPI
 YAUNA
HUITOTO MIRANA
 MUINANE BORA

ECUADOR

N

Altitud/Metros
0
300
1000
2000
3000
3500

PERÚ

YAGUA

COCAMA TIKUNA

255

Member of Kogi indigenous people,
Sierra Nevada de Santa Marta, 1976
(Reichel-Dolmatoff Archive, BLAA).

Member of Cuna indigenous people,
Caimán Nuevo river, Gulf of Urabá, 1947
(Reichel-Dolmatoff Archive, BLAA).

Member of Wayúu indigenous people,
Carraipía, Guajira, 1953
(Reichel-Dolmatoff Archive, BLAA).

Member of Tukano indigenous people,
Pirá-Paraná, Vaupés, 1968
(Reichel-Dolmatoff Archive, BLAA).

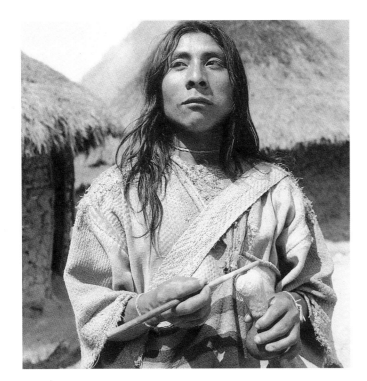
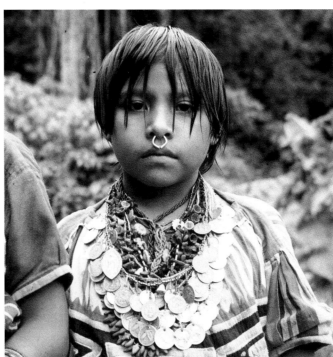
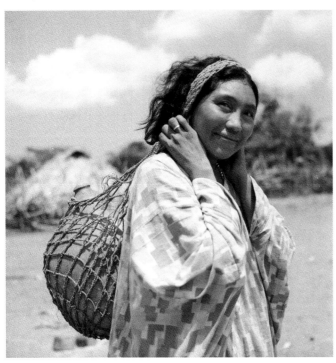
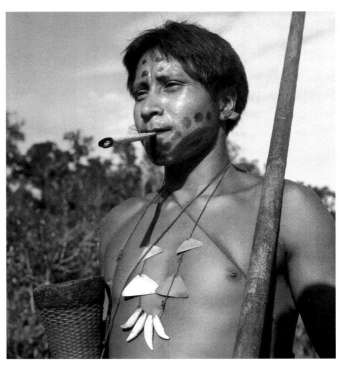

Member of Noanamá indigenous people, San Juan, River Ijúa, Pacific Coast, 1960 (Reichel-Dolmatoff Archive, BLAA).

Member of Emberá indigenous people, Catrú, River Baudó, Pacific Coast, 1960 (Reichel-Dolmatoff Archive, BLAA).

Member of Ika, Dzoagaka indigenous people, upper River Guatapurí, Sierra Nevada de Santa Marta, 1952 (Reichel-Dolmatoff Archive, BLAA).

Member of Chamí indigenous people, Corozal Region, 1945 (Reichel-Dolmatoff Archive, BLAA).

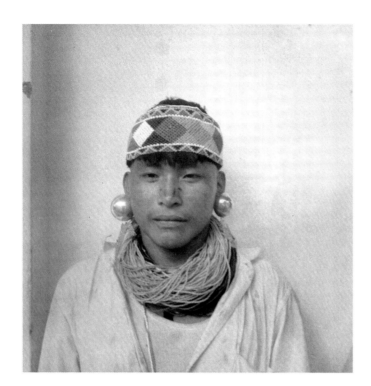
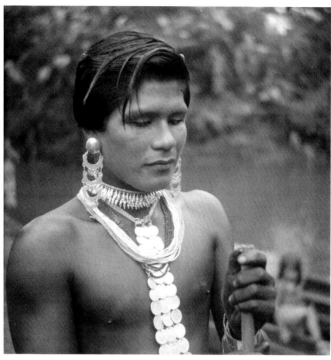
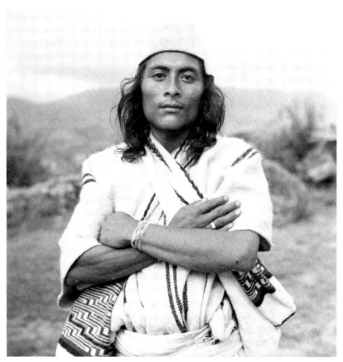
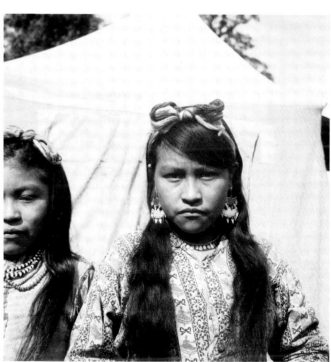

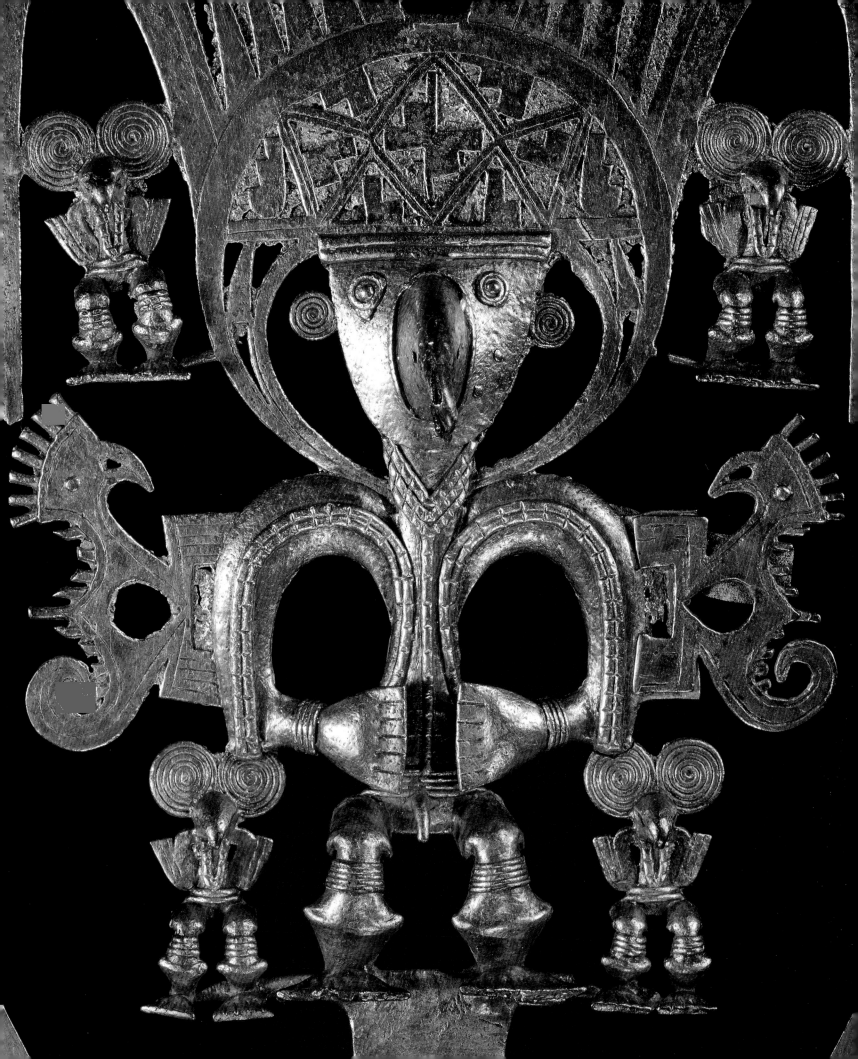

History of the Gold Museum

*Efraín Sánchez Cabra
and Clara Isabel Botero*

The Gold Museum

In 1939 the Banco de la República—founded in 1923 as the central bank of Colombia holding the monopoly on the purchase of gold—acquired an object of outstanding beauty, a Quimbaya lime container, or *poporo*, saving it from being melted down. This object was purchased from Señora Magdalena Amador de Maldonado at the request of the Ministry of Education. The Ministry also urged the Executive Committee of the bank to attempt to "purchase the gold or silver objects of indigenous manufacture and from the Pre-Columbian age, in order to conserve them" and to prevent them from leaving the country. From that moment the bank began a systematic and continuing process of acquisition of collections of prehispanic goldwork in order to conserve them. Among the first collections that the bank acquired are the Muisca collection of the Bogotá bookshop El Mensajero, and the magnificent collection of Quimbaya goldwork that had belonged to Leocadio María Arango from Antioquia, which was acquired from his heirs by the bank in 1942. A year later the bank bought 864 objects owned by Santiago Vélez, a collector from Manizales. At the end of 1943 the Banco de la República had 3,489 goldwork objects, which was the largest and most important collection of prehispanic goldwork in the world at that time. The collection had not only grown in number, but had also diversified as regards the regions of origin of its collections. Initially, the collections were made up almost exclusively of objects produced in the Quimbaya and Muisca styles from the regions of the Middle Cauca and the Eastern Andes respectively, as well as some from the Calima and Tolima regions, but the scope of the collection was expanded with the incorporation of objects from the plains of the Caribbean.

The beginning of the exhibition

Over the last sixty-five years, the Museum collection has been developed from clearly differentiated scientific, museographic, architectural and aesthetic perspectives and has been exhibited in four spaces that reflect the spirit of each age. Vis-à-vis the Museum collection, the continuing objective of the Banco de la República since 1939 has been the heritage preservation. From the early 1940s the goldwork collection was exhibited, probably in its entirety, in the boardroom of the bank. The year 1944 marked a moment of fundamental importance: the goldwork collection was designated as the "Gold Museum" when the first catalogue of the collection was published with texts by archaeologist Gregorio Hernández de Alba. Three years later, in 1947, the collection was displayed in a special hall in the Pedro A. López building and was shown for the first time in cases organised by archaeological areas, in accordance with the first classification of the collection drawn up by Mexican researcher Carlos Margain and published under the title *Estudio inicial de las colecciones del Museo del Oro del Banco de la República* (Initial study of the collections of the Gold Museum of the Banco de la República) (1945). Throughout this period, the museum was mainly open to illustrious visitors, heads of state, high-ranking foreign dignitaries, members of commercial, military and diplomatic missions, and eminent Colombians. On the occasion of the

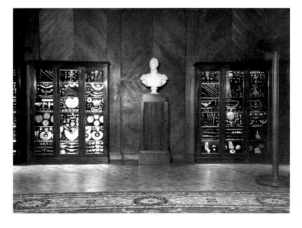
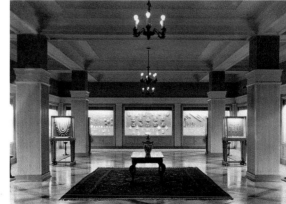

Boardroom of the Bank in the Pedro A. López building, where the goldwork collection was exhibited for the first time.

The goldwork collection was distributed around a large Persian carpet and a Chinese urn in this room for special visitors from the late 1940s until 1958.

Display case with objects in the Quimbaya style. Very characteristic of this period was the experimental presentation in the display cases, starting with the creation of highly complex settings. Heavy cloths and drapes played a key role in this assembly, covering the backs like waterfalls or concealing the bases on which the objects stood.

In the 1960s the public began to notice geometrical backgrounds to highlight objects with small formats in the Muisca style.

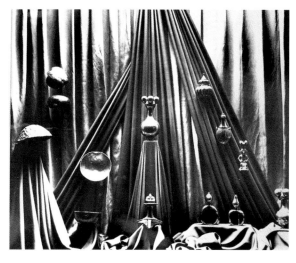 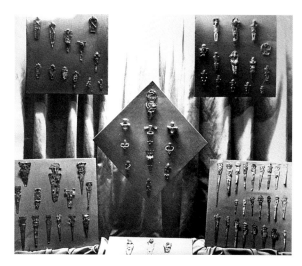

The Exhibition Room of the Museum in the basement of the Banco de la República building, where the collection was exhibited between 1959 and 1968.

celebration in Bogotá of the 9th Pan-American Conference in 1948, the second edition of the Museum catalogue was published. There, one of the main cultural commentators of the time, Gustavo Santos, wrote: "The Gold Museum is, unquestionably, the most extraordinary attraction of a cultural order that Bogotá can offer to both its own people and foreigners… Each display case… gives cause for wonder, stupor, and, at the same time, curiosity".

The collection continued to grow and diversify. In 1946 the first ceramic objects were acquired from Luis Alberto Acuña and a few months later the bank bought a collection of 264 ceramic objects from Fernando Restrepo Vélez. On the occasion of the opening of the bank building in 1959 on the corner of Avenue Jiménez and Route 7, the collection was opened to the general public for the first time in a room in the basement of the new building. The objective was therefore extended: it was no longer only to acquire and conserve, but also to exhibit the collection and make it available to the general public. At that time it already numbered more than 7,200 items. In addition to the classification work by Margain, between 1954 and 1966 the six volumes of the work *Orfebrería prehispánica de Colombia* (Prehispanic Goldwork of Colombia), by Spaniard José Pérez de Barradas, were published in Madrid, showing the classification by style or culture that would be reflected in the distribution and display of the exhibition. Maps were added to instruct and inform, a purpose that was also reflected in the bilingual

booklets in Spanish and English in front of each display case, and the archaeological information provided on the use or function of the various objects. While various ways of exhibiting the masterpieces were sought, the collection continued to grow at a sustained pace. This period was marked, in 1966, by the acquisition of a group of 215 ceramic objects, owned by Alfredo Ramos Valenzuela, and the beginning of acquisitions of conch shell and bone objects a year later.

The Modern Museum

In the 1960s a major change took place in the history of the collection: the change from exhibition rooms to a purpose-built building designed by architects Esguerra, Sáenz, Urdaneta and Samper with all the technical and museographic specifications and facilities required by a modern museum. In 1961 the Banco de la República, whose president at that time was Eduardo Arias Robledo, acquired a plot of land near its headquarters with the intention of expanding its office space by the construction of a new building and in which a complete floor was to be set aside to house the museum. To gain useful information first-hand, the architects travelled to Mexico City where the project for the construction of the National Museum of Anthropology was then under way. With the consultancy of archaeologist Luis Duque Gómez, director of the Colombian Institute of Anthropology at the time, the architects presented an ambitious project to the bank that involved the construction of not only one floor but an entire

building. Starting from a scientific description prepared by archaeologist and ethnologist Alicia Dussán de Reichel, and the selection of objects by the person who knew the collection best (Luis Barriga del Diestro, the museum director between 1939 and 1977), and a museographic design provided by British architect Alec Bright and museologist Vidal Antonio Rozo, on 22 April 1968 the Gold Museum opened its doors in its new building, which, in addition to the exhibition areas, included a room for temporary exhibitions, storage areas, a library and an area for administrative offices. The unadorned building, a firm declaration of modern architecture, was awarded first prize at the 4th Colombian Biennial of Architecture in 1970 for being, according to the jury, "a worthy, sober, well-conceived and well-executed environment … that also performs cultural functions, instructs and informs, and is of extraordinary scope for the Colombian public". The museum had three key aims: to provide information on prehispanic goldwork and pottery and to educate on this topic; to achieve an aesthetic and minimalist design, oriented towards displaying a selection of goldwork objects as works of universal art; and to create awareness through the initial strategy of accumulation and exhibition of objects in the so-called Salón Dorado (Golden Room). Following the opening in the new building, two new working areas were created: one for scientific investigation and another to furnish information to non-specialists. A team of archaeologists began to be formed, and over the last thirty years several generations of scientists have devoted their energies to the arduous, fascinating and meticulous task of classifying, describing and researching the collection. Particularly outstanding are the works and publications by the archaeologists Clemencia Plazas and Ana María Falchetti, who were respectively the Director and Technical Sub-director of the Museum. Also significant is the meticulous iconographic study of the collection conducted by archaeologist and ethnologist Gerardo Reichel-Dolmatoff, based on his major work, *Orfebrería y chamanismo* (Goldwork and shamanism). Since 1978 the *Boletín Museo de Oro* (Bulletin of the Gold Museum) began to be published, which sought to publicise the institution's most significant activities to the general public and specialists. Through its cultural policies, during the 1980s the bank forced through processes of decentralisation and democratisation

From 1968 onwards, architects and museographers made use of minimalism to create intimate atmospheres, such as this display case where the famous *popòro*, or lime container, in the Quimbaya style, with which the collection began in 1939, was exhibited.

The use of neutral backgrounds highlighted the symmetry of these exceptional objects in the Tolima style.

To create an impression of wonder inside a high-security vault, a room was fitted out in 1968 which was reached in semi-darkness. As it gradually lit up, visitors were surrounded by the bright light and splendour of thousands of ancient gold objects, *El Salón Dorado* (The Golden Room).

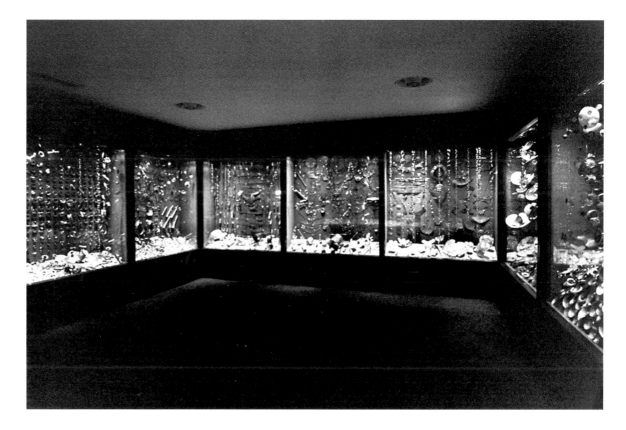

New building of the Gold Museum, inaugurated in December 2004 with the technological and functional advances required for a twenty-first-century museum.

View of a case displaying objects from the Middle Cauca region, in the Quimbaya style. Most eye-catching is the Quimbaya *poporo*.

of its cultural activities. Regional venues of the Gold Museum were therefore created in Santa Marta, Cartagena, Cali, Armenia, Pasto and Manizales, and an ethnographic museum in Leticia. The number of travelling national exhibitions to the bank's branches was increased, and cultural activities and a national strategy of educational and non-specialist information services was begun by the museum. The information activities were supplemented by guided visits and audiovisuals that supported the permanent exhibition and special efforts were made to create educational programmes aimed at children and students. Particularly significant among these were the "Maletas didácticas" (Educational schoolbags), small exhibitions containing didactic materials and replicas of archaeological objects that teachers could take to classes. The collection continued to grow and diversify, and today it has 33,800 recorded items of goldwork, 13,300 of pottery, 3,400 stone objects, 1,200 made of shell, 320 of bone, 113 archaeological wood items, 120 textile objects, and 4 mummies. Among the most important acquisitions in recent decades is the New Quimbaya Treasure, found in a tomb in Puerto Nare in the valley of the River Magdalena in 1987, and a sumptuous burial regalia and the objects found in 1992 in the cemetery of the El Bolo site, on the Hacienda Malagana in the Cauca Valley, which greatly augmented the distribution of objects of the goldwork in Colombia.

The Gold Museum enjoys enormous prestige internationally. This is proven by the great interest shown by the most important museums in the world in exhibiting its items at their venues. Between 1954 and 2004, the Museum held highly significant exhibitions at the invitation of 123 museums and galleries of recognised prestige in five continents.

The Gold Museum in the 21st century

Since 1998, the Banco de la República has been behind a project to enlarge and renovate the Gold Museum, which includes the construction of a new building, the renovation and updating of its scientific discourses, the increase in the number of objects in the permanent exhibition, technological updating for the preventive conservation of its collections, the incorporation of new services for the general public, academics and the young. Also the renovation of the museographic systems to display the exceptional and very delicate collections. In a contemporary way, the aim has been to provide scientific information, enjoyment for the public, and the preservation of the collections in aesthetic settings. The project was envisaged in two stages: in December 2004 the new building was opened to the public and in 2008 the old building is to be reopened, together with the new one. At that moment, the museum will have 13,000 m^2 of floor space, four themed galleries for permanent exhibitions, another gallery for temporary exhibitions, and the *Exploratorio* (Discovery Area), a special room for the young. Added to these innovations is a new narration of the cycle of the ancient metalworking in Colombia: it describes how gold is extracted, worked, used, symbolised and offered, before being returned to the earth. Also added, for more detailed study by the public, are special visits and educational animations, a knowledge discovery area, multidisciplinary cultural activities and a multimedia room linked to the technological "brain" of the museum, all of which are designed to increase visitors'

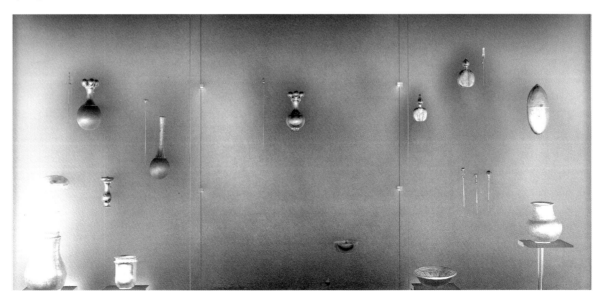

Reference to human figures, who used goldwork objects in the Muisca style in their lives or as part of their funeral trousseaux.

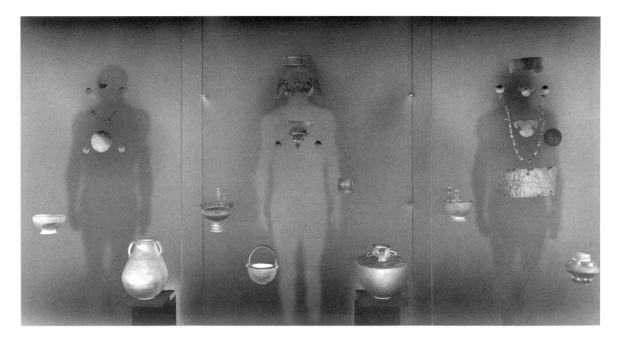

desire to return. The archaeologist Roberto Lleras, the Technical Sub-director, and the museum's team of archaeologists have developed a research project, one of the results of which is a new, themed scientific and museographic script, which brings together the results of research into the collection and Colombian archaeology over recent decades by the museum's archaeology team. Since the museum has had a strong influence on the cultural understanding of the Colombian public, and since its collections allow multiple interpretations to be made, the concept behind the new script is cyclical and all-embracing: *What is extracted from the earth—the metals and clay—is transformed, used, symbolised and returned to the earth as offerings.* In parallel to analysis of the scientific information begun in the late 1990s, discussions were started in the field of museography with the aim of producing a design that would focus on the collection's proposed themes for each of the major units in the future museum. Also analysed were the museographic systems used to conserve and display the collection, which led to the decision to renovate the type and function of the display cases, lighting and supports to ensure the optimum display and conservation of the collection. For this, architect Roberto Benavente and his team from the HB Design company were called in as consultants. The design and mounting of the project by the museum's museography team, under the direction of architect Efraín Riaño, required complex interaction between the display systems with the collection, the scientific script, the architectural design of the finished building (as in the 1960s designed by architect Germán

Samper and his GX Samper team), the museum's security requirements, and the incorporation of information and technological systems suitable for a museum in the twenty-first century.

For Colombian visitors, the Gold Museum is a symbol of identity and national pride. The museum has made a major contribution to appreciation of the country's prehispanic societies as an essential part of the nation's history, and to the profile of today's indigenous communities. This is a sentiment recorded repeatedly in the visitors' book.

Glossary

Alcarraza – Twin-spouted jar. A ceramic vessel with a double spout and bridge-handle used to hold liquids, mainly for funerary use.

Alluvium. Mud, sand, clay, gravel or loose material deposited by water currents. Alluvium deposits are natural accumulations of minerals or rocky materials that are formed after transportation through water and subsequent sedimentation. These deposits are one of the sources of gold in nature.

Anthropomorphic. Having a human form.

Application for cloth. An object, generally flat and with two holes, that was sewn onto a textile.

Application for the skin. An ornament for the face composed of a short wire and a top with a spherical, discoid, conical or other shape. It is inserted into a hole pierced in the skin in places such as the nostrils, chin or corners of the mouth.

Baton top. An object fitted to the end of a ceremonial baton, often decorated with a human or animal figure.

Breastplate. An ornament for the chest, generally flat and large, which was hung from the neck on a rope.

Burial regalia. A set of elements, devices, decorations and offerings deposited with the deceased's remains in the tomb. They may be objects of personal property, offerings to the dead person's spirit or provisions for the spirit on its journey to the afterlife.

Cast filigree. A goldwork technique in which lines of wax are used to form fine fretwork designs that are then reproduced in metal using the lost-wax casting method. The final result is similar to the filigree work in which the wires are joined by welding.

Coca. A plant of the genus *Erythroxylum* that grows in the American tropics, the leaves of which contain potent alkaloids, including cocaine. Numbered among its effects are the sharpening of intelligence, memory and speech, and the mitigation of sensations of hunger, thirst and fatigue.

Coiled. The form of, for example, a nose or ear ornament, i.e., in the form of coiled wire.

Depletion gilding. A finishing technique used in goldwork to give a golden colour to the surface of reddish objects made of *tumbaga*. The object was heated to produce the oxidation of the surface copper, the products from which were removed with acids obtained from plants, thus creating a thin layer rich in gold; the process was repeated a variable number of times, depending on the thickness of the gilding desired.

Diadem. A strip or decoration to encircle the forehead. As a decoration, it was used attached to a strip of cloth.

Ear ornament. A decoration for the ear, used in pairs, that was worn hanging or inserted into a hole pierced in the lobe.

Ear pendant. An ornament to be hung from an ear ornament with a ring shape. They were worn in pairs.

Embossing. A technique for working metals used to produce ornamental designs in relief on a sheet, using tools such as chisels, burins, hammers and others.

Gavia. The term employed by the Spaniards to denote the sacrificial stake used by the Muisca of the Altiplano of Cundiboya to offer young individuals of other groups and birds to their deities.

Hallucinogen. A plant or other substance that disrupts the central nervous system and is therefore able to produce visual, sound, olfactory and tactile sensations. They are used by shamans to achieve trance states and to travel to the supernatural world.

Hammering. A technique for working metals in which a cast nugget or ingot is hit carefully with a hammer until a sheet of the desired thickness is obtained. It requires alternate processes of working and heating the piece.

Hunter-gatherers. The collective name for the members of small-scale nomadic or semi-sedentary societies whose subsistence is based mainly on hunting and gathering wild plants and fruits. They are organised in bands with strong kinship ties.

Hypogeum. An underground tomb of considerable size reproducing the architectural structure of a building.

Icon. A figure whose representation is governed by strict rules, through which a society transmits and fixes ideas on its world view. They are identifiable as they are images that are repeated regularly in the material culture of a people.

Impression. The reproduction of images, hollowed out or in relief, in any soft or ductile material.

Jadeite. A metamorphic rock, a variety of jade, with a vivid green colour.

Lost-wax casting. A technique for working metals in which a model of the object made of beeswax is covered with a clay mould, inside which the molten metal is deposited later.

Mummification. A process that, over the course of time, through natural causes or an artificial preparation, dries and preserves the soft tissues and skin of the cadaver.

Negative painting. An ornamental technique used in pottery that consists in covering some parts of the vessel with wax, so that when the paint is applied the design stands out against the background colour.

Nose ornament. An object for decoration or with another cultural significance that was used suspended from the nose by means of pressure or through a hole pierced in the skin.

Ornithomorphic. With the form of a bird.

Pan pipes. Musical wind instrument consisting of a series of pipes of different lengths, tied together with thin ropes.
Pendant. An ornament for the neck that was used hanging from a string.

Phytomorphic. With the form of a plant.

Poporo or lime container. A container used to hold the lime powder, generally obtained from sea snails, used in the

chewing of coca leaves. It has a small hole in its upper part, where the stick is inserted to extract the alkaline powder.

Primary burial. A ritual practice of treating the dead in which the corpse is deposited inside an underground structure specially built for this purpose.

Rotating disc. A flat circular object made to rotate while suspended from a thread. The thread was fastened to a hole in the centre of the disc.

Secondary burial. The burial of the exhumed bones, almost always inside a vessel and in a tomb, accompanied by a ceremony to assign a new status to the deceased person.

Shaft tomb. An underground burial structure consisting of a hole and an enclosure to which entry is gained from the bottom of the hole.

Shaman. The religious specialist of indigenous societies, doctor, savant and expert in mythology. They possess a profound knowledge of the techniques of the trance, which they use to establish communication between the levels of the cosmos and to act as mediators between society and the gods.

Shamanism. The set of religious beliefs and practices that suppose the existence of various realities (some of which are invisible and immaterial) and a stratified cosmos, to which some specialists gain access during altered states of consciousness. It explains and regulates the relations between society, nature and the spirits.

Stick for lime. A rod that is pointed at one of its ends and finishes in a decorative tip at the other, used to extract the lime from the *poporo* and to carry it to the mouth, where it is mixed with the coca leaves. Some could also be used to pin clothing.

Sublabial ornament. An object to adorn or transform the lower part of the face. It was either inserted into a hole under the lower lip or suspended from it.

Tola. A small mound of earth, natural or artificial, where the bodies of important figures were buried and dwellings were located to avoid floods.

Trance. A state of mind different to that of ordinary consciousness, achieved through the consumption of hallucinogenic plants, meditation, fasting, visual or oral stimuli or other means.

Tray for hallucinogen. A rectangular or triangular plate where hallucinogenic snuffs were deposited to be inhaled.

Tumbaga. An alloy of gold and copper, with a reddish colour, often used in the prehispanic goldwork of Colombia.

Urn. A recipient used to hold the remains or ashes of the dead, almost always specially made for this purpose.

Votive figure. The representation on a small scale of people, animals or objects manufactured to be offered to deities in lagoons, caves or other sacred places.

Whistling vase. A vessel for liquids, almost always with a double body, with a bridge-handle and a spout. It was made so that the sound of a whistle is produced through a hole when the liquid is poured through the spout.

Yajé. A wild liana of the genus *Banisteriopsis*, from which a potent hallucinogenic drink is extracted.

Yopo. A hallucinogenic snuff prepared with the seeds of the *Anadenanthera peregrina*.

Zoomorphic. With the form of an animal.

Bibliography

Acosta, Joaquín. *Compendio histórico del descubrimiento y colonización de la Nueva Granada en el siglo décimo sexto*. Paris, 1848.

Aguado, Pedro. *Recopilación Historial*. Bogotá, (1582) 1956.

Arango, Leocadio María. *Catálogo del Museo*. Medellín, 1905.

Arango Cano, Luis. *Recuerdos de la guaquería en el Quindío*. Bogotá, 1924.

Arbeláez, José Fernando and Eduardo Londoño. "La informática al servicio de la museografía en la transformación del Museo del Oro", in *Boletín Museo del Oro*, 55 (2004), Banco de la República, Museo del Oro, Bogotá.

Archila, Sonia. *Los tesoros de los señores de Malagana*. Bogotá: Banco de la República, 1996.

Archila, Sonia, Ana María Falchetti, Clemencia Plazas and Juanita Sáenz Samper. *La sociedad hidráulica Zenú. Estudio arqueológico de 2.000 años de historia en las llanuras del Caribe colombiano*. Bogotá: Banco de la República, 1993.

Archila, Sonia and Jimena Lobo Guerrero. *Museo del Oro-Ampliación-Unidad 3, Sinopsis de contenido, Calima*. Unpublished, Bogotá, 1999.

—————. *Museo del Oro-Ampliación-Unidad 3, Sinopsis de contenido, Sociedad y poder en el Alto Magdalena*. Unpublished, Bogotá, 1999.

—————. *Museo del Oro-Ampliación-Unidad 3, Sinopsis de contenido, Vida y muerte en Tierradentro*. Unpublished, Bogotá, 1999.

Ardila Calderón, Gerardo. "El poder en escena: Colombia prehispánica", in *El poder en escena, Colombia prehispánica*. Mexico City: National Museum of Anthropology, July–September 1998.

Ardila Calderón, Gerardo and Cristóbal Gnecco. *El poder en escena. Colombia prehispánica*, Bogotá: Banco de la República, and Consejo Nacional para la Cultura y las Artes de México, Ministerio de Cultura, Colombia, 1998.

Banco de la República. *El Museo del Oro*. Bogotá: 1944.

—————. *El Museo del Oro*. Bogotá: 1948.

—————. *Museo del Oro, 50 años*. Bogotá: 1989.

—————. *Museo del Oro, sus mejores piezas. The Gold Museum, Master Works*. Bogotá: 1997.

—————. *Colecciones*. Bogotá: 1998.

—————. *El Mar, eterno retorno*. Exhibition catalogue. Bogotá: 1998.

—————. *Oro y jade, emblemas de poder en Costa Rica*. Exhibition catalogue. Bogotá: 1999.

—————. *Arte colombiano, 3.500 años de arte en Colombia*. Bogotá: Banco de la República and Villegas Editores, 2001.

—————. *Museo del Oro quimbaya*. Bogotá: 2003.

—————. *Museo del Oro. Una mirada desde la arqueología*. Bogotá: 2004.

—————. *Museo del Oro. Una mirada desde el chamanismo*. Bogotá: 2004.

Barandica, Fernando S. "La restauración de objetos cerámicos en el Museo: un estudio de caso", in *Boletín Museo del Oro*, 28 (July–September 1990), Banco de la República, Bogotá.

Bennett, Wendell, Clark. "Archaeological Regions of Colombia: A Ceramic Survey", in *Yale University Publications in Anthropology*, 30 (1944).

Botero, Clara Isabel. *The construction of the Prehispanic Past of Colombia: Collections, Museums and Early Archaeology*. PhD thesis, University of Oxford, 2001.

—————. "La renovación y ampliación del Museo del Oro del Banco de la República en Bogotá, Colombia, 2004–2007", in *Boletín Museo del Oro*, 55 (2004), Banco de la República, Bogotá.

—————. "Los conceptos y las miradas a la metalurgia prehispánica de Colombia, las exhibiciones permanentes del Museo del Oro, 1940–1968", in *Journal de la Societé des Américanistes* (2005), Paris.

Botiva Contreras, Álvaro and Eduardo Forero Lloreda. "Malagana, guaquería vs. Arqueología", in *Boletín Museo del Oro*, 24 (May–August 1989), Banco de la República, Gold Museum, Bogotá.

Bouchard, Jean-François, Inés Cavelier, Alicia Dussan de Reichel, Luisa Fernanda Herrera, Anne Legast, Roberto Lleras, and Roberto Pineda Camacho. *Les Esprits, l'Or et le Chamane*. Paris: Réunion des Musées Nationaux, Musée de l'Or de Colombie, 2000.

Bray, Warwick, *The Gold of El Dorado*. Exhibition catalogue. London: The Royal Academy of Arts, 1978.

Bray, Warwick; Marianne Cardale de Schrimpff; Leonor Herrera; Theres Gähwiler-Walder. *Calima. Colombie Précolombienne*. Lausanne, 1991.

Bright, Alec, "Informe de Actividades del Jefe Museología 1966–1983", Museo del Oro, manuscript, undated.

Caldas, Francisco José. "Estado de la geografía del virreinato de Santa Fé de Bogotá con relación a la economía y el comercio" in *Semanario del Nuevo Reino de Granada*. Bogotá, 1942.

Cardale de Schrimpff, Marianne. *Caminos prehispánicos en Calima*. Bogotá: Fundación de Investigaciones Arqueológicas Nacionales, Banco de la República, 1996.

Cardale de Scrimpff, Marianne; Warwick Bray; Leonor Herrera. "Reconstruyendo el pasado en Calima", in *Boletín Museo del Oro*, 31 (1991) pp. 125–29, Banco de la República, Gold Museum, Bogotá.

Codazzi, Agustín. "Jeografía Física i Política de la Providencia de Antioquia", in *Gaceta Oficial*, 1710 (23 March 1854), Bogotá.

De Castellanos, Juan. *Obras de Juan de Castellanos*. Bogotá, 1955.

Delgado Cerón, Ivonne and Clara Isabel Mz-Recamán. "El Museo como ente educador", in *Boletín Museo del Oro*, 28 (July–September 1990), Banco de la República, Bogotá.

Duncan, Ronald J. "Arte precolombino, estética", in *Gran Enciclopedia de Colombia*, vol. 6. Bogotá: Círculo de Lectores, 1993.

Duque Gómez, Luis. "Los últimos hallazgos arqueológicos en San Agustín", in *Revista del Instituto Etnológico Nacional*, 2 (1946) pp. 5–24, Bogotá.

—————. *Colombia: monumentos históricos y arqueológicos*, 2 vols. Mexico City, 1955.

—————. "Notas históricas sobre la orfebrería prehispánica en Colombia", in *Homenaje a Paul Rivet*. Bogotá, 1958.

—————. *Exploraciones arqueológicas en San Agustín*. Bogotá, 1964.

—————. "Etnohistoria y Arqueología", in *Historia Extensa de Colombia*, vol. 1, pp. 15–441. Bogotá, 1965.

—————. *Los Quimbayas. Reseña etnohistórica Museo del Oro*. Bogotá, 1970; Paris, 1982.

—————. "El Estado y la Ciencia en Colombia en el siglo XIX", in *Separata de la Revista de la Academia de Ciencias Exactas, Físicas y Naturales*, pp. 405–14. Bogotá, May 1990.

—————. "El oro de los indios en la historia de Colombia", in *Boletín Museo del*

Oro, 28 (July-September 1990), Banco de la República, Gold Museum, pp. 3–13.

Duquesne, José Domingo. "Disertación sobre el calendario de los muiscas", in Joaquín Acosta, *Compendio histórico del descubrimiento y colonización de la Nueva Granada en el siglo décimo sexto*. Paris, 1848.

————. "Sacrificios de los muiscas y significación o alusiones de los nombres de sus víctimas" (1795), in *Papel Periódico Ilustrado*, 68 (1884), pp. 313–16.

Dussán de Reichel, Alicia. *Colombia: Orfebrería prehispánica*. Paris: 1971.

————. "Paul Rivet y su época" in *Correo de los Andes*, 26 (May–June 1984), pp. 70–76, Bogotá.

Esguerra Sáenz Urdaneta Samper & Cia., "Informe del viaje a México de los arquitectos Álvaro Sáenz y Germán Samper sobre el Museo del Oro", Bogotá, 1966, manuscript.

Falchetti, Ana María. "Pectorales acorazonados", in *Boletín Museo del Oro*, Year 1 (1978), Banco de la República, Bogotá.

————. "Colgantes 'Darién'", in *Boletín Museo del Oro*, Year 2 (1979), Banco de la República, Bogotá.

————. "La tierra del oro y el cobre: parentesco e intercambio entre comunidades orfebres del norte de Colombia y áreas relacionadas", in *Boletín Museo del Oro*, 34–35 (January–December 1993), Banco de la República, Bogotá.

Falchetti, Ana María and Clemencia Plazas. "Orfebrería Prehispánica de Colombia", in *Boletín Museo del Oro*, Year 1 (September–December 1978), Banco de la República, Bogotá.

Fernández de Oviedo, Gonzalo. *Historia general y natural de las Indias*, vol. 4. Madrid, 1855.

Fundación La Caixa. *Los espíritus, el oro, el chamán*. Exhibition catalogue. Salamanca: 2003.

Gnecco, Cristóbal. "Praxis científica en la Periferia: notas para una historia social de la arqueología colombiana", in *Revista Española de Antropología Americana*, pp. 9–22, (1995), Madrid.

————. (ed.). *Perspectivas regionales de la arqueología del suroccidente de Colombia y norte del Ecuador*. Popayán, 1995.

————. "El poder en las sociedades prehispánicas de Colombia: un ensayo de interpretación", in *El poder en escena, Colombia prehispánica*. Mexico City: National Museum of Anthropology, July–September 1998.

————. "Sobre el discurso arqueológico en Colombia", in *Boletín de Antropología*, vol. 13, pp. 147–65, 30 (1999), Medellín.

Gómez del Corral, Luz Alba. *Museo del Oro-Ampliación-Unidad 3, Sinopsis de contenido, Nariño*. Unpublished, Bogotá, 1999.

Gómez del Corral, Luz Alba, Juanita Sáenz Obregón, and Francisco Vega Barrantes. "La gestión de las colecciones, un trabajo interdisciplinario: Su organización, traslado y almacenamiento", in *Boletín Museo del Oro*, 52 (2004), Banco de la República, Bogotá.

Gómez del Corral, Luz Alba, Roberto Lleras Pérez, Juanita Sáenz Obregón. "La conservación de colecciones en el marco de la renovación del Museo del Oro", in *Boletín Museo del Oro*, 52 (2004), Banco de la República, Bogotá.

Hernández de Alba, Gregorio. *Colombia, compendio arqueológico*. Bogotá, 1938.

————. "Los chibchas en la Exposición Arqueológica", in *Cromos*, 1138 (17 September 1938), Bogotá.

————. "De la Exposición Arqueológica, arte quimbaya", in *Cromos*, 1139 (24 September 1938), Bogotá.

————. "De la Exposición Arqueológica, San Agustín y Tierradentro", in *Cromos*, 1140 (1 October 1938), Bogotá.

————. "El Museo del Oro", in *El Museo del Oro*. Bogotá: Banco de la República, 1944.

Instituto Colombiano de Antropología. *Colombia prehispánica, regiones arqueológicas*. Bogotá, 1989.

Jaramillo, Luis Gonzalo and Augusto Oyuela-Caicedo. "Colombia: a quantitative analysis", in Oyuela-Caicedo, Augusto (ed.). *History of Latin American Archaeology*, pp. 49–68, Avebury, 1994.

Jiménez, Edith. "El Museo del Oro", in *Revista Libertador*, (February–March 1952), pp. 29–30.

Jiménez, Miriam. "Los indígenas colombianos hoy", in *Revista Credencial Historia*, 33 (September 1992).

Jiménez de Quesada, Gonzalo. *Epítome de la Conquista del Nuevo Reino de Granada*, prologue and commentaries by Carmen Millán de Benavides. Bogotá, 2001.

Julián, Antonio. *La Perla de América, la Provincia de Santa Marta* (1797). Bogotá, 1980.

Labbé, Armand J. et al. *Shamans, Gods, and Mythic Beasts: Colombian Gold and Ceramics in Antiquity*. Exhibition catalogue. New York: The American Federation of Arts, 1998.

Langebek, Carl Henrik. *Arqueología colombiana, ciencia, pasado y exclusión*, vol. 3. Bogotá: Colección Colombia Ciencia y Tecnología, Colciencias, 2003.

Legast, Anne. *La fauna en la orfebrería Sinú*. Bogotá: Fundación de Investigaciones Arqueológicas Nacionales, Banco de la República, 1980.

————. "La fauna mítica Tairona", in *Boletín Museo del Oro*, Year 5 (1982), Banco de la República, Bogotá.

————. *El animal en el mundo mítico tairona*. Bogotá: Fundación de Investigaciones Arqueológicas Nacionales, Banco de la República, 1987.

————. *La fauna en el material precolombino Calima*. Bogotá: Fundación de Investigaciones Arqueológicas Nacionales, Banco de la República, 1993.

Lleras Pérez, Roberto. "Las exposiciones temporales e itinerantes", in *Boletín Museo del Oro*, 28 (July–September 1990), Banco de la República, Bogotá.

————. "Las estructuras del pensamiento dual en el ámbito de las sociedades indígenas de los andes orientales", in *Boletín Museo del Oro*, 40 (January–June 1996), Banco de la República, Bogotá.

————. *Museo del Oro-Ampliación-Unidad 3, Sinopsis de contenido, Muiscas*. Unpublished, Bogotá, 1999.

————. *La metalurgia prehispánica en el norte de Suramérica: una visión de conjunto*. 51st International Congress of Americanists, manuscript of the Gold Museum, Bogotá, 2003.

————. "La creación del guión científico de la remodelación del Museo del Oro", in *Boletín Museo del Oro*, 52 (2004), Banco de la República, Bogotá.

Londoño, Eduardo. "Un mensaje del tiempo de los muiscas", in *Boletín Museo del Oro*, 16 (May–July 1986), Banco de la República, Bogotá.

————. "Santuarios, santillos, tunjos: objetos votivos de los muiscas en el siglo XVI", in *Boletín Museo del Oro*, 25 (1989), Banco de la República, Bogotá.

————. "El lugar de la religión en la organización social muisca", in *Boletín Museo del Oro*, 40 (January–June, 1996), Banco de la República, Bogotá.

————. "Método a dos voces: la construcción de múltiples miradas en la educación en el Museo del Oro", in *Boletín Museo del Oro*, 52 (2004), Banco de la República, Bogotá.

Londoño Vélez, Santiago. *Museo del Oro 50 años*. Bogotá: Banco de la República, 1989.

Margain, Carlos. *Estudio inicial de las colecciones del Museo del Oro del Banco de la República*. Bogotá: Banco de la República, 1950.

Mason, Alden. "Archaeological Researches in the Region of Santa Marta", in *Compte-Rendu de la XXI Session, Congrès International des Américanistes tenue à Goteborg en 1924*, pp. 159–66. Gothenburg: 1925.

————. *Archaeology of Santa Marta, Colombia, The Tairona Culture, Part I, Report on Fieldwork*. Chicago, 1931.

————. *Archaeology of Santa Marta, Colombia, The Tairona Culture, Part II, Section I, Objects of Stone, Shell, Bone and Metal*. Chicago, 1936.

————. *Archaeology of Santa Marta, Colombia, The Tairona Culture, Part II, Section II Objects of Pottery*. Chicago, 1939.

Mendoza Vargas, Sandra Patricia. *Museo del Oro-Ampliación-Unidad 3, Sinopsis de contenido, Arqueología en el Tolima*. Unpublished, Bogotá, 1999.

————. *Museo del Oro-Ampliación-Unidad 3, Sinopsis de contenido, Tumaco, la gente del manglar*. Unpublished, Bogotá, 1999.

Molina, Luis Fernando. *Empresarios colombianos del siglo XIX*. Bogotá, 1998.

Mora Camargo, Santiago (coordinator). *Ingenierías prehispánicas*. Bogotá, 1990.

Obando, Pablo. "Una nueva tecnología de montaje de colecciones: soportes de acero para objetos arqueológicos", in *Boletín Museo del Oro*, 52 (2004), Banco de la República, Bogotá.

Pérez de Barradas, José. *Orfebrería prehispánica de Colombia: estilo Calima*, 2 vols. Madrid: Banco de la República, 1954.

————. *Orfebrería prehispánica de Colombia: estilos Tolima y Muisca*, 2 vols. Madrid: Banco de la República, 1958.

————. *Orfebrería prehispánica de Colombia: estilos Quimbaya y otros*, 2 vols. Madrid: Banco de la República, 1965–1966.

Pineda Camacho, Roberto. "Intérpretes de milenios de diversidad", in *Catálogo-*

guía exposición permanente de Arqueología. Bogotá: Museo Nacional de Colombia, Instituto Colombiano de Antropología, 1994.

_____. "Reliquias y antigüedades de los indios, precursores del Americanismo en Colombia", in *Journal de la Société des Américanistes*, 83 (1997) Paris.

_____. "Demonología y Antropología en el Nuevo Reino de Granada, siglos XVI-XVII", in *Seminario sobre religiones*. Bogotá, 2000.

_____. "El doctor Luis Duque y su contribución a la antropología colombiana", in *Boletín de Historia y Antigüedades*, 813 (2001), Bogotá.

Pineda Giraldo, Roberto. "Inicios de la Antropología en Colombia", in *Revista de Estudios Sociales*, 3 (June 1999), Bogotá.

Plazas, Clemencia. *Nueva metodología para la clasificación de orfebrería*. Bogotá: Jorge Plazas Ed., 1975.

_____. "Tesoro de los Quimbayas y piezas relacionadas", in *Boletín Museo del Oro*, Year 1 (May–August 1978), Banco de la República, Bogotá.

_____. "Clasificación de objetos de orfebrería precolombina según su uso", in *Boletín Museo del Oro*, Year 3 (1980), Banco de la República, Bogotá.

_____. "Forma y función en el oro tairona", in *Boletín Museo del Oro*, 19 (1987), Banco de la República, Bogotá.

_____. "Cronología de la metalurgia colombiana", in *Boletín Museo del Oro*, 44–45 (January–December 1998), Banco de la República, Bogotá.

Plazas, Clemencia and Ana María Falchetti. *El Dorado: Colombian Gold*. Exhibition catalogue. Australian Art Exhibitions Corporation Limited, 1978.

Plazas, Clemencia and Eduardo Londoño. *Museo del Oro, sus mejores piezas*. Bogotá: Banco de la República, 1977.

Preuss, Konrad Theodor. *Arte monumental prehistórico. Excavaciones hechas en el Alto Magdalena y San Agustín, Colombia*. Bogotá, 1931.

Reichel-Dolmatoff, Gerardo. *Colombia, People and Places*. London, 1964.

_____. *San Agustín, A Culture of Colombia*. London, 1972.

_____. "Things of beauty replete with meaning: Metals and crystals in Colombian Indian cosmology", in *Sweat of the Sun, Tears of the Moon: Gold and Emerald Treasures from Colombia*. Los Angeles: 1981.

_____. *Orfebrería y chamanismo: un estudio iconográfico del Museo del Oro*. Medellín: Editorial Colina, 1988.

_____. *Indios de Colombia*. Bogotá: Villegas Editores, 1993.

_____. *Arqueología de Colombia*, Bogotá, 1997.

Reichel-Dolmatoff, Gerardo and Alicia de Reichel. "Investigaciones arqueológicas en el Departamento del Magdalena, Colombia, 1946–1950", parts 1 and 2, in *Boletín de Arqueología*, 3 (1951), Bogotá.

Restrepo, Vicente. *Estudio sobre las minas de oro y plata en Colombia*. Bogotá, 1952.

Reyes Osma, Liliana. "Memoria orfebre en la joyería contemporánea", in *Boletín Museo del Oro*, 17 (July–December 1994).

Riaño, Efraín. "La museografía del Museo del Oro", in *Boletín Museo del Oro*, 52 (2004), Banco de la República, Bogotá.

Rivet, Paul. "L'Orfevrerie Colombienne, Technique, Aire de Dispersion, Origine", in *Proceedings of the XXI International Congress of Americanists*, 2 vols., pp. 15–28 and two plates. The Hague, 1924.

_____. "La etnología, ciencia del hombre", in *Revista del Instituto Etnológico Nacional*, vol. 1, pp. 1–6, 1 (1943), Bogotá.

_____. "Justus Wolfram Schottelius", in *Boletín de Arqueología*, vol. 11, pp. 195–99, 3 (July-September 1946), Bogotá.

Rodríguez Freyle, Juan. *El Carnero, Conquista i descubrimiento del Nuevo Reino de Granada de las Indias Occidentales del Mar Océano i fundación de la ciudad de Santa Fe de Bogotá, primera de este reino donde se fundó la Real Audiencia i chancillería*. Bogotá, 1859.

Sáenz Obregón, Juanita. "Notas sobre la restauración y conservación de los metales precolombinos", in *Boletín Museo del Oro*, 28 (July–September 1990), Banco de la República, Bogotá.

Sáenz Samper, Juanita. "Mujeres de barro: estudio de las figurinas cerámicas de Montelíbano", in *Boletín Museo del Oro*, 34–35 (January–December 1993), Banco de la República, Bogotá.

_____. *Museo del Oro-Ampliación-Unidad 3, Sinopsis de contenido, Tairona*. Unpublished, Bogotá, 1999.

_____. *Museo del Oro-Ampliación-Unidad 3, Sinopsis de contenido, Zenú*. Unpublished, Bogotá, 1999.

_____. "Retos en el tránsito del conocimiento arqueológico al museo:

las llanuras del Caribe y la Sierra Nevada de Santa Marta", in *Boletín Museo del Oro*, 52 (2004), Banco de la República, Bogotá.

Samper Gnecco, Germán. "El Museo del Oro, de la Sala de Juntas del Banco de la República a la Calle Palau", in *Revista del Banco de la República* (March 1968) Bogotá.

Sánchez Cabra, Efraín. "El Museo del Oro", in *Boletín Cultural y Bibliográfico*, 64 (2004), Banco de la República, Bogotá.

Schottelius, Justus Wolfram. "Estado actual de la arqueología colombiana", in *Boletín de Arqueología*, vol. 11, pp. 201–12, 3 (July-September 1946), Bogotá.

Simón, Pedro, *Noticias historiales de las conquistas de tierra firme en las Indias Occidentales*. Bogotá, 1981.

Universidad de Salamanca. *Los espíritus, el oro, el chamán*. Exhibition catalogue, Salamanca, 2002.

Uribe Ángel, Manuel. *Geografía general y compendio histórico del Estado de Antioquia en Colombia*. París, 1885.

Uribe, María Alicia. "Introducción a la orfebrería de San Pedro de Urabá, una región del noroccidente colombiano", in *Boletín Museo del Oro*, 20 (1988), Banco de la República, Bogotá.

_____. "La orfebrería quimbaya tardía. Una investigación en la colección del Museo del Oro", in *Boletín Museo del Oro*, 31 (1991), Banco de la República, Bogotá.

_____. *Museo del Oro-Ampliación-Unidad 3, Sinopsis de contenido, Cauca, un mundo mítico saturado de transformación*. Unpublished, Bogotá, 1999.

_____. *Museo del Oro-Ampliación-Unidad 3, Sinopsis de contenido, Quimbaya*. Unpublished, Bogotá, 1999.

_____. *Museo del Oro-Ampliación-Unidad 3, Sinopsis de contenido, Urabá y Chocó*. Unpublished, Bogotá, 1999.

_____. *Museo del Oro quimbaya*. Bogotá: 2003.

_____. "Desde la mirada del arqueólogo-curador. La construcción de los guiones de la región del Cauca Medio y el Vuelo Chamánico para el Museo del Oro 2004", in *Boletín Museo del Oro*, 52 (2004), Banco de la República, Bogotá.

_____. "Una visión integral del mundo" in *Museo del Oro, Una Mirada desde el Chamanismo*. Bogotá: Banco de la República, 2004.

Uricoechea, Ezequiel. *Memoria sobre las antigüedades neogranadinas*. Berlín, 1854.

Von Humboldt, Alexander. *Researches Concerning the Institutions and Monuments of the Ancient Inhabitants of America with Descriptions of the Views of some of the Most Striking Scenes in the Cordilleras*, 2 vols. London, 1814.

Zerda, Liborio. "Antigüedades indígenas", in *Anales de la Universidad*, 6 (1 January 1874), pp. 180–86, Bogotá.

_____. *El Dorado: estudio histórico, etnográfico y arqueológico de los chibchas*. Bogotá, 1883.